CLAUDE MONET

Text by Serge George

Concept and design by Julia and Sophie Ferloni

KONECKY&KONECKY

Konecky & Konecky
156 Fifth Ave.
New York, NY 10010

Copyright © 1994 Edita S.A. Lausanne, Switzerland
English translation Copyright © 1994 Edita S.A. Lausanne,
Switzerland

All photographs from the archives of Edita S.A. and Office du Livre,
Lausanne, Switzerland and The Roger-Viollet Agency, Paris

ISBN: 1-56852-113-8

30167323 3/04

Manufactured in France

DISCOVERING
A CALLING
1840 - 1865

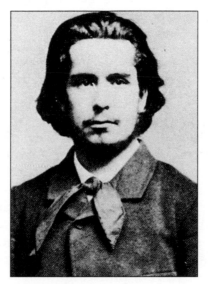

*Monet at the age of 20,
photograph taken by
Carjat,1860*

Caricaturist at the age of fifteen

Oscar Claude Monet was born in Paris on November 14, 1840 at 45 rue Lafitte in the IX arrondissement. He was the second son of Adolphe and Louise-Justine Monet who had him baptised at the Notre-Dame-de-Lorette church in Paris.

His father's occupation is not known, but he probably worked in commerce. In 1845, Monet's father joined his brother-in-law, Jules Lecadre, who owned a grocery wholesale business in Le Havre. All of the Monet family moved to Le Havre, a growing city that was to become one of the most important French ports. The Lecadre family was successful and had a large house in the city as well as a country house just outside Sainte-Adresse.

In 1851, Claude began to study at the public school in Le Havre, although he didn't seem to have liked it. *«I was naughty from the time I was born,»* he later declared. *«No one could ever make me obey a rule, even when I was young. School always seemed like a prison to me.»* On the other hand, even when he was very young, he was attracted to drawing. His mother, an accomplished singer, encouraged him to study drawing with Jean-François Ochard, who had stu-

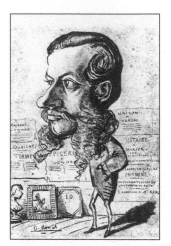

Claude Monet, Léo Machon (the notary), 1856, charcoal, The Art Institute of Chicago, Chicago

died with David. Monet's drawing classes were simply a bourgeois hobby that went hand in hand with a good education. The young Monet used his talent as a caricaturist to portray his teachers. *«I filled the margins of my books, I decorated the blue paper of my notebooks with highly fantasized ornamentations, and I depicted in the most irreverent manner, in the most deformed way possible, the face or the profile of my teachers. At the age of fifteen, I was known all over Le Havre as a caricaturist.»*

On 28 January 1857, Monet's mother died. He was only sixteen, but he left school. His aunt, Marie-Jeanne Lecadre, encouraged him to continue drawing, and as a adolescent he was able to sell his caricatures, signed *O. Monet,* to a stationer in Le Havre who also framed paintings and sold paints, canvas, brushes, and other painting supplies.

It was at the stationer's shop that the young Monet met Eugène Boudin who showed his work there, and who would be the first to introduce Monet to real painting.

The influence of Eugène Boudin

Eugène Boudin, the son of a sailor, was born in Honfleur and grew up in Le Havre. The world of the sea was to have a profound influence on Boudin. Most of his paintings depicted beaches, ports, ships, and skies. Courbet called him the «Raphael of the skies,» and Corot declared, «Boudin, you are the king of the skies!» Boudin is considered to be a direct precursor of the impressionists with whom he exhibited his paintings from the beginning of the movement in 1874.

Claude Monet, Monsieur Orchard, 1856, charcoal, The Art Institute of Chicago, Chicago

Considering the importance of the sea in Monet's future work with its coastal scenes, shores, and rocks and the importance of streams, the banks of the Seine, and ponds with the sky reflected in them, their meeting seems predestined.

How did they meet? It was a kind of revelation for the young painter, who was only seventeen. He was doubtlessly flattered that the older painter was interested in his work and that he agreed to work out of doors with him. They painted just outside Le Havre on the coast facing the sea.

Monet told the following story: *«Boudin set up his easel and began to work. Suddenly,*

it was as though the veil dropped. I immediately understood. I realized what painting could be; my fate as a painter lay before me.»

The astonished young Monet saw Boudin's brushes give birth to steep cliffs, the movement of the waves, the shivering of the wind, and to clouds travelling across the sky. From that time on, he realized that he would also become a painter and that he would devote his whole life to the search for the continuous change of the colours of light.

It must be remembered that painting with oils in the open air was a novelty made possible by the recent availability of paint tubes in the 1840s. Before that, nature had to be brought into the studio. «Everything that can be rendered directly in nature,» Boudin declared, «possesses a force, intensity, and life that is impossible to recreate in the studio.»

Claude Monet, Boudin working in Le Havre, pencil, Musée Eugène Boudin, Honfleur

This period of his life spent around Le Havre, often in the company of Boudin, marked Monet deeply.

He soon left for Paris but returned regularly to draw on the resources of the coast: the estuary of the Seine, Sainte-Adresse

Eugène Boudin, Pêcheur à Villerville, Musée des Beaux-Arts, Rouen

where his family lived, Trouville, Honfleur, and also Étretat and Dieppe.

Even when Monet was no longer painting at the sea shore, he almost always set up his easel near water: along the Seine, at Argenteuil, at Bougival, at Poissy, at Vétheuil, and at Rouen. Later, during the last years of his life at Giverny, he painted in front of the water in his pond where lilies would make him immortal.

Water is central to his work just as are skies reflected in the water. Some of his paintings could be enjoyed upside down owing to the blending of water and sky in shining, melted colours. His colours sparkle under the play of sunlight or else they break up into thousands of subtle pastel shades in the morning mists. Here were the seeds of a revolution that would lead the great impressionists to the doors of contemporary abstract art.

Le Havre, the symbol of modernism

In everyday terms, living in Le Havre during a boom period allowed Monet to experience the modernization that characterized the second half of the nineteenth century. The development of industry and commerce, rapid economic expansion and the growth of capitalism were accompanied by profound social changes.

Monet had to find his place in this materialistic world without resorting to philosophical considerations. He was modern in that he held a very contemporary vision of the world, distant from the traditional allegories and pictorial conventions then in vogue.

But as with all other periods of questioning, change would be staunchly resisted by the «established» tastes in painting, above all by the members of the jury of the annual Salon. The Salon was the reference point for every painter who wanted to reach the stylish and monied market that almost blindly followed its recommendations.

Only a few of the important collectors and art dealers such as Paul Durant-Ruel or Caillebotte gave new painters the support that allowed them to survive until many years later their talent became recognized.

But we are still in only 1858. The future great painters are only young people looking for a future. Caillebotte is sixteen. Berthe Morisot, Bazille, and Renoir are seventeen; Monet is eighteen; Sisley and Cezanne are nineteen; Degas is twenty-four; Manet is twenty-six; and Pissarro is twenty-eight. Van Gogh is five years old.

Who at this time knew Claude Monet?—only those in Le Havre who enjoyed his caricatures. Some of his pencil drawings from that period have been found. His sketchbooks reveal that he already drew not only figures but also landscapes with real talent.

One of his first oil paintings, *Vue prise* à *Rouelles*, was painted

in 1858. He had been painting for only a short time. Nonetheless, it is a sophisticated painting that suggests the influence of Boudin and of Daubigny, a painter of the Barbizon school and a friend of Boudin who had come to Le Havre to work. The subject is classical, but it is impossible not to see already a row of poplars shimmering in the light and their reflection in the water in the foreground. This painting was shown in 1858 at the Le Havre municipal exposition.

The move to Paris

Although the young Monet didn't receive a scholarship from the city of Le Havre to study in Paris, he nonetheless decided to go there, encouraged by his aunt and with the financial support of his father. In addition, he had accumulated a savings of 2,000 gold francs from the sale of his drawings and paintings.

He arrived in Paris in May 1859 at a time when Paris was undergoing a complete transformation. Napoleon III had named Baron Haussmann prefect of the Seine department with special powers to modernize the city. Whole neighbourhoods had been destroyed, new avenues were laid out geometrically and decorated with trees and street lights and comfortable cut-stone buildings lined the streets. Banks, government buildings, railway stations, markets, department stores, theatres, and public buildings sprang up. The new Paris, now called «the city of lights» was open to speculation and the flow of gold during the Second Empire.

What would Monet do in Paris?
After having visited the famous official Salon where he saw the work of Troyon, Daubigny, Delacroix, and Théodore Rousseau, he visited the painter Armand Gautier, a friend of his aunt and then Constant Troyon, Boudin's former instructor.

Troyon recognized Monet's talent. He advised him to study drawing at a studio but hired him to make copies of paintings at the Louvre—standard academic training. Monet preferred to study at the Suisse Academy, opened by Charles Suisse, a former student of David, where students could work in complete freedom. Here he met Pissarro, who would become his friend.

At the same time, he began to frequent the famous Brasserie des Martyrs, on the rue des Martyrs behind the Notre-Dame-de-Lorette church, the gathering place for the literary and artistic Bohemian set of that period.
In reality Monet was not attracted by this style of life, because he had always lived in a comfortable family setting. Although he had serious financial problems later in his adult life, as soon as his financial situation improved he returned to a satisfying comfortable bourgeois life. On the other hand, his friendships were to have a strong influence on his evolution. Here he became familiar with the most

progressive tendencies of contemporary art.

Military Service in Algeria

In 1861, everything was to change. He drew an unlucky number for his military service. Although it was common at that time for those who had the means to pay a replacement to serve the seven years of military service, Monet decided—although it might have been at his family's behest—to leave and join a cavalry regiment in Algeria. He returned slightly more than a year later after a serious illness.

He had, nonetheless, good memories of his forced stay and the impression of the dazzling light and the sky in North Africa. *«I gained a lot of insight,» he was later to observe. «My impressions of light and colour came into place only later, but the seeds of my future searches were there.»*

During his convalescence in Le Havre, he met the Dutch painter Johan Barthold Jongkind, considered to be one of the precursors of impressionism. Jongkind was to have as much influence on Monet's work as Boudin. The three of them painted in the region around Le Havre using nature, the sea, and the Normandy sky as their studio. Monet always considered the two older painters as the masters from whom he learned everything he knew about painting.

The studio of Charles Gleyre

In the fall of 1862, Monet was twenty-two years old and returned to settle in Paris to dedicate himself to painting.

He began to study at Charles Gleyre's studio, well-known at the time but very conventional. Gleyre had the merit of giving complete freedom to his students among whom were Pierre-Auguste Renoir, Alfred Sisley, and Frédéric Bazille. All these painters were about the same age and soon became close friends. They helped each other, often living at the place of the most successful, and went together to paint out of doors in the Fontainebleau forest. They frequented the same Parisian cafés or the same country inns. All of them were ready to innovate in order to impose their personalities against all forms of academic limitations, the idealization of themes, and the use of references to antiquity.

This is how Monet described that period fifty years later:
«I met Renoir, Sisley, and Bazille at Gleyre's studio. We were drawing using a live model who was superb. Gleyre criticized my work:
'It's not bad,' he said, 'but the bust is heavy, the shoulder is too strong, and the foot is exaggerated.'»
«I can draw only what I see,» I shyly replied.
«Praxiteles took the best features from a hundred imperfect

Claude Monet, La Falaise d'êtretat, circa 1855, pastel, Musée Marmottan, Paris

models in order to create a masterpiece,» Gleyre abruptly answered. «When you do something, think of Antiquity.»

«That same evening I took Renoir, Sisley, and Bazille aside and told them: 'Let's get out of here. This place is unhealthy, there's a lack of sincerity.'»

This dialogue gives a good feeling for the difference between the official establishment represented by Gleyre, referred to as the neo-Greeks, and the new blood of the young painters. They were going to revolutionize the end of the nineteenth century. The group of future impressionists was already gestating.

Monet established himself among the new painters through his perseverant and ready character. He was always confident about his own ideas. Renoir declared some time later, «Without Monet, who gave encouragement to all of us, we would have dropped out.» He described Monet as a dandy who never had a cent but who wore shirts with lace cuffs and affected the arrogance of an aristocrat. Rumour had it that he went to the best tailor in Paris whom he never paid.

Edouard Manet's *Le Déjeuner sur l'herbe*

One event marked the world of art in 1863. Alongside the immutable official Salon, the reference point for every painter that wanted to have a chance at being sold and recognized, a Salon des Refusés ope-ned for the first time with Edouard Manet's painting *Le Déjeuner sur l'herbe* causing a real public scandal.

While the nude was often represented in the academic painting style with references to mythology or allegorical works, Manet had dared to place his figures in a modern world in the name of realism: a *nude woman* with two dressed men. This painting was to make Manet notorious.

When not in Paris or the Fontainebleau forest, Monet returned to paint in Normandy or on the coast at Rouen, Sainte-Adresse, and Honfleur. In 1863 he painted *Coin de ferme en Normandie* that evokes the work of Boudin and Daubigny. But it was at the 1865 Salon that the public really discovered his talent. Two of his paintings were exhibited there: *L'Embouchure de la Seine* à *Honfleur* and *La Pointe de la Havre* à *marée basse,* two well-composed paintings with excellent stormy skies.

Both paintings were well received by the public and the critics. Paul Mantz wrote in the *Gazette des Beaux-Arts*, «his style evokes a taste for harmonious colour, combining complementary tones, a feeling for values, a good appreciation of the overall work, and a robust way of seeing life and attracting the viewer's attention.»

Edouard Manet, Le Déjeuner sur l'herbe (detail), Musée d'Orsay,

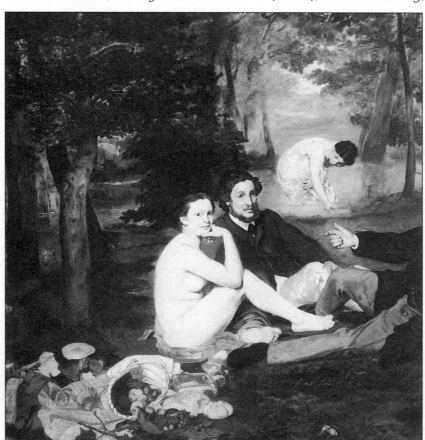

THE AFFIRMATION OF A TALENT 1866 - 1871

Claude Monet's *Le Déjeuner sur l'herbe*

Monet spent his time working on an immense painting 4.6 meters high and 6 meters wide to which he gave the same name as Manet's famous painting, *Le Déjeuner sur l'herbe.*

He intended to enter it in the 1866 Salon and hoped to attract the public's attention by abandoning traditional themes in order to portray an avant-garde subject situated in everyday life, namely, a simple picnic in the forest with life-size figures.

Unfortunately, the painting was not ready in time, and Monet never finished it. The story of this *Le Déjeuner sur l'herbe,* never exhibited but considered one of the painter's first masterpieces, is a strange one. It was stored in a humid place where it deteriorated to the point that Monet, later after he found it, felt obliged to destroy the whole right side and cut off part of the left side in order to balance it.

In fact, the original painting is known only thanks to preliminary studies and an oil painting, smaller in dimensions, with the same title, in the Pushkin Museum in Moscow. The setting for the painting is a clearing in the Fontainebleau forest where friends are gathered, dressed as they did during that period. They do not pose but stand or sit in natural positions. The whole is wonderfully lit by the sunlight through the trees where spots of light play with patches of shade. Monet's friends are recognizable: Bazille, Sisley, Courbet, and Camille Doncieux who would later become his mistress and then his wife.

No one is looking directly at the painter, everyone is going about his business, some are chatting, one woman is taking off her hat, another begins to pass out plates, and on the right Bazille—he was the model for two of the figures—stretches out his legs relaxing on the ground.

There is no formal order. Monet painted the scene as it happened each time the young

The Salon

people got away from the city to relax in the outdoors. Open-air painting was the name given to this type of revolutionary painting.

Femme à la robe verte

Not having finished *Le Déjeuner sur l'herbe* in time, Monet entered a painting in the 1866 Salon that he had painted earlier, *Le Pavé de Chailly* and another painting which he did in a few days entitled *Camille*, but soon referred to as *Femme à la robe verte*. Both paintings were accepted by the jury. The second painting was widely acclaimed, perhaps owing to the skill with which Monet portrayed the silk, the velvet, and the fur on Camille. This portrait is nonetheless quite traditional, if not conventional, compared, for example, with *Le Déjeuner*.

Emile Zola did not run out of praise in the *L'Evénement*. «There's energetic and lively painting. I had just finished going through so many cold and empty rooms disappointed at not finding any new talent, when I saw a young lady dragging her long dress along the ground and fitting perfectly into the wall, as if there were a hole. You can't imagine how good it feels to find something to admire, after growing tired of laughing and shrugging.»

The success of *Camille* in the Salon allowed Monet to sell several paintings, including a copy of this painting that went to America. He was beginning to leave behind his financial worries, but his relationship with Camille, his model, was not accepted by their families. His family cut off support. Once again he had to flee his creditors. He moved to Ville-d'Avray to paint a large painting (2.56 x 2.08 meters) entitled *Femmes au jardin* that he entered in the 1867 Salon. The oversize height of the painting forced him to dig a trench in his garden, in order to reach the top of the painting. Camille served as model for at least one of the four «female figures dressed for summer, picking flowers in the garden with the sun striking the white skirts making them a shining white, and the warm shade from a tree cutting a grey patch in the paths and the dresses.» These were Zola's comments on the painting in *L'Evénement illustré*.

In Honfleur he painted *Le Port de Honfleur*, also a very large painting (1.48 x 2.26 meters). Both paintings were, however, rejected by the jury for inclusion in the 1867 Salon. Also rejected were the paintings submitted by Bazille, Renoir, Sisley, and Pissarro. After all the young realists were turned away, they begin to consider organizing a private exhibition on their own. This would come about seven years later in 1874. It would be the first impressionist exhibition.

In the meantime, their material situation was desparate, and Bazille, from a more wealthy family, supported them. He took in at his home, 20 rue Visconti in Paris, both Renoir and Monet, and he bought *Femmes au jardin* from Monet.

In Paris, Monet painted several scenes of life in the capital with

his friend Renoir. For example, *Saint-Germain-l'Auxerrois, Le Quai du Louvre,* and *Le Jardin de l'Infante,* all three paintings date from 1867. Monet, nonetheless, never liked cities and always preferred to escape to the seashore, the countryside, or to the Normandy coast where he could revisit the scene of his first steps in painting.

Return to Sainte-Adresse

He returned home to Sainte-Adresse without Camille and was warmly welcomed by his family. Camille, who was pregnant, remained alone in Paris. On Auugust 8, 1867, she gave birth to their son Jean. Bazille, who was the godfather, once again helped them financially.

On the coast, Monet painted several seascapes, among them *Les Régates à Sainte-Adresse* and *La Plage de Sainte-Adresse,* but especially a famous canvas in which two of Monet's favourite themes were to reappear: water and gardens. This painting is entitled *La Terrasse à Sainte-Adresse* and several members of Monet's family can be recognized, especially his father in the foreground. This view of the terrace flooded with sunlight is painted from a raised viewpoint, and the sea in the background is flattened, easing the conventional perspective of depth. The scene is the wealthy bourgeois residence of people from Le Havre, in this case his aunt. Monet structured the painting using the Japanese approach then in fashion. He dared to render the intensity of the sunlight with large swatches of colour that were then touched up with small bits of bright and shining colour in order to give a special translation to the vibrations of the leaves and flowers in the garden.

With Camille and his small son Jean

In 1868, Monet decided to leave Paris with Camille and their small son Jean to live in the Auberge de Gloton near Bennecourt on the Seine where the cost of living was lower. There, he painted *Au bord de l'eau, Bennecourt* where Camille, sitting on the river bank in the shade of trees, watches the setting reflected in the quiet water. This is a theme that was going to become an obsession with Monet.

Always trying to find money to support his small family, Monet made frequent trips to Le Havre to visit an art collector who was interested in his work and who commissioned the portrait of his wife, *Portrait de Madame Gaudibert.*

He participated, also in Le Havre, in an international seascape exhibition and won a silver medal. In the 1868 Salon, Monet decided to show two paintings he had done during his stay in Sainte-Adresse: *La Jetée du Havre* with its wonderful effects of waves was rejected, but *Navires sortant des jetées du Havre* was accepted owing to Daubigny's efforts. This painting has since disappeared.

Towards the end of the year, he took his wife and son to the Normandy coast where he painted a famous landscape of snow under

a pale sun, *La Pie.*

He wrote to Bazille, *«I walk in the countryside which is so beautiful here that I actually prefer the winter to the summer.»* But his two paintings for the 1869 Salon, one of which was *La Pie,* were rejected, and his economic situation worsened.

La Grenouillère, the cradle of impressionism

He was now living in the small village of Saint-Michel À Bougival where he painted with his friend Renoir the baths at La Grenouillère that are considered by many to be the cradle of impressionism.

La Grenouillère was both a bathing spot and a roadside café where all sorts of people from different social classes came on Sundays to have fun, dance, and boat on the river. Some people called it the «Trouville on the banks of the Seine.» Although Maupassant referred to it as a place that «sweated of stupidity, smelled of vulgarity, and had the chivalry of the marketplace,» Renoir commented, «I always find lovely girls to paint, and we knew how to laugh during those days!»

The two painters set up their easels side by side and some canvases entitled *La Grenouillère* were painted by both using exactly the same subject seen from the same angle—for instance, the small island joined to the shore and to the main building by narrow bridges, and an old barge with a wooden balcony. The two painters' work, composed of innumerable strokes of color, is already clearly impressionistic.

There was, nonetheless, already a difference in the two styles. Renoir, was attracted especially to figures while Monet concentrated on the play of light and shade on water. All his life Renoir painted female portraits and nudes in sunlight. Monet spent his whole life seeking to capture light in the reflections of water. After he settled in Giverny, human figures were only infrequently represented. Monet's evolution as a painter can be observed in two of his paintings *Au bord de l'eau* and *La Grenouillère*—two paintings made only one year apart. His painting had become freer, especially when painting light reflected on water.

All this time Monet's financial situation showed no signs of improvement. As often in the past, Monet turned to Bazille for help. *«No bread for eight days now, no money for fuel, no light. I can't paint, I have hardly any paints left.»* Monet's entries in the 1870 Salon, *La Grenouillère* and *Le Déjeuner,* were rejected. He was in the Salon, nonetheless, in Fantin-Latour's famous painting *L'Atelier des Batignolles* along with Edouard Manet, Auguste Renoir, Edmond Maître, Frédéric Bazille, and Emile Zola.

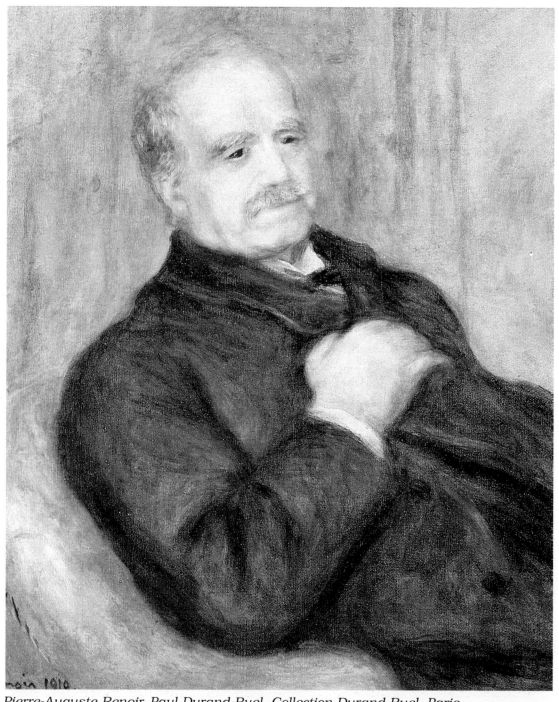

Pierre-Auguste Renoir, Paul Durand-Ruel, Collection Durand-Ruel, Paris

Mired in financial difficulties, Monet found comfort in his own family, not the family in Le Havre, but the family he created with Camille whom he married on June 28, 1870, three years after the birth of their son Jean. Courbet was one of the witnesses at the wedding. The flavour of this family atmosphere can be found in *Le Déjeuner*, another painting rejected by the Salon. Camille posed as both the mother and the visitor in this painting.

Friendship with Durand-Ruel in England

Monet took his wife and son to Trouville in the summer. There he painted several canvases including *L'Hotel des Roches Noires.* In the middle of the summer season, on July 19, Napoleon III declared war on Prussia. Bazille, Monet's faithful friend, was killed on the battlefield on November 18. Monet decided to go to England.

There he found a few exiles and for the first time met the art dealer Paul Durand-Ruel who was to give support to the impressionists until his death in 1922. Monet declared, «*Without Durand we all would have starved to death, all of the impressionists. We owe him everything.*» Durand-Ruel's Parisian gallery on rue Lafitte was a gathering place for the impressionists.

William Turner's influence

In England, accompanied by Pissarro, Monet visited the London museums where John Constable and especially William Turner left a deep impression on him. Turner's influence can be found in depiction of the sunlight through the fog in the famous painting *Impression, soleil levant* painted in 1873.

Monet settled in Picadilly Circus with Camille and Jean and then in Kensington. But he spent more time in museums than painting, except for the series of paintings of the Thames and Parliament, Green Park, and Hyde Park.

When he left England in 1871, he stopped at Zaandam in Holland and painted windmills, houses, boats, and the port, always maintaining the relationship with water that dominated his work. Boudin saw the paintings when Monet returned and declared: «He brought back from Holland some incredibly beautiful studies and I think that he has what it takes. One day he will be the leader of our movement.» What a beautiful prediction and acknowledgement by the very person who had first inspired the young Oscar Monet.

THE HEIGHT OF IMPRESSIONISM 1872 -1877

The masterpieces painted at Argenteuil

After returning to France in the fall of 1871, Monet stayed for a while in Paris, but soon moved to Argenteuil where he lived from 1872 to 1878. This was the core period for Monet's work and for the impressionist movement.

Monet never grew tired of watching the sky, the boats, and the bridges reflected in the water. Painting on the banks of the Seine, he created a series of masterpieces.

Le Petit Bras d'Argenteuil, La Promenade d'Argenteuil, Régates à Argenteuil painted in 1872; *La Seine à Argenteuil, Le Pont du chemin de fer à Argenteuil* painted in 1873; *Le Bateau-atelier, Les Barques régates à Argenteuil, Le Pont routier, Argenteuil, Le Pont d'Argenteuil* painted in 1874; and *Bateaux de plaisance à Argenteuil* painted in 1875 are several examples.

Even in deep winter and the worse storms, Monet painted out of doors the landscapes around Argenteuil: *Neige à Argenteuil* in 1874, *Le Train dans la neige, la locomotive*, and *Le Boulevard de Pontoise à Argenteuil, neige*, painted the following year.

Another favorite subject from this period is that of gardens and flowers, which would reach its fullest expression later in Giverny. Works such as *Les Dahlias* and *La Maison de l'artiste à Argenteuil*, painted in 1873, take up this theme. In the latter on the right side of the canvas is a house covered with climbing plants and surrounded by flower beds, flower pots, and trees sprinkled with sunlight. The centre of the painting is almost empty with only a tiny white silhouette of Jean and his hoop seen from the back.

Another painting from the same year is the famous *Le Déjeuner*. The meal has just finished, the table has not yet been cleared, a parasol has been left on a bench, a straw hat hangs in the branches, sunlight floods the flowering bushes, two elegant women are chatting in the background, and a small child, Jean, sits alone completely absorbed playing.

The same persons were sometimes painted walking in the fields near the house. His paintings of poppies are outstanding.

Later in 1875, Jean has grown and he stands out slightly behind the large figure of Camille silhouetted against the sky and in the wind in one of his most famous paintings, *La Promenade*, also called *La Femme à l'ombrelle*.

Monet as seen by Renoir and Manet

His friends among the painters, with whom he liked to spend time, painted him working out of doors on the two subjects just mentioned: *Monet peignant dans son bateau-atelier* by Edouard Manet and *Monet peignant dans son jardin à Argenteuil* by Renoir.

They also painted scenes of Camille and Jean relaxing. One is *La Famille Monet au jardin* by Manet who depicted Monet working in the garden, one of his passions, with his wife and son in the foreground.

Renoir painted the same subject, at the same time, but with just Monet's wife and son in *Madame Monet et son fils*.

Monet loved to paint in the calm countryside, but he often visited Paris to meet with the young avant-garde of painting that met to chat at the Café Guerbois, avenue de Clichy.

They talked about everything that distinguished them from official academic painting. They despised the Salon jury that closed the Salon's doors to them and that systematically rejected their entries, preventing them from selling their paintings and obliging them to live in general misery.

Monet's financial situation had improved, and the year 1872 had been prolific in production and sales thanks to Durand-Ruel and his relationship with art collectors.

Among the art collectors was the critic Théodore Duret who was to become the official spokesman for impressionism when in 1878 he published his book *Les Peintres impressionnistes*. Duret also became a faithful friend of Monet.

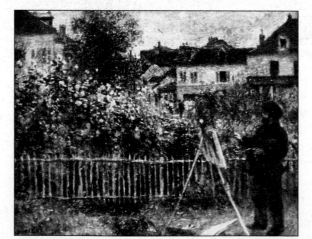

Pierre-August Renoir, Monet peignant dans son jardin à Argenteuil, Wadsworth Atheneum, Hartford

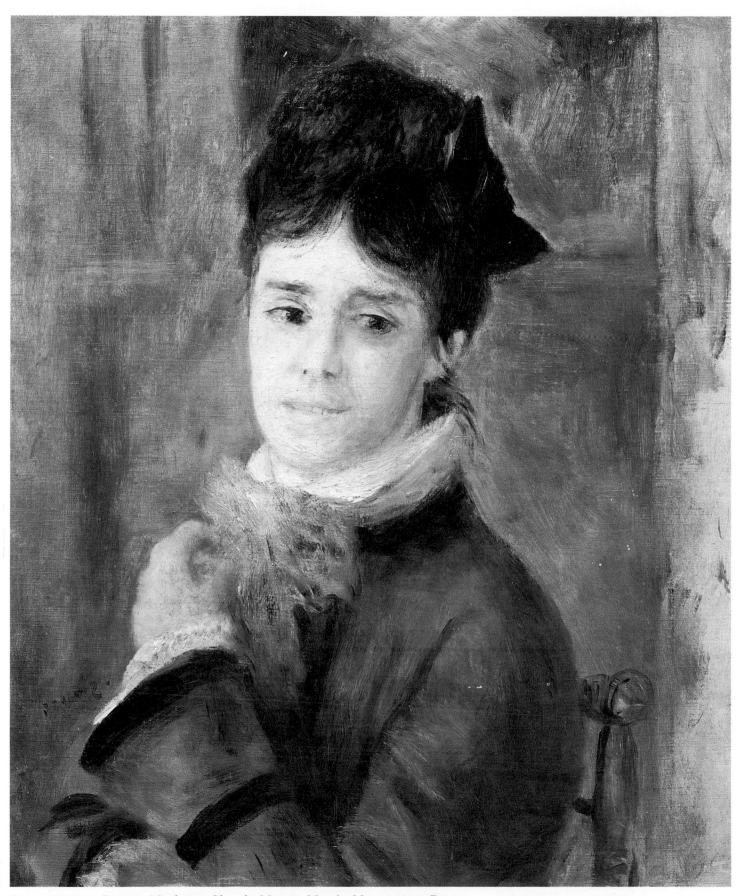

Pierre-August Renoir, Madame Claude Monet, Musée Marmottan, Paris

Landscape painter of Paris

Whenever he was in Paris, Monet also painted. He maintained a studio and at any rate Argenteuil was only a few kilometres from the Saint Lazare train station. It must not be forgotten that Monet wanted to be a realist and to be modern. The modernization of Paris and the growth of the industrial world directly affected him, and he showed great interest in the literature that declared science and industry to be the pillars of the new world.

He depicted «the bustling Paris» as a city landscape in such paintings as *Le Pont-Neuf* in 1872, several paintings of the Seine and the movement in the streets in two versions of *Boulevard des Capucines* in 1873 using an overhead viewpoint.

Later in 1877, he painted a famous series of the Gare Saint-Lazare, and city parks—*Les Tuileries* and *Le Parc Monceau* as well as *La Rue Saint-Denis* and *La Rue Montorgueil* showing swelling crowds and colourful flags on the occasion of the June 30, 1878 celebrations.

Along with the paintings of Paris and its fashions is a curious painting more than two metres high, *La Japonaise* (1875-76). This painting shows a Parisian dressed as a Japanese.

Again it was Camille who modeled for the painting with a blond wig. But it is more than just a portrait; it is the painter's virtuosity in portraying this lavish dress from the Japanese theatre that is important.

This was a time when interest in Japan was at its height among painters and writers. To collect Japanese prints was the height of fashion. Some saw an erotic content in this painting.

The critic for *La Gazette de France* wrote, «This Chinese [sic] has two heads: one of a socialite on her shoulders and the other of a monster hidden, we don't dare say where....

Luigi Loir, La Construction du métro à Paris, 1900, Musée de Roubaix, Roubaix

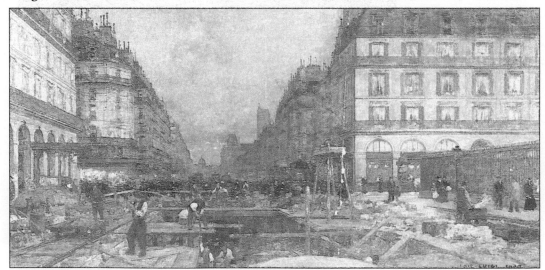

The first impressionist exhibition

After his paintings were rejected by the 1869 and 1870 Salons, Monet gave up trying to please the jury. He wasn't alone.
The members of «Manet's gang,» all the future great impressionists, spent their time in the Café Guerbois or the Café Nouvelle Athènes bemoaning their fate.

It was here that an old idea, dropped in 1867, of organizing an independent exhibition came up again. It was decided to create an association to run the operation. Renoir insisted on not giving it a name that would suggest a new school of painting.
Monet was the mediator and helped the artists adopt the name «*Société anonyme coopérative des artistes-peintres, sculpteurs, graveurs.*» The name was not particularly enticing, but fate would see that the group found a name that posterity would recognize.

They lacked a place to hold the exhibition. Finally the studios of the photographer Nadar on the Boulevard des Capucines and the Rue Daunou were found. The exhibition took place from April 15 until May 5, 1874, just a bit before the official Salon in order to avoid being considered a «Salon des Refusés.» It was later referred to as «La Première exposition des Impressionnistes.»

Thirty painters participated, including Boudin, Bracquemond, Cezanne, Degas, Guillaumin, Monet, Berthe Morisot, Pissarro, Renoir, and Sisley. There was one notable absence, Manet, who didn't want to jeopardize his showing in the Salon.

One hundred and sixty-five paintings were shown. Monet chose to present *Le Déjeuner, Les Coquelicots à Argenteuil, Le Boulevard des Capucines,* and *Impression, soleil levant,* as well as a seascape painted in Le Havre. It was a varied selection with a sharp

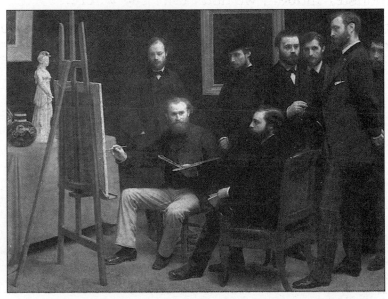

Henri Fantin-Latour,
L'Atelier des
Batignolles, 1870,
Musée d'Orsay, Paris

21

contrast between *Le Déjeuner* and the other paintings that were considered by the critics to be sketches.

A joke appeared in *Le Charivari,* a popular journal, concerning Monet's painting *Impression, soleil levant* which gave the name to the group: «There's impression in it or else I don't know anything.... I also feel it because I am impressed, there has to be some impression there....»

The critics had a field day

The exhibition drew only 3,500 people compared to the 400,000 who attended the official Salon. The critics had a field day, the cartoonists went wild, and the viewers didn't understand the painters and made fun of them. Only a few minor collectors and the painters' friends were pleased with the show.

Le Figaro wrote «All these paintings left us with the impression that this is painting to be looked at fifteen paces away through half-closed eyes. You would need a huge apartment to hang these paintings. The impression sought after by the impressionists is like that made by a cat walking on the keys of a piano or that made by a monkey who has got hold of a box of coloured crayons.»

La Presse wrote «...a disagreeable mystification for the public or the result of a mental breakdown.»

La Patrie wrote, «There is an exhibition of intransigents on the Boulevard des Capucines; they're all mad.»

Two years later,Jules Claretie had this to say about the 1874 Salon in his book *L'Art et les artistes français contemporains* published in 1876: «We've seen an exhibition by these *impressionalists* on the Boulevard des Capucines, in Nadar's studios. It was completely upsetting. It seems that Monet, a more inflexible Manet, Pissarro, Ms. Morisot, and others have declared war on beauty. Some landscape painters' impressions are just a cloud of soot.»

Cartoon by Cham

While the painters exhibiting their work were often criticized for using banal themes taken from everyday life and differing from those of established academic painting, they were even more harshly criticized for their painting techniques that were considered to resemble sketches—the placing of strokes of colour that broke the outline of forms—and for the brightness of colours used even to create shadows.

Some observers discover the impressionists' contribution

However, many critics saw the utility of such an exhibition independent of the official tendencies of the Salon; others thought they were trying to make a political statement.

Even before this exhibition, Armand Silvestre, in a catalogue for a sale at Durand-Ruel's gallery, described the «enveloping harmony» of Monet's, Pissarro's, and Sisley's work owing to their use of the subtle and precise relationship among colour tones.

He declared that «Monet likes to juxtapose the multicoloured reflections of the setting sun, colourful boats, and the evolving bareness on slightly ruffled water against metallic tones created by the polished water that laps at small patches of his paintings, the image of the trembling shore, and the houses that stand out as in a children's game where shapes are formed from their parts.» This article of praise was partially reprinted in *L'Opinion nationale* describing the 1874 exhibition.

Blémont's analysis in *Le Rappel* is much more subtle. «Their only rule is that of the required relationship among things. And just as there are perhaps no two people on earth who perceive the exact same relationship in any single object, they don't feel the need to follow any convention in adapting their direct personal perceptions.» The individual nature of perception was a dig at the conventions of the very conservative official view of painting.

Silvestre wrote in *L'Opinion nationale* along the same line, «Impressionism starts from a completely new principle of simplification that can't be argued with. In order to create sensations, they paint basic harmonies without regard to form, giving importance to colours.

They have raised painting out of doors to new heights. They have brought up to date a range of colours both light and charming. They have brought out new relationships. In place of a vision that is so refined that it is stifling and suffers from too many conventions, they have substituted a sort of analytical impression, brief and very bright.»

Writing in *La Nouvelle Peinture*, Duranty went on to describe the notion of the relationship between perception and the decomposition of light: «Through the use of intuition they have slowly succeeded in breaking down the energy of sunlight and its rays into elements in order to reconstitute the general harmony of the whole by the iridescence in the paintings.»

One of the first positive results is that all the press began to take notice, even if it was often in ironic terms, of what was to become known as the impressionists.

The very idea of an independent exhibition, organized by a group of painters without a jury, without any selection, where each painter hung in alphabetical order in a space where each painting could be well seen from close up like in an apartment, where each critic, art collector, or the general public could appreciate, take a stand, and come to a conclusion was considered to be an important innovation. It was directly opposed to the established ideology and the principles of the official Salon.

A few critics, often friends of the painters and collectors themselves, studied the impressionists' work and began to identify some of the elements of the impressionists' quest.

Nonetheless, questions of principle or of a school established by the impressionists were out of place. The impressionists didn't want theoreticians. They sought to develop their work empirically. Each painter followed his own instincts. There was, it is true to say, a tendency or a movement or an attitude in opposition to the official Salon and its way of functioning.

The impressionists were called independents or intransigents before being called impressionists. If this name stuck it is because it seemed to best describe the uniqueness of their work.

History has brought them together because they knew how to paint people from everyday life and nature's plenitude. For them colour was more important than form, light was sunlight, and brush strokes did not seek to blend shades. This was in direct contradiction to the dogma of classical painting with its dark, blended colours evoking stylized nature and religious or mythological subjects.

Financial failure

But... and there is always a but, the exhibition also had a commercial interest and there it was a complete failure. In December 1874, the association entered liquidation and on March 24, 1875, a large auction of «impressionist» paintings was organized at the Hôtel Drouot on Renoir's initiative in order to try to recover some money. It was another disaster filled with boos, insults, and even some fighting.

A second impressionist exhibition was held, nonetheless, the year after, in April 1876, in the Durand-Ruel gallery, rue Le Peletier. This was also without much financial success, but this time the press was slightly more favourable. Eighteen of Monet's paintings were shown, including *La Japonaise.*

Zola wrote about Monet, «he is without a doubt the group's leader. His brush shows remarkable talent.»

The first collectors

Fortunately, amateur collectors and some art dealers began to give the impressionists support. Collections that much later were to be worth fortunes were put together at rock-bottom prices, because the paintings had not yet been assigned a value. In the meantime, Monet made many new friends. If Durand-Ruel was his first friend in 1870, other friends were the baritone Jean-Baptiste Faure, the critic Théodore Duret, the wealthy and excellent painter Gustave Caillebotte, Victor Choquet, a low-ranking customs official (it was from his apartment on the rue de Rivoli that Monet painted *Les Tuileries)*, Georges de Bellio, a Rumanian physician, the restaurant owner, writer and self-taught painter Eugène Murer, the publisher Georges Charpentier who commissioned the painting by Renoir entitled *Madame Georges Charpentier et ses enfants* that was to become an enormous success at the 1879 Salon, and the cloth wholesaler Ernest Hoschedé an ardent collector whose wife Alice was to become the second wife of Monet in 1892, after Hoschedé's death and that of Camille in 1879.

In 1876 Hoschedé invited Monet to his home, the château de Rottenbourg at Montgeron, to paint four large decorative panels for his dining room. Monet spent several months there and painted several paintings including *Coin de jardin à Montgeron* and *L'Etang à Montgeron* with his favourite subjects, flowers and trees reflected in the water. He also painted a bold work, bold both because of its perspective as well as the subject: *Les Dindons* (The Turkeys).

Gustave Caillebotte, Le Pont de l'Europe, 1876, Musée du Petit Palais, Geneva

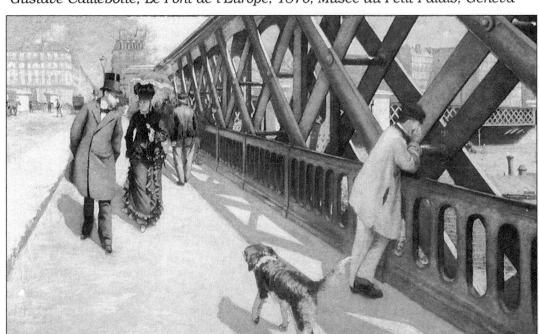

On August 20, 1877, Alice Hoschedé gave birth to her sixth child: some consider him to be Monet's son.

The theme of the Gare Saint-Lazare

Monet knew the Gare Saint-Lazare well, where trains left for Argenteuil and Le Havre. In January 1877, he rented an apartment on rue Moncey, close to the station, in order to paint some remarkable work including several sketches and twelve masterful paintings. All the paintings were entitled *La Gare Saint-Lazare* with indications added by the painter of the point of view and the weather. Among them are *Le Train de Normandie, Le Pont de l'Europe, Le Signal, Arrivée d'un train, Vue extérieure,* and others.

The railway station represented industrialization, speed, the revolutionary architecture of glass and steel beams, the new vitality of Paris, the glory of that period of the Empire, modernness, and the expansion of contemporary society.
The Gare Saint-Lazare was the temple of the new civilization. The locomotive and its surroundings became a symbol for Monet. Zola summed up its mythic quality in the hero of *La Bête humaine.*

Apart from the attraction of the modernness of progress, what exactly attracted Monet, a landscape painter, to the railway station? It would be tempting to reply; above all the smoke, the puffs of smoke and steam exhaled by the locomotives, smoke and steam that dance in the daylight accompanied by an infernal noise of iron and steel.

Zola wrote in *Le Sémaphore de Marseille,* «Claude Monet is the outstanding personality in the group of impressionists. This year he painted some wonderful interiors of train stations. You can even hear the wincing and roaring of the trains as they enter; smoke and steam flow about in the high stations.»
Rivière described the paintings as evoking, «the shouts of the workers, the blowing of whistles, a crunching of metal, and the puffing of steam.» *L'Homme libre* wrote, «It's just incredible, but this painting captures the noise, the loud shouting, and the whistles. It's a real pictorial symphony.»

If the paintings in the series of the Gare Saint-Lazare give us a snapshot taken on the spot, the work of the painter should not be underestimated.
Monet made many sketches as preliminary work for his paintings. He then built up his paintings with the steel-beamed buildings, the glass fronts, the bridges, and the surrounding buildings, before «awaiting» the arrival of the trains surrounded by clouds of smoke and steam that flow into the rest of the composition.
It was said that he once had a train delayed in order to obtain better lighting conditions and that he was able to have the locomotives stoked up so that they would spit out more steam.

He then went to the quiet studio that he rented nearby to touch up his canvases.

The impressionist painters

At the third impressionist exhibition in April 1877, Monet showed thirty-five paintings including *Les Dindons* and seven versions of *La Gare Saint-Lazare.*

The critics were positive, but financially it was again a failure. Hoschedé was close to bankruptcy, and Camille was very ill and had just given birth to a second son, Michel, in March.

The Impressionnist, drawing that appeared in the Assiette au Beurre on 30 April 1904

The most important event of 1878 was the Exposition universelle, inaugurated on May 1. Because of the Exposition universelle, the impressionists did not organize their fourth exhibition that year, but waited until 1879.

Duret published a book entitled *Les Peintres impressionnistes* in which he described the group and noted that in spite of criticism the impressionists had succeeded in attracting the public's attention and in interesting art collectors.

He classified Claude Monet as simply the outstanding impressionist. «He succeeds in capturing the fleeting impressions that his predecessors neglected or considered impossible to capture with a brush. Monet translated the essence of the thousands of nuances that the sea and the streams take on, the play of light in the clouds, the vibrant colours of flowers and the mottled reflection of the leaves in the bright sunlight.

In painting not only what is immobile and permanent in the landscape but also its fleeting aspects that the chance circumstances of nature give it, Monet is able to turn what he has seen into a vivid and moving emotion.»

THE PERIOD IN VETHEUIL
1878 - 1883

On the banks of the Seine

In September 1878, Monet moved to Vétheuil, a small village on the banks of the Seine. He stayed there for four years, until he discovered Giverny not far away. The surrounding landscape of old houses gathered around a church, the loops of the Seine with wooded islands, chalk cliffs, and vast fields of poppies were pure seduction for the landscape painter. This landscape was the subject of many canvases painted in the impressionist style; paintings such as *La Seine à Vétheuil, Champ de coquelicots près de Vétheuil*, and *Le Jardin de Monet à Vétheuil.*

Vétheuil, seen from Lavacourt, photograph

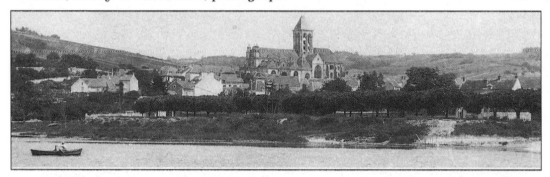

But in contrast to the brightness and the serenity of his paintings, Monet's financial difficulties increased. He moved into a house on the road to Mantes which had a garden that extended to the bank of the river. There he tied up his floating studio. Later he moved to La Roche-Guyon with Camille, their two sons, and Alice and Ernest Hoschedé along with their six children. In all they were twelve people and three servants.

Camille's death

The financial situation of the two families grew desparate. Camille's illness grew worse, and Monet became isolated from the other impressionists. He wrote, *«I can't earn enough painting to support the life we lead in Vétheuil.»*

The winter of 1878 was 'exceptionally cold, but Monet continued to paint the village covered with snow. He painted *La Route à Vétheuil, l'hiver, Vétheuil dans le brouillard, L'Eglise de Vétheuil, neige* and the following year *Le Givre* and *La Débâcle sur la Seine, les glaçons.* You can already see the pieces of ice floating in the foreground reappearing as the lilies at Giverny.

In April of that year he unwillingly participated in the fourth impressionist exhibition and showed the scenes painted around Vétheuil and other paintings. The critics accused him once again of having painted too quickly. This was often the case because he needed money.

On September 5 Camille died and Monet painted her in a moving canvas entitled *Camille Monet sur son lit de mort.*

A long time later he was still talking about this painting, rendered as though seen through the snow, and in spite of his mourning commented about the *«shades of colour that death creates on the immobile face.»* He wrote to his friend Pissarro, *«You, more than anyone else, must know the pain that I feel. I am overwhelmed. I don't know how I'm going to be able to carry on and organize my life with my two children. I am to be pitied.»*

Ernest Hoschedé left for Paris in order to try to sell some of Monet's paintings while Monet stayed with Alice and the eight children in Vétheuil. Their neighbours in the village considered the situation to be very ambiguous.

Often forced to stay in the house because of the cold, Monet painted several still lifes, an uncommon subject matter in his oeuvre. These paintings were *Corbeille de fruits (poires et raisin)* as well as bouquets of sunflowers that recall those of Vincent van Gogh.

More originality

In 1880 he decided to stop participating in the impressionists' exhibitions and did not show in their fifth exhibition. On the other hand, he once again submitted work to the official Salon that he had neglected for the past ten years. Perhaps he had been influenced by Renoir's success in 1879 with his painting *Madame Georges Charpentier et ses enfants.* At the same time, relations among the impressionists began to deteriorate. Monet wrote to his friend Duret confiding, *«I'm taking a great chance, and in addition I am treated as a deserter by the whole group, but I think that it is in my best interests to seize this chance because once I've broken into the Salon I am almost sure of making some sales, especially with Petit.»* Georges Petit was an art dealer who was a competitor of Durand-Ruel.

The jury of the Salon accepted only one painting by Monet, *Lavacourt*, that didn't seem to have been painted out of doors and seemed to show that Monet had made certain compromises. In a letter to Duret, he wrote, *«I had to do something nice and more bourgeois.»* His other entry, the painting of ice on the Seine, was rejected by the jury.

After that, Monet never again submitted entries to the Salon, but he always tried his luck with gallery exhibitions. In June, *La Vie*

Jean-Pierre Hoschedé and Michel Monet upon their arrival at Giverny, photograph

moderne, a periodical founded by the publisher Georges Charpentier, organized an exhibition of Monet's work at its gallery on the Boulevard des Italiens with eighteen canvases. In August of that year, Monet participated in an exhibition of the Société des amis des Arts du Havre.

Théodore Duret wrote the following about Monet's work in the forward to the catalogue of the exhibition organized by *La Vie moderne:*

«Claude Monet is the painter after Corot who in the painting of landscapes has shown the most originality and imagination. If we were to classify painters by their degree of imagination and the unexpected emotions that their work produces, Monet would be at the head of the list. But because the public is strongly prejudiced against anything new or original in painting, Monet's very talent causes him to be rejected by the public and by most critics. We feel that Claude Monet will be ranked among the landscape painters along with Rousseau, Corot, and Courbet.»

He went on to describe Monet's way of painting nature in his capturing of «the most delicate and ephemeral effect, the play of light and the tiniest reflections in the air.» As a matter of fact, Monet always touched up his canvases in a studio.

Mrs. George Charpentier bought the painting *Glaçons,* his painting of ice on the Seine rejected by the Salon.

Maturity

Vétheuil was a fruitful interlude between Argenteuil and Giverny.

Monet was forty, a mature adult. His personality had developed, and he had left the group of impressionists and did not participate in their sixth exhibition in 1881. Alice played an increasing role in his private life. And in his professional life Durand-Ruel backed him with support and encouragement.

Towards the end of 1881, the Hoschedé and Monet families moved to Poissy, but Monet was not happy there and escaped as often as possible to the Normandy coast around Dieppe. He settled in Pourville, a small fishing village near Varengeville.

Monet always enjoyed being on the coast where he grew up and where he began painting with Boudin. He painted a series of

Claude Monet, Pêcheurs à Poissy,
circa 1882, pencil, Fogg Museum,
Cambridge, Massachussetts

paintings with the same subjects: the cliff, the sea, the sky, and sometimes a house or cabin and tiny people in order to give a scale to the wild and strong landscape. There he painted *La Falaise à Dieppe, Promenade sur la falaise à Pourville, Cabane de douanier.* All three paintings are typical of this period. The same feeling can be found later in the paintings of the cliffs at Étretat and the gigantic stone arch in the painting *La Manneporte.*

In 1882 he returned to participate in the seventh and next-to-last exhibition held by the impressionists. It was called the «Seventh Exhibition of Independent Painters.» Monet entered thirty paintings, partly in order to help Durand-Ruel who was in financial difficulties following the collapse of the Union Générale bank. Renoir entered twenty-five paintings including the well-known *Déjeuner des canotiers.*

During the same year, Monet began to paint the decoration of the main room of Durand-Ruel's apartment on the Rue de Rome. He painted six double doors and a total of thirty-six panels of flowers and fruit, working until 1885.

In 1883, Durand-Ruel held a retrospective of Monet's work in his gallery on the Boulevard de la Madeleine with a total of fifty-six paintings. The critics were favourable including Gustave Geffroy, who wrote for *La Justice.* Geffroy was to first meet Monet in 1886 at Belle-Ile-en-Mer. He and Georges Clemenceau became Monet's closest friends. In 1922 Geffroy published the first book dealing with Monet in which there is a treasure of descriptions of this period. The book was entitled *Monet, sa vie, son oeuvre.*

Monet wanted to leave Poissy and began to look for a place where he could settle with his family and that of Alice Hoschedé. He discovered a small village near Vernon on the right bank of the Seine close to both Paris for business and to the Normandy coast for time near the sea.

This is Giverny where he was to spend the second half of his life and paint his famous masterpieces in his garden.

HIS TRAVELS
1883 - 1889

The light of the Mediterranean

Only recently settled in Giverny, Monet learned of the death of Edouard Manet on April 30, 1883. The only representative of the young generation of painters that were referred to as Manet's gang, Monet travelled to Paris for the funeral and helped carry the casket.

The calm life in Giverny with Alice and their eight children gave Monet the stability that he sought. Surrounded with affection, far from Paris in a countryside that he loved, he lived among flowers that became his passion. Alice was an intelligent, educated woman who knew how to receive guests. Alice's daughters brought a touch of elegance and heightened Monet's feeling for the landscapes where he often painted them.

Finally financially comfortable, he began to travel.
In December 1883, he travelled with Renoir to the Mediterranean coast where they visited Cézanne at Estaque. Just having recently returned to Giverny, he left again, this time alone, between January and April 1884, for Bordighera on the Italian Riviera, a place that he considered to be the most beautiful spot he had discovered on his visit to the Mediterranean. He was thrilled by this coastal resort with its luxurious vegetation where he could paint a whole new range of colours. He brought back about fifty paintings that have such an intense element of light that they make one think of the future Fauvists.
Monet wrote in voluptuous terms about his new impressions. He called his colours *«pigeon breast and punch flame»* and wrote that he sought *a palette of diamonds and gems* in order to better portray the light of the Mediterranean.
Among the most characteristic paintings of his visit to Bordighera are *Menton vu du Cap Martin, Palmiers à Bordighera,* and *Les Villas à Bordighera.*

The ocean at Etretat

In August 1884, he left for Etretat, which had always been one of his favourite places. He visited Etretat once again in 1885 and stayed with the singer Jean-Baptiste Faure. He brought back to Paris several important seascapes such as *Bateaux sur la plage à Etretat* and above all the views of La Manneporte, an impressive meeting of the strength of the sea and the stone arch in the sun light. He wrote to Alice, *«You can't imagine how beautiful the ocean is. And the cliffs, they're more beautiful here than anywhere else.»*

The tulips in Holland

In the spring of 1886, he spent several days in Holland where large fields of tulips probably attracted him. Two paintings from this visit were included in the Fifth International Exhibition of Painting and Sculpture held in the Georges Petit gallery. Huysmans wrote, «There are some outstanding fields of Dutch tulips by Claude Monet. They're a real feast for the eyes.»

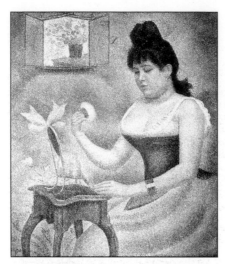

Georges Seurat, Jeune femme se poudrant, 1889-1890, oil on canvas, The Courtault Institute Gallery, London

In the meantime, Durand-Ruel who didn't particularly like his favourite to work with other art dealers such as Georges Petit organized an exhibition in the United States. About forty of Monet's paintings were included in the exhibition «Oil and Pastel Paintings of the Paris Impressionists» held in New York in 1886.

The year 1886 is also the year of the eighth and last of the impressionist exhibitions. Monet did not want to participate because he did not agree with the new directions the group was taking. Seurat, Signac, and Pissarro were the leaders of the group considered to be neo-impressionists.

They believed that the idea of the division and the arrangement of colour should be systematic and raised to the level of dogma. They built their theories on recent scientific discoveries in optics and wanted their results to be precise and objective as opposed to the subjectivity of established impressionism. Seurat was the leader of the neo-impressionists. His most famous painting is entitled *La Grande Jatte.* All the impressionists eventually abandoned this excessively rigid approach. Pissarro was the first to leave the neo-impressionists.

This was also the period when van Gogh moved to Paris and Gauguin began the Pont-Aven group in Brittany. Gauguin's Synthetism was influenced by the Symbolism in literature created by Stéphane Mallarmé and Joris-Karl Huysmans.

Wild Brittany

In the fall of 1886, Monet went to Belle-Ile in Brittany, an island in the gulf of Morbihan where he stayed with a fisherman on the most uninhabited part of the island. There he painted about forty paintings inspired by the struggle between land and sea on the exposed coast. He wrote to Caillebotte, *«I'm staying on this incredibly wild coast; a pile of beautiful rocks and a sea with the most amazing colours.»*

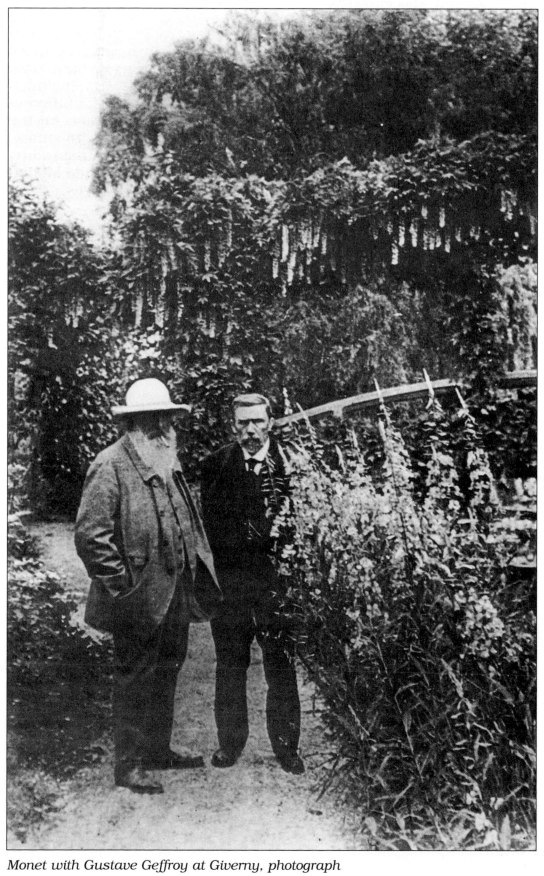

Monet with Gustave Geffroy at Giverny, photograph

Among the canvases that he painted are: *Pyramides de Port-Coton, Belle-Ile, La Côte sauvage,* and *Les Rochers de Belle-Ile.* These are powerful paintings, almost tragic. Dark rocks filled with deep cracks wrestle with the ocean's green reflections. This was very different from the Normandy coast with its chalk cliffs that Monet knew so well.

On Belle-Ile he met Gustave Geffroy who would become one of his great friends and a faithful defender. Geffroy described how Monet had to paint, «...in the wind and rain. He had to dress like the local people wearing rubber boots, covered with several sweaters, and wrapped in a hooded oilskin. The gusts sometimes tore away his palette and his brushes. He didn't stop. He continued to work with determination.»

And sometimes, like in October 1886, there were storms. Geffroy wrote, «The whole ocean is in movement. A weak wave appears to throw itself at a rock within its reach. The rocks disappear beneath the swell's fury. They break apart, beaten by the persistent effort of this biting and clawing attack. The violet, soapy foam is thrown against the coast by the southerly winds. It is a world of water and raging winds.» Geffroy should be read while looking at Monet's *Tempête, Côte de Belle-Ile.*

Another discovery arose from Monet's stay on this wild Brittany coast. He began to use a technique that he would later systematically adopt for his famous series. He wrote to Alice, *«I now know that in order to paint the sea with accuracy, I have to observe it every day, at all times of the day, and from the same place. That's how I can feel life at that place. I also paint the same subjects up to four or even six times.»*

Antibes, a bath of blue air

At the beginning of 1888, Monet left in the opposite direction from his stay on the Brittany coast for the Mediterranean where he stayed at the château de la Pinède in Antibes recommended by Maupassant.

«After the harshness of Belle-Ile,» he wrote, *«this is going to be tender. Here there are only shades of blue, pink, and gold. I'm working away like the devil, but I'm worried about what I'm doing. Everything is so beautiful here; so clear and filled with light. It's like bathing in the blue air, it's amazing.»* He painted about thirty-five canvases, adapting his palette to the warmth and brightness of the Midi. In *Antibes vue de la Salis,* two towers in the sun appear reflected in the distance. The tones he uses are pastels. In *Antibes, effet d'après-midi* there is so much light that the colours blend and it's possible to feel the physical weight of the heat. This rendering was later used to paint his series of the Rouen Cathedral.

In the foreground, Monet sometimes uses a tree to give depth

to his painting. It can be an olive tree against the light, a dark and twisted pine tree, or even smaller vegetation, like in *Antibes vue du cap* where he uses slanting brush strokes to represent leaves blown by the Mistral.

All these paintings were enormously successful. Théo van Gogh, the brother of Vincent, arranged an exhibition entitled «Ten Seascapes from Antibes» at the Boussod-Valadon gallery, a competitor of Durand-Ruel for Monet's work. Unfortunately, a lot of Monet's work left France for the United States.

Return to Giverny

After his visits to Brittany and the south of France, Monet was always glad to return home to Giverny to his home, his garden, his flowers, and above all to his family.

He wrote to Alice, *«I'll be so glad to return to my life in the country. I know that I'll be delighted to paint at home.»* The proof of his satisfaction is in his painting after returning home.

Paintings depicting the beautiful fields surrounding Giverny are *Champ d'iris jaunes à Giverny, Champ de coquelicots, environs de Giverny,* and *Les Saules, Giverny, le printemps.*

Monet already had a special attraction for the poplar trees because each of their leaves shine in the sun with sparkling yellows and golds. This is evidenced in *Un Tournant de l'Epte* or in *Brouillard matinal* with the tall silhouetted trees fading in the distance.

Monet painted the Epte, a small stream that flows near Giverny, with the play of small boats reflected in the calm water. Three of these paintings are *La Barque, En canot sur l'Epte,* and *En Norvégienne.* Alice's daughters Germaine, Suzanne, and Blanche often posed for Monet with their light-coloured dresses shining in the sun and reflected in the water. Monet often depicted the grasses growing in the water.

His two best known paintings from this period are without a doubt his two versions of *Femme à l'ombrelle (tournée vers la droite* and *tournée vers la gauche).* These two paintings clearly recall *La Promenade* painted eleven years earlier with Camille, his first wife, and Jean when he was still young. The scenes in the early and the later paintings are the same, with elegant silhouettes outlined against a bright blue sky dotted with small clouds and the shadow created by the green parasol on the white dresses billowing in the wind.

Grande Creuse and Petite Creuse

In 1889, Gustave Geffroy took Monet with him to visit the poet and musician Maurice Rollinat in the Creuse Valley. «From the first time we went for a walk,» Geffroy wrote, «Monet stopped to observe the low, bubbling water flowing among the rocks on a bed of gravel. The rocky hills, covered with moss and heather, rose everywhere

about us forming a dark background for the running water. It was a weird scene of endless sadness.»

In this landscape recalling «*the terrible wildness of Belle-Ile,*» Monet sought to portray nature in its forever changing aspects varying with the time of the day, the weather, and the seasons. But he was always frustrated by the speed with which the rain started or by the effects of spring that caused the budding of a bare tree that he wanted to paint. On one occasion he was forced to nip off the first buds on a tree he was painting.

Out of the twenty-three landscapes that have survived, an important group of nine paintings from the same viewpoint form a real series. These are Monet's rendering of the joining of the Grande Creuse and Petite Creuse at different times of the day. Three of the paintings are *Les Eaux semblantes, Creuse, effet de soleil, Le Ravin de la Creuse au déclin du jour,* and *Soleil couchant.*

On April 24, Monet wrote to Geffroy, «*I am forced to change constantly because everything grows and turns greener. Because of the constant changes, I am just running after nature without being able to capture it. The river empties, fills up again, one day it's green, then yellow, then it dries up. Tomorrow it will be roaring after the rain that's falling right now.*»

The Monet-Rodin exhibition

Monet was worried about being ready in time for the Monet-Rodin exhibition that was going to be held that same year at the Georges Petit gallery. The exhibition was to include forty-five of Monet's paintings and thirty-six of Rodin's sculptures. Rodin was showing his sculpture *Les Bourgeois de Calais* among other works, and Monet was presenting a retrospective of his work of the past twenty-five years from 1864 to 1889. There were *Le Port de Honfleur* (1886), *La Grenouillère* (1869)—both paintings had been rejected by the Salon, some paintings done in Holland and London, many canvases painted at Argenteuil and Vétheuil, *Le Boulevard des Capucines, La Gare Saint-Lazare,* and landscapes painted in Bordighera, Etretat, on Belle-Ile, and in Antibes. The most recent paintings were painted in Giverny and in the Creuse Valley and had never been exhibited.

GALERIE GEORGES PETIT

8, rue de Sèze, 8

CLAUDE MONET

A. RODIN

PARIS
—
1889

The forward to the catalogue was written by Mirbeau who declared «There's a feeling that I've often had looking at Monet's paintings. Artistic portrayal disappears and withdraws. We are left confronting nature itself, captured by this remarkable painter.»

Three of Monet's paintings were shown at the Exposition of One Hundred Years of French art held in connection with the 1889 World Exposition. Also shown was Edouard Manet's *Olympia*, a painting that had caused a scandal at the 1865 Salon. This painting was to be sold to America, but Monet organized a public subscription to buy it and donated it to the Louvre. All of this took time and almost prevented Monet from painting that year.

He finally returned to the calm of Giverny and in 1890 began the decade of his paintings in series.

THE DECADE OF THE SERIES
1890 - 1904

The poppy fields

Monet liked to return to places where he had already painted and to set up his easel and discover how the landscape changed with the hours of the day, the lighting, the season, or simply because of what he called the fragmentation of time. This led to his painting many versions of the same subject.

You can already find in the different perspectives of the Gare Saint-Lazare, in the rocks at Etretat and those on Belle-Ile, or in the views of the Creuse Valley an approach to painting that he systematically adopted after 1890. During the second half of that year, he began to paint a series of the poppy fields surrounding his house at Giverny.

Georges Clémenceau, who had become Monet's close friend, described what he had observed. «When I saw Monet with four canvases set up in front of the poppy field, changing his palette as the sun moved along its course, I had the impression that Monet was paying more attention to light than to his subject. This made the subject seem to be affected even more by the changing light. It was an evolution that became stronger and stronger. It was a new way of seeing, feeling, and expressing. It was a revolution. From this time on, right here in the poppy field bordered by three poplar trees, began a new period in our history in both our way of feeling and expressing things. *The haystacks* and *the poplars* were to follow.»

This new method of painting described by Clémenceau would grow to become a sort of obsession for Monet. He began to add to the number of easels he used, placing one next to the other, in order to go from one to the other as quickly as possible following the changing light. According to Mirbeau, Monet was sometimes forced «to work on up to ten different versions at any one time, almost as many versions as there are hours of daylight.»

The haystacks

At the beginning of the following year, Monet returned to a subject that he had already painted: haystacks, which, during that period were piled up in the middle of the fields in order to keep the hay dry for the winter.

The first important series of *haystacks* included more than twenty canvases that he finished in his studio. About fifteen of them were exhibited at the Durand-Ruel gallery in May 1891. They were all very well received.

«These haystacks, in an open field,» declared Gustave Geffroy with his usual lyrical prose, «they are temporary objects marked by the surroundings, atmospheric changes, and passing breezes like sudden bursts of light on a mirror. Shadows and light concentrate their energy on the haystacks; the sun and shade run around them in a continual chase. The haystacks reflect warmth and the sun's evening rays. They become covered with mist, are rained on, and are frozen in snow. The haystacks are in harmony with the distant surroundings, with the sun, and with the sky.»

The names of the paintings in this series evoke well the fragmentation of time: *Meules au soleil, lever du jour; Deux meules, déclin du jour; Meule, soleil couchant; Meule, soleil dans la brume; Meules, effet de neige, effet d'hiver, effet de gelées blanches, temps couvert.*

Pissarro wrote, «Everyone is asking for Monet's paintings. It seems that he can't paint enough. The worst is that everyone wants a *Meules au soleil couchant.*» Mallarmé wrote, «You overwhelmed me with your haystacks, Monet. So much so that I find myself looking at fields and recalling your painting.»

Kandinsky, one of the masters of abstract painting who discovered Monet before the age of thirty at an exhibition in Moscow and whose influence led him to abstract painting, wrote, «I have experienced two events that strongly marked my life and that greatly influenced me.

One was the impressionist exhibition in Moscow—especially Monet's haystacks—and the other was music by Wagner. I vaguely felt a lack of focus in the paintings, but what was very clear was the unimaginable power of the palette that was suddenly revealed and that went beyond my wildest dreams.»

The poplars

In opposition to the monolithic mass of the *haystacks* anchored to the ground, Monet painted poplars, thin and elongated and outlined against the sky or sometimes reflected in water. He took his studio boat up river from Giverny near the poplars along the stream called L'Epte. He even bought an island, the île aux Orties, in order to tie up his boat. He also paid a wood merchant who had bought some of his poplars to delay cutting them down.

He painted them by threes or fours or even by whole rows in the foreground, but he also worked from a bend in the Epte in order to have in the background a curving line of poplars that he painted from a distance.

The long curving line formed against the sky plays against the tall, vertical trees reflected in the water. The paintings are flooded with the sky's colours and their reflection in the water.

Complementing these systematic compositions are the colours that vary infinitely according to the light at different times of the day or the different seasons. In *Les Quatre arbres* and *Effet de vent, série des peupliers* the flowers seem to tremble and bend over. In *Peupliers, coucher de soleil* the colours range from pink to deep violet. Again in *Les Trois arbres, été* and *Trois arbres roses, automne* the tones of colour in the golden sunlight on the trees have the delicacy of pastels. Daylight sparkles off each leaf.

Gustave Geffroy wrote, «In the paintings of the poplars the actual presence of the forms and their subtle fading are captured with a truly moving elegance and charm. At the same time, the tall trees are flashes. The vegetation along the winding bank of the stream appears to dance on wings.»

This series of about twenty paintings was an enormous success and was exhibited at both the Boussod-Valadon and Durand-Ruel galleries.

Now that Monet was financially secure, he became more demanding with his dealers: *«From now on I don't want to sell my paintings before they are finished. I want to go slowly, at my own pace, finish them, and then choose later those that I want to sell.»* In most cases, each of his paintings was touched up in his studio. This gave him a chance to study the series of paintings done at different times of the day and on very different days.

The Durand-Ruel Gallery, drawing

The purchase of Giverny

Now owing to his new financial stability, Monet could finally buy the house at Giverny where he had lived since 1883. He also began rebuilding the house and, especially, the garden. In 1892, he had six gardeners working for him.

Ernest Hoschedé had been dead for one year which allowed Monet to leave behind his ambiguous situation with Alice. He married her on July 16,1892.

From that time on, he left Giverny less and less, although he invited friends and admirers to stay at Giverny, especially his faithful friends Georges Clémenceau and Gustave Geffroy. When he did travel, he didn't stop writing to Alice with his recommendations. *«Are there any flowers in the garden? I would like some chrysanthemums when I come back (1885). I'm grateful that you have taken care of my dear flowers. You are a good gardener (1886). I finally found some wild radishes. In one of the baskets, unwrap it carefully, there are some other plants—perennials and some passion fruit plants for the greenhouse, along with two very beautiful yellow flowers and two small delicate nasturtiums (1893). Has someone remembered to cover the Japanese poppies? It would be close to murder if they haven't (1895). Dear loved ones, I would be lying if I told you that I would not be happy to be with you and my flowers (1913).»*

The cathedrals

In February 1892, Monet rented a room facing the cathedral in Rouen in order to paint at two different times, in 1892 and again in 1893, an exceptionally beautiful series of the cathedral seen from three slightly different vantage points. The paintings are centred on the entrance and the two towers, the Albane tower on the left and the Saint-Romain tower on the right. The painting at such close quarters of a monumental Gothic cathedral had never been done before.

Rouen cathederal, photograph

He painted about thirty versions, just as he did for the series of haystacks, trying to follow the light on the façade at different times of the day from dawn to dusk including in bright sunlight.

By blurring the architectural details, Monet made this series the most spectacular demonstration of

light's fleeting qualities. The flat façade is treated like a cliff whose many sculptures catch and reflect the various different intensities of light in a coloured vibration. The painter has suppressed all references to religion—he has even taken out the cross on the church front—and any reference to modernness—he has wiped out the face on the clock. Monet also left out any human presence—except for tiny silhouettes in one of the versions. He separated the façade from the rest of the building, leaving only a snippet of sky and doing away with the foreground.

Monet worked passionately in bad physical conditions—he worked in a cramped space—from early morning until sundown, moving from canvas to canvas as the light changed. After three weeks, he had nine canvases under way. Monet wrote to Alice, «*My God this blasted cathedral is difficult to do. Every day I touch it up or discover something else that I hadn't yet seen. I'm worn out, I can't do any more. Something happened that has never happened before, last night I had nightmares. The cathedral fell on top of me. It was blue, pink, and yellow.*»

During almost two years, he worked to finish the paintings in his studio at Giverny and dated them 1894. Only in May 1895 about twenty versions were exhibited at the Durand-Ruel gallery. Everyone was overwhelmed and delighted.

He should have painted fifty, a hundred, a thousand

Gustave Geffroy wrote, «With these versions, or rather visions, of the Rouen Cathedral this determined and hard-working painter has attempted and achieved the impossible. More than ever, I now understand what he is attempting and how determined he is to find it. Looking closely at Monet's cathedrals, it seems that they are made from some sort of mortar ground into the canvas at a moment of anger. Just how the painter, only a few centimetres away from his canvas, can understand the effect that is both precise and subtle that can be appreciated only by stepping back. It's all part of the amazing mystery of his retina.»

Georges Clémenceau declared, «I entered Durand-Ruel's gallery to look leisurely again at the studies of the Rouen Cathedral and right then and there I became obsessed in a way that I cannot explain. I haven't been able to get rid of them since. It's become an obsession. In about twenty paintings with well-chosen effects, Monet has given us the impression that he could have, that he ought to have painted fifty, a hundred, a thousand, as many as there are seconds in his life, if his life lasted as long as stone monuments. With each pulse beat he could have captured on canvas just as many versions of the model. As long as the sun was shining on it, there were as many different ways of seeing the Rouen Cathedral as man could

make division of time. Monet's eye, that of a precursor, leads us and guides us in the visual evolution that makes our perception of the universe more penetrating and more subtle.»

Pissarro wrote to his son, «Above all it has to be seen in context. I am quite thrilled by his extraordinary mastery. Cezanne agrees that it is the work of an individualist, a careful calculator trying to catch the fleeting nuances of the effects, a feat that I have never seen done by any other painter. Some painters reject the need for this searching. Personally I find any search justified when the urge is so great.»

In the 1895 exhibition, the public would discover along side the twenty cathedrals, eight Norwegian landscapes that Monet painted in the village of Sandviken near Oslo. He fell in love with the effects of light on the snow's whiteness—»absolutely overwhelming and of an unheard of prowess,» he wrote. *Mount Kolsaas, roses reflections* reminded him of Mount Fuji-Yama.

Pilgrimages to his first love

About this time, Monet felt a need to return to the place of his first love and made a pilgrimage to where he had painted during his youth: Pourville, Dieppe, and Varengeville. It is amazing to compare canvases painted at an interval of fifteen years and to discover the painter's evolution. Take for example *La Maison du pêcheur, Varengeville* (1882) and *Falaise à Varengeville* (1897) that would become a series of paintings. Monet's treatment evolved towards a sort of abstraction of forms and colours just like in *Mer agitée à Pourville* (1897).

He also painted a series of canvases inspired by the Seine near Giverny. Always up before dawn in the summer, he captured the subtleties of daybreak when the mist is still lying on the river in marvellous perspectives such as in *Matinées sur la Seine* and *Bras de Seine près de Giverny*. There is a glow of light from the sky reflected in the water everywhere.

A journalist told the story of how at 3:30 in the morning he followed Monet to his studio boat where he worked on fourteen paintings at the same time—paintings that he had begun the previous summer—moving from one canvas to another as the sun slowly melted the mist.

These paintings were exhibited in June 1898 at the Georges Petit gallery and at the Bernheim-Jeune gallery—a new art dealer—in February 1902. The exhibit also included a series of new paintings entitled *Vue de Vétheuil.*

Fog on the Thames

He also made pilgrimages to London, travelling three times in 1899, 1900, and 1901. He stayed at the Savoy Hotel and painted

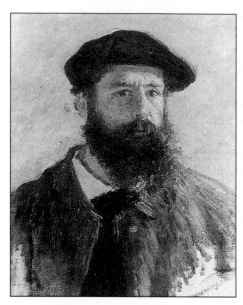
Claude Monet, Self-portrait with a beret, 1886

only Parliament and the Waterloo and Charing Cross bridges from his balcony.

What he wanted to do was *«to try to paint some of the effects of the fog on the Thames.»* In these paintings the buildings seem like ghosts surrounded by a sky filled with fog reflected in the Thames. Monet was waiting for *«a stormy sky»* or *«a hole of sunlight in the fog,»* or else an *«effect of the sun through smoke»* to render better the effect of mixed fog, light, and water. He used vibrant, almost hallucinatory colours that bring to mind the visions of Turner, Whistler, and the famous painting from Le Havre that gave the name to the group of impressionists in 1874, *Impression, soleil levant.*

These are works of a visionary who was both playful and dramatic. Rare rays of sunlight set off strange bursts of warmth in the passing veil of fog.

As usual, Monet touched up his paintings in his studio at Giverny, but he wasn't satisfied with the results. He had doubts and didn't want to deliver his work to Durand-Ruel. Sometimes he reworked the colours from memory. Finally, of the more than one hundred canvases painted in London, thirty-seven were exhibited in the spring of 1904 at the Durand-Ruel gallery in a show entitled *«Series of Views of the Thames in London (1900-1904).»* It was an important, very well attended, social event where almost all the paintings were sold, but the critics were divided. Some saw the paintings as representing the height of Impressionism, while others decried the disappearance of form and the lack of serious rendering.

Monet was also criticized for having used a photograph to paint part of his work. He reacted strongly to this, insisting that the final result is what counts. «Whether my *cathedrals*, my *Londons*, and my other paintings are painted from real life or not is nobody's business and has no importance.»

The forward to the exhibition catalog

Let's reread what Octave Mirbeau wrote as the forward to the exhibition's catalogue.

«A unique subject for his paintings, unique and different: the Thames. There are smoke and fog; forms and architectural volumes,

perspectives, a whole silent and buzzing city in the fog, real fog; the play of light in all its aspects; the sun as a prisoner of the mists or otherwise shining through in dissectible rays with the atmosphere shining, radiant, and deeply coloured; the multifarious drama infinitely changing and subtle, dark or fairy-like, sad, delightful, flowerlike, incredible, reflections on the Thames; an element of nightmare, of dreams, of mystery, of fire, of stifling heat, of chaos, of floating gardens, of the invisible and the unreal, and all of that combined with nature, a special nature peculiar to this throbbing city created for painters and one that painters, until Claude Monet came along, could not see or have not been able to express.

A city which they have not seen and portrayed except for occasional glimpses or chopped-off anecdotes, but not the overall view, not the magnificent and beautiful fleeting spirit that here, finally before us, has been captured.»

His last trip to Venice

Monet visited Venice with Alice from October to December 1908. It was his last major trip. He chose this city of myths, the city par excellence for painters, as a place in which to confront once again architecture, water, and the special light that was to be found there. He began work on some of his most memorable canvases. He wrote to Gustave Geffroy, *I really admire Venice. I almost forget that I am the old man that I am.»*

He was fascinated and spoke of a perpetual enchantment. Alice wrote to her daughter as they were leaving, «he painted up until the last minute a sketch of a gondola that is especially beautiful in spite of everything.» The canvases painted in Venice can be categorized in accordance with the painter's vantage point: *Le Grand Canal, Le Palais des Doges vu de San Giorgio Maggiore,* and different views of the palaces such as those of the Contarini Palace with its rose and violet facades reflected in the thousands of ripples on the water.

This last visit away from Giverny was a break from his work on the lilies that he had begun. Some consider that the paintings of Venice were painted in the purest of impressionist traditions.

Upon returning to Giverny, he reworked some of his canvases and thought that he could return to Venice to finish them, but family considerations and, above all, the death of his second wife on May 19, 1911 prevented him.

At the beginning of 1912, the Bernheim-Jeune gallery organized an exhibition of twenty-nine paintings in the series *Vues de Venice.* Once again the reactions of the critics and the public were enthusiastic, and the exhibition was extended.

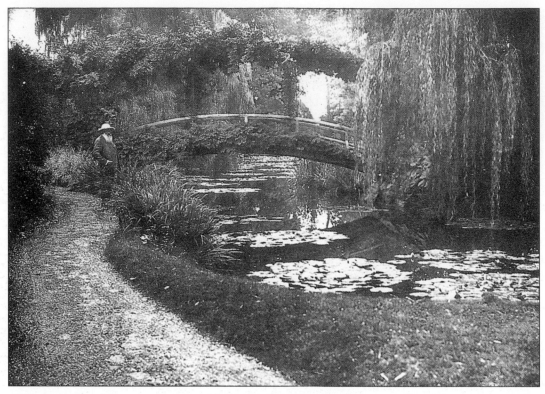

Monet at the Japanese bridge at Giverny, photograph

The neo-impressionist Signac wrote the following to Monet: «In viewing your series of paintings of Venice, with their incredible interpretation of subjects with which I am very familiar, I felt as strongly moved as in 1879 when I first saw your series on the Gare Saint-Lazare, your *Rue pavoisée,* your *Arbres en fleur* that decided the course of my life. They are the epitome of your art, and I admire them.»

Henri Genet wrote in *L'Opinion,* «Monet is above all the painter of light. This genial and glorious painter just had to go to Venice which is the city of real light. Lying between the water and the sky, Venice is liquid and diaphanous. There are no rough spots. The light is blond, fluid, purple, and slippery and surrounds the palaces and houses. Blue and pink facades float on the water. The ivory domes appear to melt in a sky that absorbs them and to melt in the water that reflects them.»

THE AQUATIC GARDEN AT GIVERNY 1905 -1926

At home at Giverny

Geffroy wrote, «This strong landscape artist who so very well expressed the majesty of the sea, cliffs, rocks, old trees, rivers, and cities delighted in such sweet and charmingly simple subjects, this wonderful corner of a garden, this tiny pond where several mysterious flowers bloomed.»

First discovered in 1883 and finally finished in 1890, Monet's house at Giverny with its garden and pond was to become his achievement and his refuge. He almost never left it until his death in 1926.

Because of his health problems—dizziness, asthma, eye trouble—and because his close family gave him some concern—Alice and Jean were ill and soon died, his wife in 1911 and his son in 1914—Giverny became the refuge that Monet needed. It was his daughter-in-law Blanche who would care for him and who became the mistress of the house.

But Giverny should also be considered as a true creation of the painter—a three-dimensional work of art and his final pleasure.

Edouard Manet's 1874 painting showed Monet in his garden at Argenteuil. He also gardened at his house at Vétheuil, but at Giverny he was really in his own house. Here he truly fell in love with his flowers. He often had them sent from far away and became a real expert in horticulture.

In the last stage of his life at Giverny, however, he went even farther in his efforts, incorporating water in his garden to create his famous aquatic garden immortalized by his paintings of water-lilies. Giverny was transformed by stages through the purchase of additional land and by increasing the pond from twenty to sixty meters in length.

Now famous and established, safe from financial worries, he led a life of relative luxury. He often invited journalists, critics, and young painters such as Bonnard, Vuillard, and Matisse; writers like Huysmans, Mallarmé, and Paul Valéry; art dealers like Durand-Ruel, one of his first friends, and Bernheim; and friends like Sacha Guitry, George Clémenceau, and Gustave Geffroy.

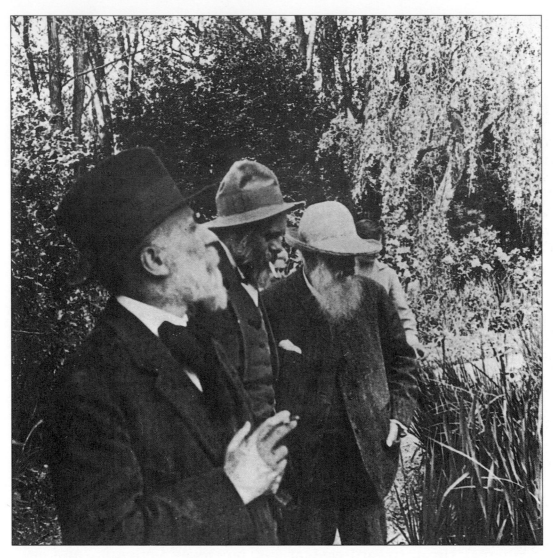

Monet with Ker-Xavier Roussel and Edouard Vuillard, 1920, photograph

He went so far as to design a blue and yellow dining service in harmony with his dining room where he hung his Japanese prints. His dinners were those of a true gourmet and gave much pleasure to his guests.

The Japanese bridge

Between 1890 when Monet began to redecorate Giverny and the exhibition in November and December 1900 at the Durand-Ruel gallery, Monet painted about twelve canvases of what was to be a series of sixteen of the aquatic garden and especially the famous Japanese bridge that he had built out of wood in the form of an arch at a narrow point in the pond.

For example, in an 1890 painting *Le Bassin aux Nymphéas, harmonie verte* or in the *Harmonie rose* (1900) the bridge is depicted

in full view against a background of weeping willows and luxurious vegetation, before being covered with wisteria.

This is in contrast to his later rendering of this subject. Once the pond was enlarged, Monet focused on its surface and painted only the lilies, water, and the sky that was reflected there. He declared: «*What is important about this subject is the reflecting water whose nature is all the time changing owing to the patches of sky that are reflected in it and that give it life and movement. The fleeting cloud, the breeze that stiffens, the squall that threatens and then hits, the wind that picks up and then drops suddenly, the light that drops and then strengthens, these are so many reasons that cannot be grasped by the uninitiated's eye. They change colour tone and alter the surface of the water.*»

In the painting *Paysages d'eau, les nuages* (1903), the painting appears to move away from the eye. Only a slight strip of green appears still at the very top of a painting that is completely covered by water that reflects the inverted landscape. There the trees, the blue sky and the passing clouds no longer exist in themselves, but only in their reflections.

A little bit later, Monet went so far as to suppress the opposite shore at the top of his paintings and cut off the lily pads at the bottom that then seem to be at the viewer's feet. The successive application of colours suggest depth below the water's surface.

Sometimes, he would destroy paintings that didn't please him and move towards sharper contrasts of colour. He also tried different formats, for example several large circular canvases, in order to break away from the pond's dimensions and to create a world enclosing itself.

The lilies, waterscapes in series

From May 6 until June 5, 1909, Durand-Ruel organized a new exhibition—several times cancelled on Monet's insistence—entitled «*Les Nymphéas, séries de paysages d'eau*» with forty-eight paintings done between 1903 and 1908, thus the longest of Monet's series.

The dates don't always mean a lot because Monet touched up his canvases in the studio and would take them up sometimes even one summer after the other during the flowering period of the lilies that usually lasts from the end of May until the end of September. «*I need to have the finished paintings right before me,*» he wrote to Durand-Ruel, «*in order to compare them to those that I am working on.*» He confided to Geffroy, «*This is to tell you that I'm absorbed in my work. These paintings of water and reflections have become an obsession. It's more than an old man like me can do, but I still want to portray what I feel. I've destroyed some, I've begun others again, and I hope that something will come out of all my efforts.*»

The exhibition was a great success.

Louis de Fourcaud wrote in *Le Gaulois*, «We are in the presence of something unexpected but sought after, intimately poetic and absolutely real. The most perfect harmony is created by the glorious whole, full of lovely life and bathed in tender silence. We can't break loose from it.» He adds how much he regrets that such a work can be dispersed to the four corners of the earth. He concludes, «They should be preserved in the hall of a palace where they could be observed by us as an act of splendour and serenity.» Eighteen years later his wish would be fulfilled. Other paintings by Claude Monet, also entitled waterlilies will be the only decoration in the Orangerie des Tuileries.

Roger Marx wrote an imaginary dialogue in which Monet says the following, «I was tempted to use the lilies as the theme for the decoration of a Salon spreading along the walls and creating the impression of being endless, of being a wave without a horizon and without shores. It will be relaxing there just like the soothing still waters of the pond. Whoever visits there will experience a kind of meditation in the middle of a flowering aquarium.»

Looking at a photograph taken in the early 1920's, you can almost imagine Monet there in his studio built especially for painting the *Grandes Décorations* that were destined for L'Orangerie after his death.

His greatest masterpieces

Louis Gillet wrote a study in the *Revue hebdomadaire* on August 21, 1909 under the title *L'Epilogue de l'Impressionnisme* in which he declared Monet's water landscapes to be «the most charming, the acme of his masterpieces» and that the painter was «one of the greatest inventors ever in the portrayal of landscapes.» Further on he writes,:«Water and its reflections interact in mysterious ways. The interplay of the atmosphere and the waves, one influencing the other is like a shadow fleeting across a mirror. What spectacle is more appropriate for mortals to consider! No philosophical proposition could be more profound.» In conclusion Gillet writes: «There was a rush to condemn impressionism. If impressionism produced only the work of Monet, it would still be one of the most original movements of contemporary art.»

Impressionism is pure Monet

Remy de Gourmont wrote later in the *Mercure de France* an article entitled *L'il de Claude Monet*: «Taking the word impressionism in the strictest sense, Monet would have been the only impressionist because only he was capable of bringing together theory and practice of the art of painting. He was open to all the coloured impressions

that an eye can see. Impressionism is Monet himself, isolated in his genius, glorious, and miraculous.»

Lucien Descaves wrote to Monet, «I have just come out of your exhibition thrilled and dazzled.» Romain Rolland wrote, «An art like yours is the glory of a country and of a epoch. When I am disappointed by the mediocrity of today's music and literature, I have only to turn my eyes to painting where there is work like your *Nymphéas* in order to find satisfaction with our artistic epoch and to realize that painting has never been so great.»

Official recognition

To all of these testimonies could be added others that describe not only the success of an exhibition but also the official recognition of Monet's unique contribution. His work began to be regularly exhibited in the world's great cities and especially in the United States.

The prices for his paintings kept climbing and reaching prices never even imagined by Monet himself. Durand-Ruel and his sons and the Bernheim-Jeune brothers shared the market for the sale of Monet's work and organized exhibitions.

The important museums abroad as well as those in France and Paris at the Luxembourg Museum sought out his work and the Louvre Museum opened its doors to him a few years later.

The hardships of old age

After the successful exhibition of waterlilies, Monet went through a difficult period. Ever since 1908 his health had been worsening, especially his eyes—he suffered from double cataracts. He was afraid of becoming blind, but made the decision to be operated on in 1923. He claimed that his poor eyesight forced him to use more and more darker colours. He also destroyed many of his paintings.

An unusual rise in the Seine flooded his garden and its pond. Monet thought that everything was lost and that he would have to sell everything. Fortunately this was not the case. But a series of funerals were to darken his horizon during the last years of his life. He was the last of the impressionist group and their successors to survive. Bazille died in 1870 during the war, Manet in 1883, van Gogh in 1890, Seurat in 1891, Caillebotte in 1894, Berthe Morisot in 1895, Sisley in 1899, Toulouse-Lautrec in 1901, Pissarro and Gauguin in 1903, Cézanne in 1906, Degas in 1917, Renoir in 1919, and Monet in 1926, having survived all of his friends.

The death of Alice in 1911 and his son Jean in 1914 deeply marked him. The woman who was his companion for more than thirty years had created a supportive and family environment around

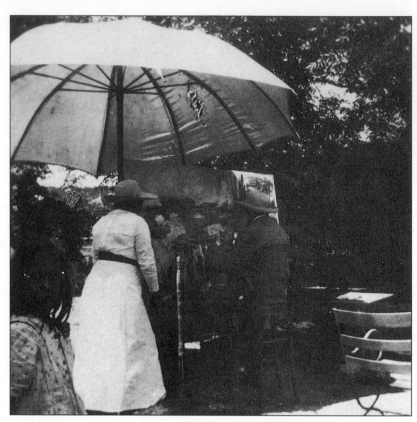

Monet working on his studies of lilies watched by Blanche, photograph

him. Suddenly he was left alone. It was owing to the support of Blanche, Jean's widow, that Monet was able to take up painting again and it was again she who, after 1926, dedicated herself to maintaining the house at Giverny in its original state.

Monet was also encouraged by his two faithful friends Gustave Geffroy and Georges Clémenceau. Not only did they support him through all his troubles, but they left important documents that have been often quoted throughout this study in order to bring Monet back to life.

The conflict of 1914-1918

During the First World War, Monet had a special studio—24 x 12 meters— built for him with a large skylight in order to paint the monumental series called *Grandes Décorations de Nymphéas*. In 1915 he wrote, «*I'm going ahead with my idea for the Grande Décoration. It's a huge undertaking, especially at my age. It's part of the project that I have been pursuing for a long time already: the pond,*

the lilies, and plants, but on a very large surface.»

Nonetheless, the early and numerous victims of the conflict and the beginning of the horrible trench warfare upset him. He wrote to Geffroy, *«I've begun my work again, it's still the best way to avoid thinking about today's sad events, although I'm a bit ashamed to be thinking about studies of forms and colours while so many people suffer and die for us.»*

The beginning of *Grandes Décorations*

His productivity was astonishing. In 1920 he claimed to have painted between forty and fifty large panels (ranging between 2 x 4.25 meters and 2 x 6 meters). He completed most of these during the war, and that figure does not include the large number of studies he executed.

These panels form a continuous canvas. Monet placed them on moveable easels so that he could change their order. It is difficult to date the final work now displayed in the Orangerie des Tuileries, because Monet worked on so many different canvases at different times, often returning to earlier paintings and transforming them. Later, when he was no longer confident about his eyesight, he worked from memory. The entire achievement is an impressive synthesis of this famous aquatic garden that Monet dreamt up, built, sowed and cared for over a period of decades. The painter knew his garden so well that he could capture it without having to look at it.

Throughout his life, Monet never stopped searching to portray natural light and sunlight in nature's own colours, and its effect on the leaves and the flowers. And on every occasion, whether in the sea, in the Seine, in the Epte or in his pond at Giverny, he repeated his vision mirrored in the water.

Les Nymphéas are therefore, the final result of the talent and work of a man as well as being the legacy—and that's why he hesitated so long before exhibiting his final work—of a life uniquely devoted to painting.

The pain of going blind

Before turning to Monet's final work on *Les Nymphéas* to which he devoted most of his time, a look should be taken at other subjects that held his attention during his final years at Giverny. For example, several paintings in the series *L'Allée des rosiers* and an important series entitled *Pont japonais* date from the period in the 1920s before his eye operation.

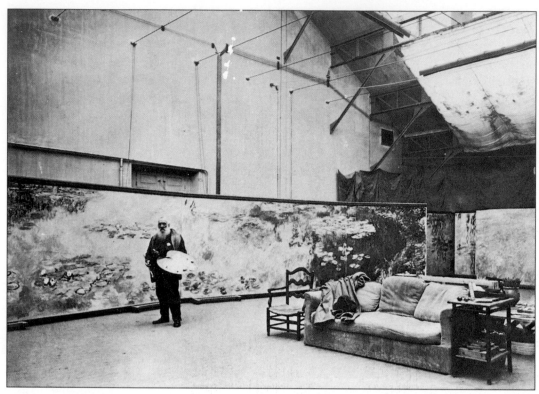

Monet working in his studio at Giverny circa 1920, photograph

There is some reason to believe that his perception of colours had been slightly changed. Monet began to paint in a frenzy. He admitted that he chose his colours only owing to the names on the tubes. A mass of rose bushes invades *L'Allée* just like those of the wisteria covering up *Le Pont japonais*. The resulting canvas has something demented about it that reflects Monet's terrible fear of losing his eyesight and the knowledge that his life is almost over. He wrote to G. Bernheim-Jeune, «*I don't have much longer to live and have to devote all my time to painting, with the hope of finally doing something outstanding, something that will finally satisfy me. I'm forcing myself to work and would like to paint everything before going blind.*»

Another beautiful painting from this important period is *Le Jardin de Giverny* dated 1917 that belongs to the Musée d'Art in Grenoble. Maurice Guillard in his book entitled *Claude Monet au temps de Giverny* gave the following description: «What is amazing is the musical quality given to the subject by the rough brush strokes. It's absolutely lyrical. Monet doesn't work by brush stroke or coloured surface or shadings, but with fast movements of long emphasis with the brush, using a blended range of colours where blues, yellows, and greens run together. He is able to express the special musical moment of an interior garden.»

The struggle and determination of the old man is admirable and passionate. Fortunately, the operations that he had after 1923 and the use of eyeglasses improved his sight. His enthusiasm returned. In 1925 he wrote, «I am well, although rather old. I am so happy to have recovered my eyesight. I've been working all summer with more joy and drive than ever.»

Donation to France of *Les Nymphéas*

After the 1918 armistice, Monet wanted to participate in the celebration of the victory and, upon the urging of Clémenceau and Geffroy, he offered a donation of two panels of waterlilies to France as a symbol of peace. He wrote to Clémenceau, « *Dear and true friend, I have almost finished two panels that I intend to date with the day of the victory and request that you offer them to the country. It's not much, but it's the only way that I can take part in the victory.»*

In compensation for the donation, the State agreed to buy *Femmes au jardin,* a large painting dated 1866-67 that had been refused earlier by the Salon's jury.

It's quite possible that Monet and Clémenceau had begun to think of a donation of twelve panels as early as 1918, but an appropriate building for their exhibition was lacking. In addition, Clémenceau's loss in the 1920 presidential elections jeopardized the hanging of the panels. Furthermore, Monet never felt that they were ready and constantly delayed the date and the conditions for the donation. The press played an important role in this affair that went on and on, giving it an importance and a notoriety that raised the level of curiosity, especially as the public had never seen the paintings involved.

Towards the end of 1920, everything seemed arranged. The Government agreed to build a hall on the site of the Hìtel Biron. The architect Louis Bonnier drew up plans for a single circular hall. But parliament delayed in appropriating money owing to the high cost of the project. Monet finally rejected the plan. He didn't want a round hall, he wanted an elliptical hall.

Finally an adaptation of the Orangerie des Tuileries was proposed. The site, right in the heart of Paris overlooking the Seine and the Place de la Concorde, is prestigious. The orientation and the form of the two main halls reminded Monet of his aquatic garden at Giverny. He accepted and on April 12, 1922, the act confirming the donation was signed. Monet immediately began working touching up the paintings in his studio. The contract gave him two more years to finish.

Suddenly in 1924, he wanted to annul the contract. Clémenceau became angry and Monet, having regained his eyesight, happily continued his last great work. In February 1926, he informed Clémenceau that he was waiting for the paint to dry before sending the first set of panels to Paris. Two months later, Monet's faithful friend wrote after a visit to Giverny, «The panels are ready, but he can't bear to separate himself from them.»

By August Monet had become very ill, but he continued to struggle to paint and dream about the changes that he wanted to make in his cherished garden.

In September he wrote to Clemenceau, *I have been thinking about preparing my palette and brushes to begin painting again, but weakness and more pains have prevented me. That doesn't disappoint me and I've begun to make some changes in the studio and have some ideas for improving the garden.* The very old man continued to struggle, surrounded by all his huge canvases for the *Grandes Décorations de Nymphéas*, from which he never really wanted to be parted, and the beautiful flower beds in his garden.

With Blanche Hoschedé-Monet looking after him and Clemenceau at his bedside, Claude Monet died at the age of eighty-six on December 5, 1926.

.

Second room of the Orangerie devoted to the Lilies, Paris, photograph

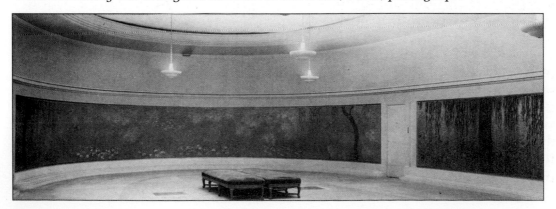

THE LEGACY OF CLAUDE MONET: THE LILIES

The official inauguration

Only six months after his death the official inauguration of the *Nymphéas* was held on May 17, 1927 at the Orangerie des Tuileries.

This was the last message from him who was called the master of Giverny. His artistic legacy, a legacy he had jealously kept close to himself until the end of his life and that was to influence generations to come, was finally visible to the public. Perhaps the painter had preferred to die before giving it up.

The two halls at the Orangerie

After going down, like the descent into a crypt, into what André Masson called «the Sistine Chapel of impressionism,» you enter a large room, room number one, surrounded by a coloured oval of water and lilies. It is the only decoration to be seen. You should silently wait and then slowly turn your attention from the middle of the room towards the four enormous compositions, each with several canvases without apparent seams.

To the rear upon entering, is *Reflets verts*, to the left *Les Nuages*, to the right *Matin*, and just behind you *Soleil couchant*. In the second hall, even larger than the first, are *Les Deux saules* at the back, *Le Matin aux saules* on the left, *Matin clair aux saules* on the right, and behind *Reflets d'arbres*.

It is impossible to express in words the feeling that is created upon being enveloped by Monet's paintings. It's difficult to know where to stand and where to look. Depending on where you are standing, the water seems to come to your feet or else the concave canvases seem to recede and lose themselves in the distance.

First room of the Orangerie, photograph

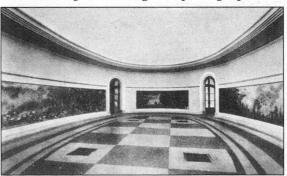

As for the colours, they seem to change from painting to painting while always staying within the

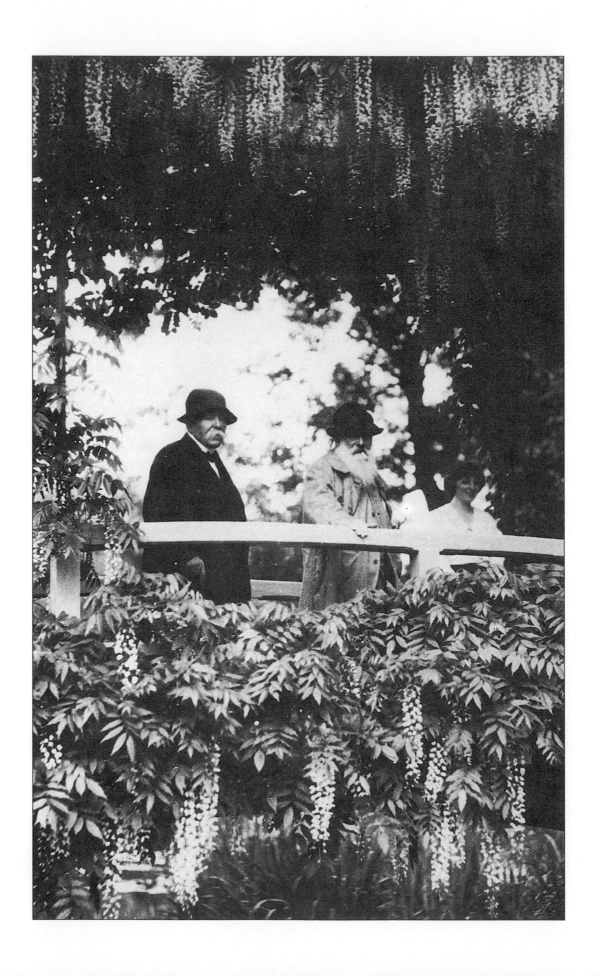

same range of tone. For instance, the dark colours in *Reflets d'arbres,* painted in dark greens, deep blues and violets, crossed by the reflections of the leaves and spotted with the lighter lilies, some of which have a bright flower, give us the image of night falling on the quiet water. In contrast, *Soleil couchant,* on the wall just opposite, is bright with the last reflections of the golds and reds from the sun. On the left side of the canvas where Monet's brush has suppressed all forms, it has become an abstract composition with a craze of fiery colours, while on the right side of the canvas, night is already invading the pond.

Between the two paintings, *Les Nuages* on one side and *Matin* on the other, stretch almost thirteen metres painted in much more subtle colours. It is impossible for the visitor's eyes to take them all in. You must move about and look at the water wrinkled by a slight breeze in *Matin* or at the first lilies on the left already lit by the sun. Here Monet wasn't able to equalize the panel's colours. On the extreme right-hand side it is still dark. In *Les Nuages,* clouds are reflected in the water almost like cotton.

In the second hall, the light leaves of the willows dominate the paintings. At the rear when you enter, the longest of all the panels is visible, *Les Deux Saules.* It is seventeen metres long by two metres in height and was painted on only four panels with each of the end panels portraying a willow. All that is visible is the trunk of the willow and some leaves against a background of very blue water in which rose-coloured clouds are reflected. This huge painting is exceptionally beautiful and shines in the light.

The painting on the left is *Le Matin aux Saules* with the same bright light and the same intense blue. Here, the trunk of the willows and their leaves cut the canvas vertically in two. On the right, *Le Matin clair aux saules* is painted from the same vantage point but with different lighting already brightened by the early rays of the sun. Finally, behind the entrance is *Reflets d'arbres,* the darkest of the paintings in these two rooms; where reflections join the approaching night darkness.

On the left *Claude Monet with Blanche Hoschedé and his friend Georges Clemenceau, photograph*

Below *The garden at Giverny, photograph*

A great pantheist poem

A great deal has been written on the *Nymphéas* at the Orangerie, with great admiration, that Monet never read . Some writers find a cosmic dimension in them. Gustave Geffroy, who died shortly before Monet but who had closely followed the slow birth and the many revisions to these paintings, wrote of «a great pantheist poem in which Monet closely immersed himself in nature giving supreme meaning to his art and his admiration for the universe.

After having travelled the world admiring the light everywhere, he learned that this light was reflected in all its splendour and mysteries in this magical hollow surrounded by willow branches and bamboo, by irises and roses reflected in the mirroring water from which grew the strange flowers that seemed even more silent and sealed than all the other flowers.»

Paul Claudel wrote in his *Journal,* «Monet has the same passion for colour that the great makers of stained glass for our cathedrals had. Colour rises to the surface of the water from the bottom, in clouds, in whirlpools.»

In his book *Claude Monet, les Nymphéas*, Georges Clémenceau wrote, «This emotion, who hasn't felt it, even without understanding it right away, when looking at the triumph of the *Nymphéas?* This is the way Monet painted action, the action of the universe struggling with itself for creation through stages of suddenly caught images from the surface of his lily pond. It is a drama climaxed by the blinding flash in the last panel at the Orangerie of the sun setting in the dried reeds of the winter marsh and from which the enchanting flowers of the spring will be born out of the unfathomable abyss of eternal renaissance.»

Michel Butor declared, «We are in the presence of a whole system of signs: long furry reeds and rushes along the streams, woolly vertical trunks in the second hall, short erect threads on the willows, areas wrought by spilling clouds, more or less long horizontal planes, water that is alive, and large blotches forming the lily pads with bright touches representing the flowers.»

A WORLD THAT NO ONE SAW BEFORE HIM

Gustave Geffroy relates in the forward to his book *Monet, sa vie, son œuvre* that the painter often remarked: «*All the praise that I receive is disproportionate when I think of the work of the great masters who have given us so many wonderful balanced masterpieces; masters such as Titian, Veronese, Rubens, Velasquez, and Rembrandt whose genius at painting is undeniable. Alongside their work, what is ours, what is mine?*»

Geffroy gives his answer thus, «The answer to Monet's question is that his work, effectively, does not resemble any that has been done in the course of the history of art. Monet's merit is intact. His work is a revelation and a poem that reveals the universe as no one before him did.»

Contemplating the effect Monet's work had on him, Geffroy observes: «Monet's work, a landscape from Normandy, Belle-Ile-en-Mer, Holland, the Creuse Valley, Rouen, the lily pond, London, or Venice, it's also reality, a reality seen by Monet that shows us a beauty in nature that hadn't been seen before him, but that will remain established by him.»

All his life, Monet sought to reproduce what he saw «at a precise moment in time.» He tried to capture an instant picture of the ever-changing relationship between light and nature. Monet proceeded unemotionally, returning to the same subjects in his famous series, always searching, in vain, to discover in them their real essence.

Monet spoke of «*the clash of colours in spite of his best efforts*» that obsessed him all the time. He was driven to capture a particular moment, thus effacing the onward march of time. Monet did not paint the images of the real world, but the image that he himself felt.

There were never any nudes in his paintings in contrast to Renoir for whom the female body was the source of all beauty. Monet didn't paint any of Renoir's numerous realistic portraits that revelled in the play of subtle colours portraying his subjects' complexions. When Monet depicted a person in one of his paintings, for example in *La Maison de l'artiste à Argenteuil* (1873), the tiny silhouette seen from the back is reduced to a couple of brush strokes in the middle of a burst of trees, plants, and flowers that play in the sunlight with all the nuances of Monet's palette. Monet created the same effect in *Le Jardin de l'artiste à Vétheuil* (1881).

And when a human figure fills the canvas, like Camille in *La Promenade* (1875) and Suzanne Hoschedé in *Femme à l'ombrelle tournée vers la gauche* (1886) or the other version of this same painting, the personal traits of Camille or Suzanne are not even recognizable. Monet's wife and daughter-in-law have become an element of decoration, a veil that floats in the wind, a parasol whose colouring contributes to the subtlety of the other colours. A dress becomes simply cloth allowing the wind and the sun to play with its folds.

When Monet chose to portray his domestic life, he painted his house, the lanes in his garden bordered by flower beds through which he walked every day, the trees that fluttered in the wind along the water that reflected the sky and the clouds. He painted everything that his ready eye didn't grow tired of appreciating. He sometimes added a family member because the person fitted into the décor. During the later part of his life in numerous views of his garden, his pond, his flowers, his willow trees, rose-covered arches, his Japanese bridge, and his beloved lilies, Monet never included a human figure. Nonetheless, Monets and Hoschedés never were lacking around the house, and many visitors flocked to Giverny to meet the master who enjoyed guests and who would also provide a good meal.

Monet's quest as a painter and as a human being were one and the same, but took a different directions. He pursued the light around him and saw only the light. It is easy to imagine that Monet, all his life, never saw the same landscape twice. In tune with the time of day, the season, the atmospheric conditions, and the continuously changing light, each meadow, each tree, each flower, every corner of the sky, and each reflection in the water was an object that Monet's brush attempted to capture. Monet chased the infinite portrayal of the eternal present, at every moment, tirelessly tried to paint it.

And in an attempt to be precise, true to his never ending quest, he ended up concentrating on a single object in order to discover it better, to follow it better, and to attempt to reveal the essence of the subject. When focusing on part of the object in his observation and confronted with the inevitable passage of time, he was always in a hurry. His brush could not keep up with his eye. He tried to work around this impossibility through his invention of paintings in series, something unique to him. It was never intended to be a repetitive system; it was the natural progression of his life's quest.

He didn't see the meadow, just the haystack, and that not as a pile of hay or straw, but as a shape that caught the sun's light, and therefore a composition of constantly changing colour. Every moment - morning in late summer, or after a snowfall or a thaw, or again in full sunlight - had its own range of colour.

He didn't paint the entire Rouen Cathedral, just a detail on the facade; namely, an assemblage of stone carved into entrances, arches, niches, columns, and other architectural details whose Gothic diversity interested the painter only insofar as they caught the light differently at different times of the day. He saw the church facade as a harmony of blues or of whites, as an effect of light at the end of the day or early the morning; a symphony in grey and rose or the sun, drowning in the mist.

For Monet working from his studio-boat along the quiet Epte, the three or four poplars, or even their outline against the distant horizon, became a sort of mirage or some «rose-coloured trees in the fall» depending on whether the light was cold and still or intense with the unnatural colours of a sunset.

The same thing could be said about the rocks at Belle-Ile-en-Mer, in the Creuse Valley, the Manneporte at Etretat, the paintings in Normandy of a morning filled with fog or at the height of an afternoon when each leaf reflects the golden sun.

The constant quest to capture the instant, the startling observation of light out of doors in nature, and the endless reflection of sky in the mirror formed by the water, all of this translated through the juxtaposition of thousands of brush strokes of infinite colour reached its apex at Giverny. This was a setting that Monet had chosen for himself, had designed, enlarged, pruned, planted, decorated, and watched flower just like his painter's eye and palette wanted.

His home at Giverny was and remains his outstanding masterpiece. He chose everything, even the colour of the walls where his collection of Japanese prints was hung, even the table settings for his dining room where he loved to receive his guests.

Out of doors, his garden was the living metamorphosis of his constantly changing palette. He ordered flowers from around the world to establish the colour patterns he wanted. The lanes in his

The garden at Giverny in winter, photograph

garden were covered by abundant climbing or crawling plants. His well-known wooden Japanese bridge almost disappeared behind the violet flowered roof of wisteria in the middle of the garden.

His aquatic garden, a pond, was his pride.
He had chosen each tree, each plant that surrounded it. The nimble branches of the willows touched their reflections in the water. The aquatic plants floated among the reeds. The transparent pond itself was designed to reflect each of the changing colours of the sky, each passing cloud, every pale glow of the dawn, and every golden or fiery burst of the setting sun.

Water, as used by Monet, was an element of supreme subtlety. There is water in almost all his canvases because of its tranquility, and its ability to reflect the sky, the trees, and the plants that grew along its banks. The water of Giverny was his water. He had diverted and chosen it over all others. He chose to add the wide green lily pads whose colourful flowers opened every morning and closed every evening. Sown like jewels, they decorated the surface with multicoloured details.

Let's listen to the person who knew him best, who was always at Giverny among the painter's family, his faithful friend Gustave Geffroy:
«For Monet, nature was a wonderful refuge, a splendid source of sublime images, always varied and forever growing. He took skillful advantage of the treasures that nature offered. Nature was his inexhaustible theme, the origin of his love for light, the force that determined form and created infinite varieties of colour.»

Writing specifically about Giverny, he said,
«He who imagined and put together this tight little universe, both loving and magnificent, is not only a great painter in the creation of his paintings, but is also a genius in the art of living. He created a universe in order to be happy away from all the temptations of luxury. He could have luxury whenever he wanted, in agreement with his attitude and philosophy towards life. This house and this garden are also a work of art. Monet spent his whole life creating it and perfecting it.»

Geffroy died shortly before Monet and never saw the final in stallation of the lilies at the Orangerie des Tuileries. Before his death the government had already agreed in principle to the donation, only the preparation of the exhibition space was lacking. He was especially afraid that «the poem might be broken up.» There was a danger that all the canvases that were meant to form «a single composition at the centre of which was to be the viewer» would be dispersed to different places in the world, broken up. Potential buyers were not lacking, especially Americans and Japanese who were numerous and insistent. Fortunately Monet's and Geffroy's wishes were re

spected after his and Geffroy's death.

Geffroy dreamed about the future and ended his seminal work on Monet with these words:

«It will be a museum created for the future, a museum without precedents and without equal where in the future man will go to dream about the poetry of the world and to reflect on the unfathomable nature of emptiness.

And then, after everything has become vanity again, even images and thoughts, there will be in front of us only water, still and silent, flowers that open and close, light that quivers, clouds that pass, nature and its mysteries, a man who dreams, and a great painter who finds expression for the dream of infinity.»

———————

Claude Monet's history, like that of many great creators, is difficult to tell. It is even more difficult to explore the unfathomable depths wherein the artist is always alone with himself, his feelings and the «impressions» that trigger and propel the act of conception and therefore of creation.

Of course it's possible to study the stages of his life, and to learn about those who lived with him, helped him, or opposed him. It's possible to consult the more than 2,685 letters that make up his correspondence or the studies that his friends like Geffroy, Clemenceau, Duret, and Mirbeau wrote about him, or even to read the abundant critical literature.

But how can we really know him? How can we explain why a man would paint with such determination for almost seventy years without ever stopping? What truth was he pursuing, what absolute value?

He never surrendered despite the slights of the well-off official art circles during long years of struggle. At times his financial situation was so desperate that his friends felt obliged to buy his paintings for ridiculously small amounts of money so that he could eat. When success finally came, along with fame in France and abroad, why was he plagued by self-doubt, why did he feel driven to destroy so many paintings, and touch others up so many times before allowing them to be exhibited?

Finally, why in the last years of his life did he continue to paint every day, as though driven? Why did he develop the enormous circular painting, without a beginning and without an end, for his *Grandes Décorations*? We imagine him alone, weak with age and illness, but still standing with his palette in his hand searching in each

individual reflection of the water surrounding him on all sides the forever changing light that obsessed him: and never being able to stop time.

It has been said that he was the greatest of the impressionists. He was the painter of the famous 1872 canvas *Impression, soleil levant* that gave the name to this group of painters. He is recognized as the leader of his generation and as the greatest landscape painter of his time. The Orangerie and his *Nymphéas* are often called the Sistine Chapel of impressionism.

Culminating in his famous series paintings done in order to catch the variation of forms under the conditions of changing light, he transcended the academic idea of form and reached a type of subjective abstraction close to non-figurative painting. He was a precursor who had a decisive influence on the painters of the twentieth century. His quest led him to the doors of abstraction.

He left us the precious gift of his life and more than two thousand paintings that make him one of the most prodigious painters of all time. He is a source of endless admiration and emotion.

WORKS

Coin d'atelier

1861 - oil on canvas - 182 x 127
Musée d'Orsay, Paris

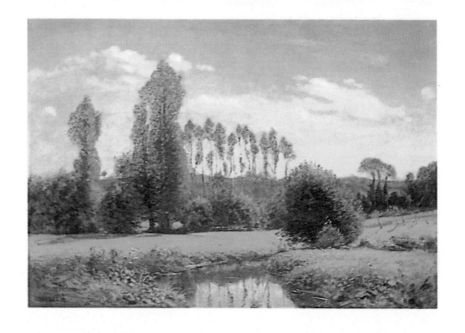

Vue prise à Rouelles

1858 - oil on canvas - 46 x 65
Private collection, Japan

Trophée de chasse

1862 - oil on canvas - 104 x 75
Musée d'Orsay, Paris

73

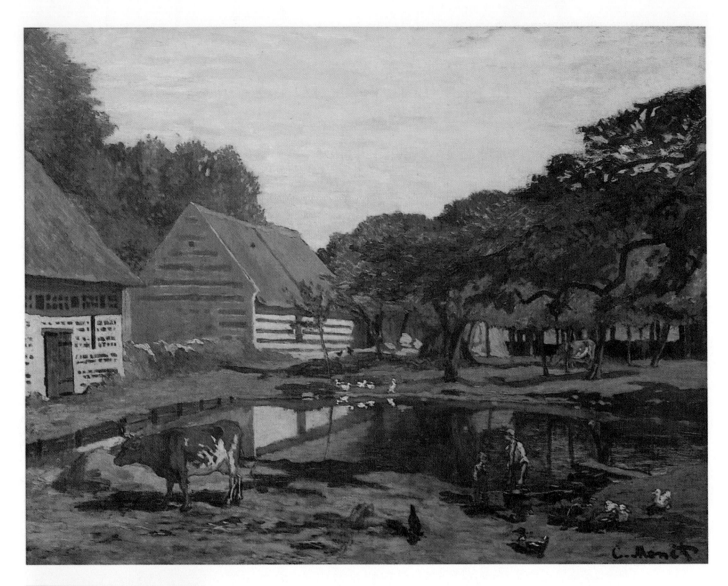

Cour de ferme en Normandie

circa 1863 - oil on canvas - 65 x 80
Musée d'Orsay, Paris

La Route de la Ferme Saint-Siméon

1864 - oil on canvas - 82 x 46
National Museum of Western Art,
Collection Matsukata, Tokyo

Nature morte: le quartier de viande

circa 1864 - oil on canvas - 24 x 32
Musée d'Orsay, Paris

Le Pavé de Chailly

1864 - oil on canvas - 98 x 130
Private collection

La Rue de la Bavolle, à Honfleur

1864 - oil on canvas - 58 x 63
Städtishe Kunsthalle Mannheim, Mannheim

Bord de la mer à Sainte-Adresse

1864 - oil on canvas - 40 x 73
Minneapolis Institute of Arts, Minneapolis

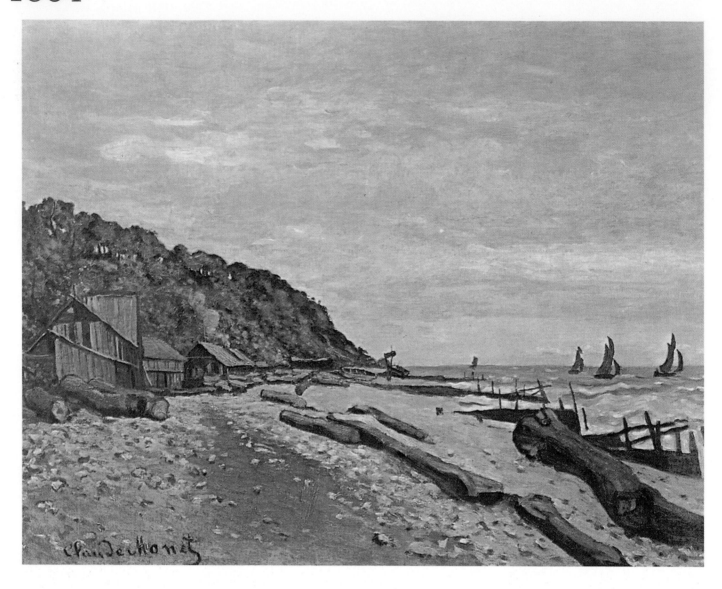

Le Chantier de petits navires, près de Honfleur

1864 - oil on canvas - 57 x 81
Private collection

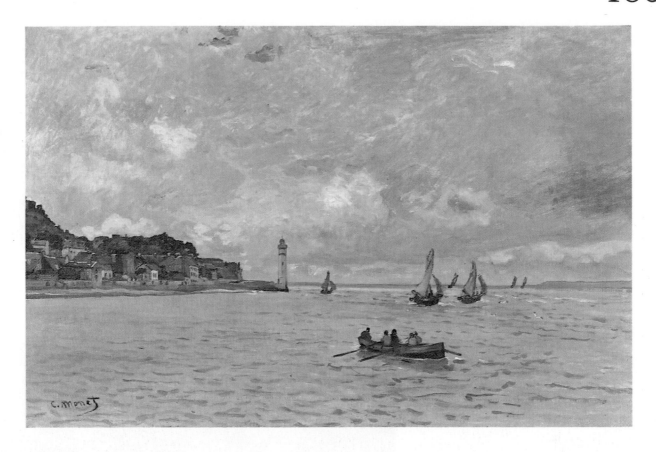

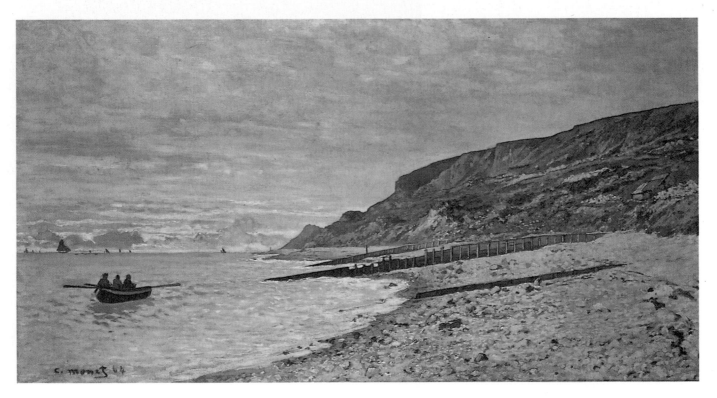

Le Phare de l'hospice

1864 - oil on canvas - 54 x 81
Kunsthaus, Zurich

La Pointe de la Hève

1864 - oil on canvas - 41 x 73
Private collection

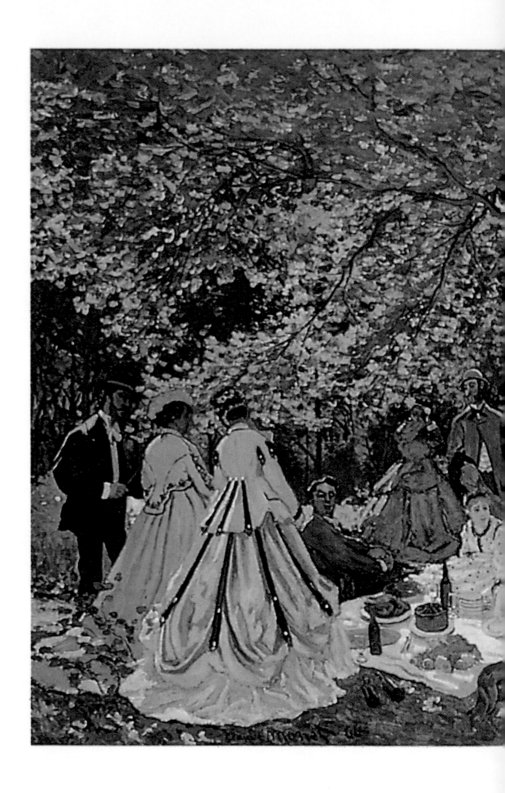

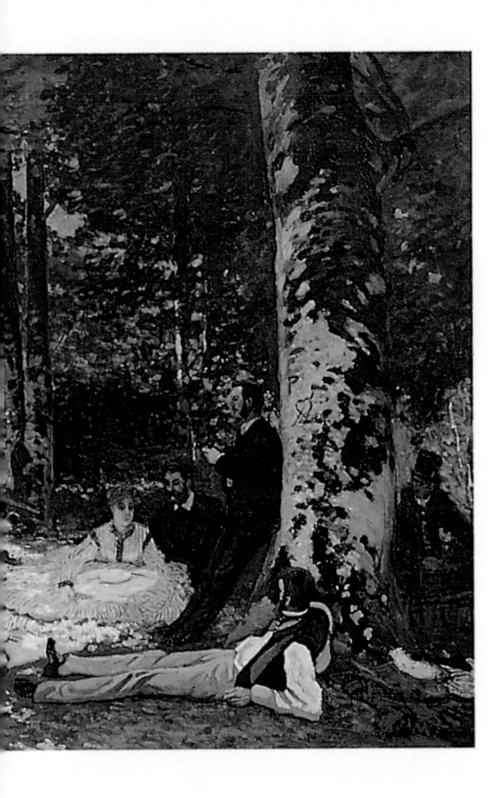

Le Déjeuner sur l'herbe (study)

1865 - oil on canvas - 130 x 181
A.S. Pushkin State Museum, Moscow

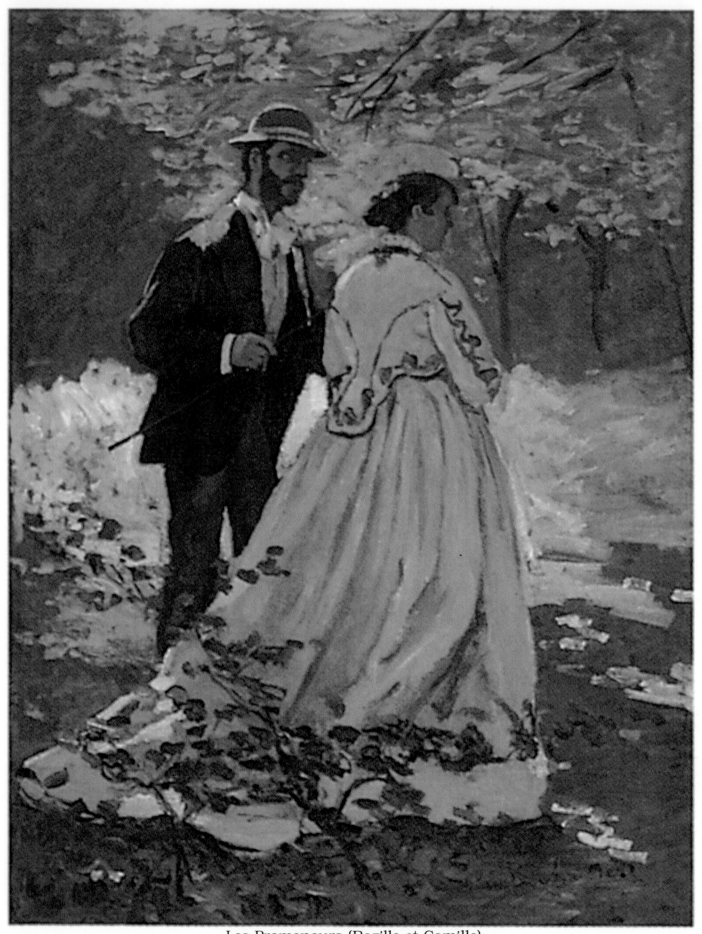

Les Promeneurs (Bazille et Camille)

1865 - oil on canvas - 93 x 69
National Gallery of Art,
Alisa Mellon Bruce collection Washington, D.C.

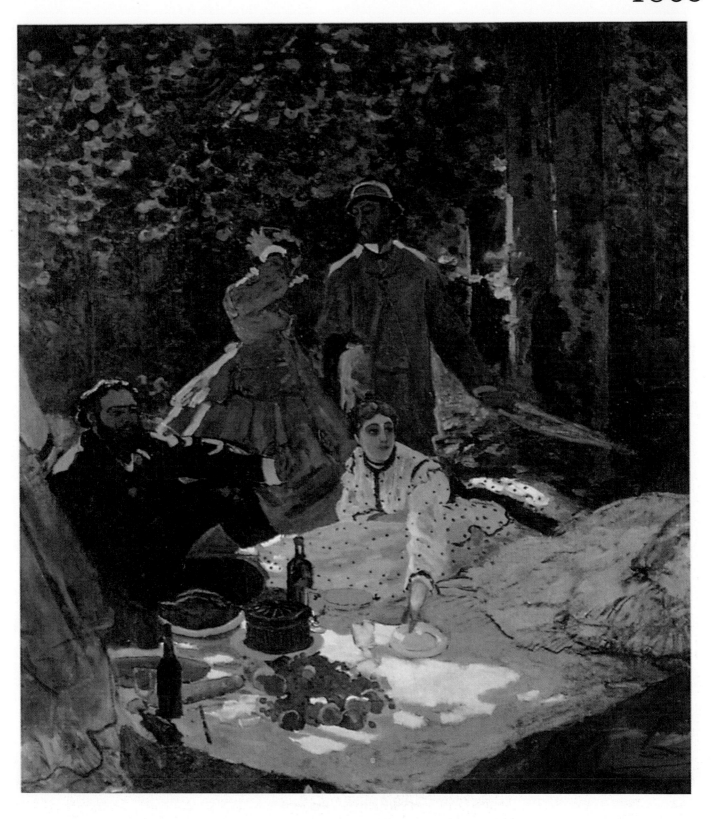

Le Déjeuner sur l'herbe (central portion)

1865 - oil on canvas - 248 x 217
Musée d'Orsay, Paris

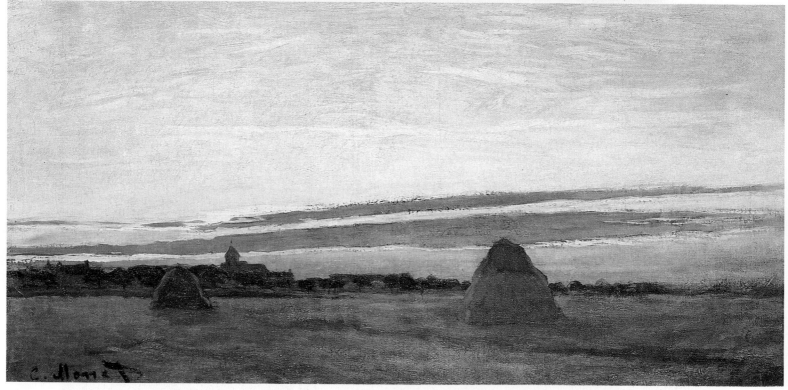

Le Pavé de Chailly

1865 - oil on canvas - 42 x 59
Musée d'Orsay, Paris

Meules près de Chailly, soleil levant

1865 - oil on canvas - 30 x 60
San Diego Museum of Art, San Diego

Portrait de J.F. Jacquemart au parasol

1865 - oil on canvas - 105 x 61
Kunsthaus Zurich, Zurich

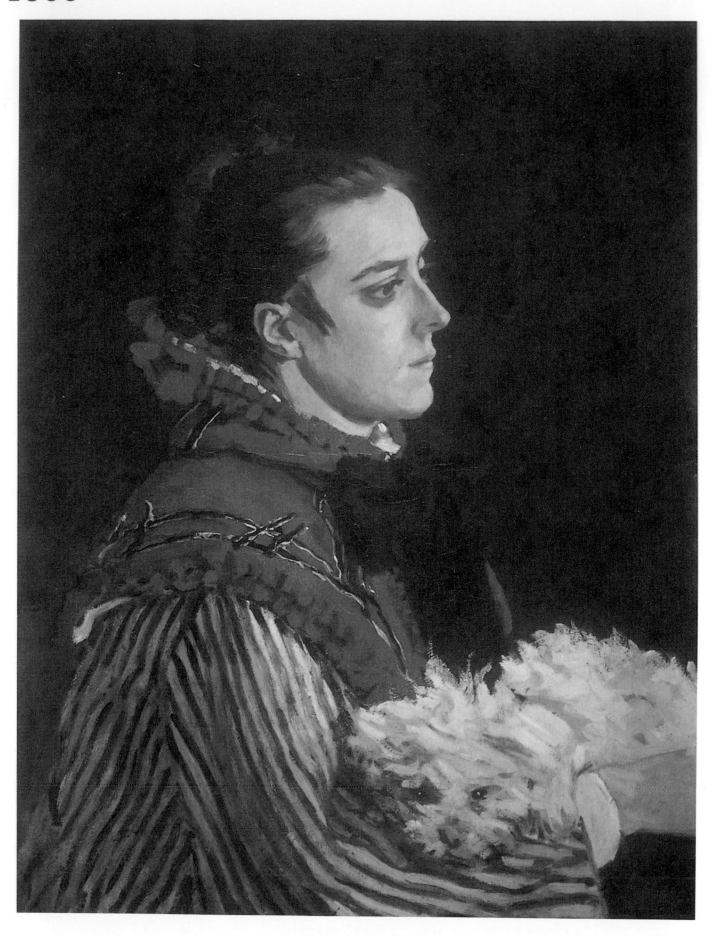

Camille au petit chien

1866 - oil on canvas - 73 x 54
Kunsthaus Zurich, Zurich

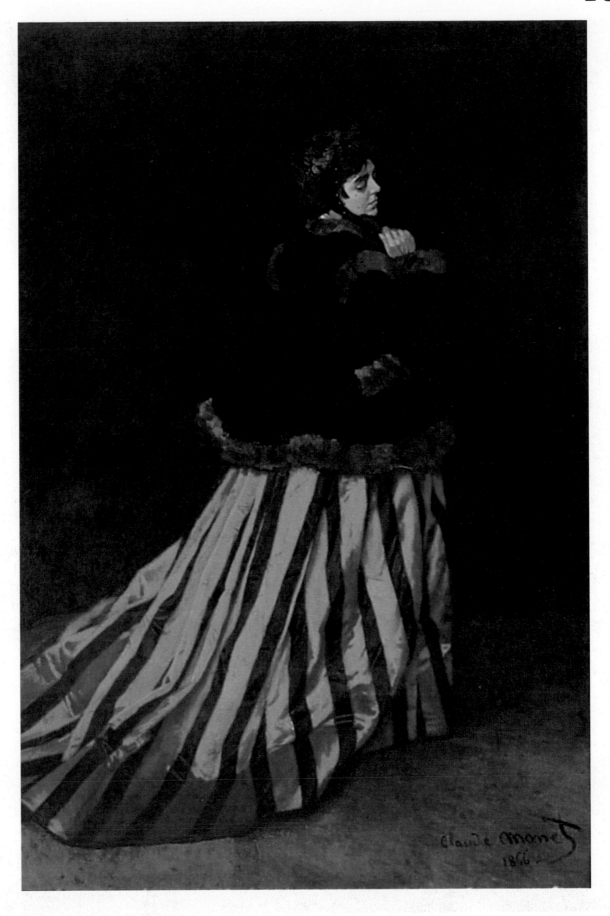

Camille *or* Femme à la robe verte

1866 - oil on canvas - 231 x 151
Kunsthalle Bremen, Bremen

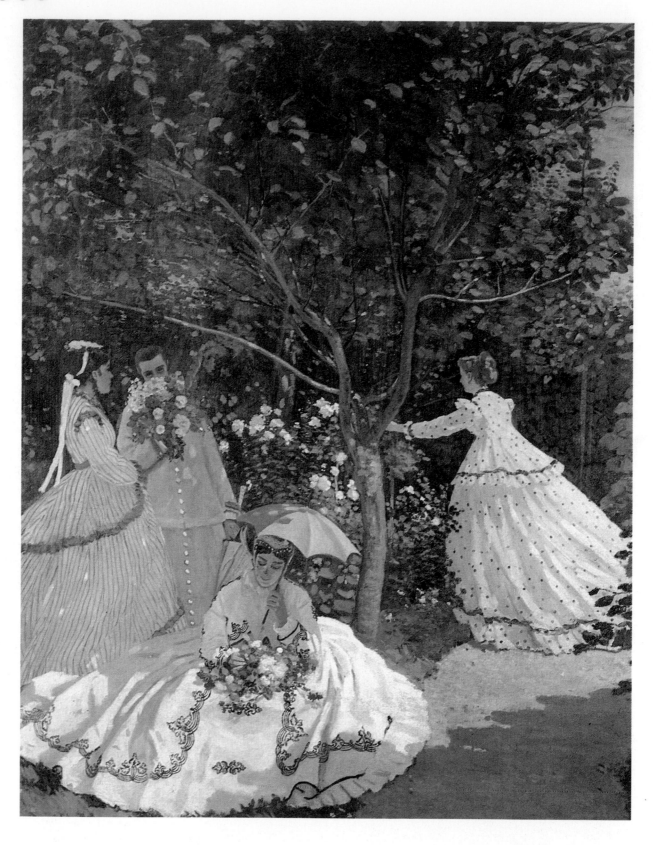

Femmes au jardin

1866 - oil on canvas - 256 x 208
Musée d'Orsay, Paris

Jardin en fleurs

1866 - oil on canvas - 65 x 54
Musée d'Orsay, Paris

Saint-Germain-l'Auxerrois

1866 - oil on canvas - 79 x 98
Nationalgalerie, Berlin

La Charette, route sous la neige à Honfleur

1867 - oil on canvas - 65 x 92
Musée d'Orsay, Paris

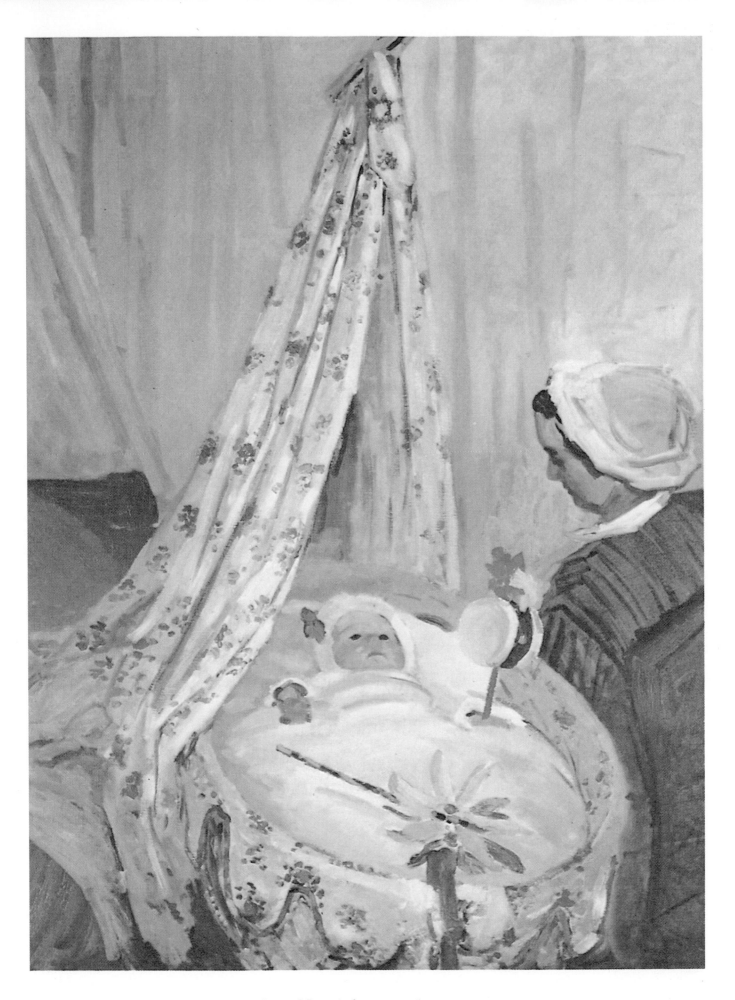

Jean Monet dans son berceau

1867 - oil on canvas - 116 x 89
National Gallery of Art, Washington, D.C.

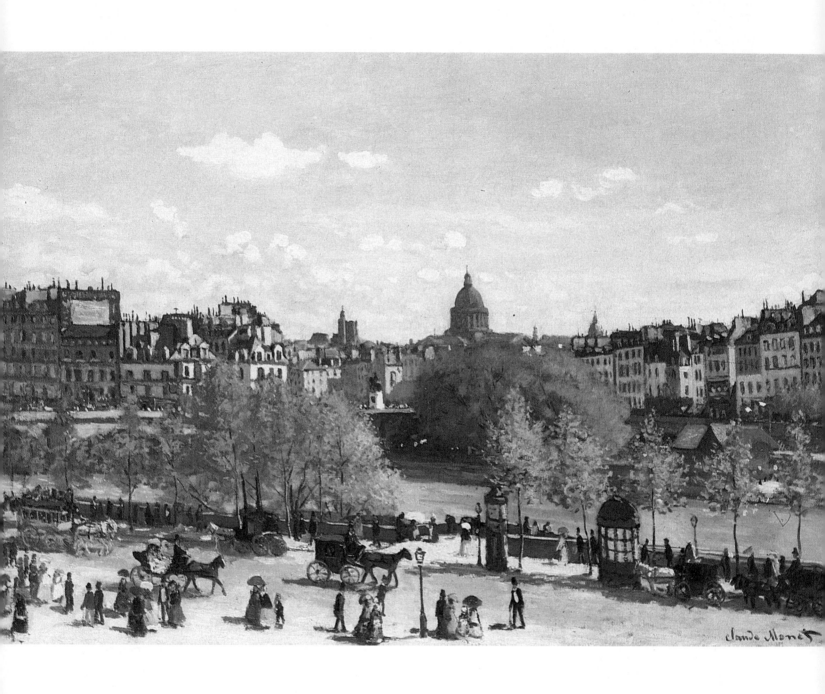

Le Quai du Louvre

1866-67 - oil on canvas - 65 x 93
Gemeetemuseum, The Hague

Le Jardin de l'Infante

1867 - oil on canvas - 91 x 62
Allen Memorial Art Museum, Oberlin, Ohio

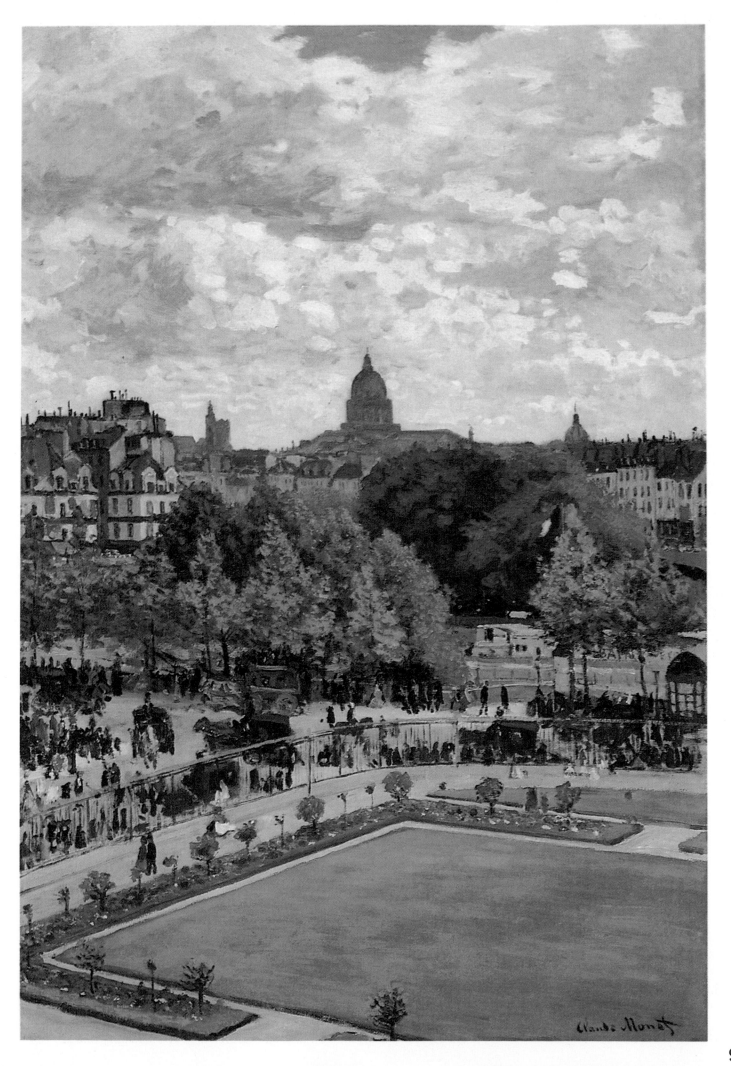

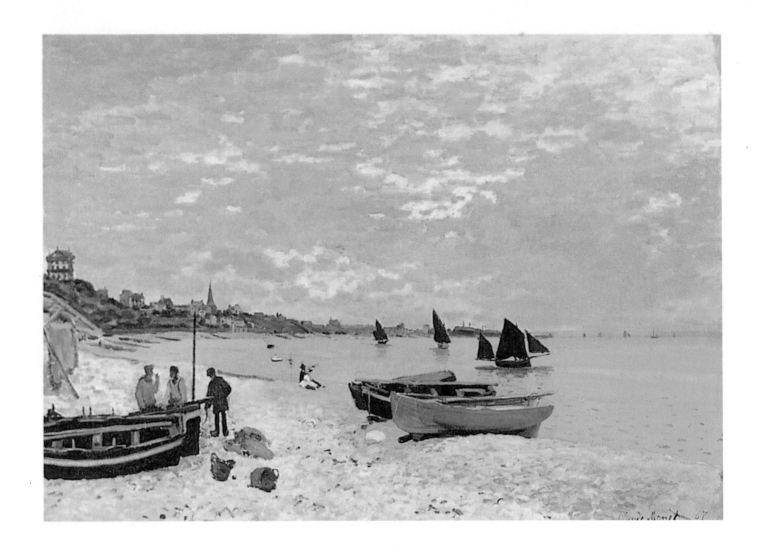

La Plage de Sainte-Adresse

1867 - oil on canvas - 75 x 101
The Art Institue of Chicago, Chicago

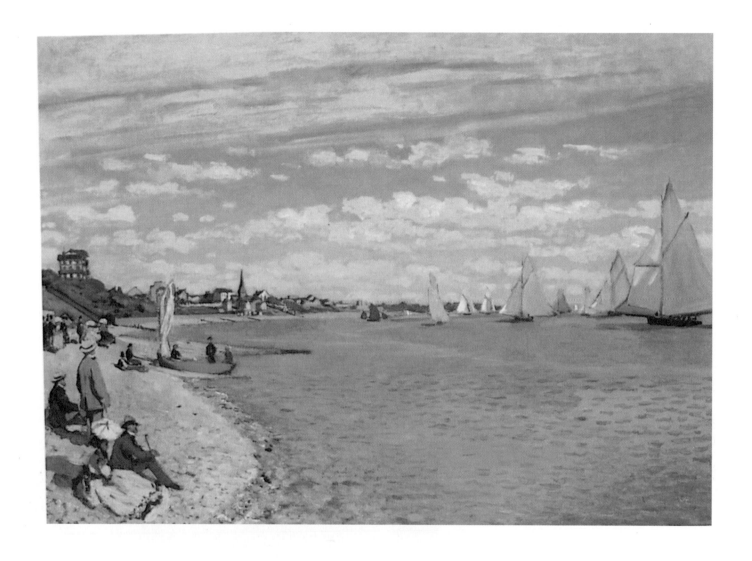

Les Régates à Sainte-Adresse

1867 - oil on canvas - 75 x 101
Metropolitan Museum of Art, New York

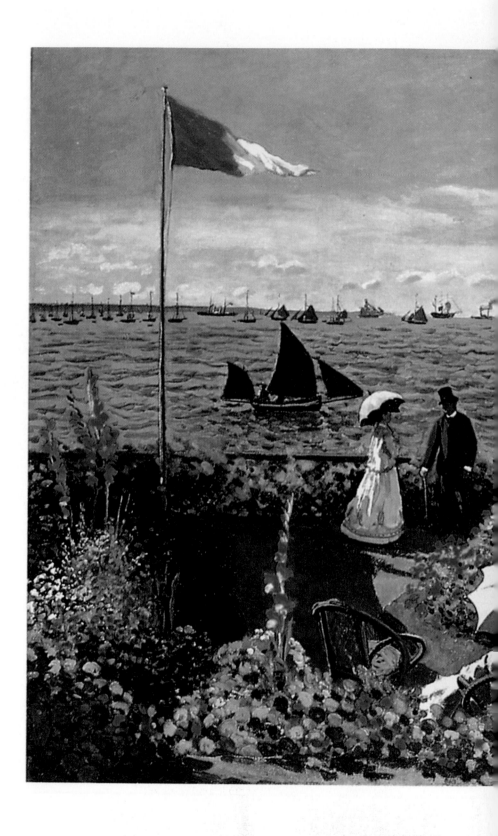

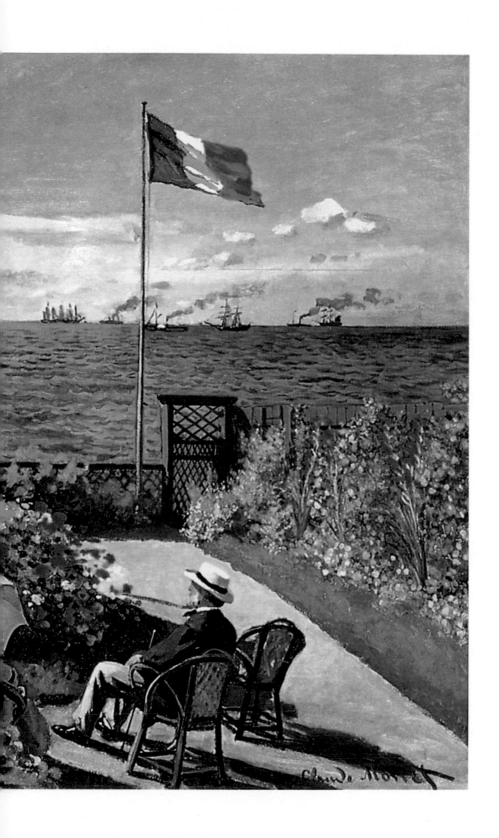

Terrasse à Sainte-Adresse

1867 - oil on canvas - 98 x 130
Metropolitan Museum of Art, New York

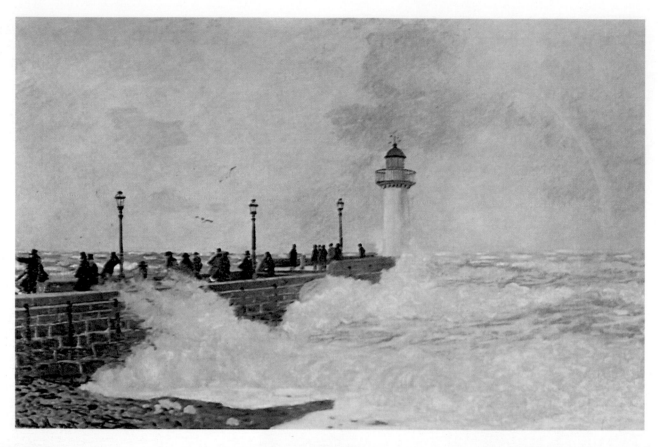

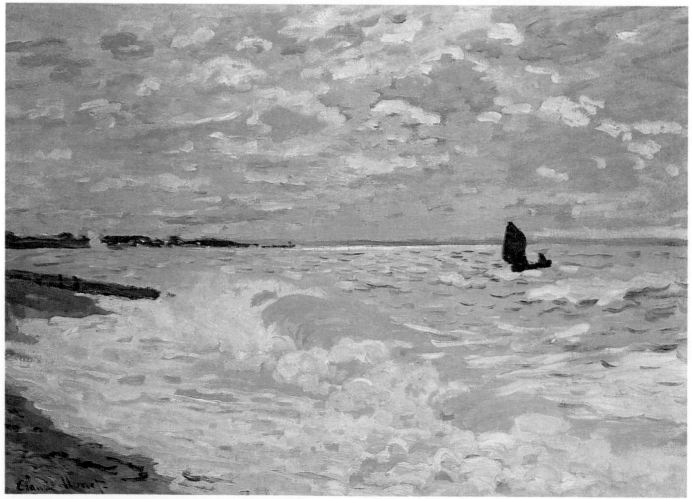

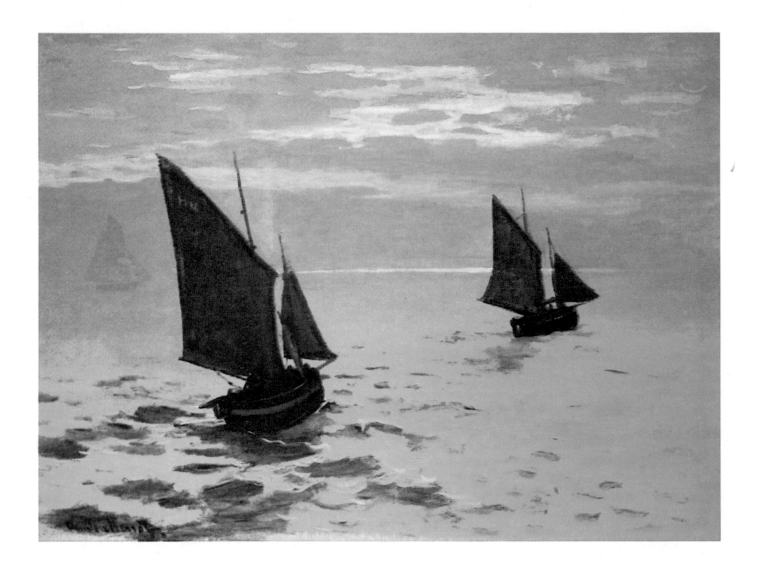

Bateaux de pêche en mer

1868-69 - oil on canvas - 96 x 130
Hill-Stead Museum, Farmington, Connecticut

La Jetée du Havre

1868 - oil on canvas - 147 x 226
Private collection

La Mer à Sainte-Adresse

1868 - oil on canvas - 60 x 80
Carnegie Museum of Art, Pittsburgh

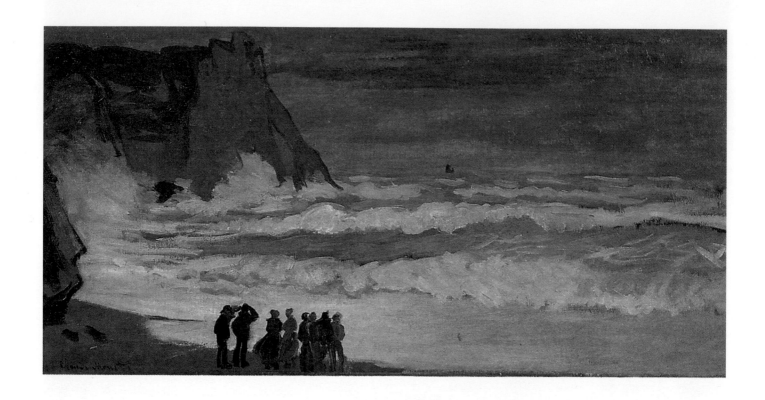

Grosse mer à êtretat

1868-69 - oil on canvas - 66 x 131
Musée d'Orsay, Paris

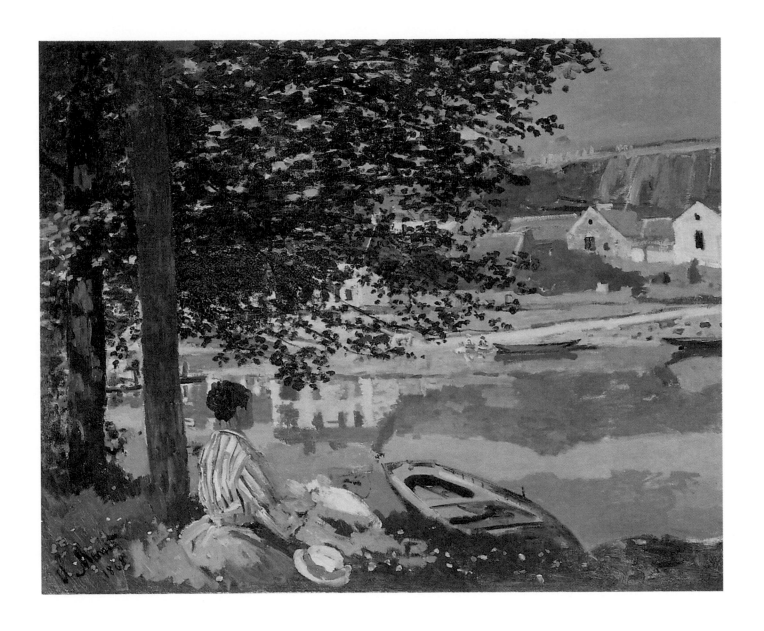

Au bord de l'eau, Bennecourt

1868 - oil on canvas - 81 x 100
The Art Institute of Chicago,
Potter Palmer collection, Chicago

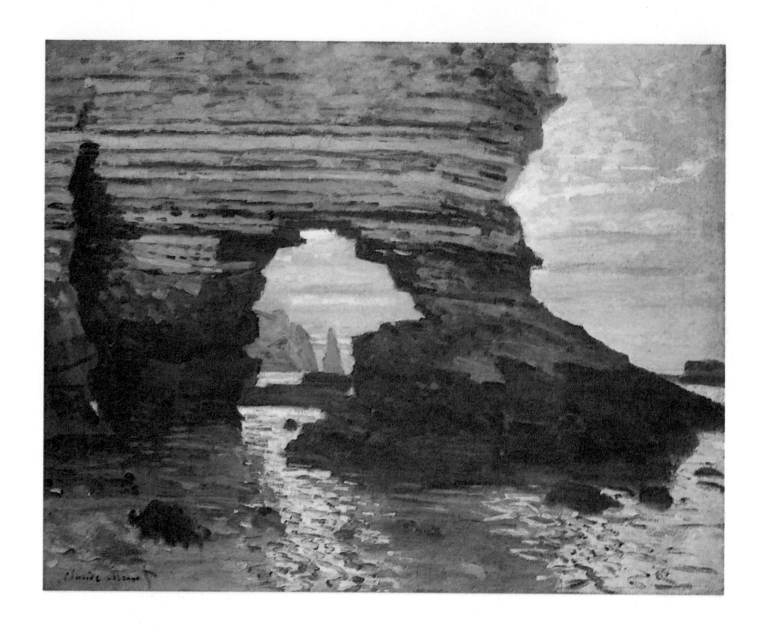

La Porte d'Amont, êtretat

1868-69 - oil on canvas - 81 x 100
Fogg Art Museum, Cambridge, Massachussetts

Portrait de Madame Gaudibert

1868 - oil on canvas - 216 x 138
Musée d'Orsay, Paris

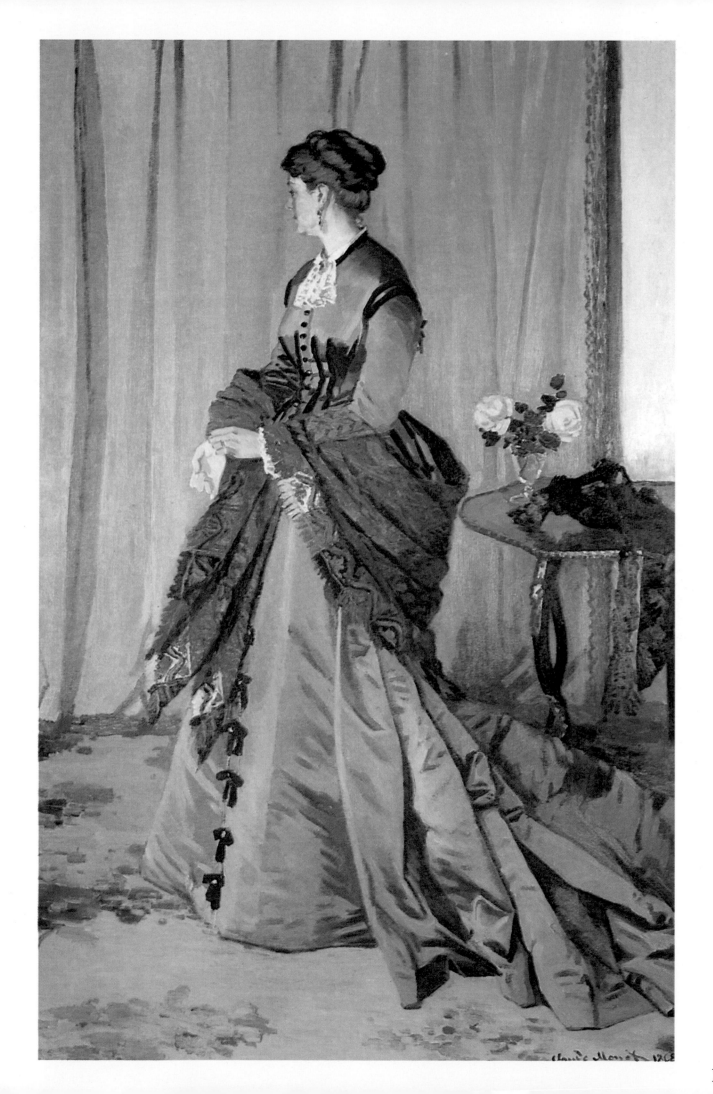

Le Dîner

circa 1869 - oil on canvas - 52 x 65
Stiftung und Sammlung Bühle, Zurich

Le Déjeuner

1868 - oil on canvas - 230 x 150
Städelsches Kunstinstitut und Städtische Galerie, Frankfurt

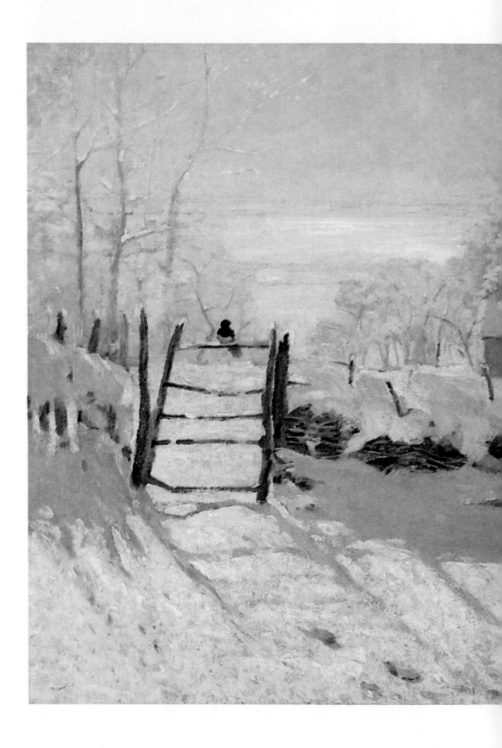

La Pie

1869 - oil on canvas - 89 x 130
Musée d'Orsay, Paris

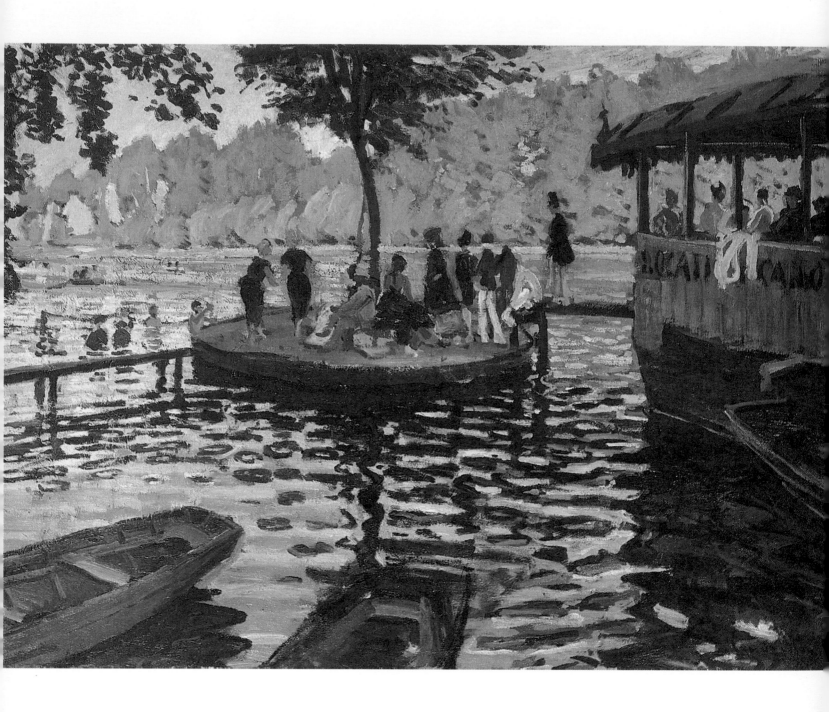

La Grenouillère

1869 - oil on canvas - 75 x 100
Metropolitain Museum of Art, New York

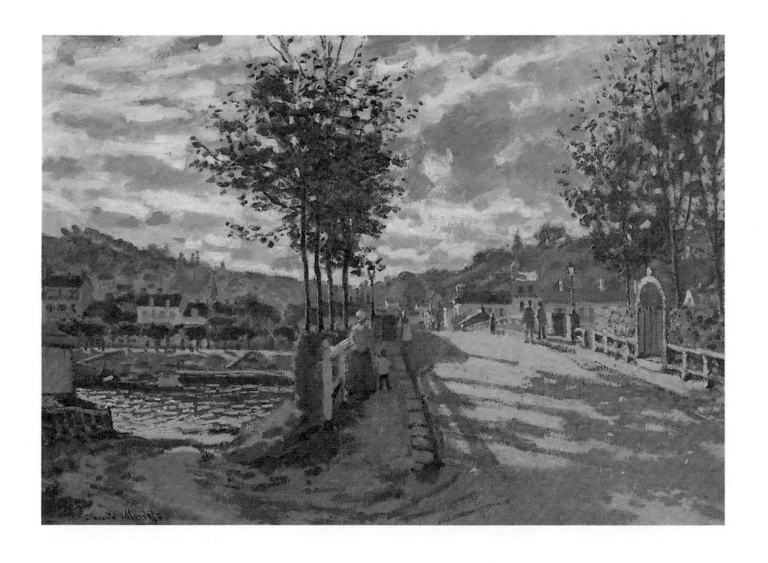

Le Pont de Bougival

1870 - oil on canvas - 63 x 91
Currier Gallery of Art, Manchester, New Hampshire

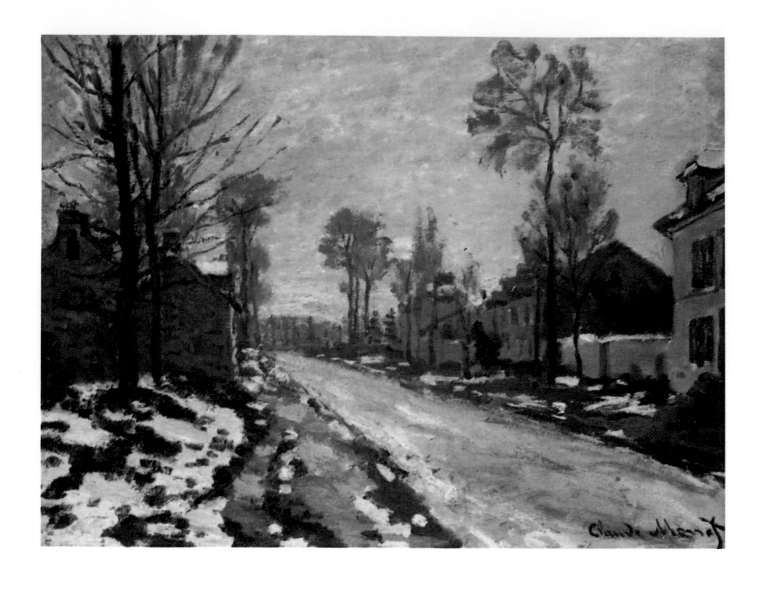

Route à Louveciennes,
neige fondante, soleil couchant

circa 1870 - oil on canvas - 40 x 54
Private collection

Train dans la campagne

1870-71 - oil on canvas - 50 x 65
Musée d'Orsay, Paris

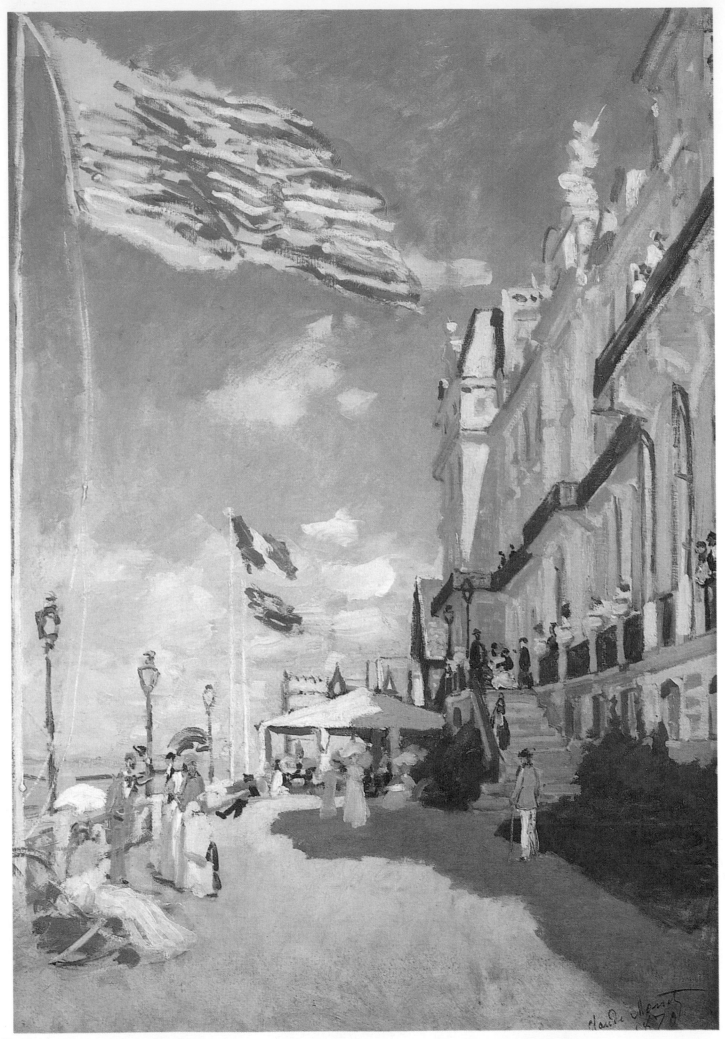

112

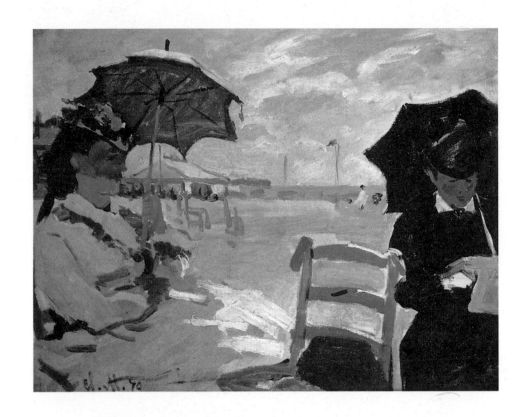

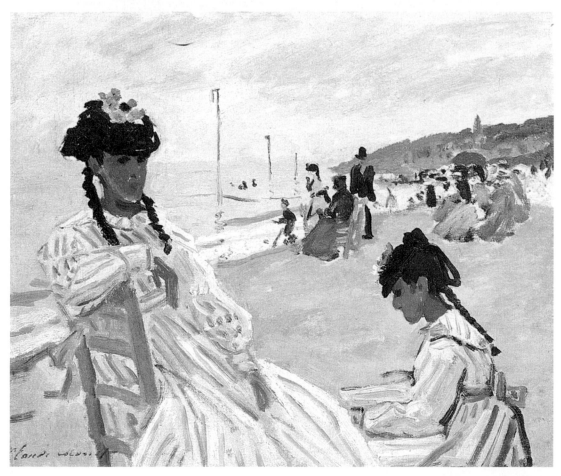

L'Hotel des Roches Noires, à Trouville

La Plage de Trouville

Sur la plage à Trouville

1870 - oil on canvas - 80 x 55
Musée d'Orsay, Paris

1870 - oil on canvas - 38 x 46
National Gallery, London

1870 - oil on canvas - 38 x 46
Musée Marmottan, Paris

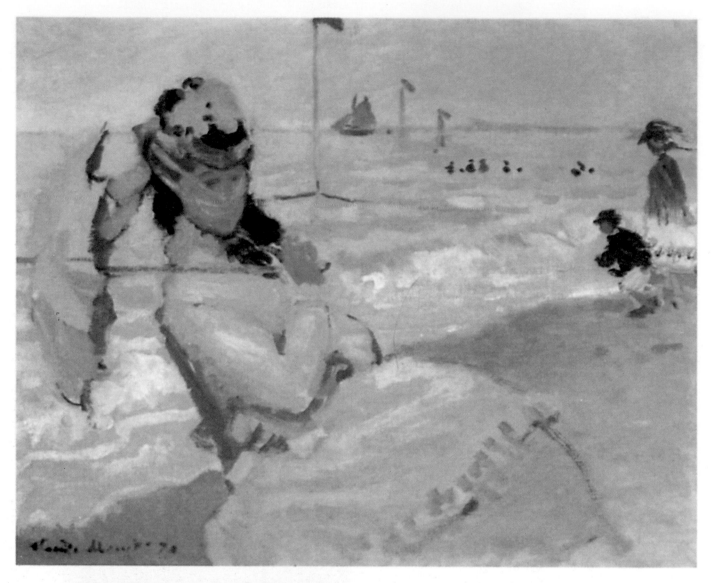

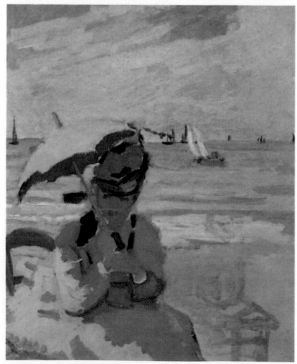

Camille sur la plage de Trouville

1870 - oil on canvas - 38 x 47
Private collection

Camille assise sur la plage à Trouville

1870 - oil on canvas - 45 x 36
Private collection

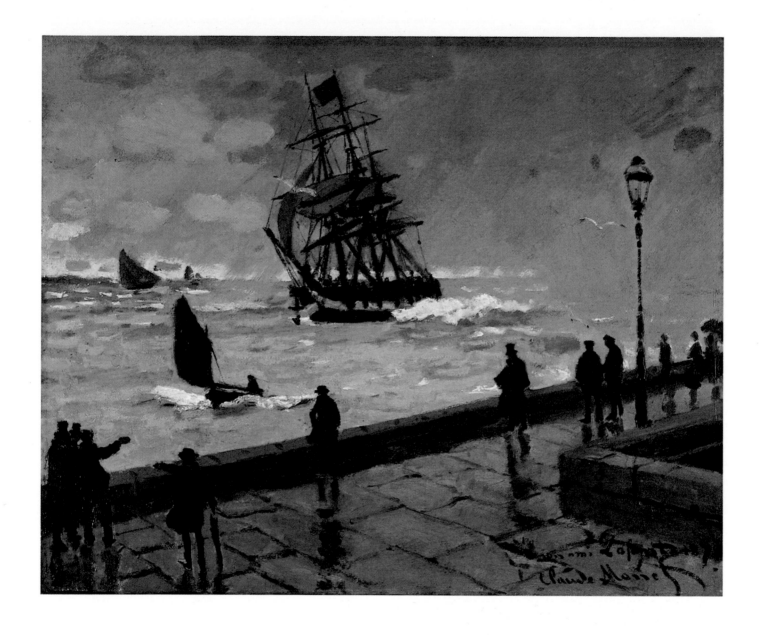

La Jetée du Havre par mauvais temps

1870 - oil on canvas - 50 x 61
Private collection

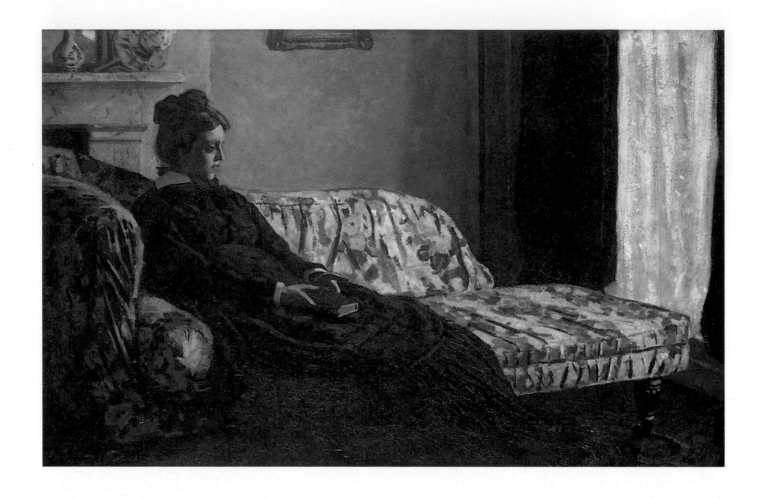

Méditation, Madame Monet au canapé

1871 - oil on canvas - 48 x 75
Musée d'Orsay, Paris

La Voorzaan

1871 - oil on canvas - 39 x 71
Private collection

La Zaan à Zaandam (partial)

1871 - oil on canvas - 42 x 73
Private collection

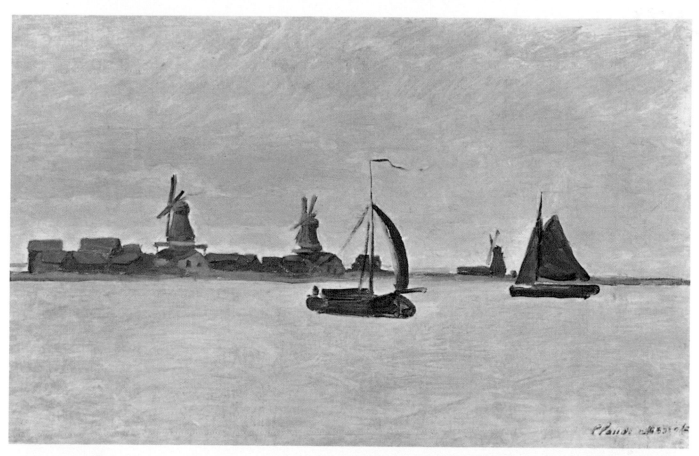

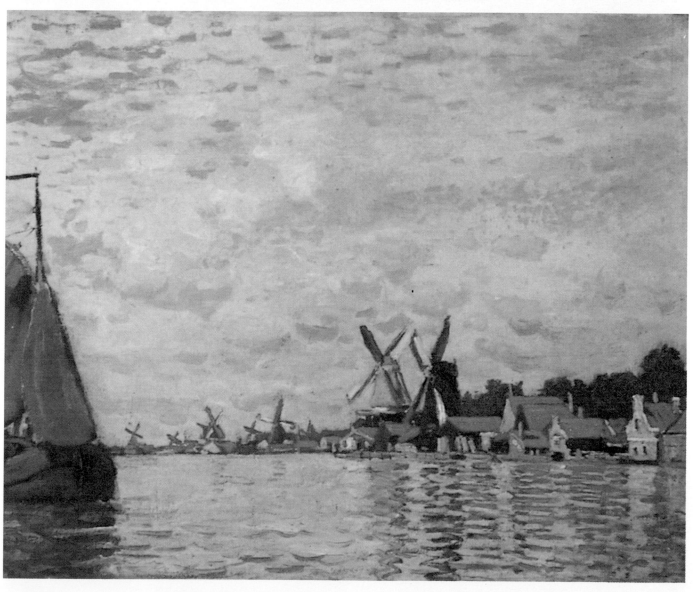

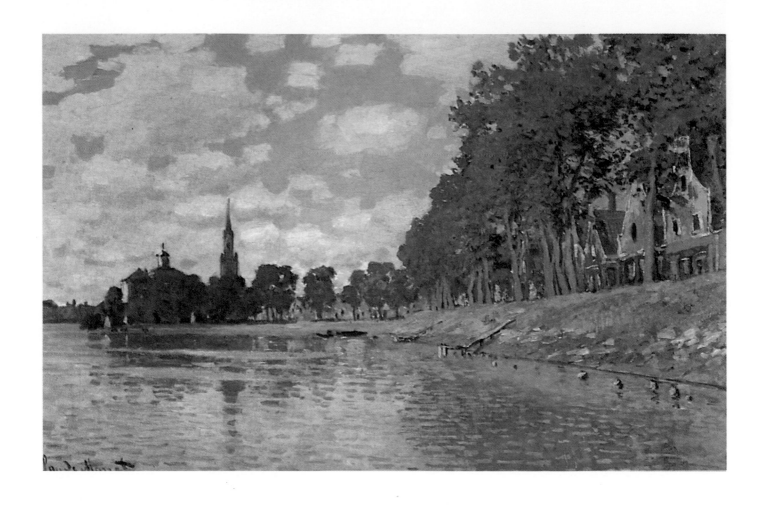

Zaandam

1871 - oil on canvas - 47 x 73
Musée d'Orsay, Paris

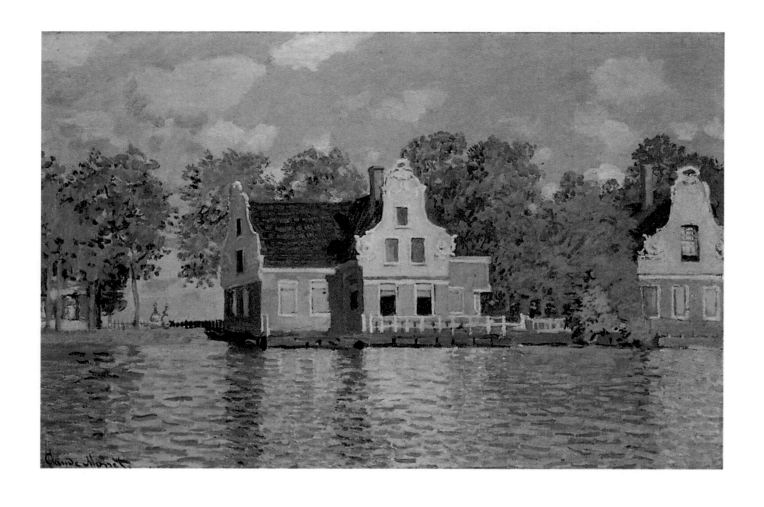

Maisons au bord de la Zaan, à Zaandam

1871 - oil on canvas - 47.5 x 73.5
Städelsches Kunstinstitut und Stätische Galerie, Frankfurt

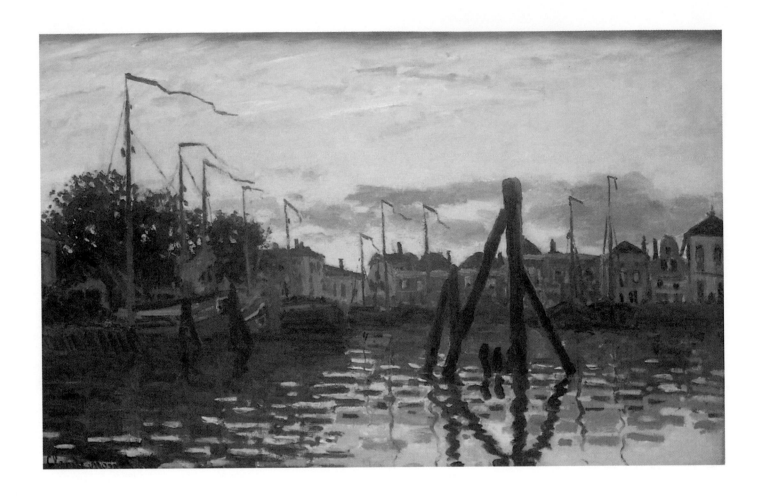

Le Port de Zaandam

1871 - oil on canvas - 47 x 74
Private collection

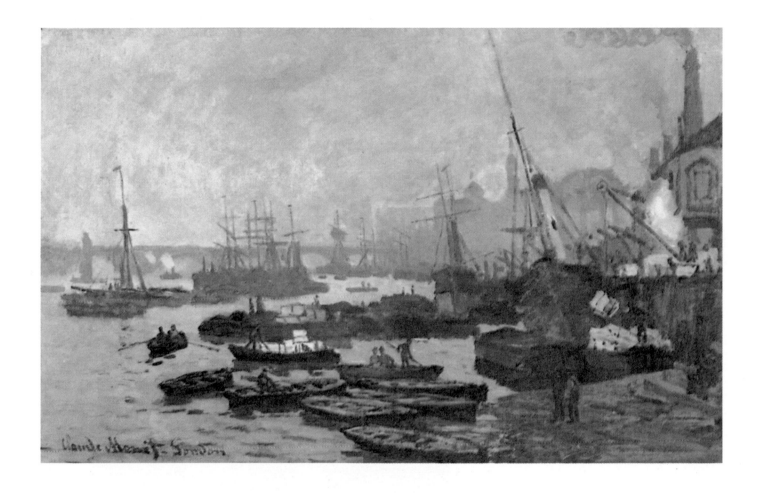

Bateaux dans le bassin de Londres

1871 - oil on canvas - 47 x 72
Private collection, Paris

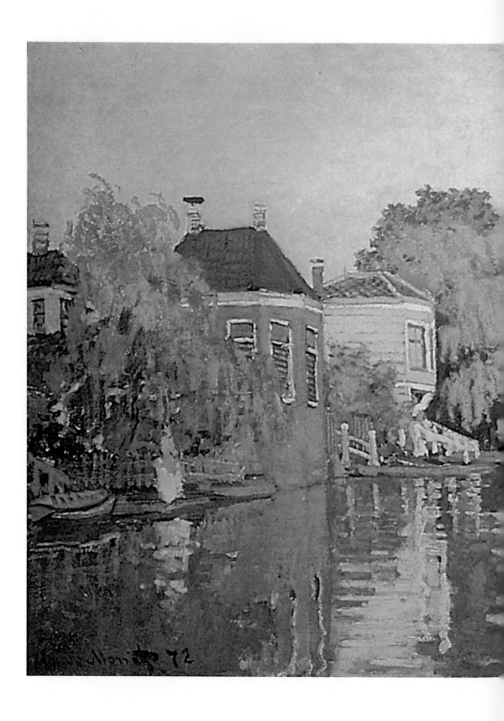

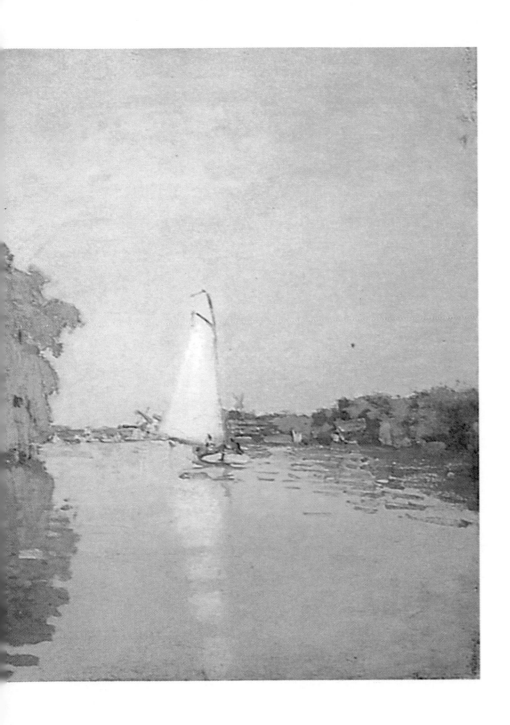

Zaandam

1872 - oil on canvas - 48 x 73
Metropolitan Museum of Art, New York

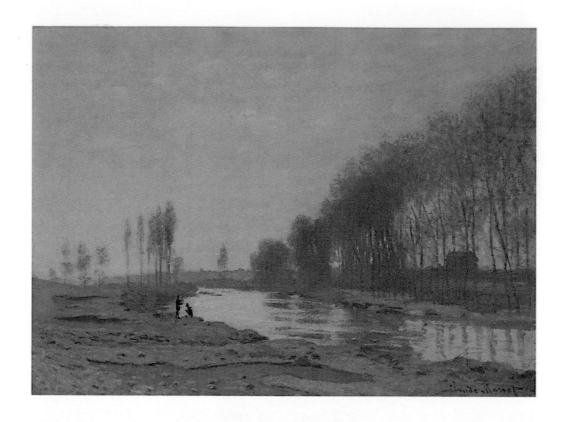

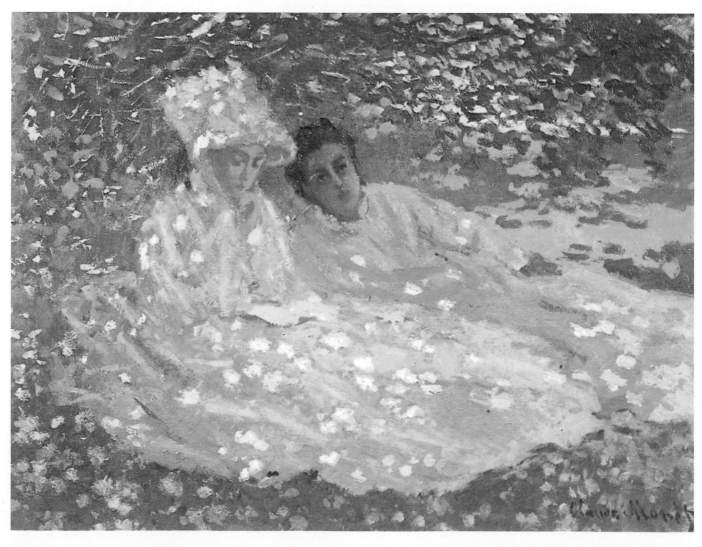

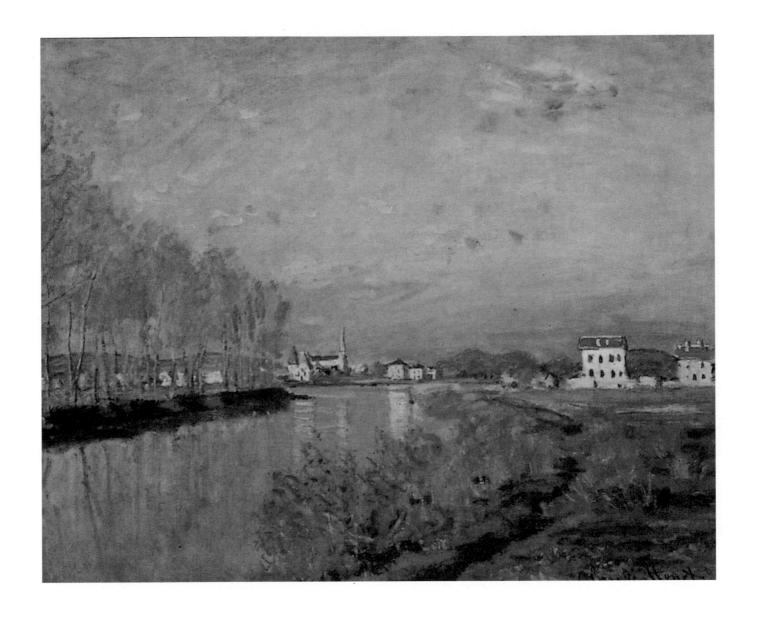

La Seine à Argenteuil

1873 - oil on canvas - 50 x 61
Musée d'Orsay, Paris

Le Petit-bras d'Argenteuil

1872 - oil on canvas - 53 x 73
National Gallery, London

Madame Monet et une amie au jardin

circa 1872 - oil on canvas - 51.5 x 66
Private collection

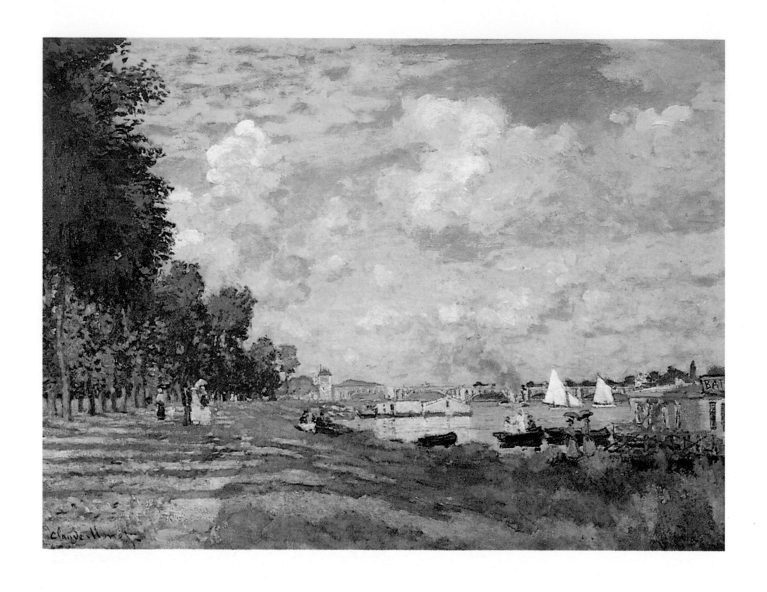

Le Bassin d'Argenteuil

1872 · oil on canvas · 60 x 80.5
Musée d'Orsay, Paris

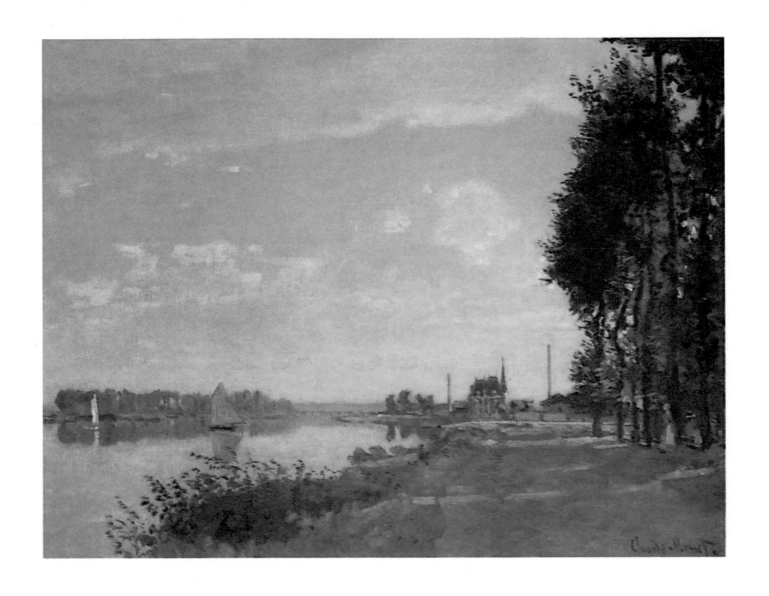

La Promenade d'Argenteuil

1872 - oil on canvas - 50.4 x 65
National Gallery of Art,
Alisa Mellon Bruce collection, Washington, D.C.

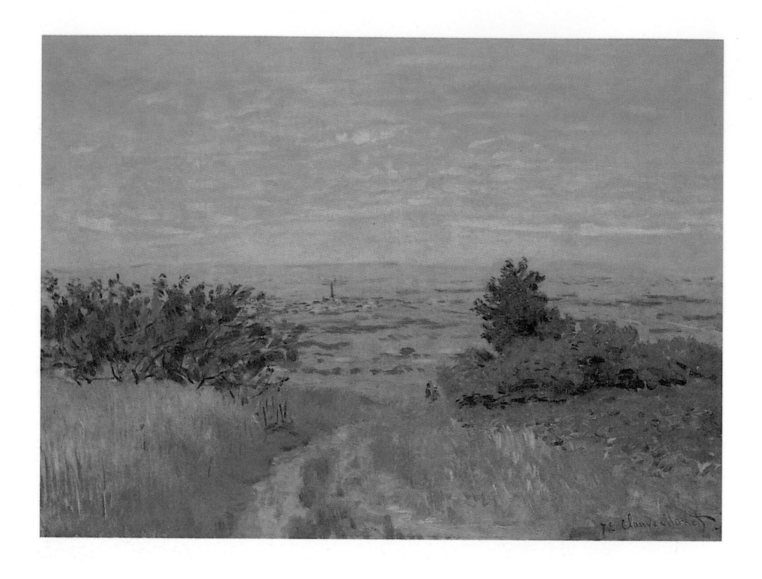

Vue de la plaine à Argenteuil,

1872 - oil on canvas - 53 x 72
Musée d'Orsay, Paris

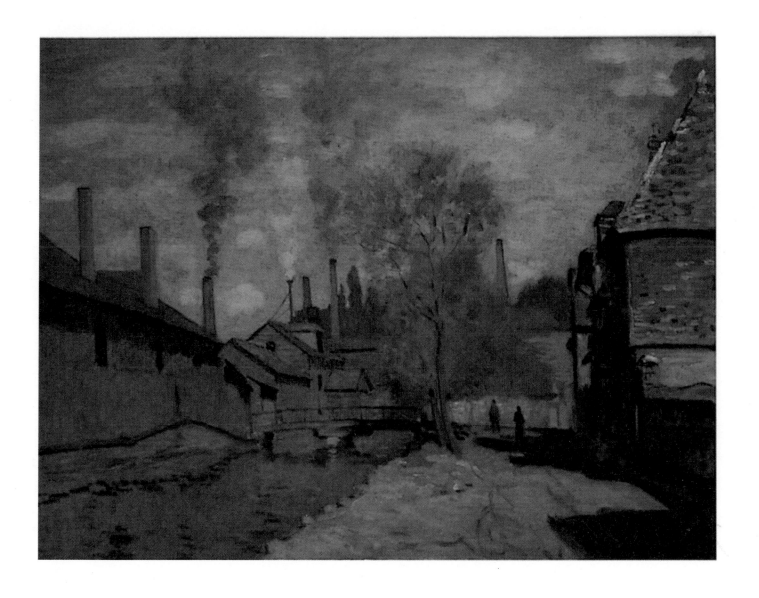

Le Ruisseau de Robec

1872 - oil on canvas - 60 x 65
Musée d'Orsay, Paris

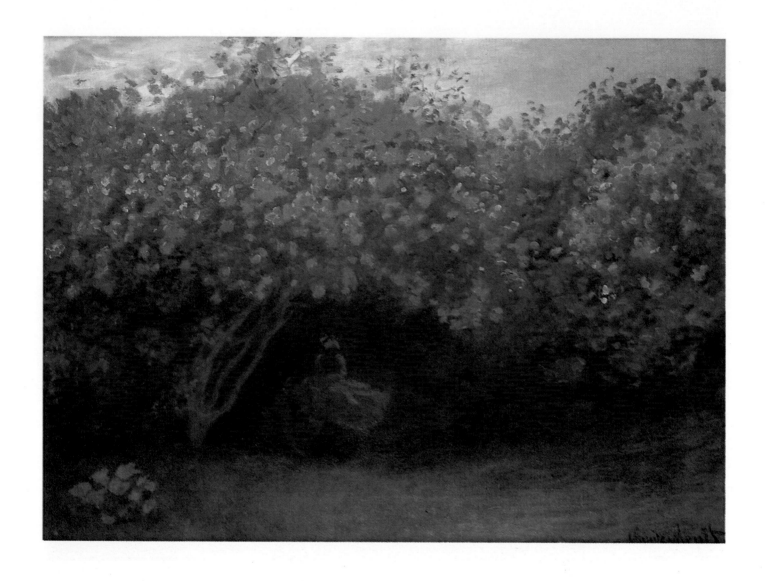

Les Lilas, temps gris

1872 - oil on canvas - 48 x 64
Musée d'Orsay, Paris

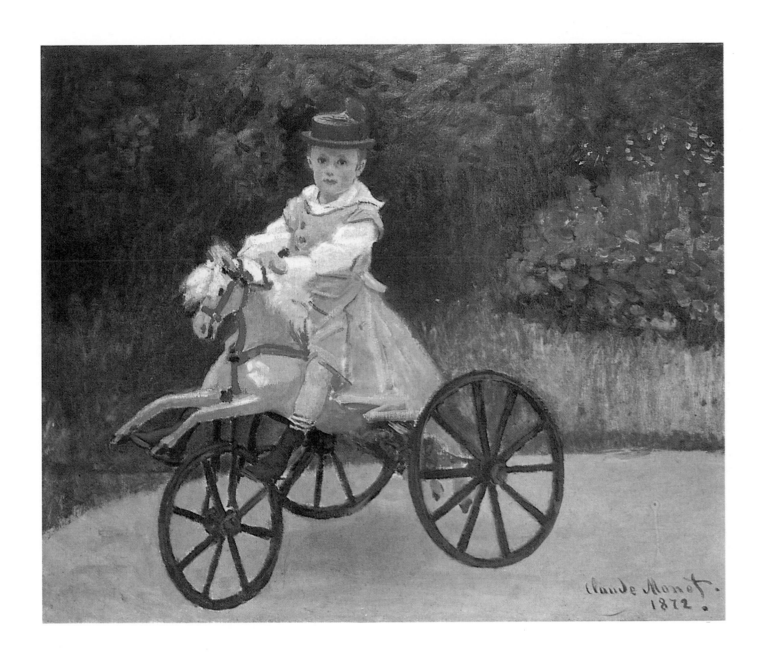

Jean Monet sur son cheval mécanique

1872 - oil on canvas - 59 x 73
Private collection, U.S.A.

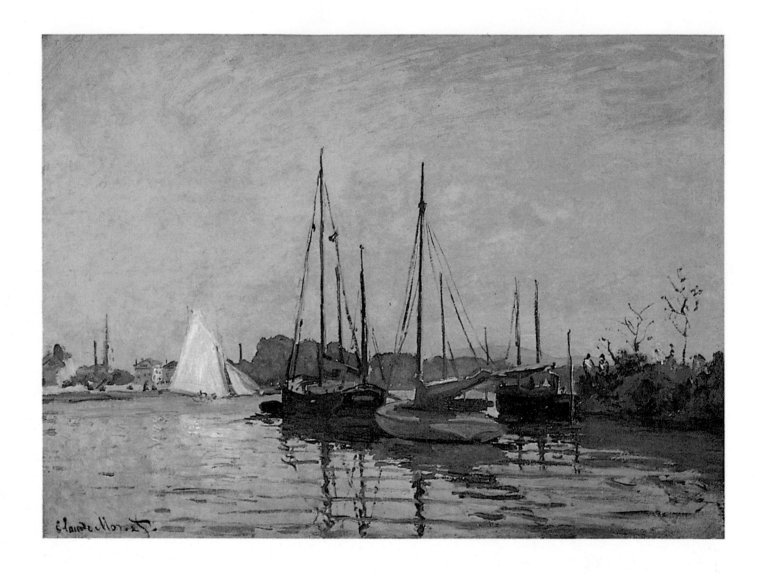

Bateaux de plaisance

1872 - oil on canvas - 47 x 65
Musée d'Orsay, Paris

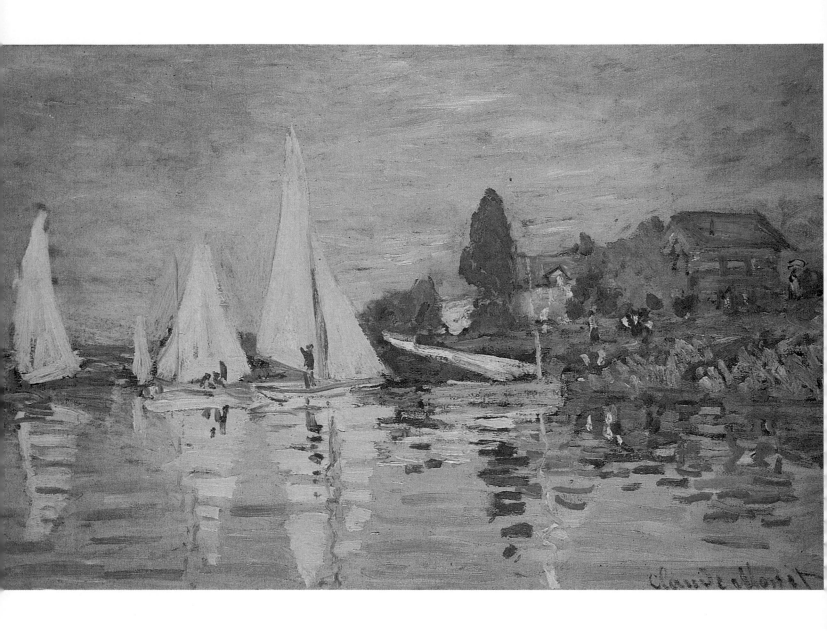

Régates à Argenteuil

1872 - oil on canvas - 48 x 75
Musée d'Orsay, Paris

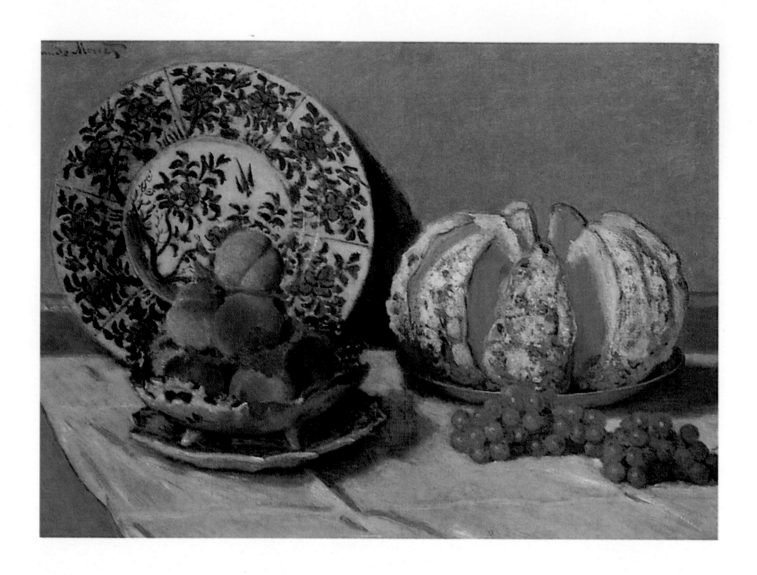

Nature morte au melon

1872 - oil on canvas - 53 x 73
Museu Calouste Gulbenkian, Lisbon

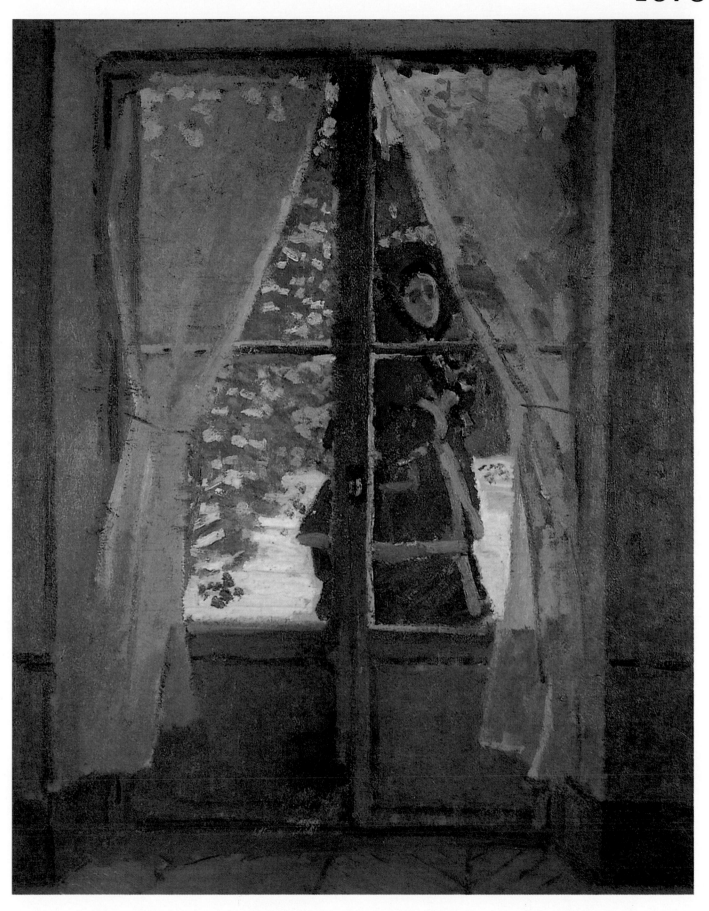

La Capeline rouge, portrait de Madame Monet

1873 - oil on canvas - 100 x 80
Cleveland Museum of Art, Cleveland

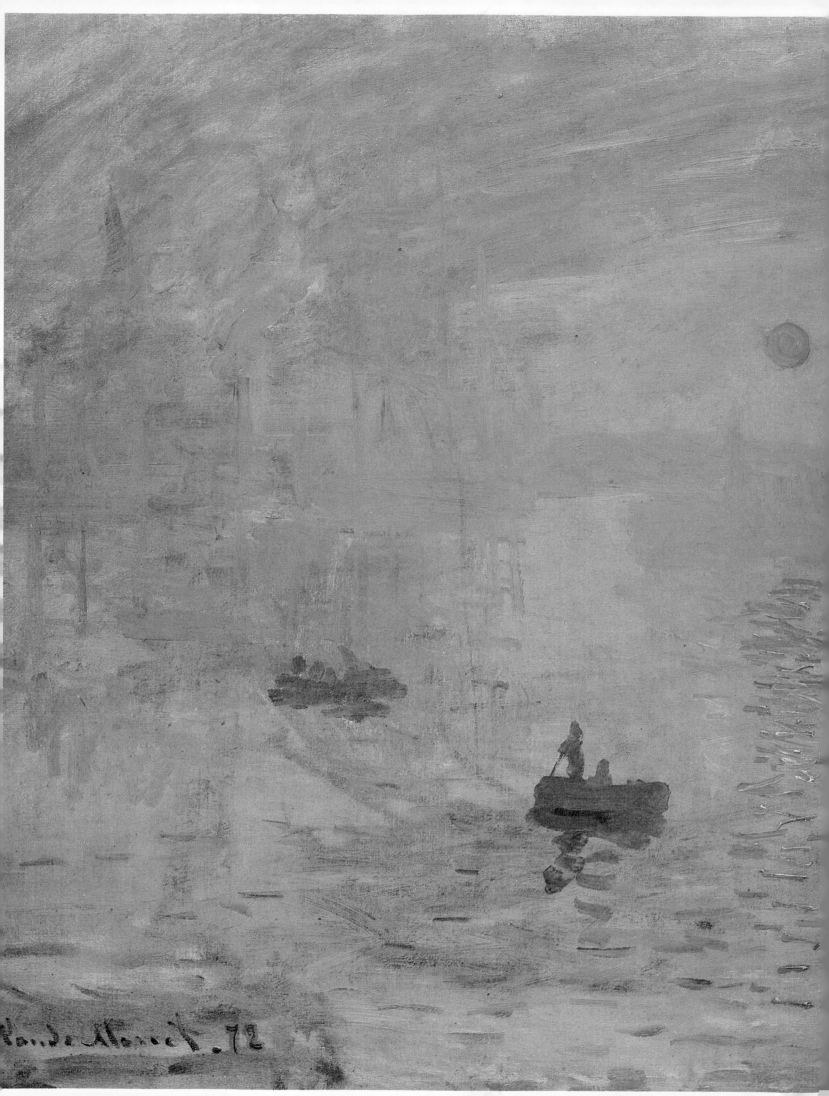

Impression, soleil levant

1873 - oil on canvas - 48 x 63
Musée Marmottan, Paris

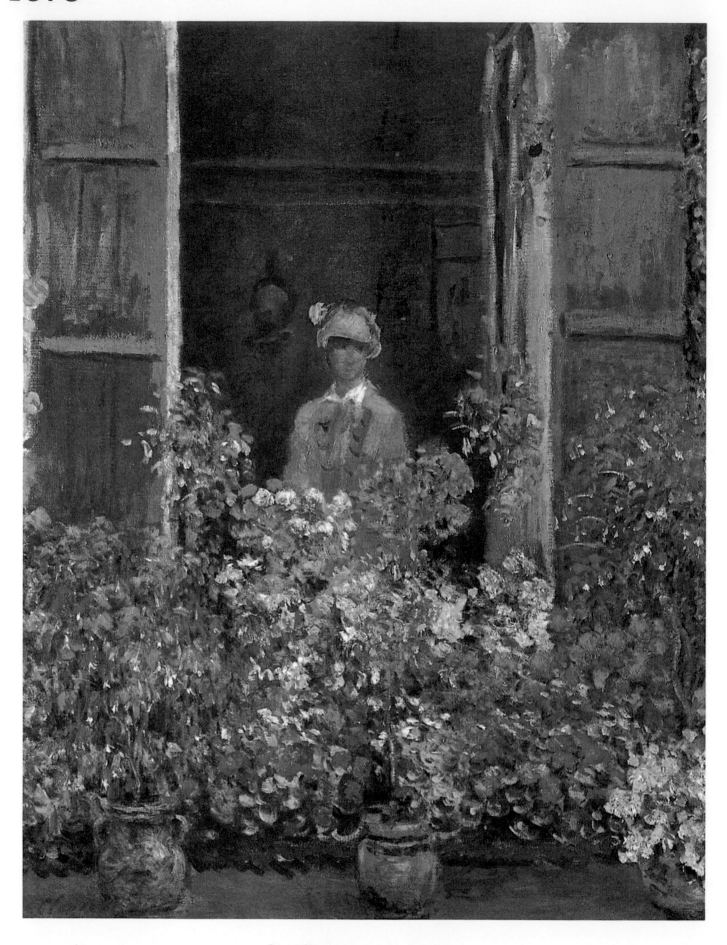

Camille Monet à la fenêtre

1873 - oil on canvas - 60 x 49
Private collection

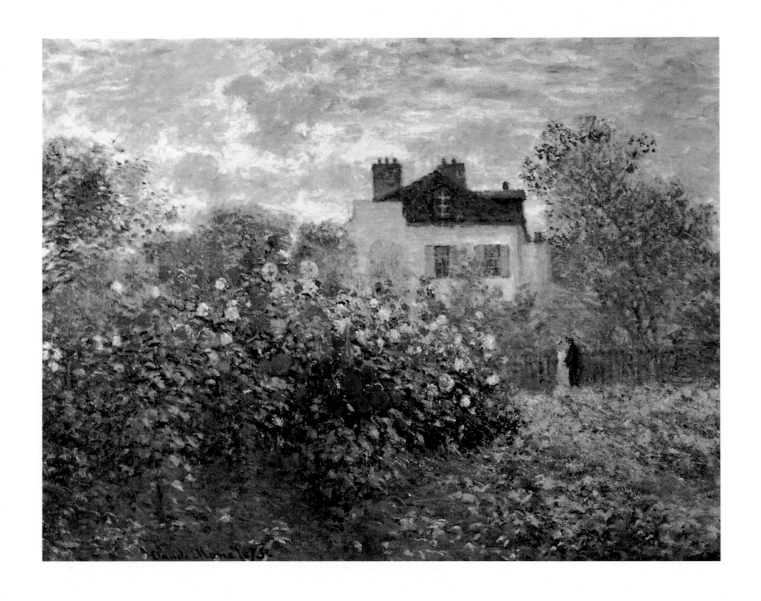

Le Jardin de Monet à Argenteuil (Les Dahlias)

1873 - oil on canvas - 61 x 82
Private collection

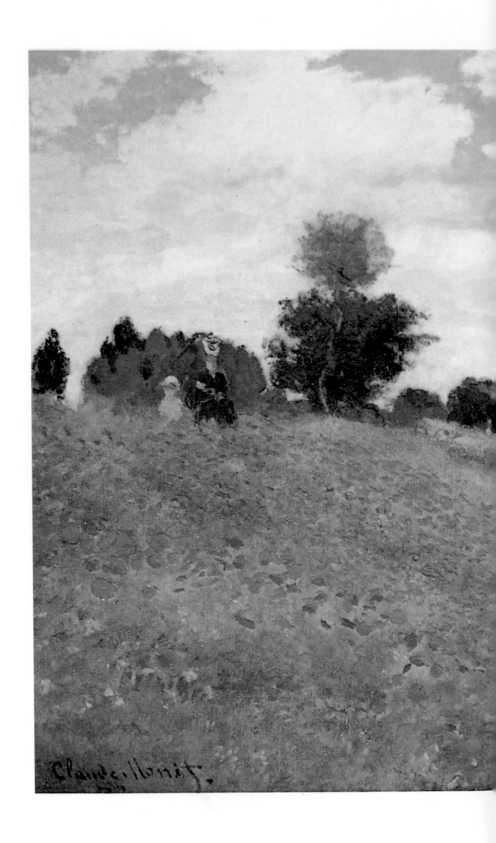

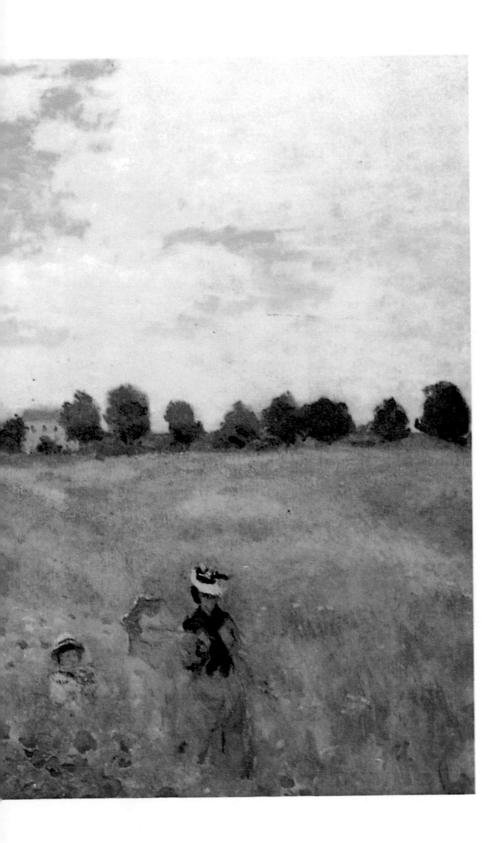

Les Coquelicots à Argenteuil

1873 - oil on canvas - 50 x 65
Musée d'Orsay, Paris

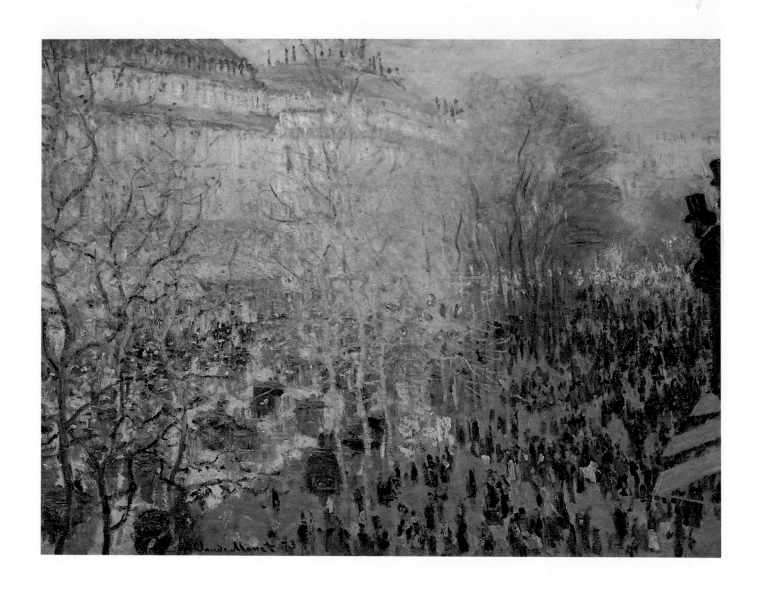

Le Boulevard des Capucines

1873 - oil on canvas - 61 x 80
A.S. Pushkin State Museum, Moscow

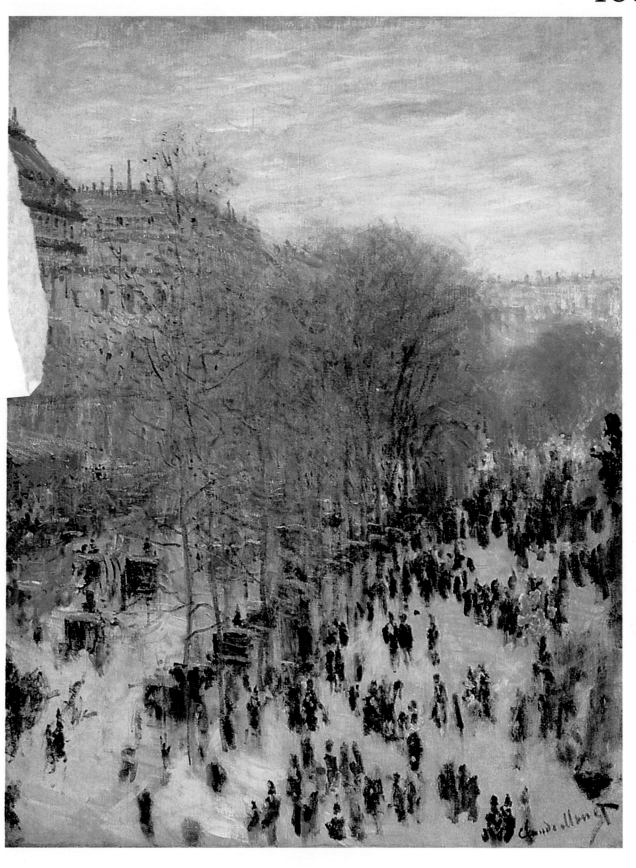

Le Boulevard des Capucines

1873 - oil on canvas - 80 x 61
Nelson-Atkins Museum of Art, Kansas City

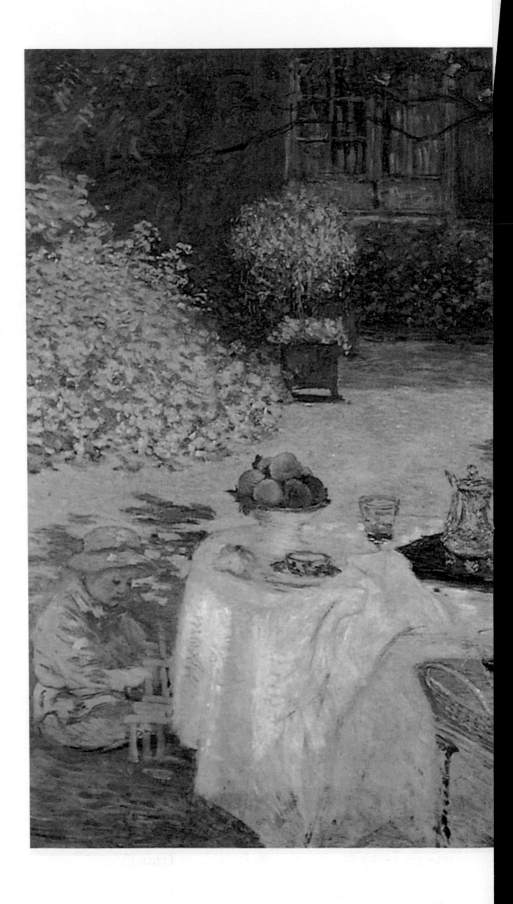

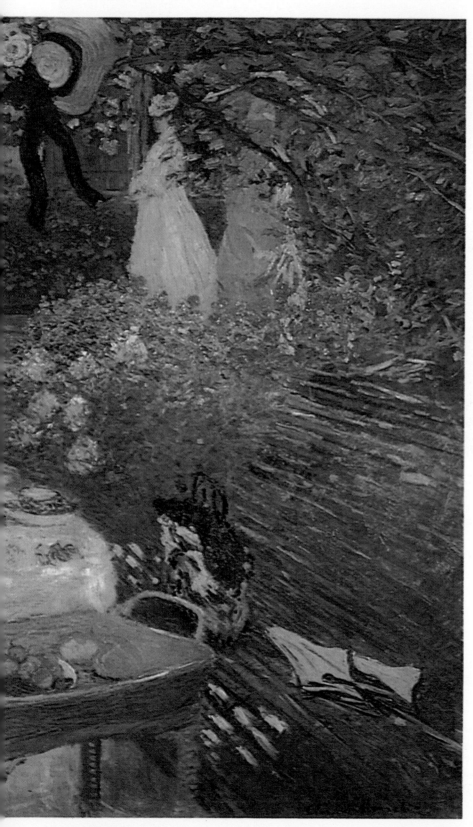

Le Déjeuner

1873 - oil on canvas - 162 x 203
Musée d'Orsay, Paris

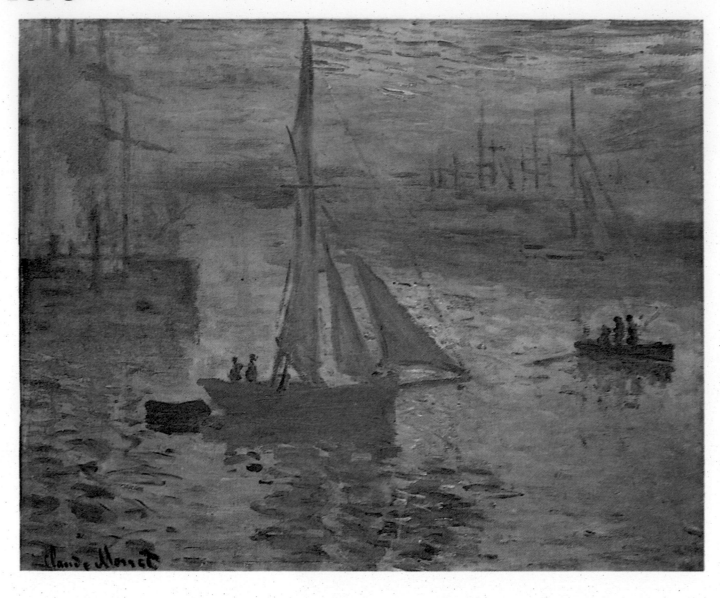

Soleil levant (marine)

1873 - oil on canvas - 49 x 60
Private collection, Paris

La Maison de l'artiste à Argenteuil

1873 - oil on canvas - 60.5 x 74
The Art Institute of Chicago,
Mr. and Mrs. Martin A. Ryerson collection, Chicago

Le Musée du Havre

1873 - oil on canvas - 75 x 100
Private collection

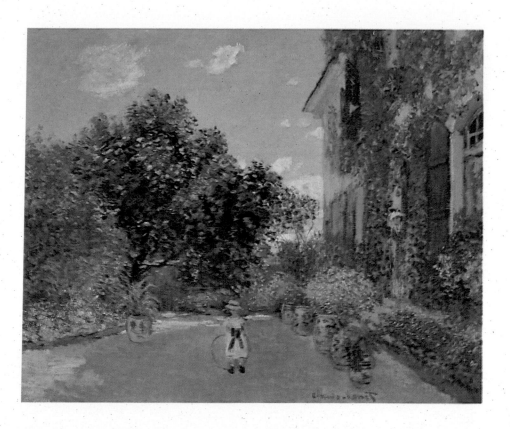

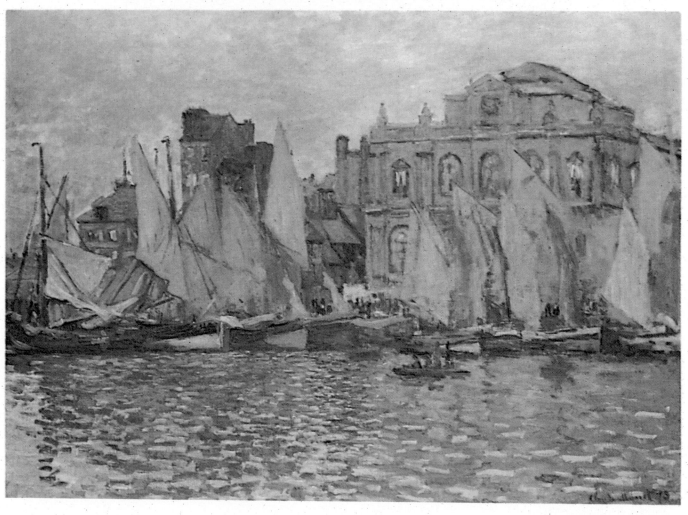

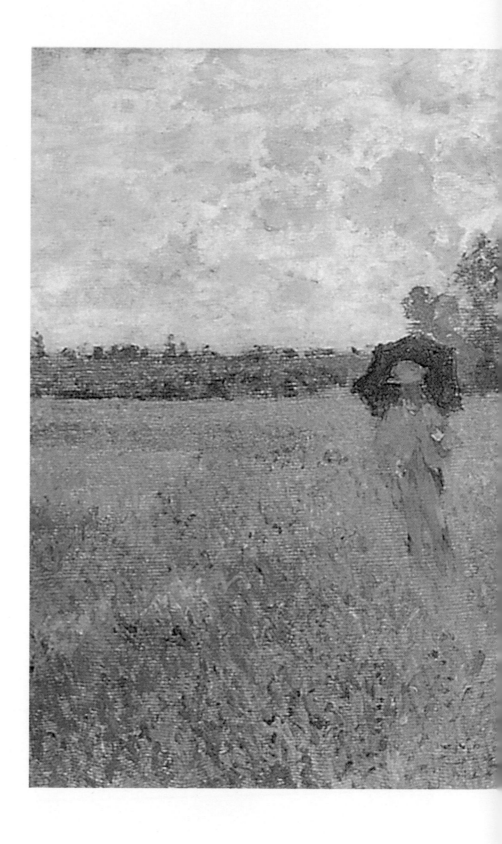

Promenade près d'Argenteuil

1873 - oil on canvas - 60 x 81
Musée Marmottan, Paris

Coucher du soleil sur la Seine

1874 - oil on canvas - 50 x 65
Philadelphia Museum of Art, Philadelphia

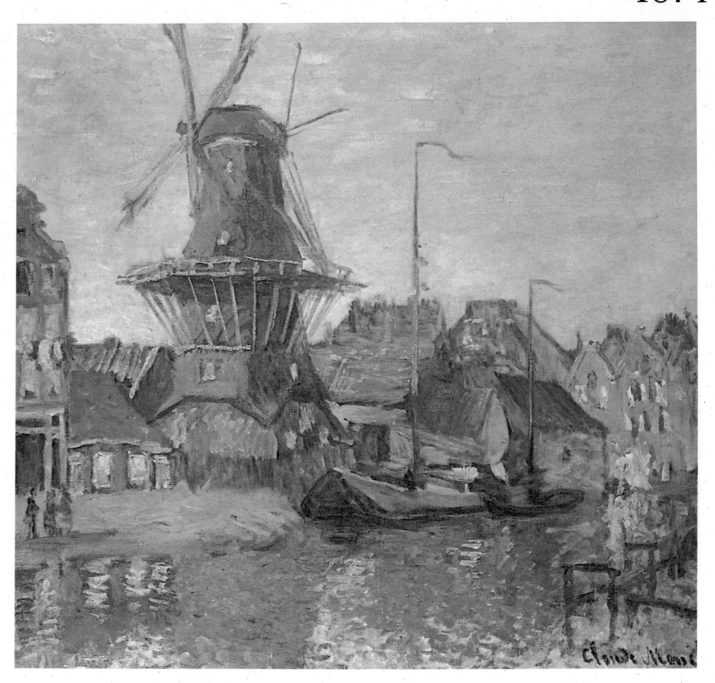

Le Moulin de l'Onbekende Gracht

1874 - oil on canvas - 56 x 65
Private collection

Le Pont, Amsterdam

1874 - oil on canvas - 53.5 x 63.5
Shelburne Museum, Shelburne, Vermont

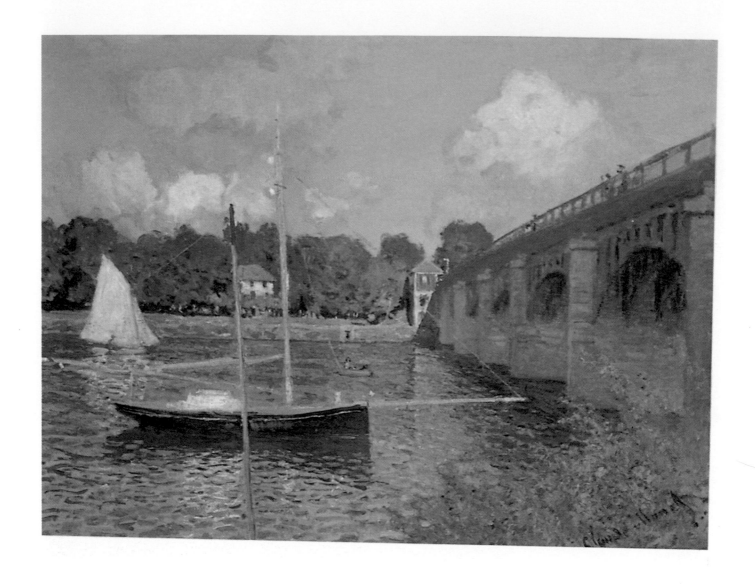

Le Pont routier, Argenteuil

1874 · oil on canvas · 60 x 80
National Gallery of Art,
Mr. and Mrs. Paul Mellon collection, Washington, D.C.

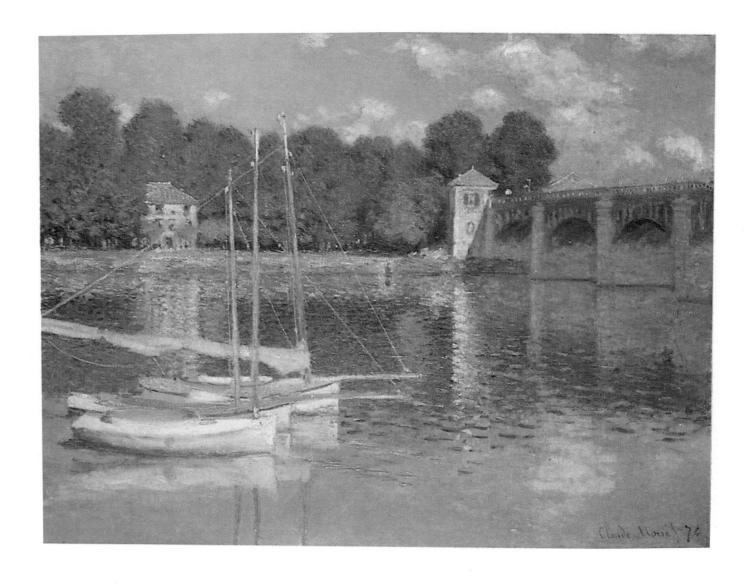

Le Pont d'Argenteuil

1874 - oil on canvas - 60 x 80
Musée d'Orsay, Paris

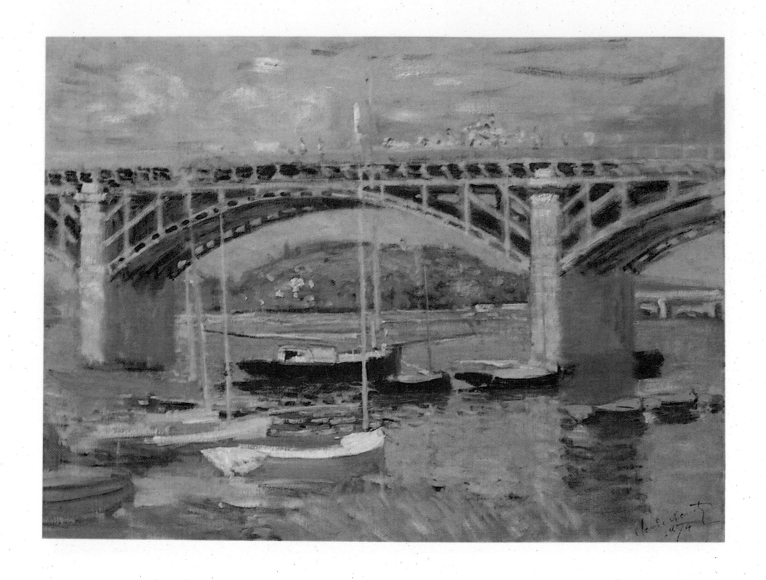

Le Pont d'Argenteuil

1874 - oil on canvas - 58 x 80
Neue Pinakothek, Munich

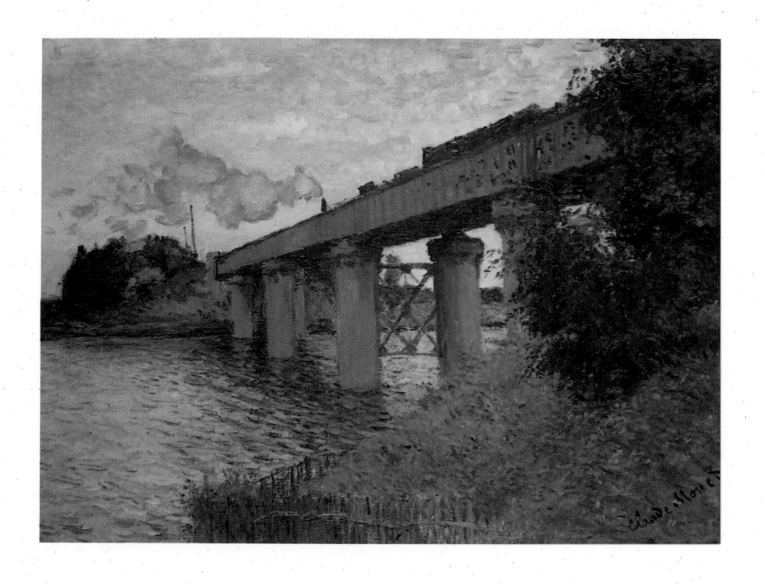

Le Pont du chemin de fer, Argenteuil

1873 - oil on canvas - 55 x 72
Musée d'Orsay, Paris

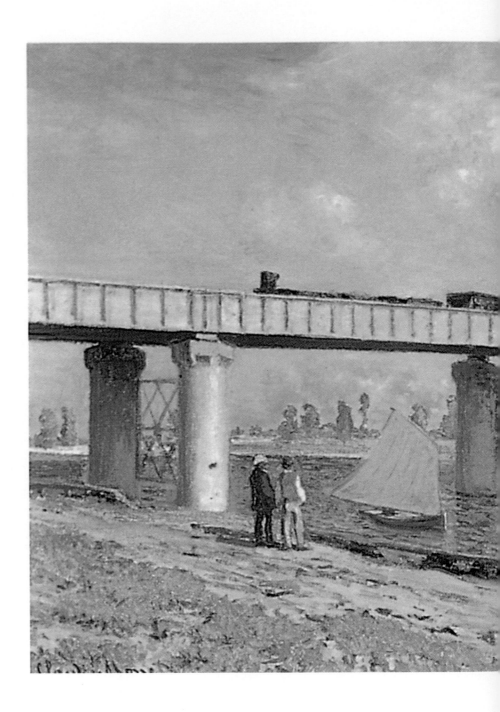

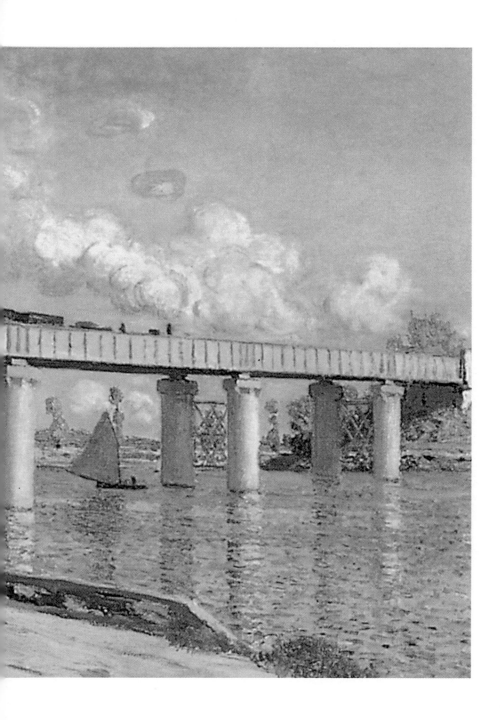

Le Pont du chemin de fer à Argenteuil

1874 - oil on canvas - 60 x 99
Private collection

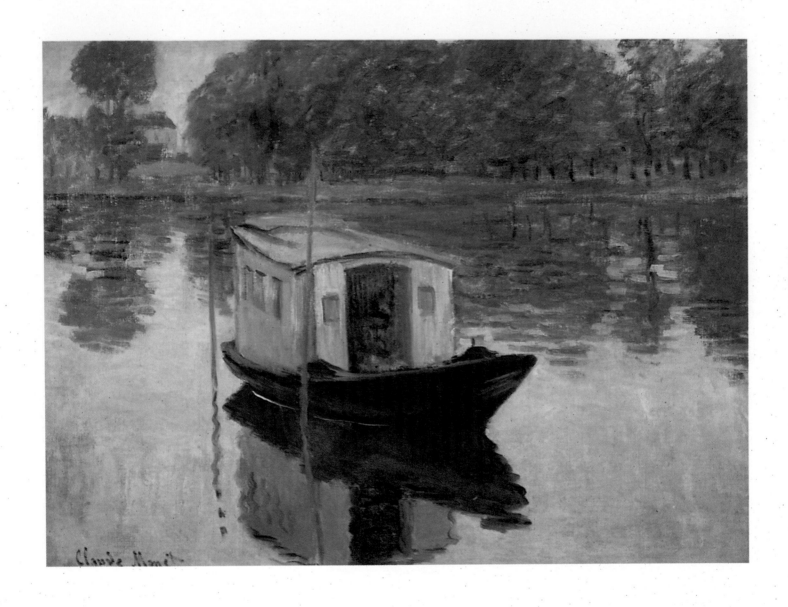

Le Bateau-atelier

1874 - oil on canvas - 50 x 64
Rijksmuseum Krïller-MÜller, Otterloo, The Netherlands

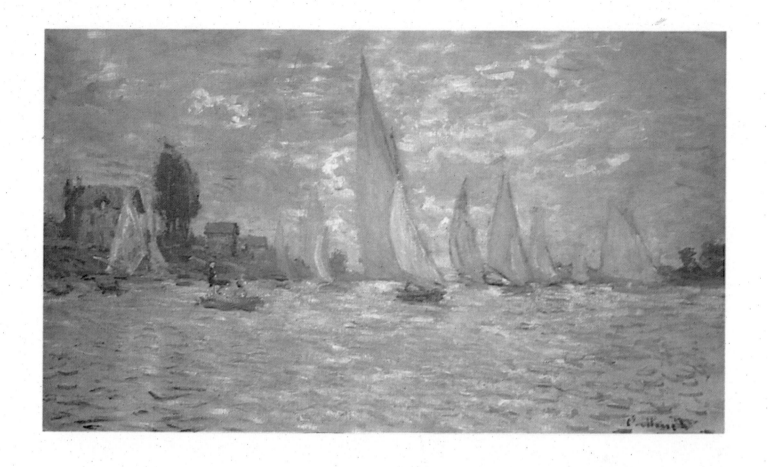

Les Barques régates à Argenteuil

1874 - oil on canvas - 60 x 100
Musée d'Orsay, Paris

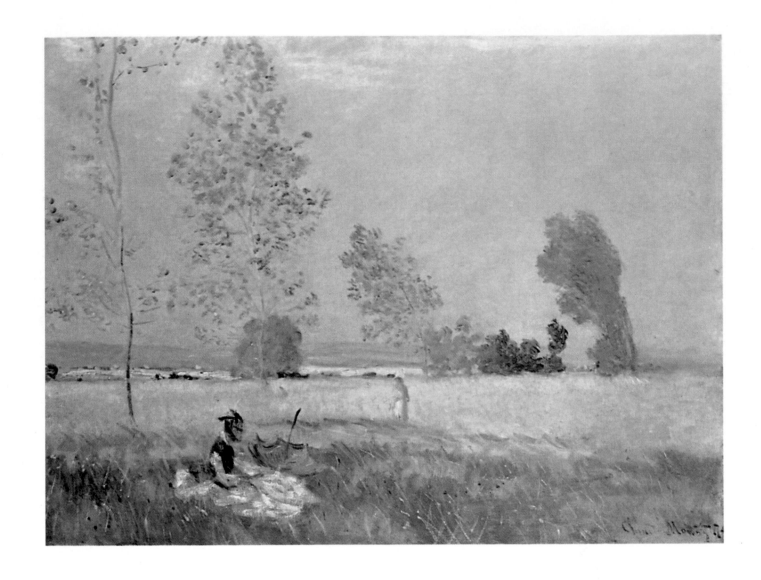

Prairie à Bezons

1874 - oil on canvas - 57 x 80
Nationalgalerie, Berlin

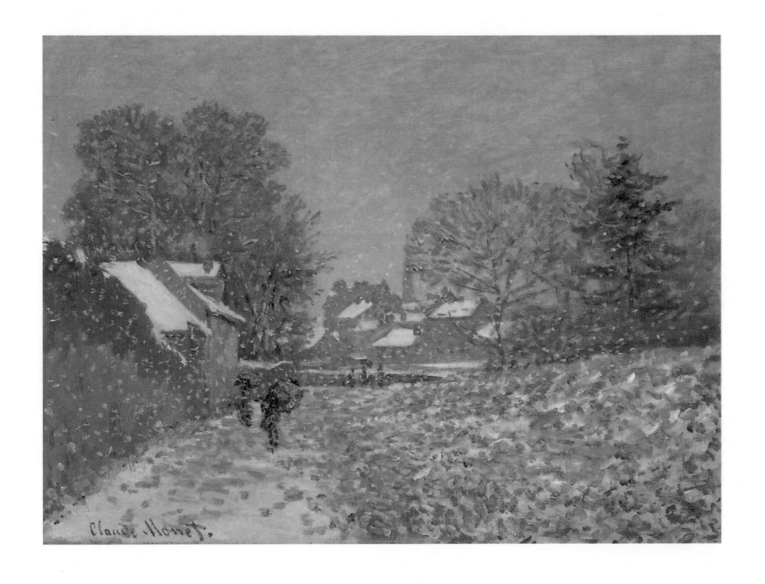

Neige à Argenteuil

1874 · oil on canvas · 57 x 74
Museum of Fine Arts, Boston

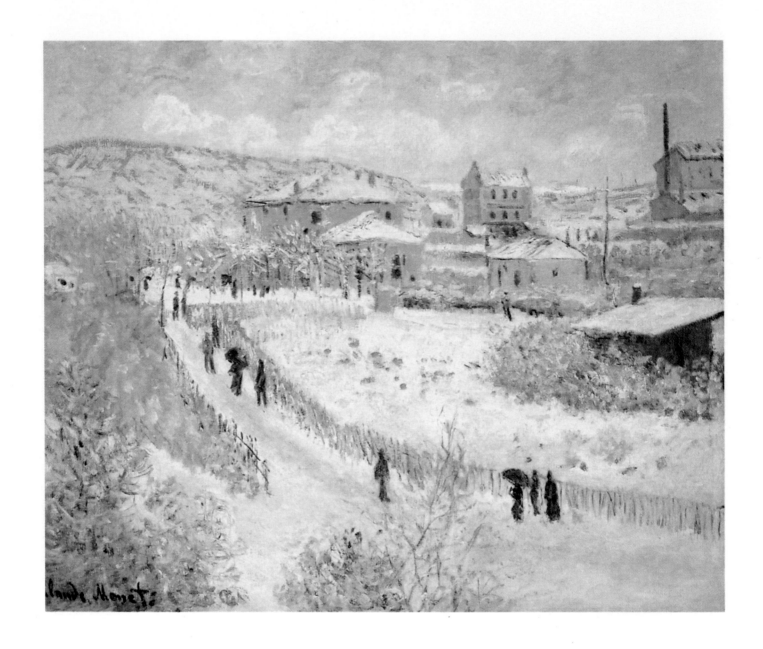

Vue d'Argenteuil, neige

1875 - oil on canvas - 55 x 68
Nelson-Atkins Museum of Art, Kansas City

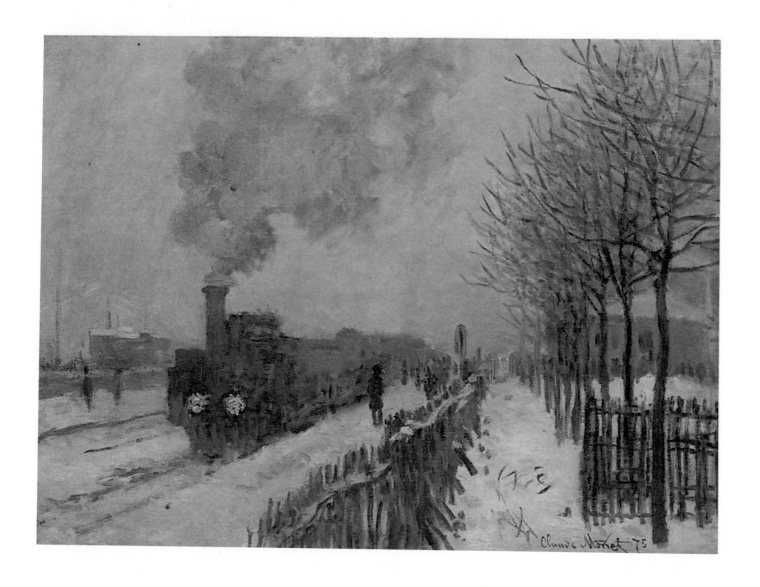

Le Train dans la neige, la locomotive

1875 - oil on canvas - 59 x 78
Musée Marmottan, Paris

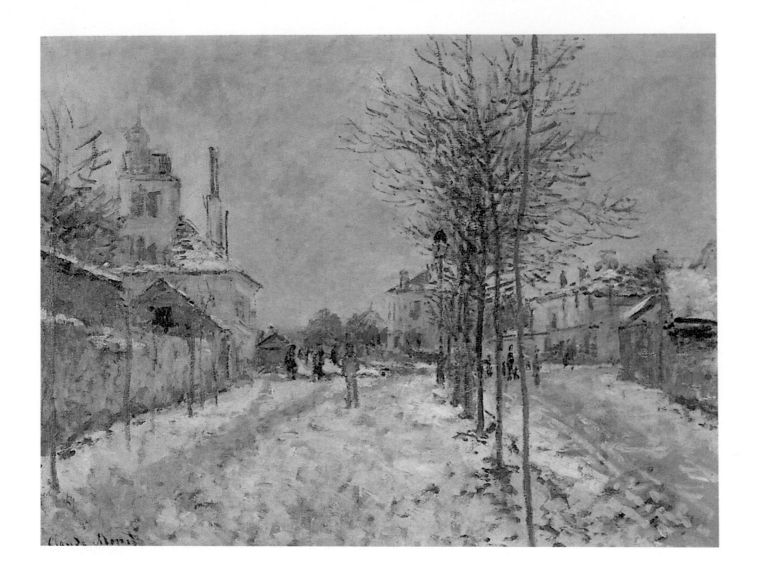

Le Boulevard de Pontoise à Argenteuil, neige

1875 - oil on canvas - 60 x 81
Öffentliche Kunstsammlung, Basel

Bateaux de plaisance à Argenteuil

1875 - oil on canvas - 54 x 65
Private collection

Les Déchargeurs de charbon

1875 - oil on canvas - 55 x 66
Private collection, Paris

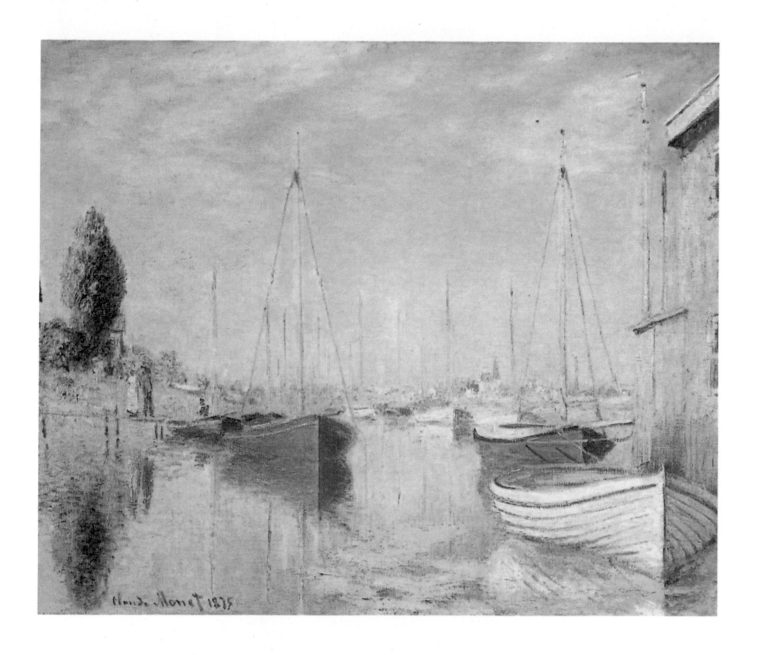

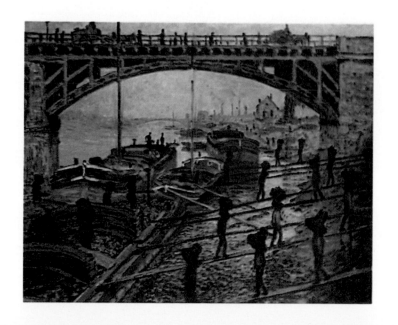

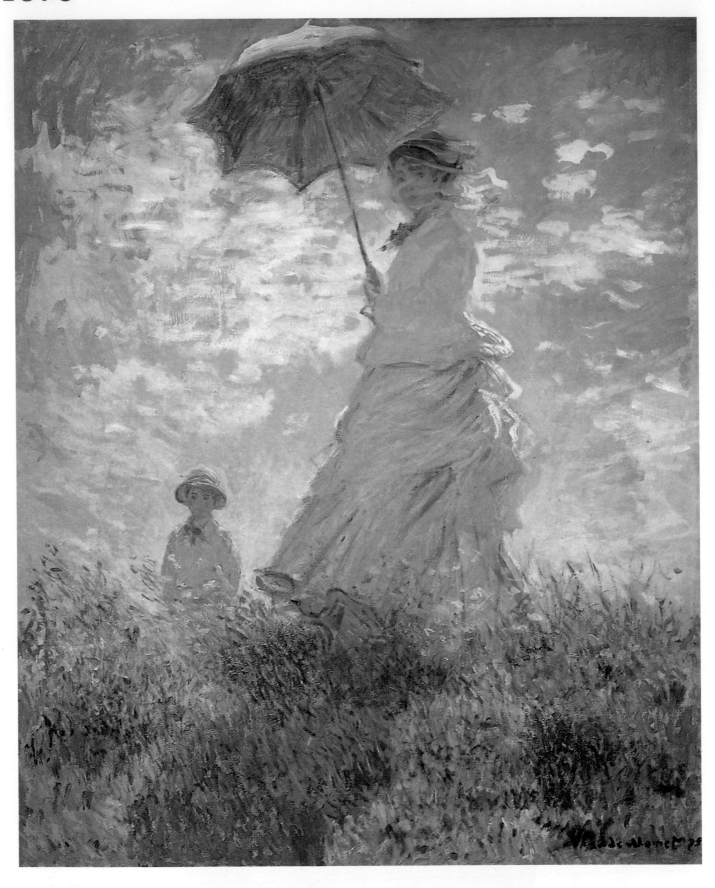

La Promenade, la femme à l'ombrelle

1875 - oil on canvas - 100 x 81
National Gallery of Art,
Mr. and Mrs. Paul Mellon collection, Washington, D.C.

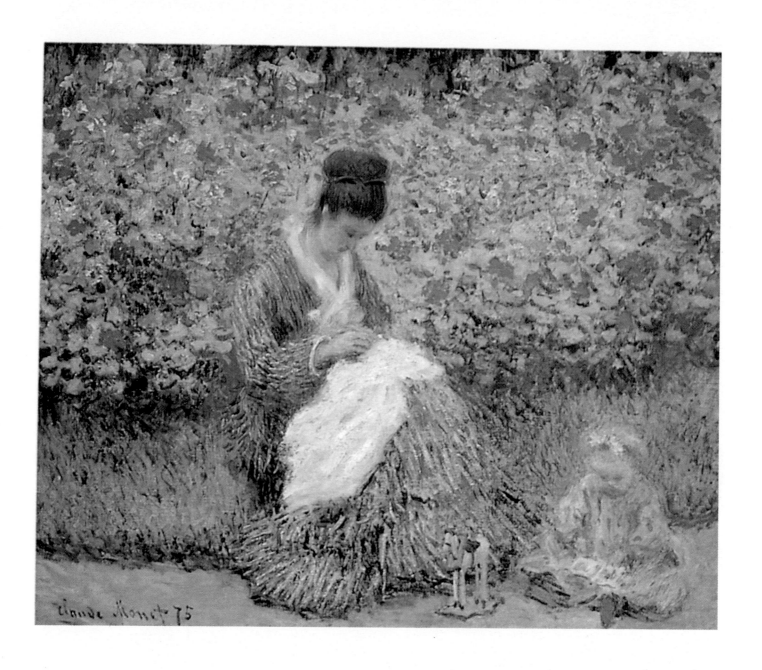

Camille Monet et un enfant au jardin

1875 - oil on canvas - 55 x 66
Museum of Fine Arts, Boston

Au jardin, la famille de l'artiste

1875 - oil on canvas - 61 x 80
Private collection

Un Coin d'appartement

1875 - oil on canvas - 80 x 60
Musée d'Orsay, Paris

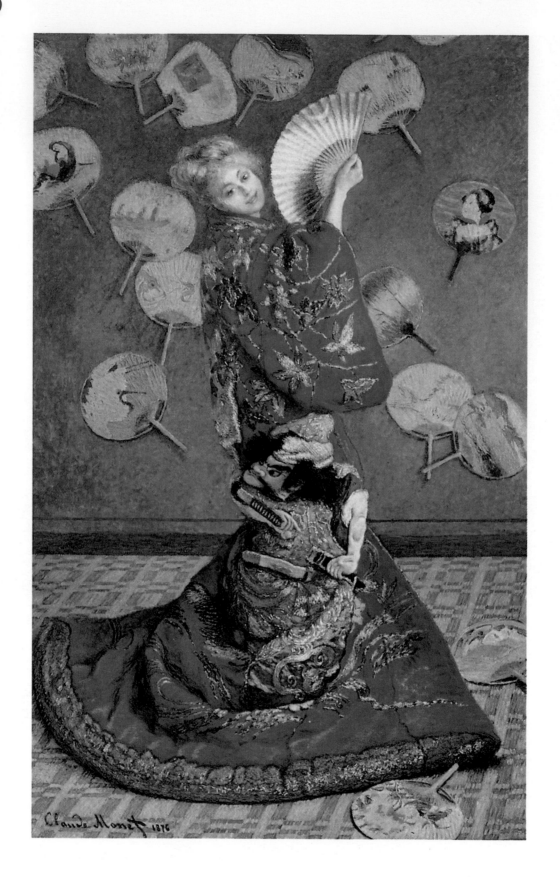

La Japonaise

1875-76 - oil on canvas - 231 x 142
Museum of Fine Arts, Boston

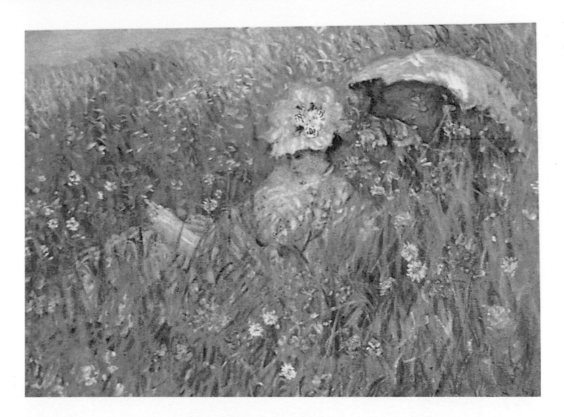

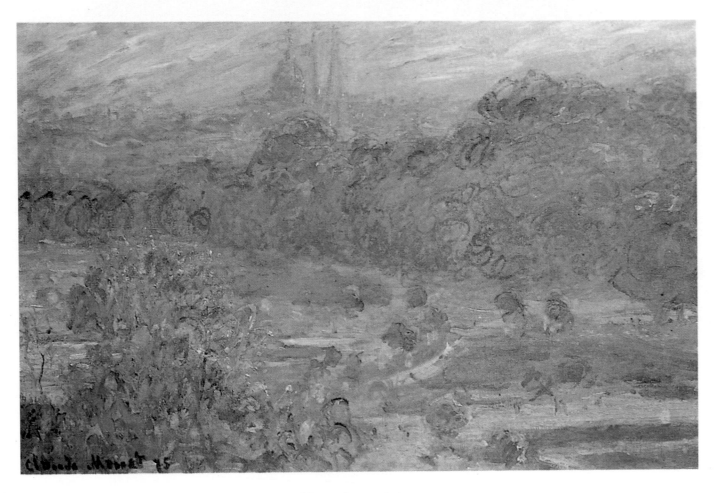

Dans la prairie

1876 - oil on canvas - 60 x 82
Private collection

Les Tuileries

1875 - oil on canvas - 50 x 74
Musée d'Orsay, Paris

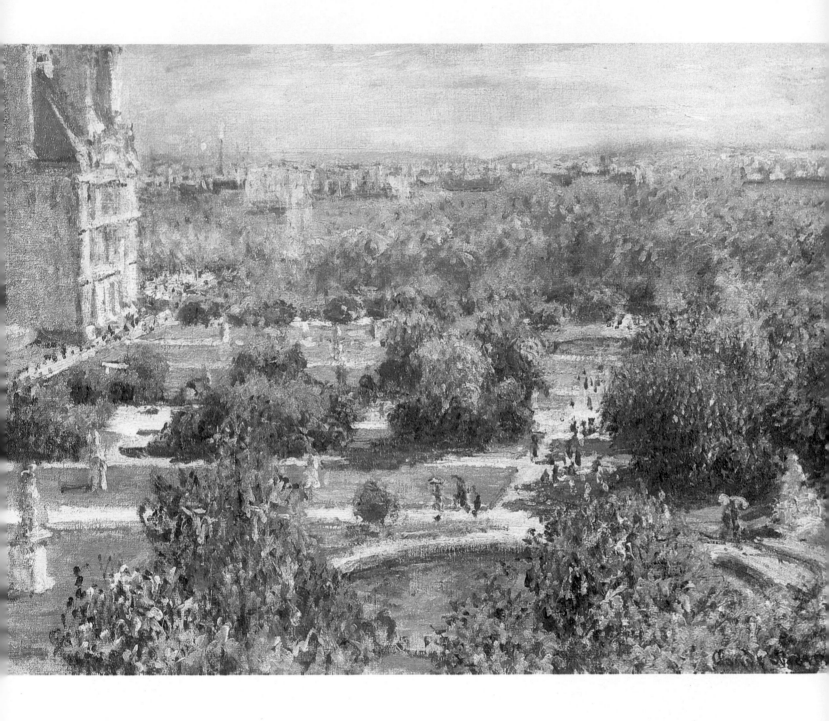

Les Tuileries

1876 - oil on canvas - 54 x 73
Musée Marmottan, Paris

La Maison de Monet à Argenteuil

1876 - oil on canvas - 63 x 52
Private collection

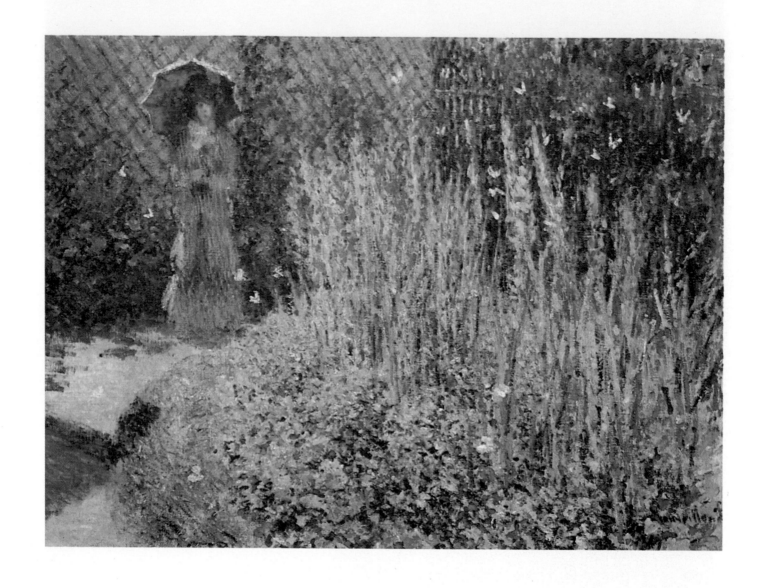

Les Glaïeuls

1876 - oil on canvas - 60 x 81
Detroit Institute of Arts, Detroit

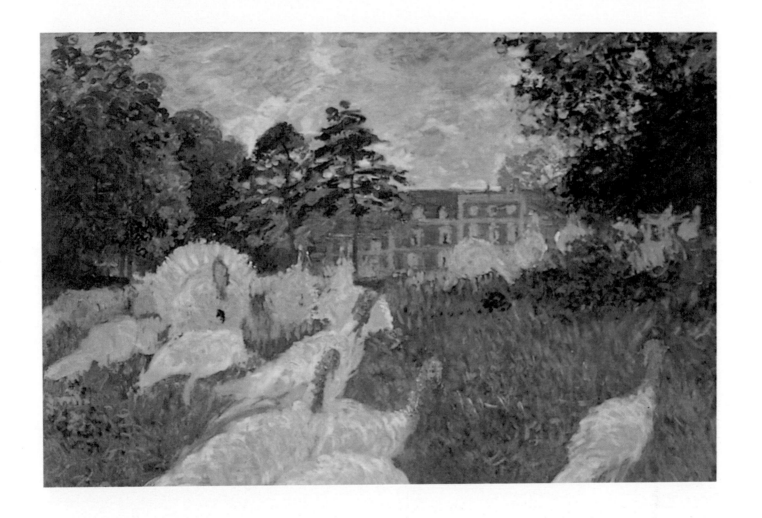

Les Dindons (partial)

1876 - oil on canvas - 172 x 175
Musée d'Orsay, Paris

Le Bateau-atelier

1876 - oil on canvas - 54 x 65
Musée d'Art et d'Histoire, Neuchâtel

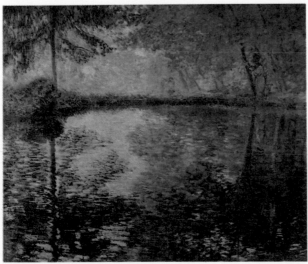

Coin de jardin à Montgeron

1877 - oil on canvas - 172 x 193
State Heritage Museum, St. Petersburg

Coin d'étang à Montgeron

1876 - oil on canvas - 60 x 81
Private collection

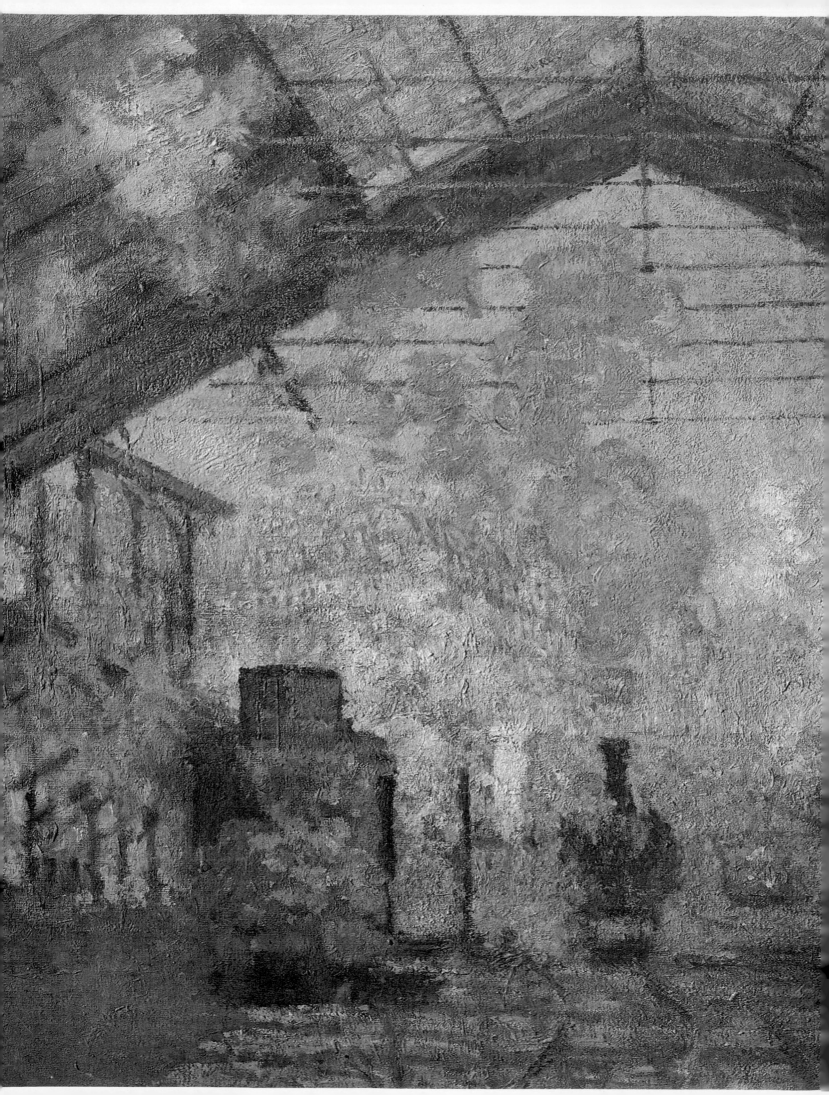

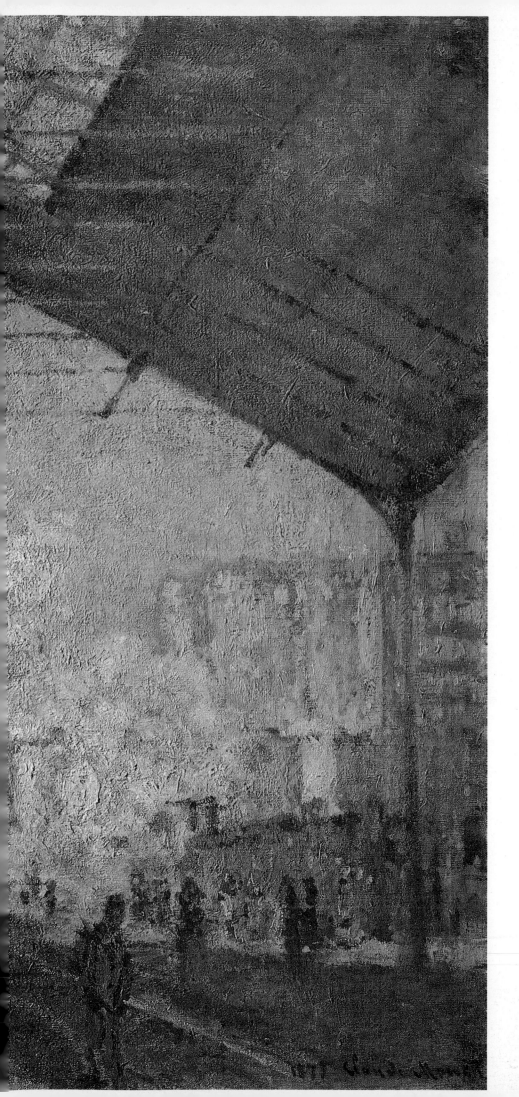

La Gare Saint-Lazare

1877 - oil on canvas - 75 x 100
Musée Marmottan, Paris

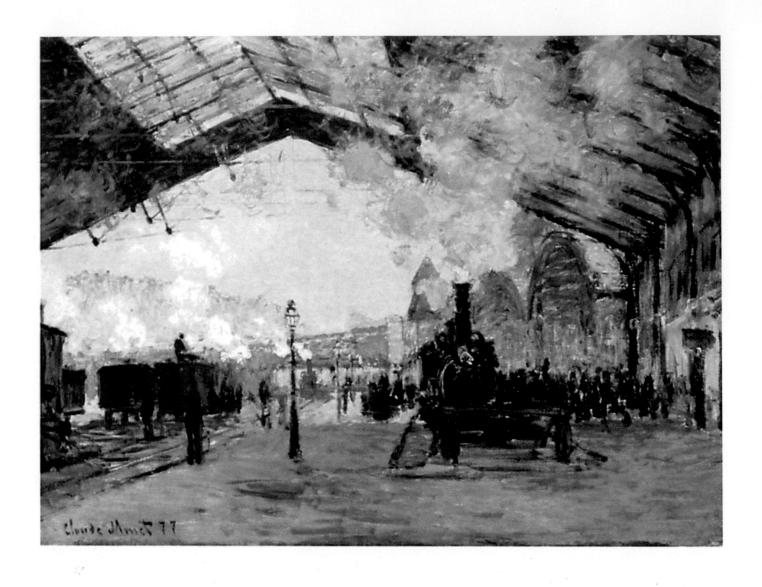

La Gare Saint-Lazare, le train de Normandie

1877 - oil on canvas - 59.5 x 80
The Art Institute of Chicago,
Mr. and Mrs. Martin A. Ryerson collection, Chicago

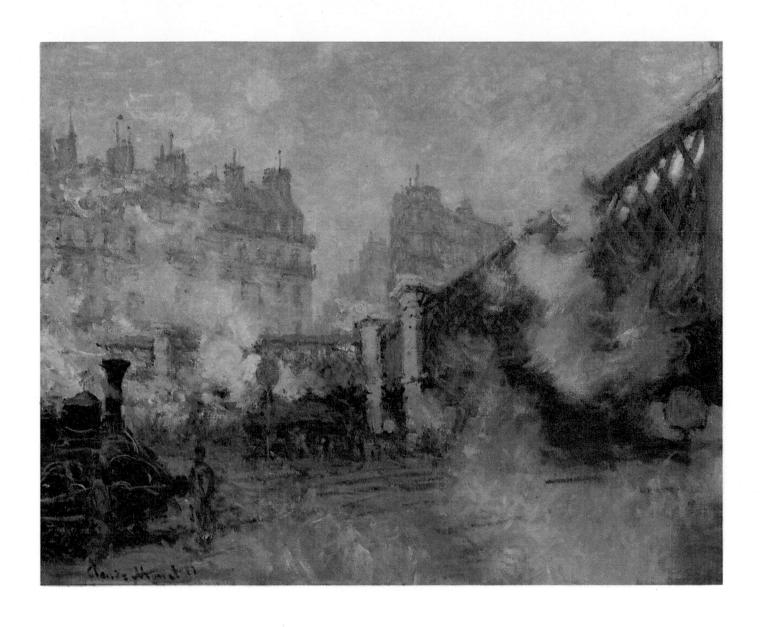

Le Pont de l'Europe, Gare Saint-Lazare

1877 - oil on canvas - 64 x 81
Musée Marmottan, Paris

Le Printemps, à travers les branches

Le Parc Monceau

1878 - oil on canvas - 52 x 63
Musée Marmottan, Paris

1878 - oil on canvas - 73 x 55
Metropolitan Museum of Art, New York

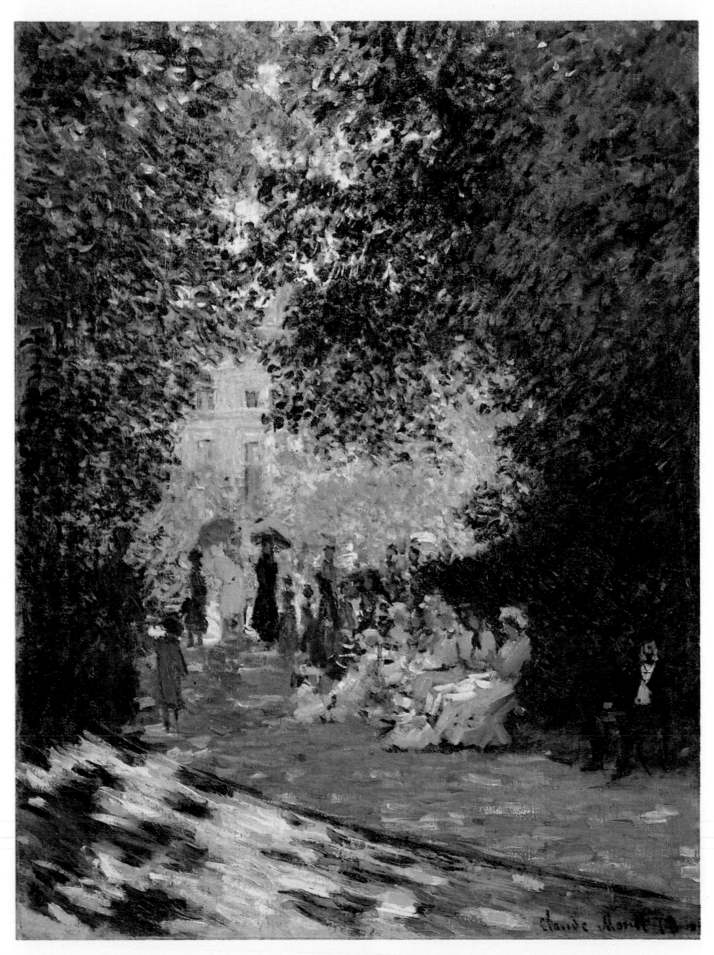

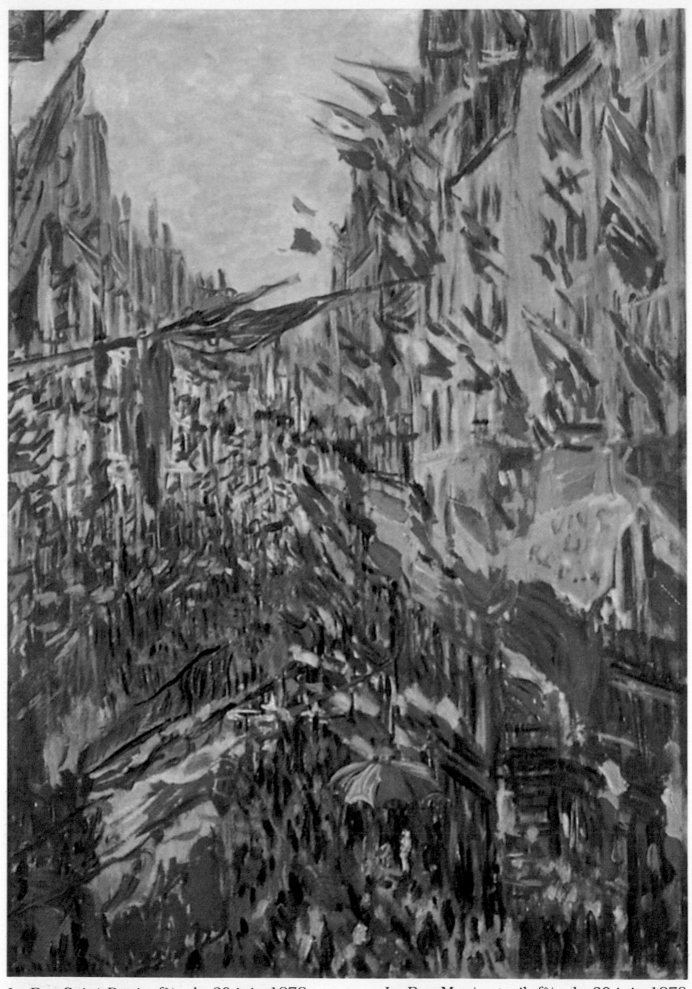

La Rue Saint-Denis, fête du 30 juin 1878

1878 - oil on canvas - 76 x 52

Musée des Beaux-Arts et de la Céramique, Rouen

La Rue Montorgueil, fête du 30 juin 1878

1878 - oil on canvas - 80 x 48.5

Musée d'Orsay, Paris

184

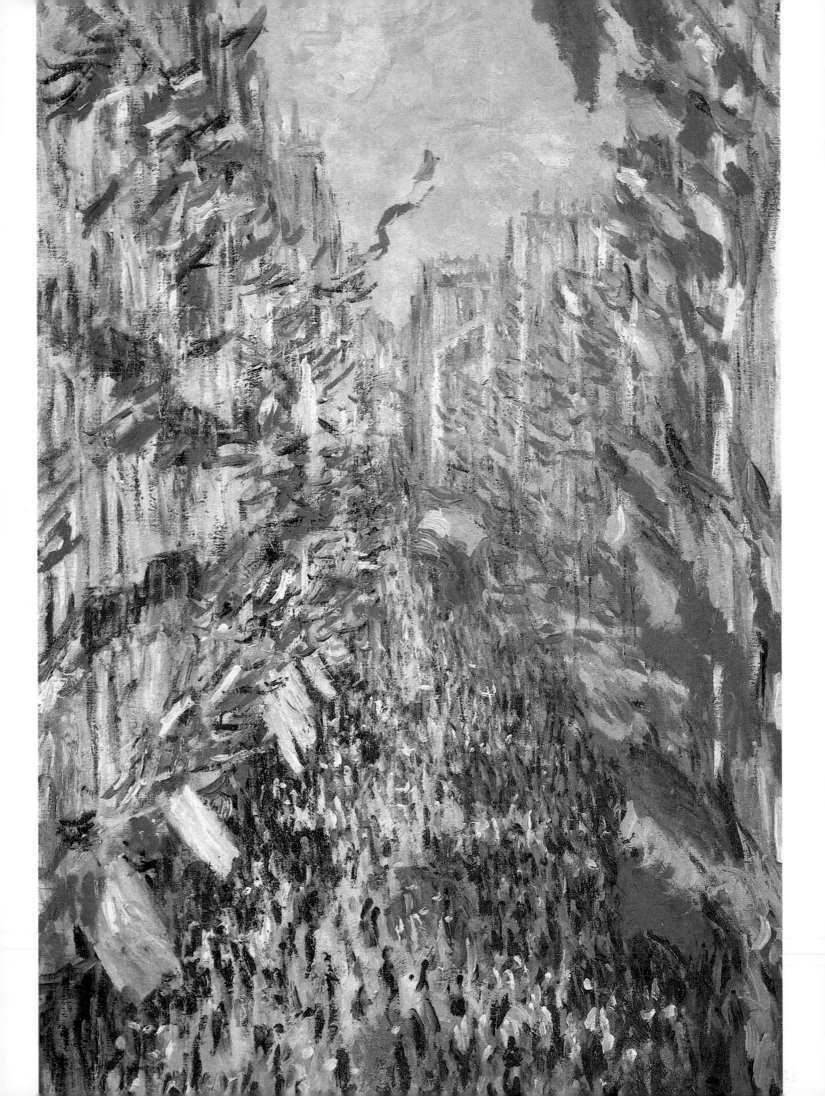

Chysanthèmes

1878 - oil on canvas - 54 x 65
Musée d'Orsay, Paris

La Berge à Lavacourt

1879 - oil on canvas - 65 x 80
Staatliche Kunstsammlungen Gemäldegalerie, Dresden

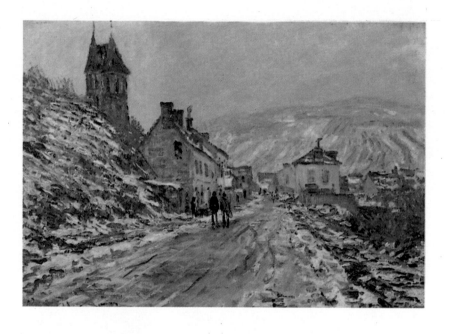

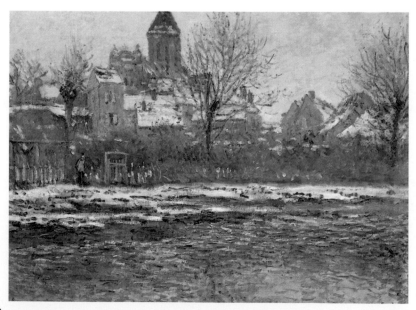

Vétheuil dans le brouillard

1879 - oil on canvas - 60 x 71
Musée Marmottan, Paris

La Route à Vétheuil, l'hiver

1879 - oil on canvas - 52 x 71
Göteborgs Konstmuseum, Göteborg

L'êglise de Vétheuil, neige

1879 - oil on canvas - 53 x 71
Musée d'Orsay, Paris

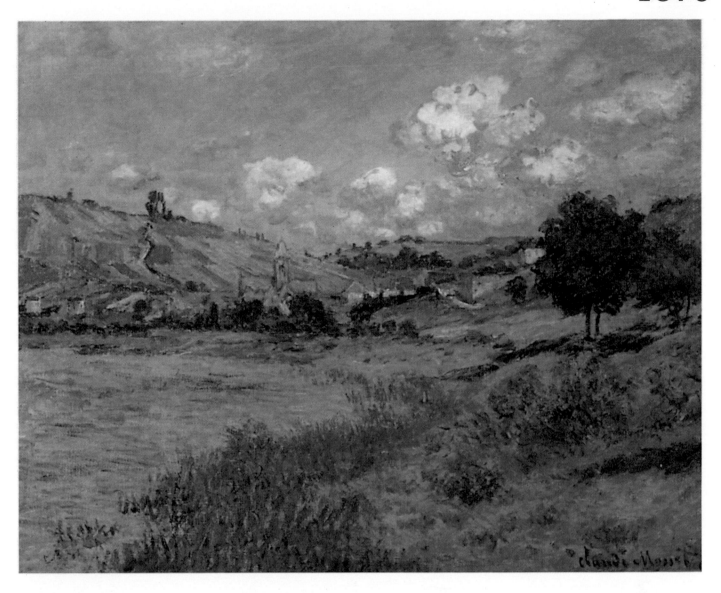

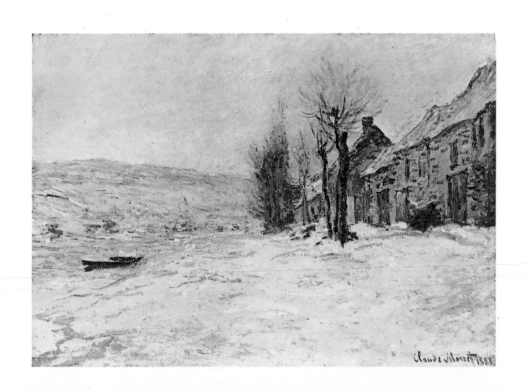

Paysage, Vétheuil

1879 - oil on canvas - 60 x 73
Musée d'Orsay, Paris

Lavacourt, soleil et neige

1881 - oil on canvas - 59 x 81
National Gallery, London

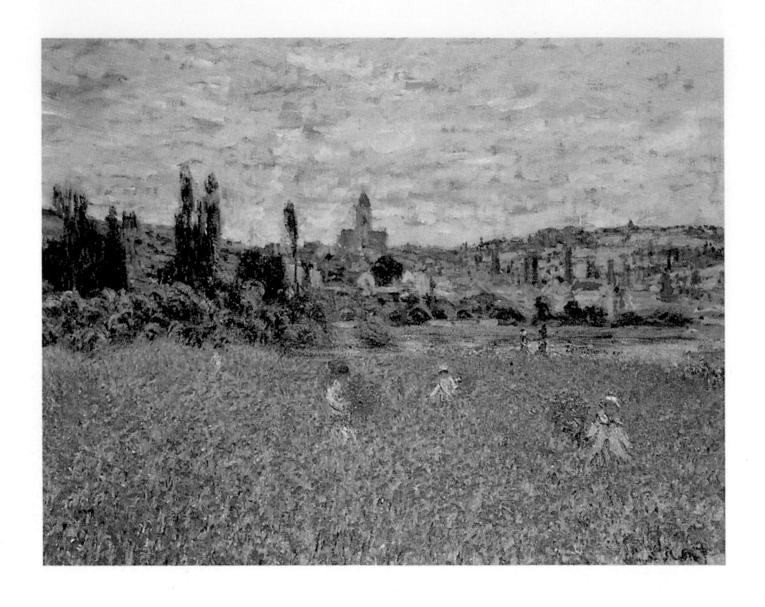

Champ de coquelicots près de Vétheuil

1879 - oil on canvas - 70 x 90
Stiftung Sammlung Bühle, Zurich

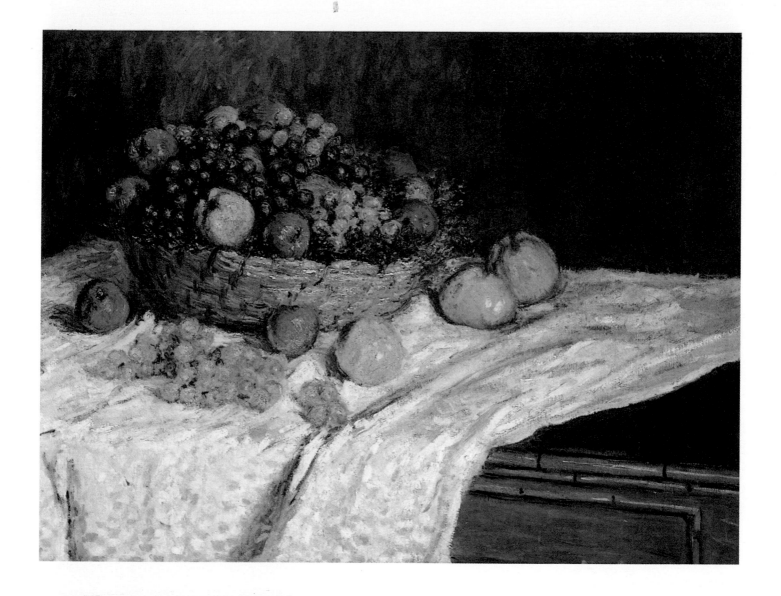

Corbeille de fruits (pommes et raisin)

1880 - oil on canvas - 68 x 90
Metropolitan Museum of Art, New York

Camille Monet sur son lit de mort

1879 - oil on canvas - 90 x 68
Musée d'Orsay, Paris

Le Givre

1880 - oil on canvas - 61 x 100
Musée d'Orsay, Paris

Soleil d'hiver, Lavacourt

1880 - oil on canvas - 55 x 81
Musée des Beaux-Arts 'André Malraux', Le Havre

La Débâcle près de Vétheuil

1880 - oil on canvas - 65 x 91
Musée d'Orsay, Paris

La Débâcle, temps gris

1880 - oil on canvas - 68 x 90
Museu Calouste Gulbenkian, Lisbon

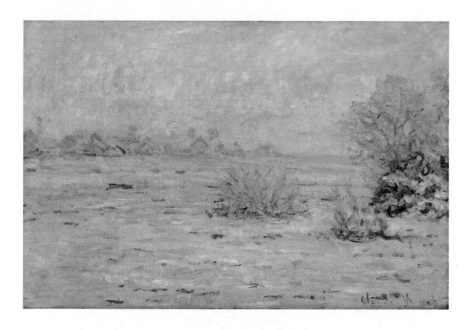

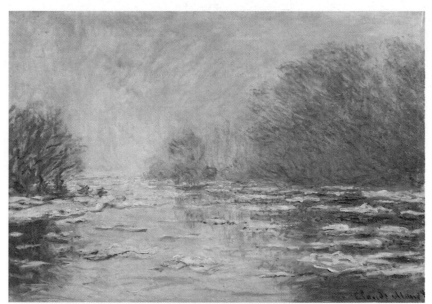

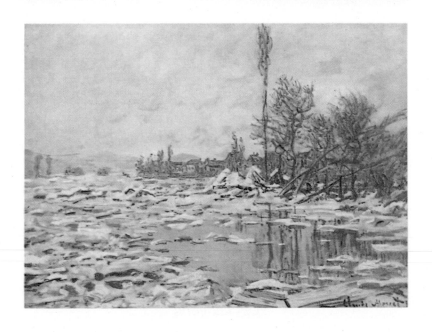

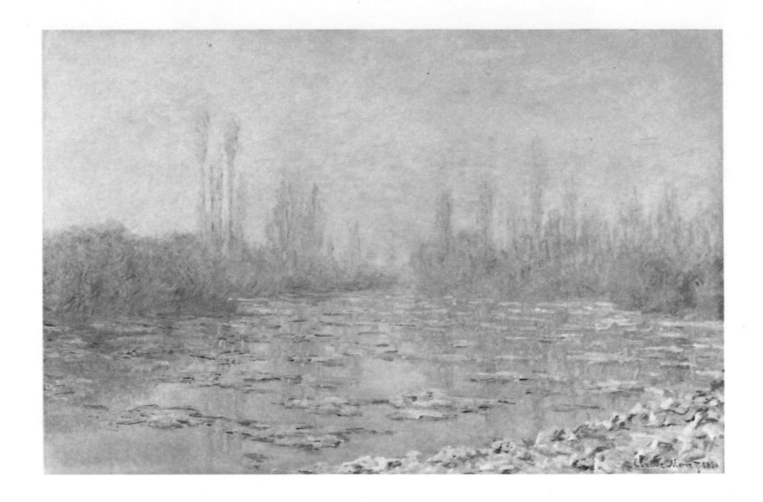

Les Glaçons

1880 - oil on canvas - 97 x 150.5
Shelburne Museum, Shelburne, Vermont

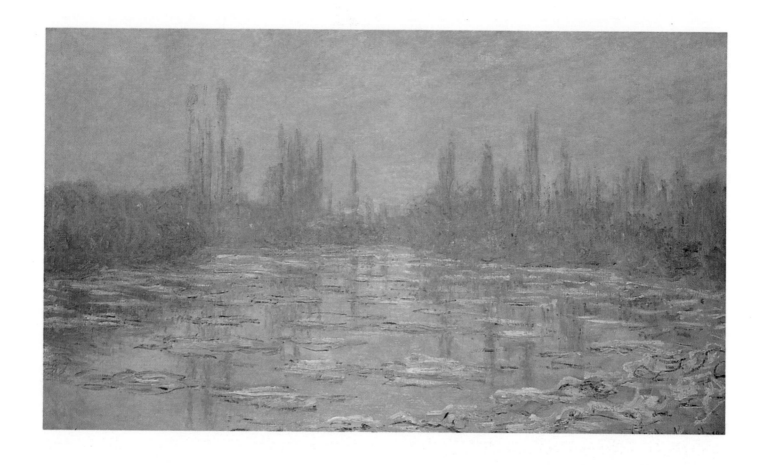

Les Glaçons (study)

1880 - oil on canvas - 61 x 100
Musée d'Orsay, Paris

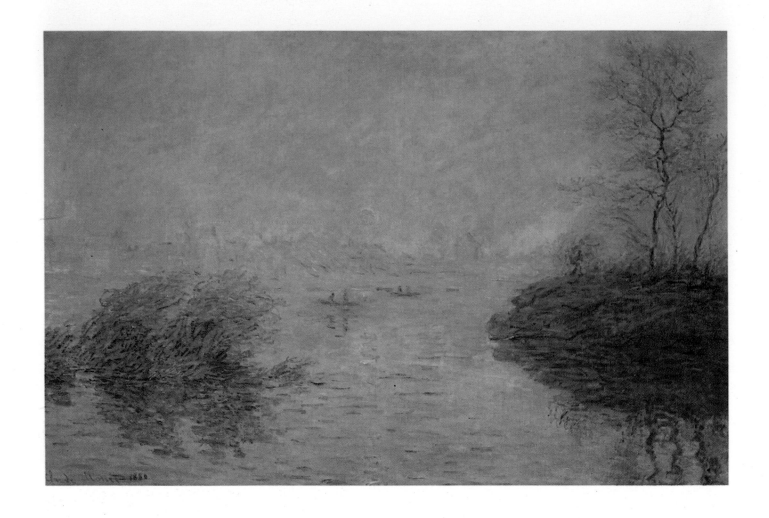

Soleil couchant sur la Seine, effet d'hiver

1880 - oil on canvas - 100 x 152
Musée du Petit Palais, Paris

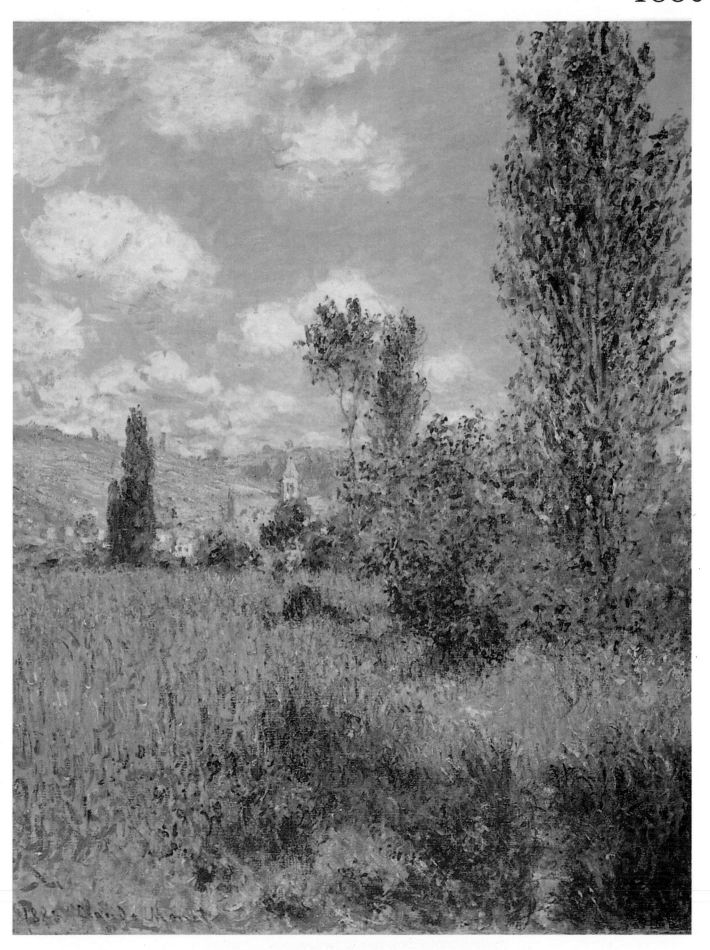

Sentier dans les coquelicots, île Saint-Martin

1880 - oil on canvas - 80 x 60
Metropolitan Museum of Art, New York

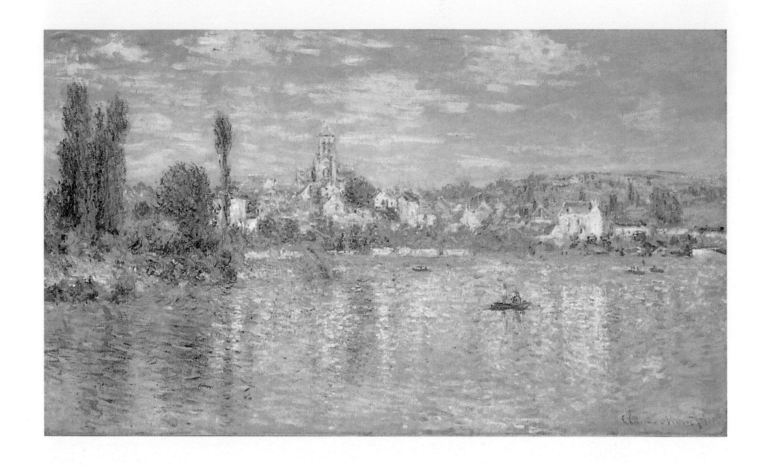

Vétheuil en été

1880 - oil on canvas - 60 x 100
Metropolitan Museum of Art, New York

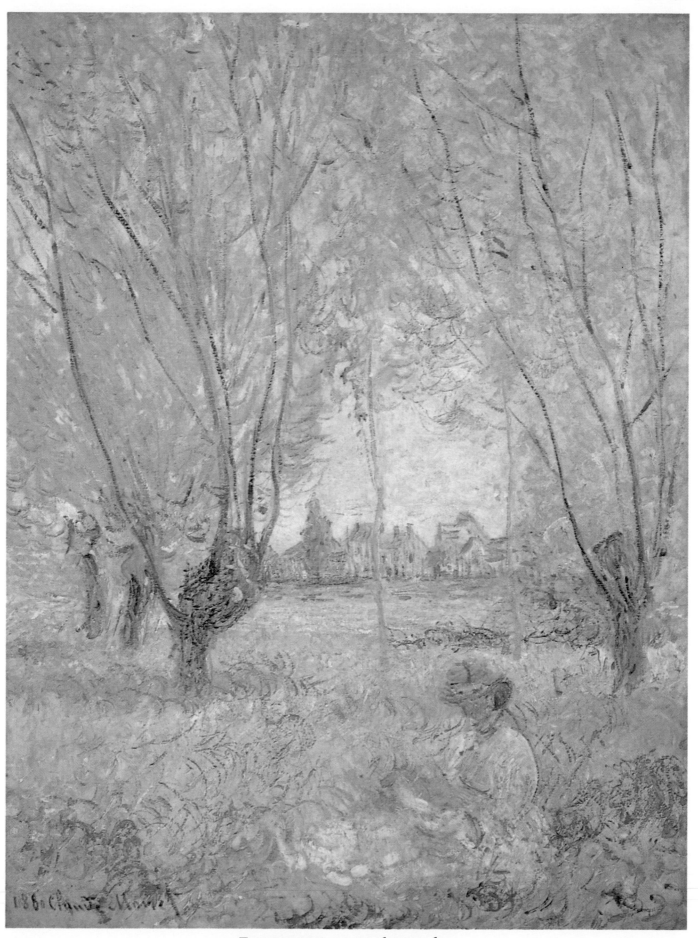

Femme assise sous les saules
1880 - oil on canvas - 81 x 60
National Gallery of Art,
Chester Dale collection, Washington, D.C.

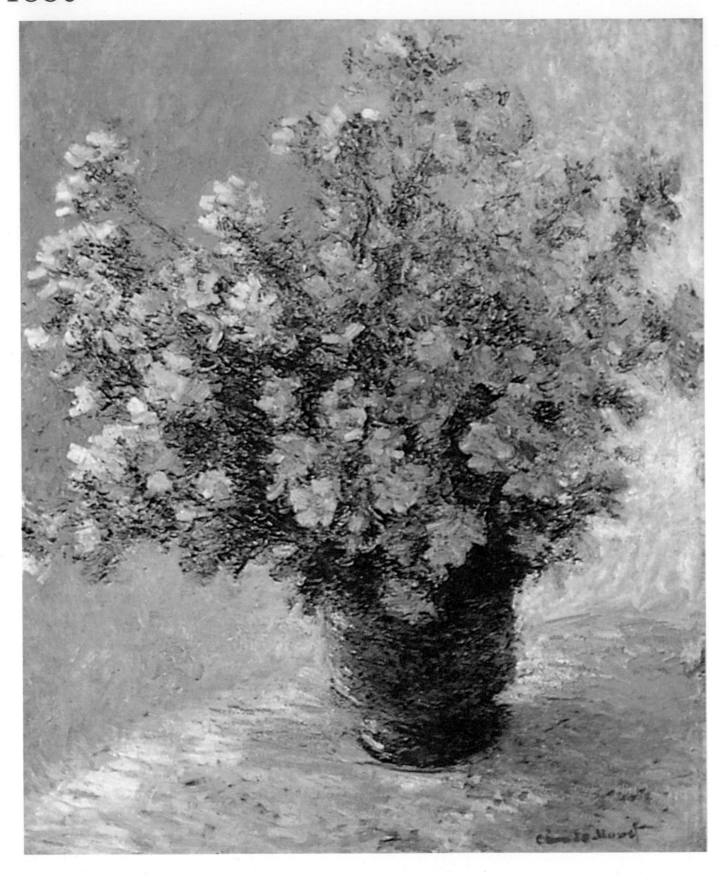

Bouquets de mauves

1880 - oil on canvas - 100 x 81
Private collection

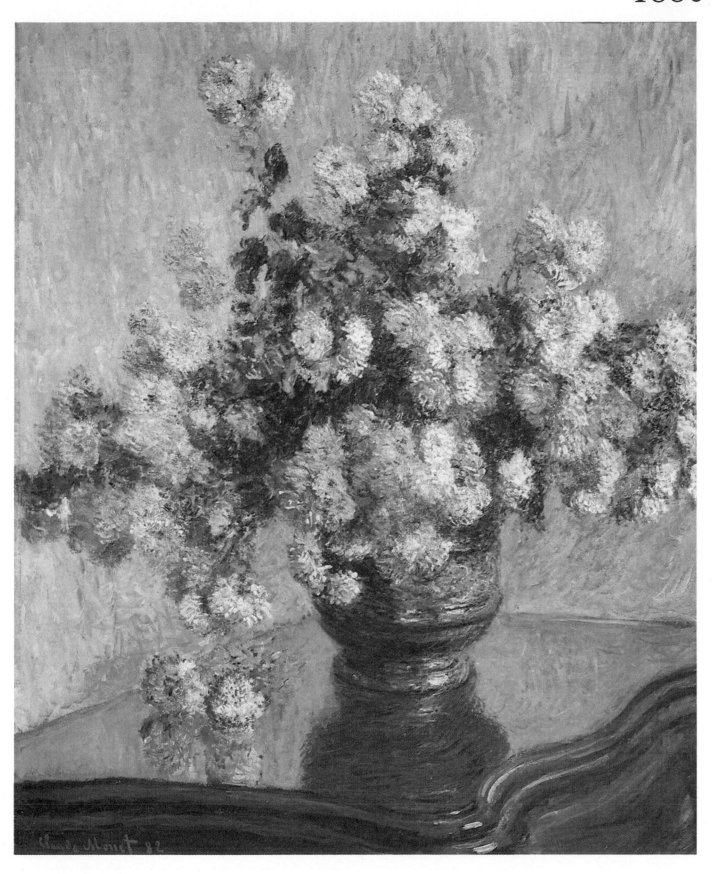

Chrysanthèmes

1882 - oil on canvas - 100 x 81
Metropolitan Museum of Art, New York

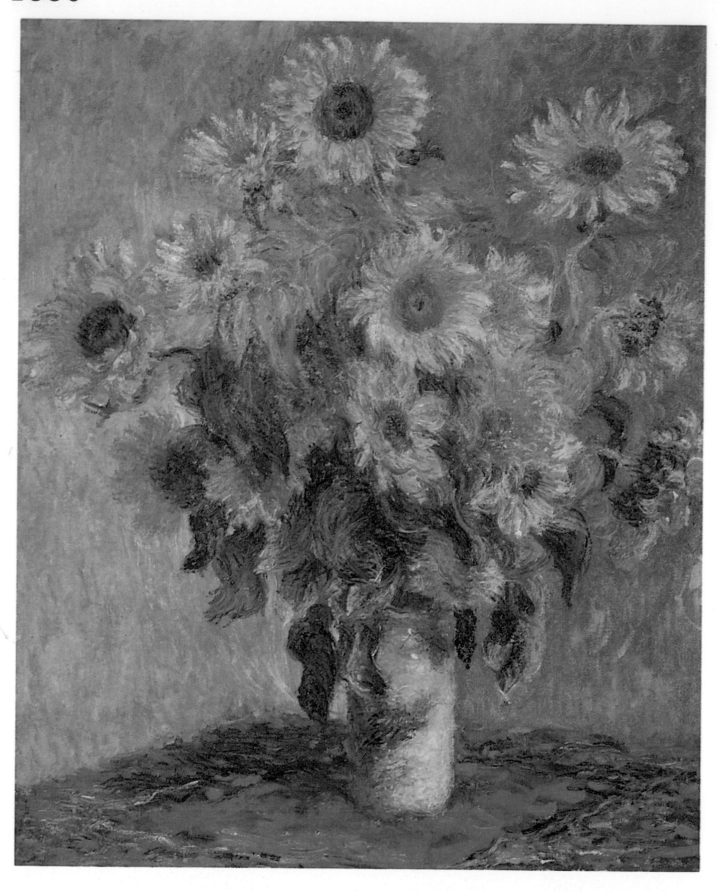

Bouquet de soleils

1880 - oil on canvas - 101 x 81.5
Metropolitan Museum of Art,
H.O. Havemeyer collection, New York

Fleurs de topinambours

1880 - oil on canvas - 100 x 73
National Gallery of Art,
Chester Dale collection, Washington, D.C.

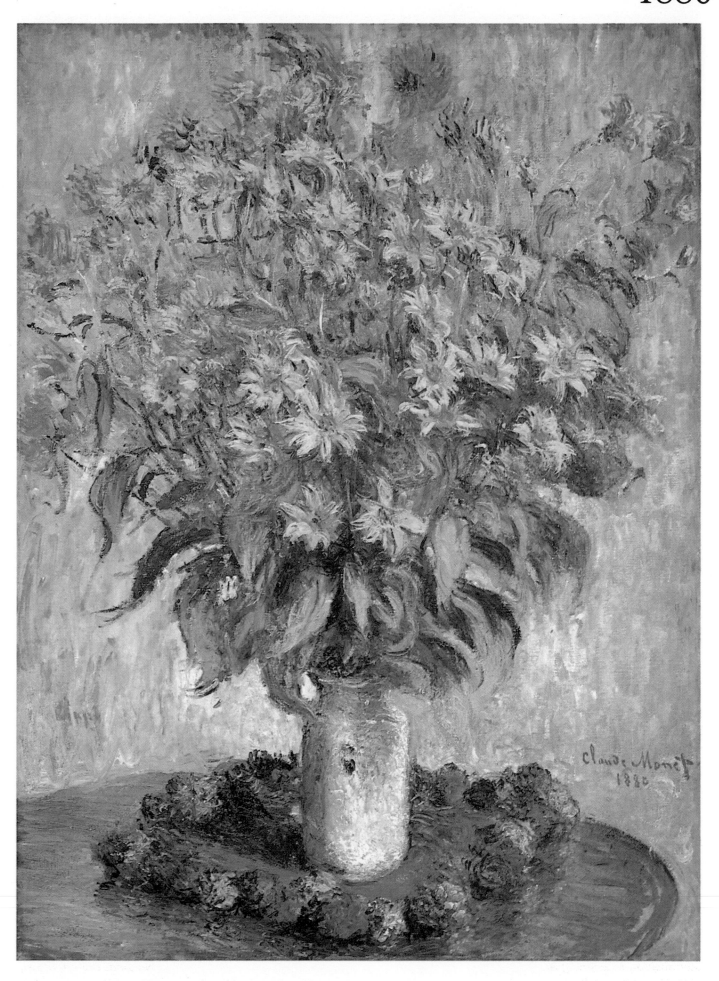

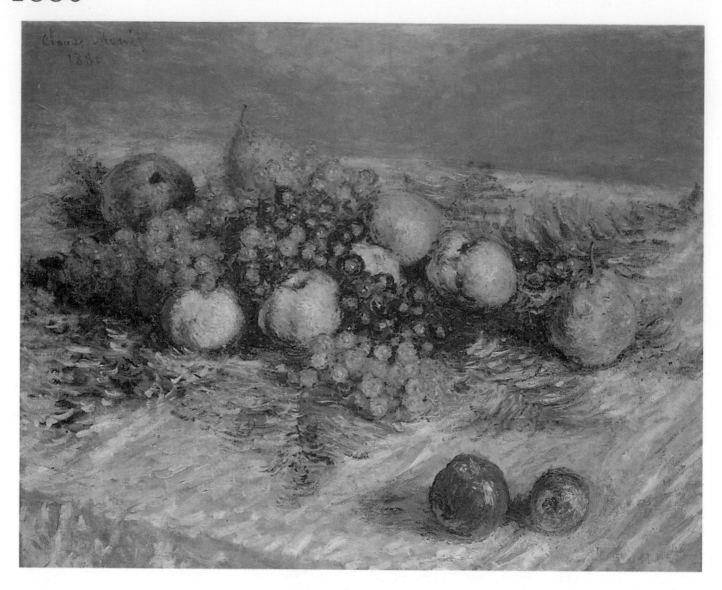

Poires et Raisin

1880 - oil on canvas - 65 x 81
Hamburger Kunsthalle, Hamburg

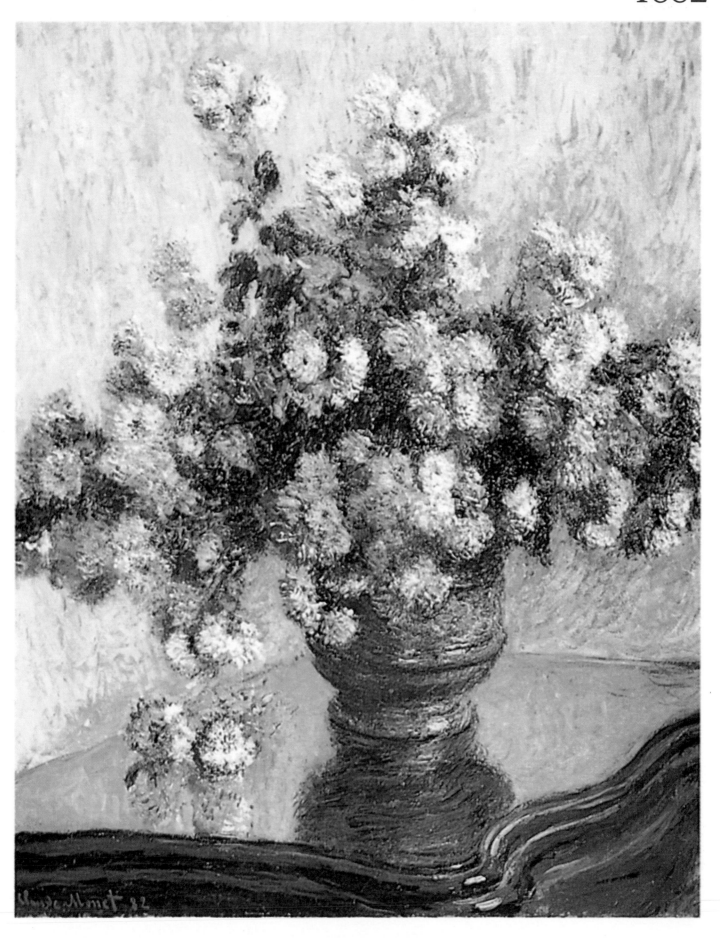

Chrysanthèmes

1882 - oil on canvas - 100 x 81
Metropolitan Museum of Art, New York

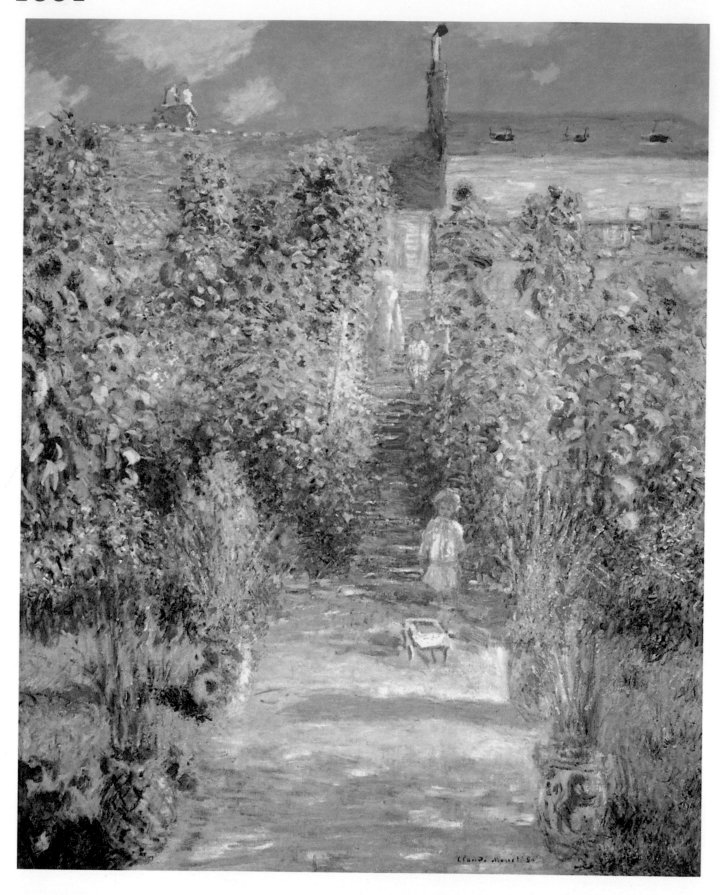

Le Jardin de Monet à Vétheuil

1881 - oil on canvas - 150 x 120
National Gallery of Art,
Alisa Mellon Bruce collection, Washington, D. C.

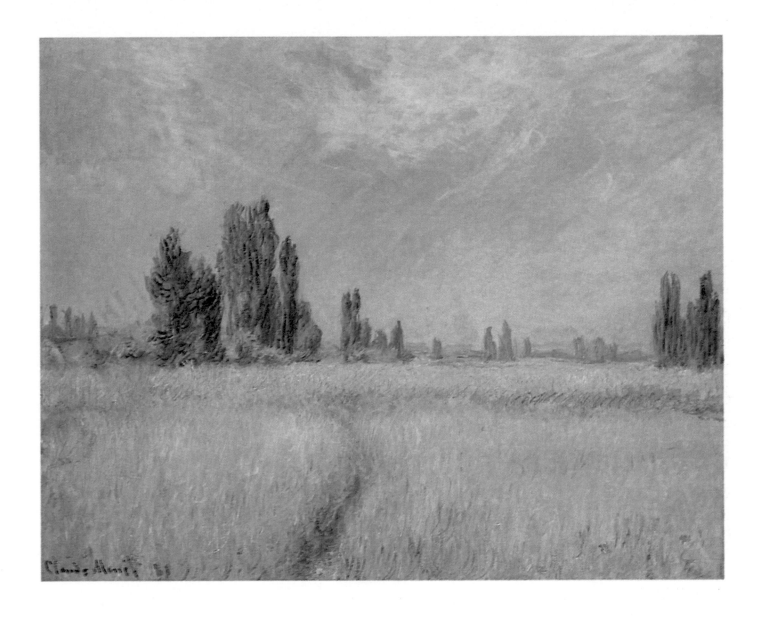

Champ de blé

1881 - oil on canvas - 65 x 81
Cleveland Museum of Art, Cleveland

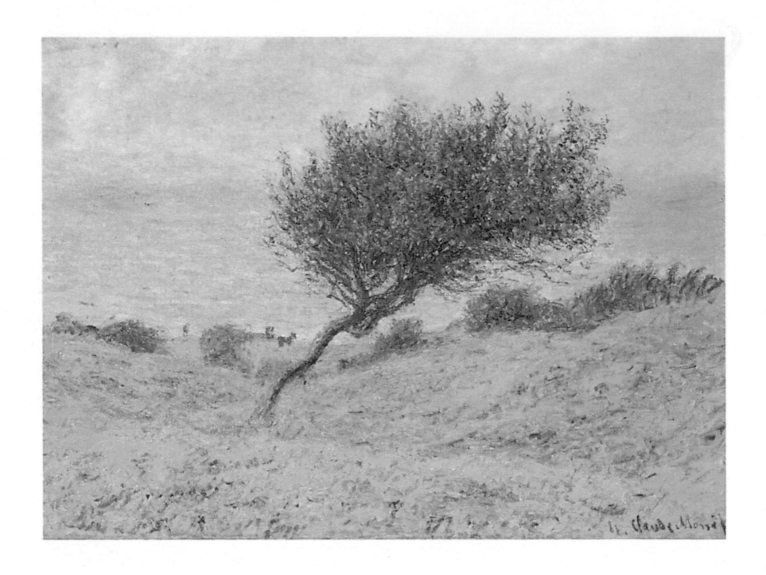

Sur la côte à Trouville

1881 - oil on canvas - 60 x 81
Museum of Fine Arts,
John Pickering Lyman collection, Boston

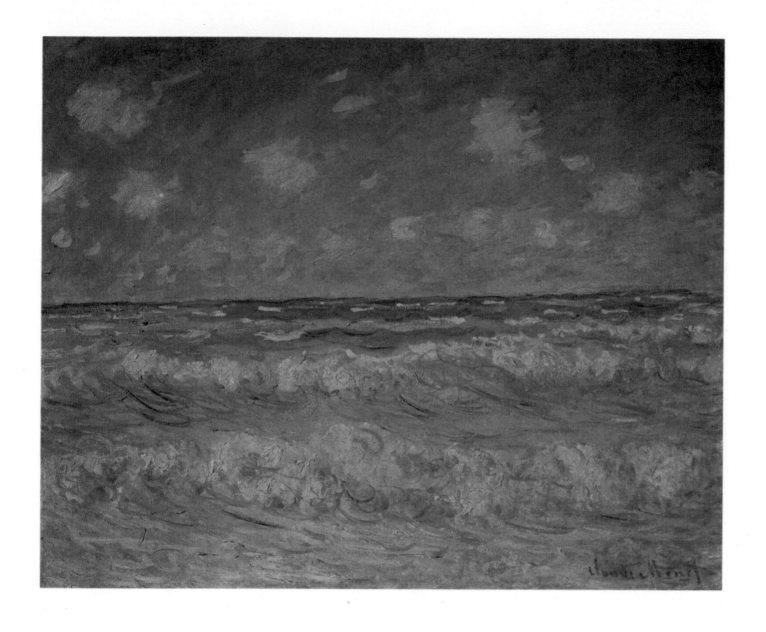

Mer agitée

1881 - oil on canvas - 60 x 74
National Gallery of Canada, Ottawa

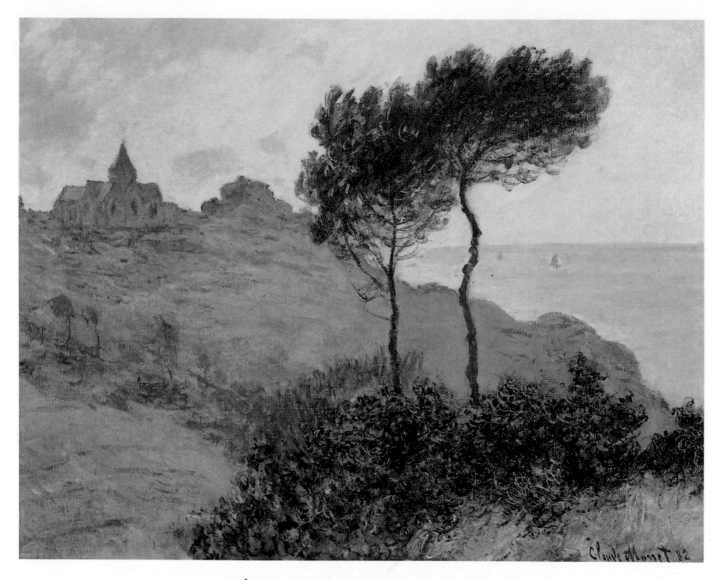

Église de Varengeville, temps gris

1882 - oil on canvas - 65 x 81
J.B. Speed Art Museum, Louisville, Kentucky

Cabane de douanier

1882 - oil on canvas - 60 x 81
Philadelphia Museum of Art,
William L. Elkins collection, Philadelphia

La Maison du pêcheur, à Varengeville

1882 - oil on canvas - 60 x 78
Museum Boymans-Van Beuningen, Rotterdam

Promenade sur la falaise, Pourville

1882 - oil on canvas - 65 x 81
The Art Institute of Chicago, Chicago

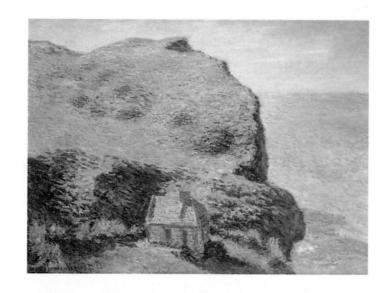

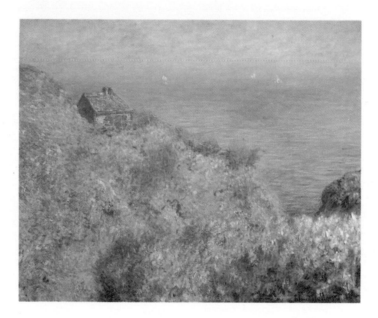

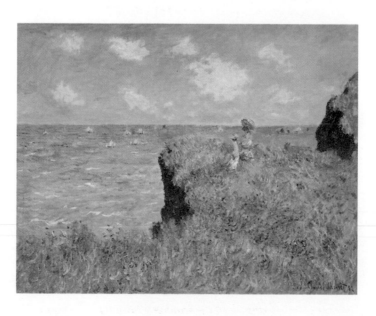

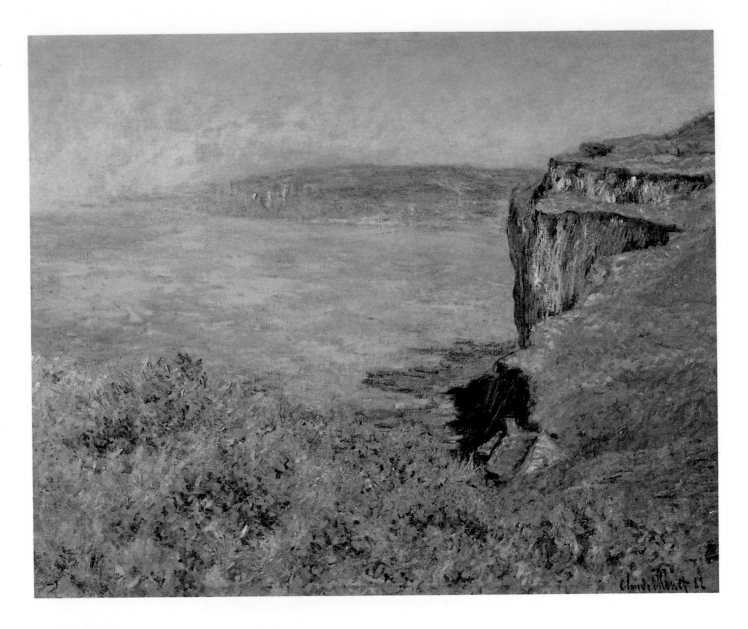

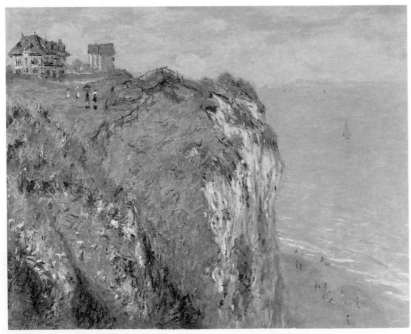

Falaise à Varengeville

1882 - oil on canvas - 65 x 81
Private collection

La Falaise à Dieppe

1882 - oil on canvas - 65 x 81
Kunsthaus Zurich, Zurich

Les Rochers à marée basse, Pourville

1882 - oil on canvas - 63 x 77
Memorial Art Gallery of the University of Rochester,
Rochester, New York

Le Printemps

1880 - oil on canvas - 60 x 81
Musée des Beaux-Arts, Lyon

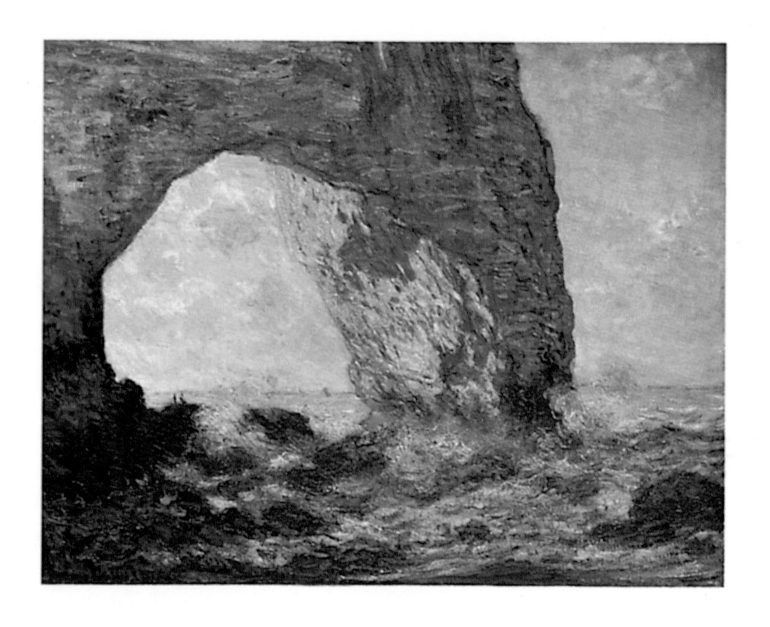

La Manneporte

1883 - oil on canvas - 65 x 81
Metropolitan Museum of Art, New York

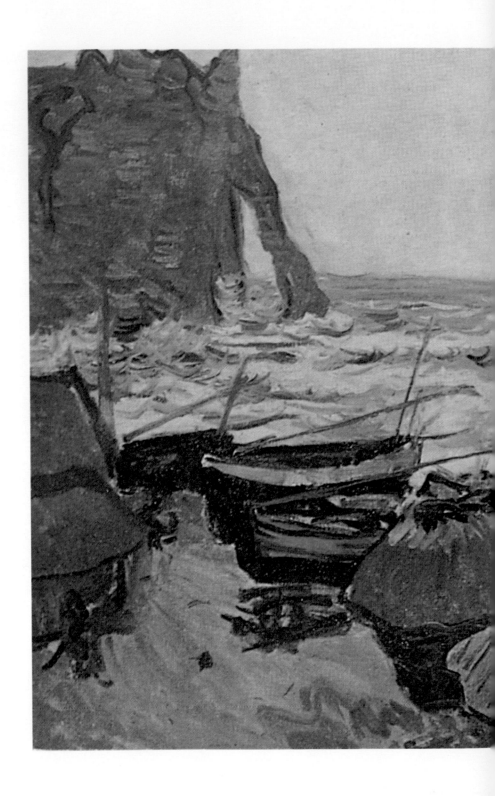

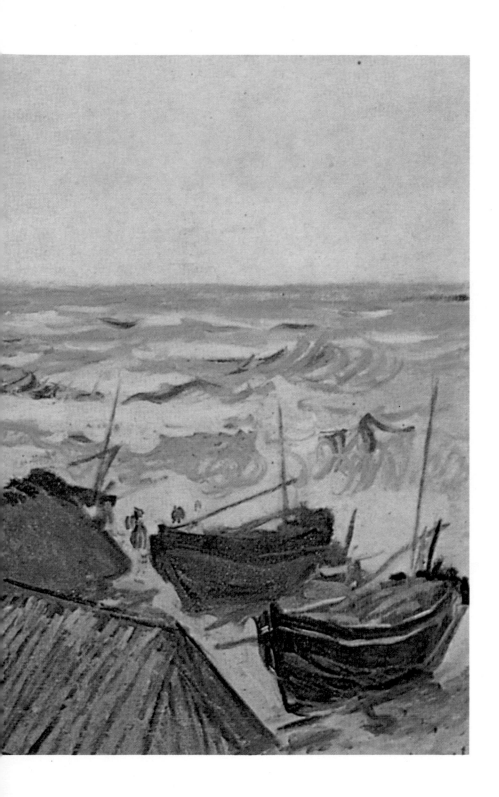

Bateaux de pêche et porte d'Aval

1883 - oil on canvas - 73 x 100
Wallraf-Richartz-Museum, Cologne

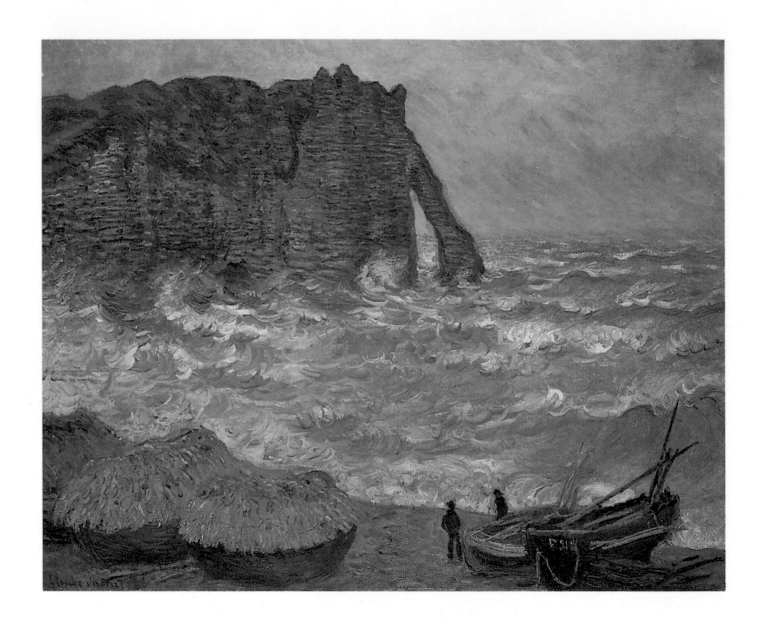

Étretat, mer agitée

1883 - oil on canvas - 81 x 100
Musée des Beaux-Arts, Lyon

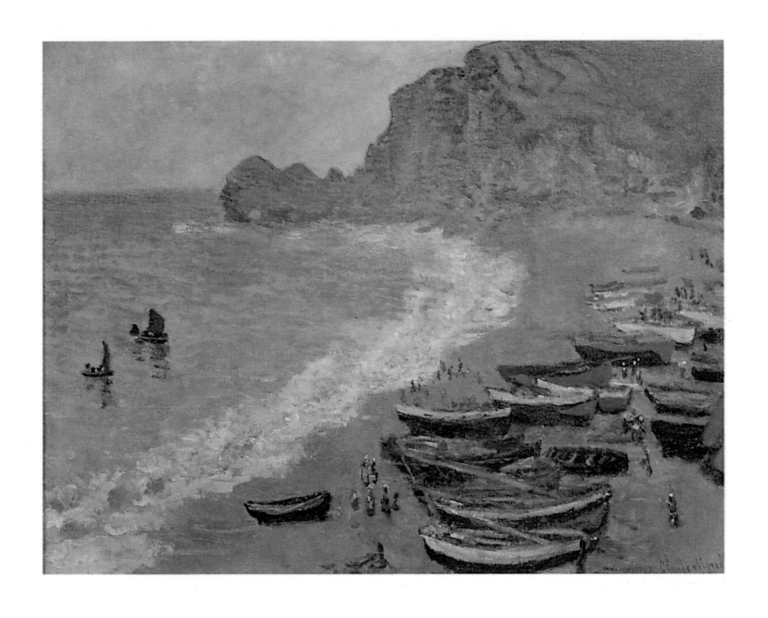

Plage d'Étretat

1883 · oil on canvas · 65 x 81
Musée d'Orsay, Paris

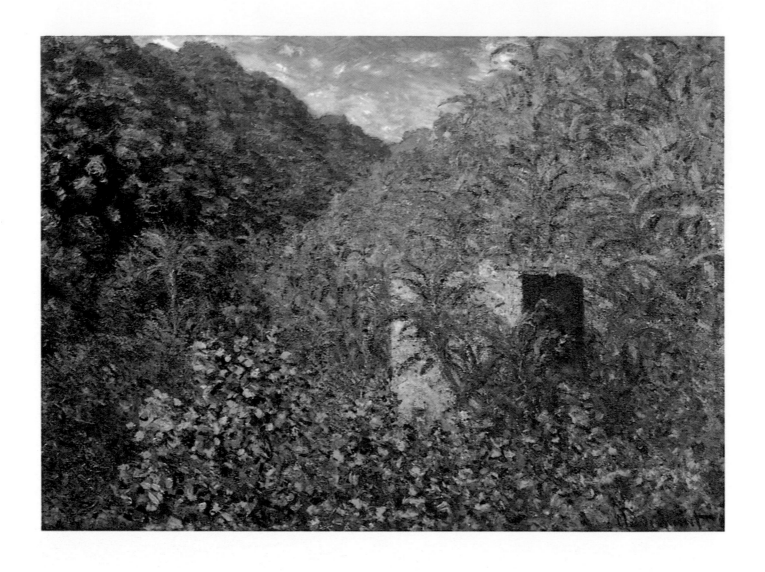

La Vallée de Sasso, effet bleu

1884 - oil on canvas - 65 x 92
Private colection

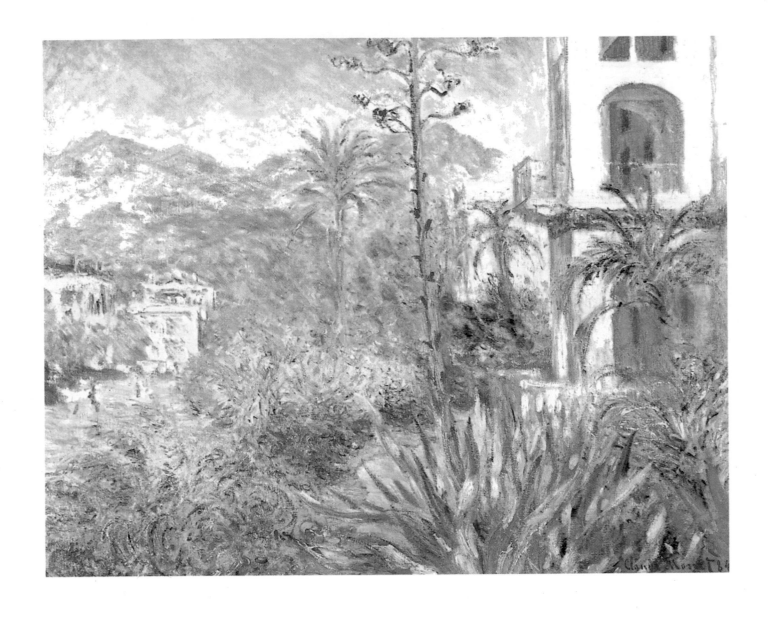

Villas à Bordighera

1884 - oil on canvas - 73 x 92
Santa Barbara Museum of Art, Santa Barbara, California

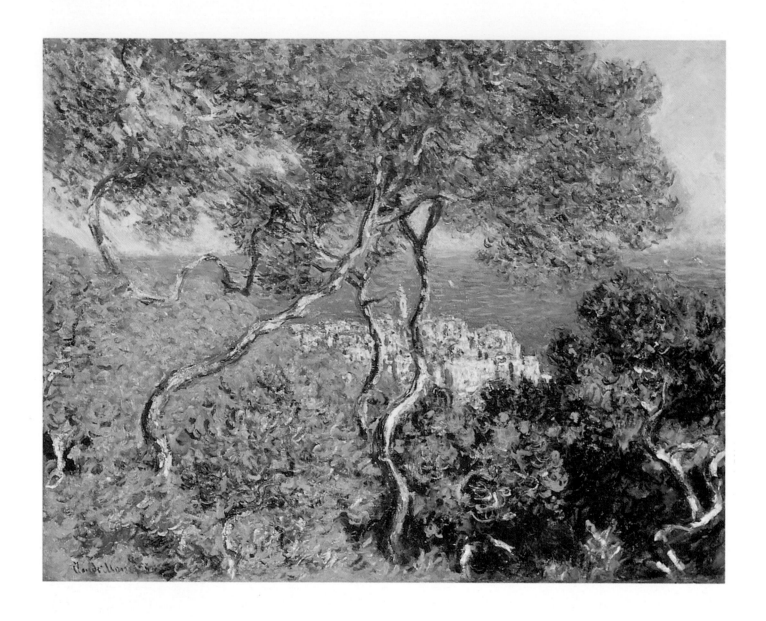

Bordighera

1884 - oil on canvas - 65 x 81
Art Institute of Chicago,
Potter Palmer collection, Chicago

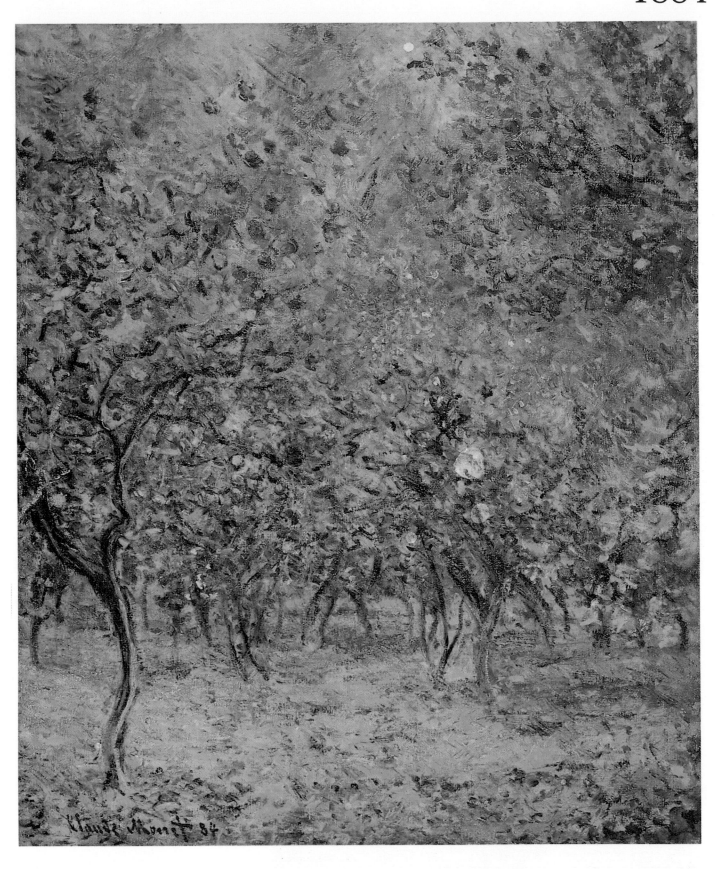

Sous les citronniers

1884 - oil on canvas - 73 x 60
Ny Carlsberg Glyptotek, Copenhagen

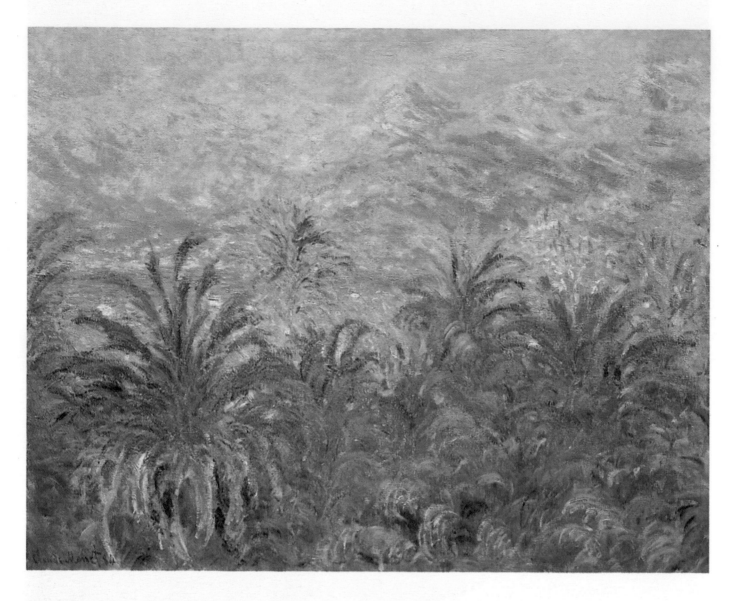

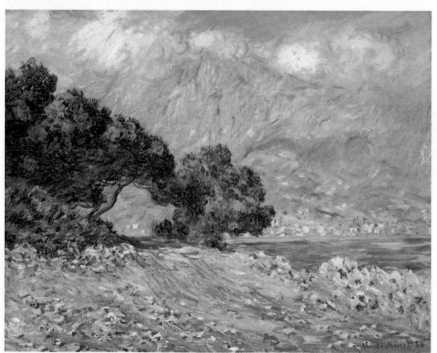

Palmiers à Bordighera

1884 - oil on canvas - 65 x 81
Metropolitan Museum of Art, New York

Menton vu du Cap Martin

1884 - oil on canvas - 68 x 84
Museum of Fine Arts,
Juliana Cherny Edwards collection, Boston

Le Château de Dolceacqua

1884 - oil on canvas - 92 x 73
Musée Marmottan, Paris

Champ de coquelicots, environs de Giverny

1885 - oil on canvas - 65 x 81
Museum of Fine Arts,
Juliana Cherny Edwards collection, Boston

Bateaux sur la plage à Étretat

1885 - oil on canvas - 65.5 x 81.3
Art Institute of Chicago,
Charles H. and Mary F. S. Worcester collection, Chicago

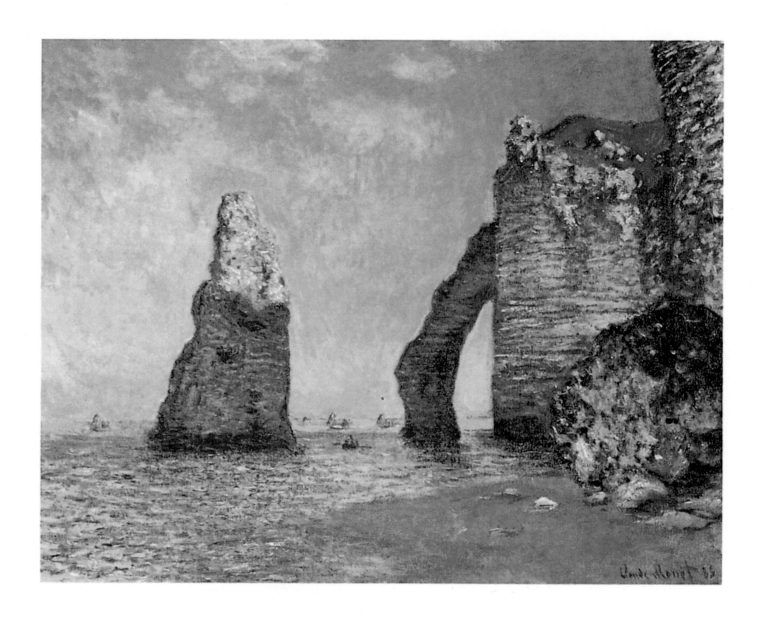

L'Aiguille et la Falaise d'Aval

1885 · oil on canvas · 65 x 81
Sterling and Francine Clark Art Institute,
Williamstown, Massachussetts

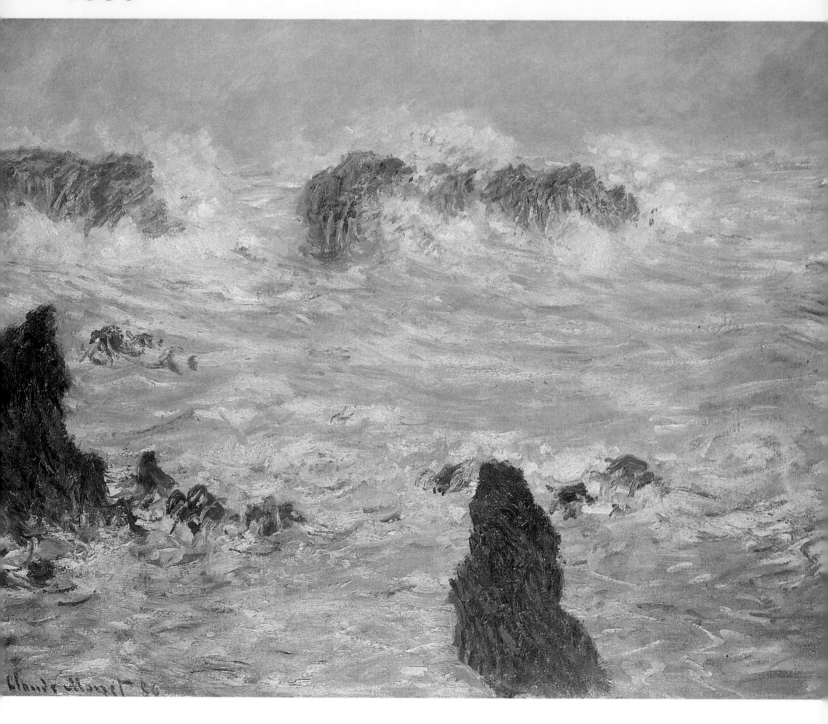

Tempête, côtes de Belle-Ile

1886 - oil on canvas - 65 x 81
Musée d'Orsay, Paris

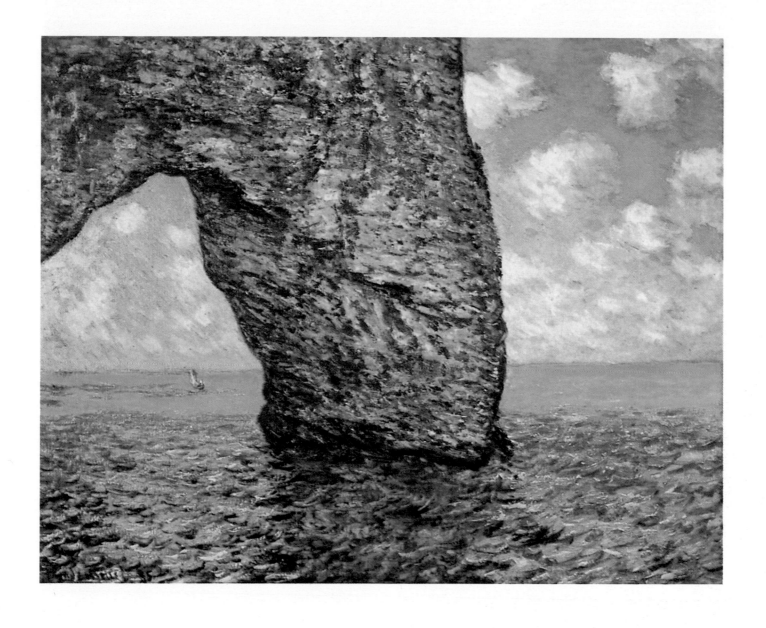

La Manneporte, marée haute

1885-86 - oil on canvas - 65 x 81
Private collection

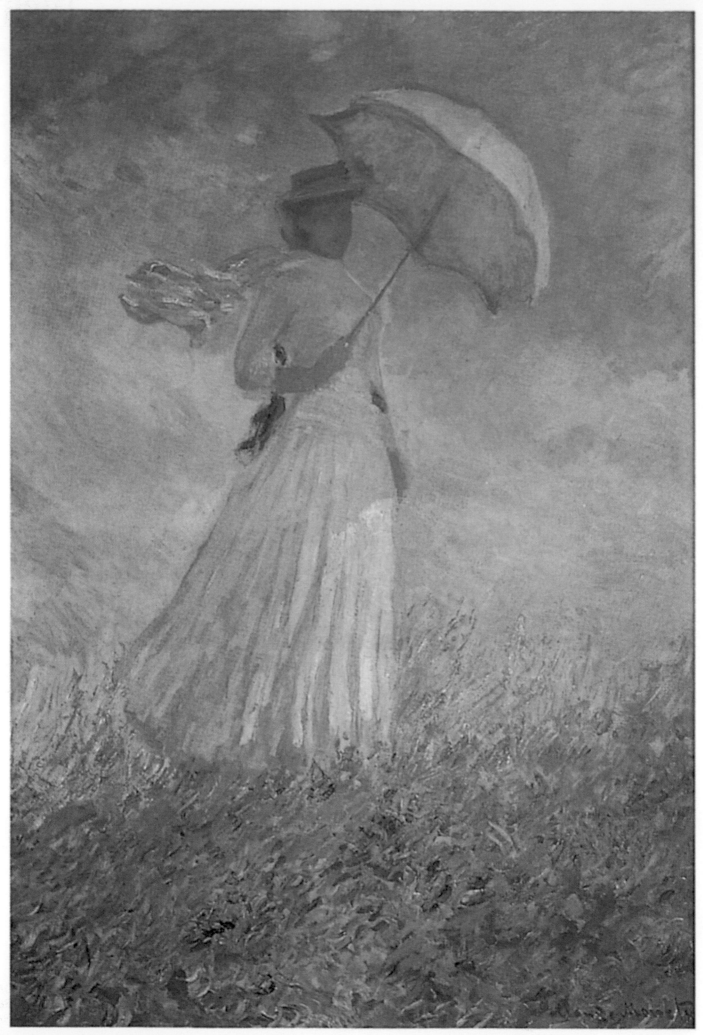

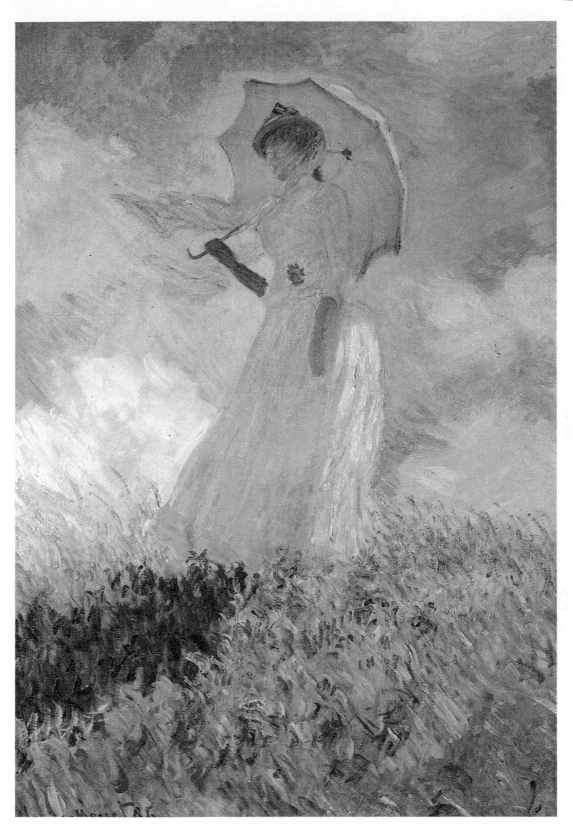

Essai de figure en plein air
1886 - oil on canvas - 131 x 88
Musée d'Orsay, Paris

Essai de figure en plein air
1886 - oil on canvas - 131 x 88
Musée d'Orsay, Paris

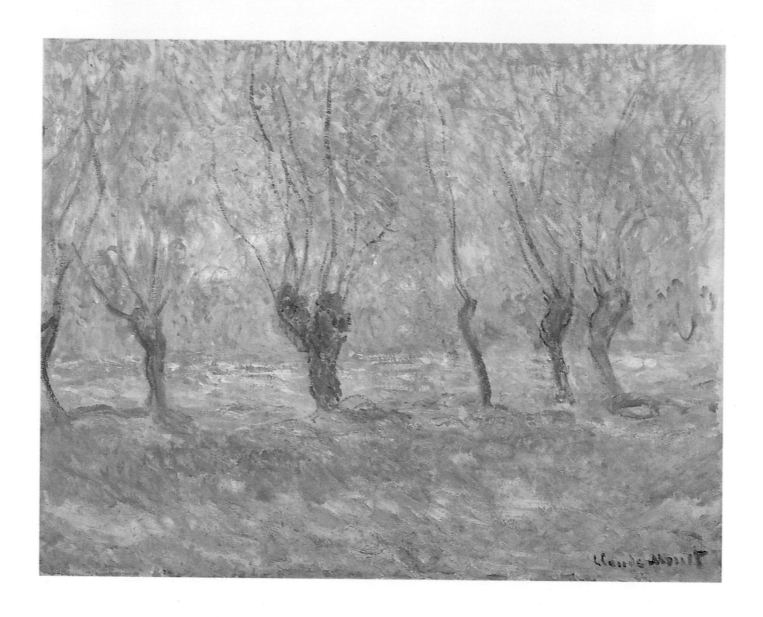

Les Saules, Giverny

1886 - oil on canvas - 74 x 93
Göteborgs Konstmuseum, Göteborg

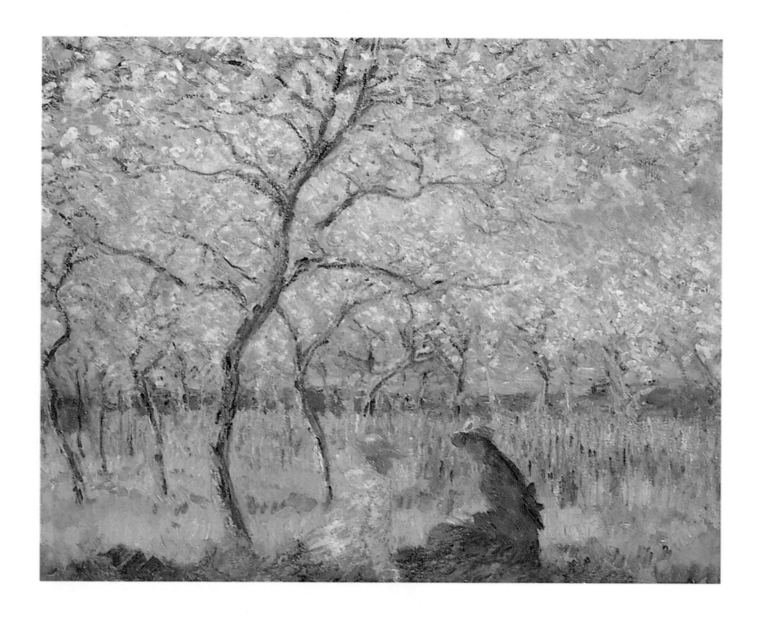

Le Printemps

1886 - oil on canvas - 65 x 81
Fitzwilliam Museum, Cambridge, Great Britain

La Meule de foin

1886 - oil on canvas - 61 x 81
State Heritage Museum, St. Petersburg

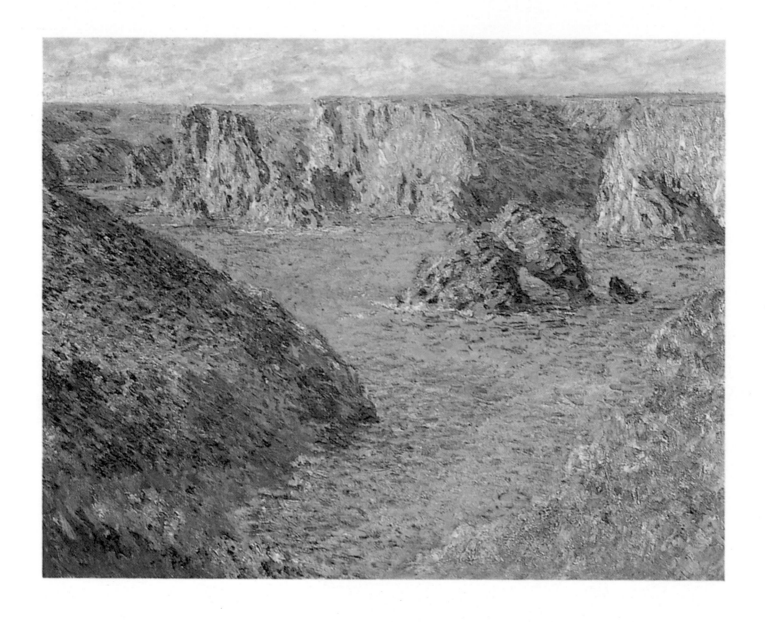

Port-Domois

1886 - oil on canvas - 65 x 81
Musée Saint-Denis, Rheims

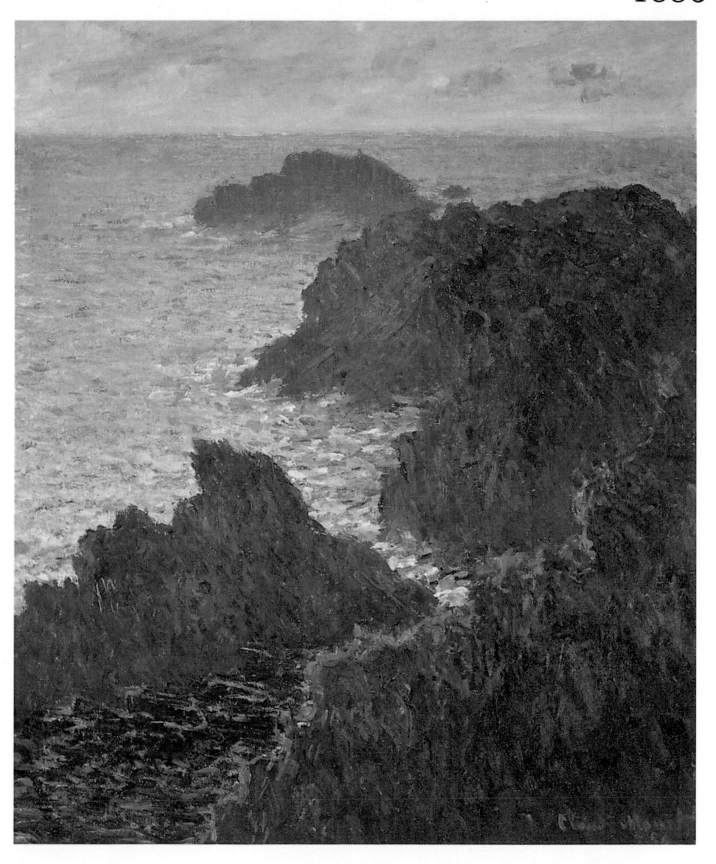

Rochers à Belle-Ile, Port-Domois

1886 - oil on canvas - 73 x 60
Musée d'Orsay, Paris

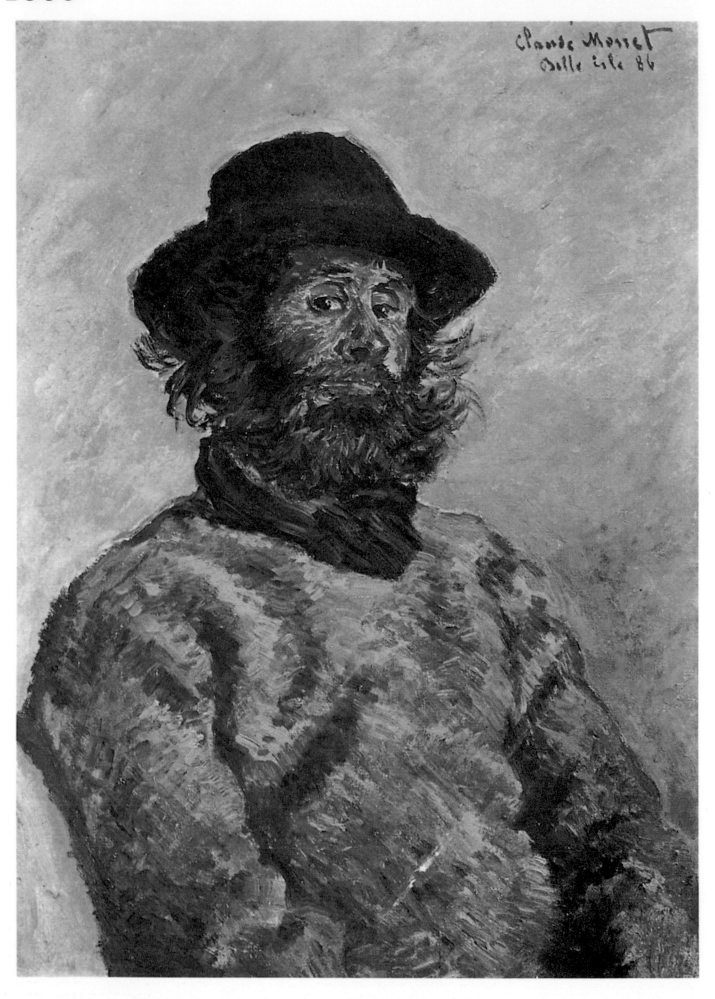

Portrait de Poly

1886 - oil on canvas - 74 x 53
Musée Marmottan, Paris

La Barque

1887 - oil on canvas - 146 x 133
Musée Marmottan, Paris

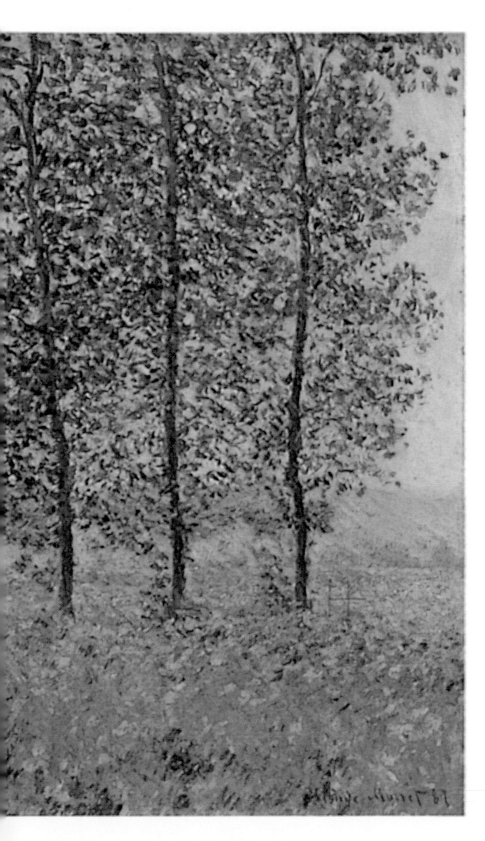

Sous les peupliers, effet de soleil

1887 - oil on canvas - 74 x 93
Staatsgalerie Stuttgart, Stuttgart

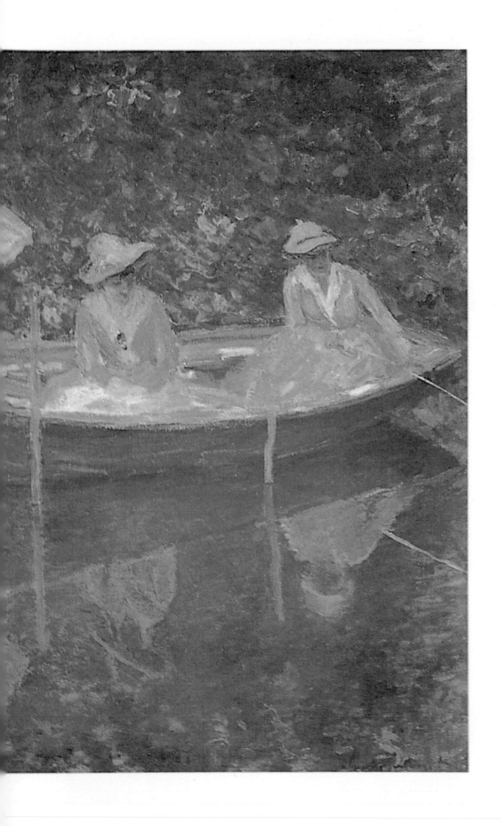

En norvégienne

1887 - oil on canvas - 98 x 131
Musée d'Orsay, Paris

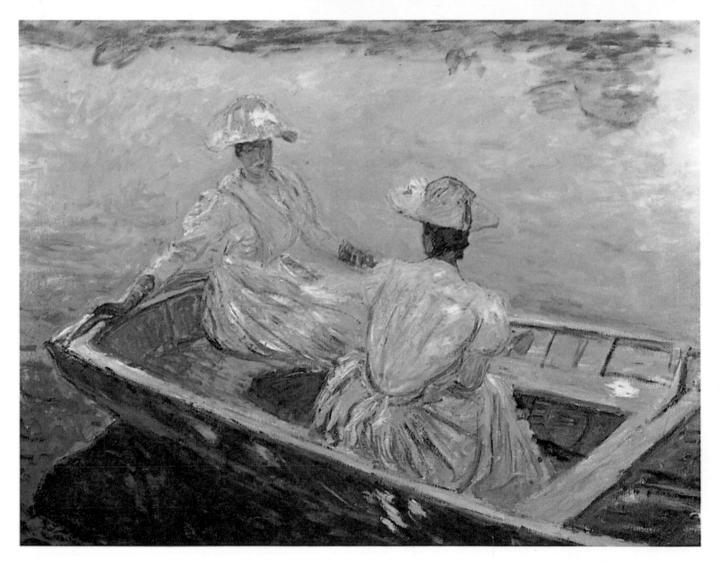

Champs d'iris jaunes à Giverny

1887 - oil on canvas - 45 x 100
Musée Marmottan, Paris

La Barque bleue

1887 - oil on canvas - 109 x 129
Collection Thyssen-Bornemisza, Lugano

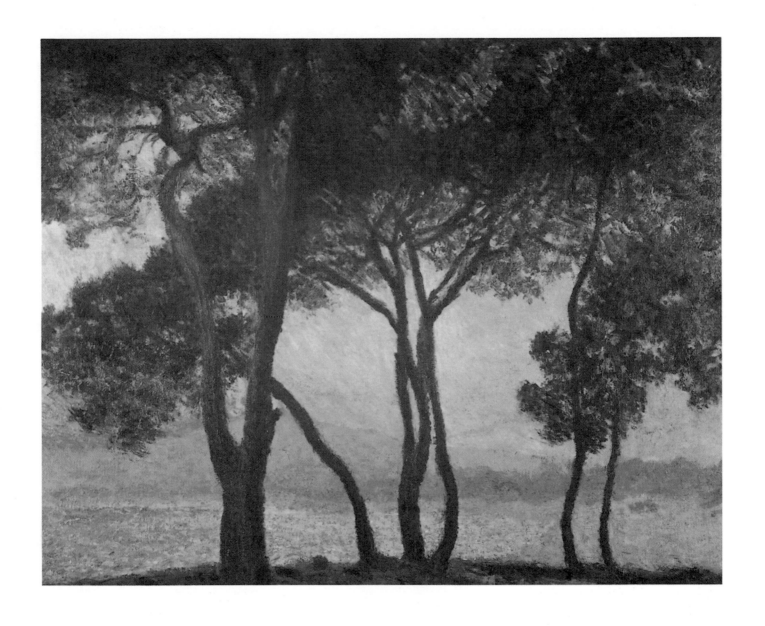

Juan-les-Pins

1888 - oil on canvas - 73 x 92
Private collection

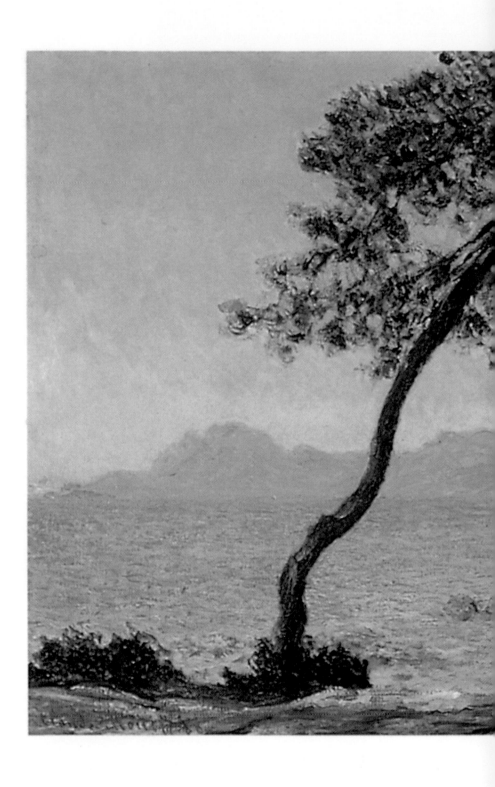

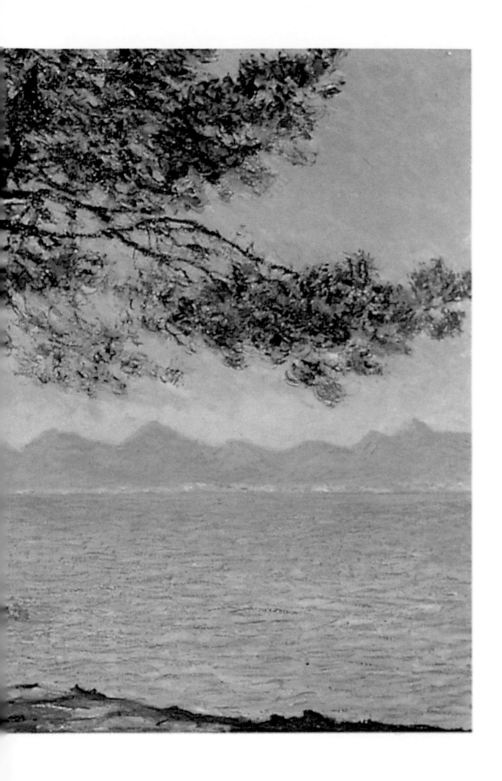

Montagnes de l'Estérel

1888 · oil on canvas · 65 x 92
Institute Gallery, University of London, London

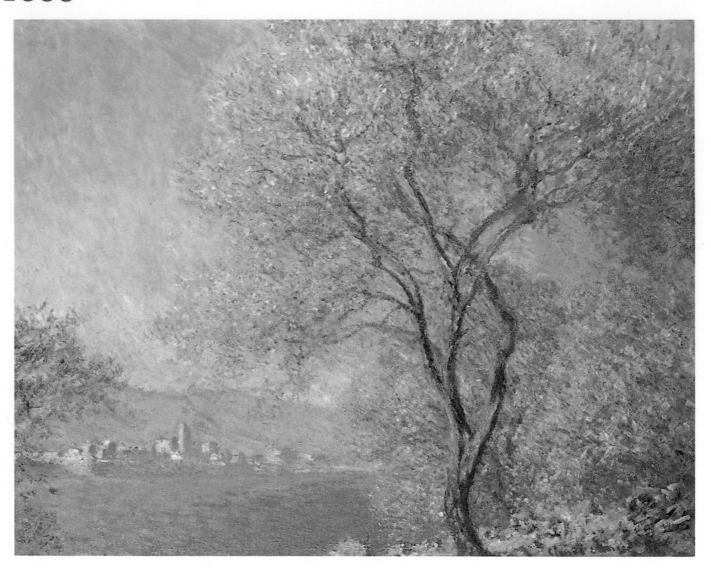

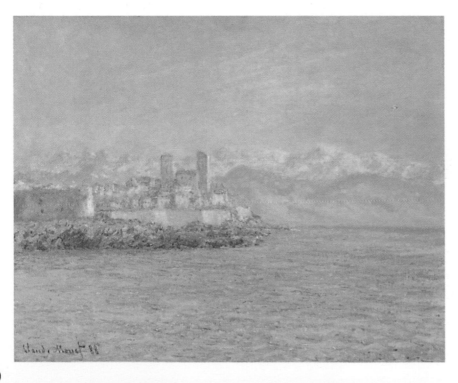

Antibes vue de la Salis

1888 - oil on canvas - 73 x 92
Toledo Museum of Art, Toledo, U.S.A.

Antibes, effet d'après-midi

1888 - oil on canvas - 65 x 81
Museum of Fine Arts, Boston

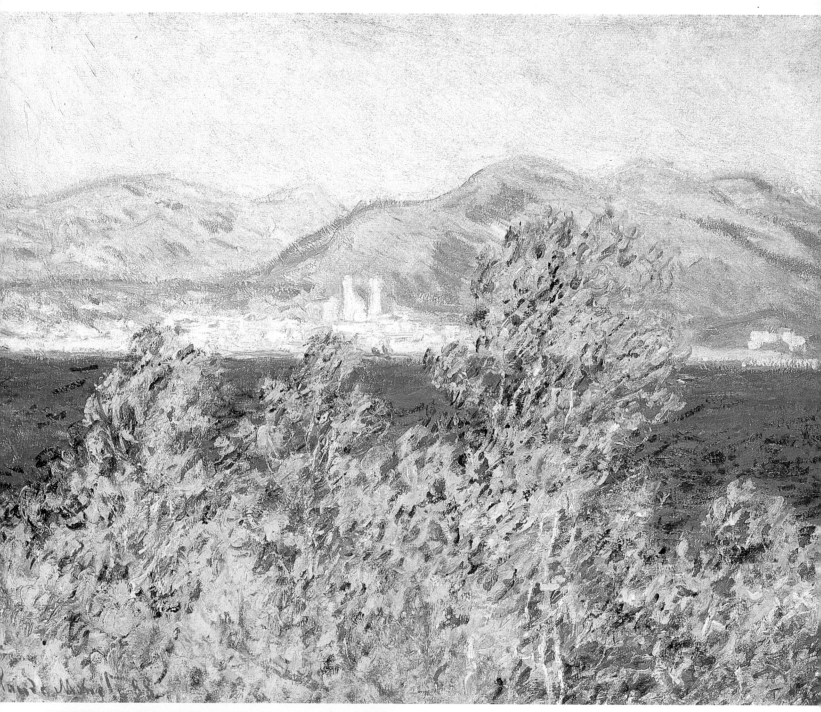

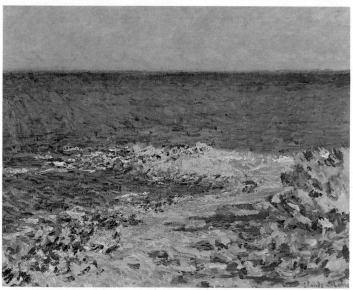

Antibes, vue du Cap, vent de Mistral

1888 - oil on canvas - 65 x 81
Private collection

La Méditerranée

1888 - oil on canvas - 60 x 73
Private collection

La Maison du jardinier

1884 - oil on canvas - 60 x 73
Private collection

Le Soir dans la prairie, Giverny

1888 - oil on canvas - 82 x 81
Private collection

Creuse, soleil couchant

1889 - oil on canvas - 73 x 70
Musée d'Unterlinden, Colmar

Vallée de la Creuse, soleil d'après-midi

1889 - oil on canvas - 73 x 92
Private collection

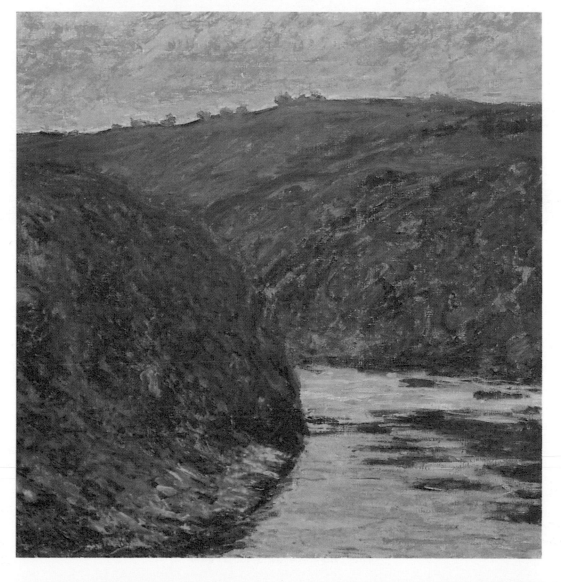

256

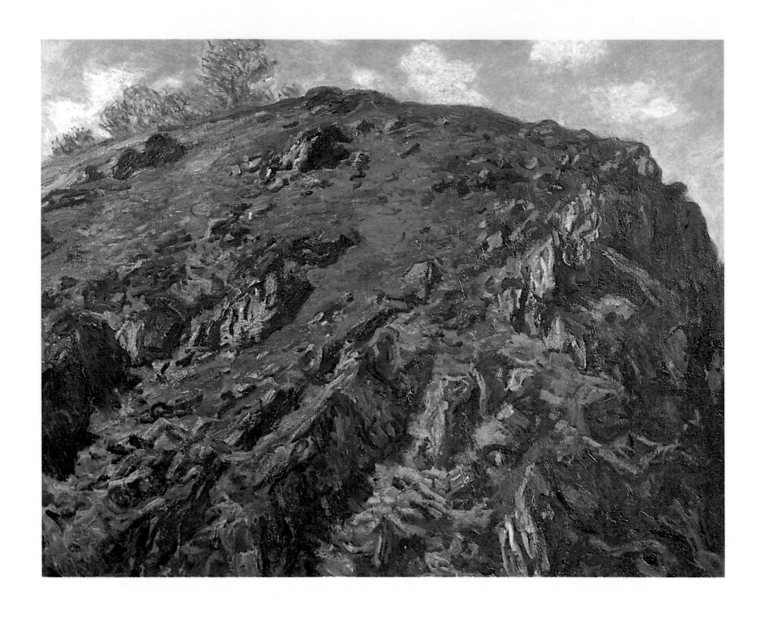

Le Bloc

1889 - oil on canvas - 73 x 91
British Royal Collections, London

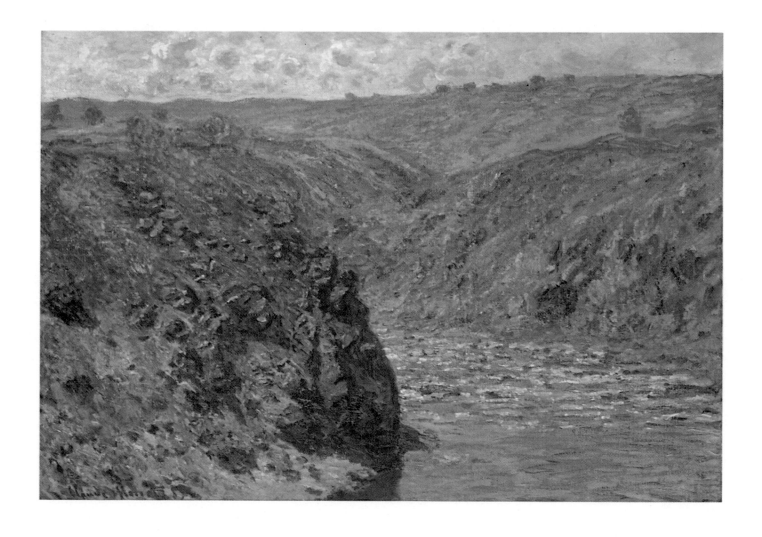

Les Eaux semblantes, Creuse, effet de soleil

1889 - oil on canvas - 65 x 92
Museum of Fine Arts,
Juliana Cherny Edwards collection, Boston

258

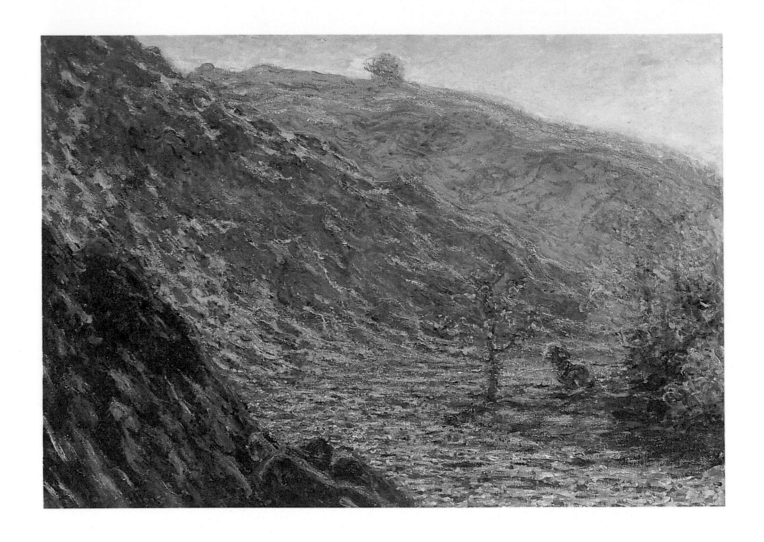

Le Viel arbre au confluent

1889 - oil on canvas - 65 x 92
The Art Institute of Chicago, Chicago

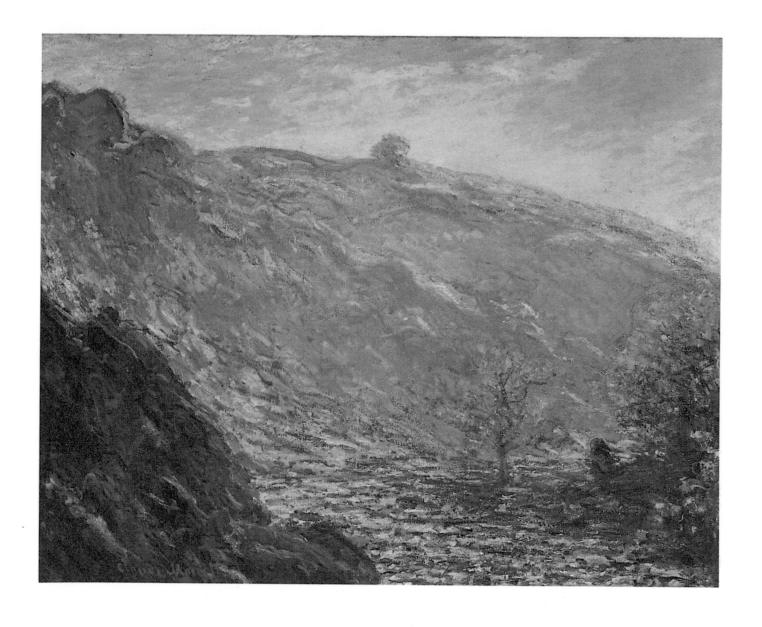

Soleil sur la petite Creuse

1889 - oil on canvas - 73 x 92
Private collection

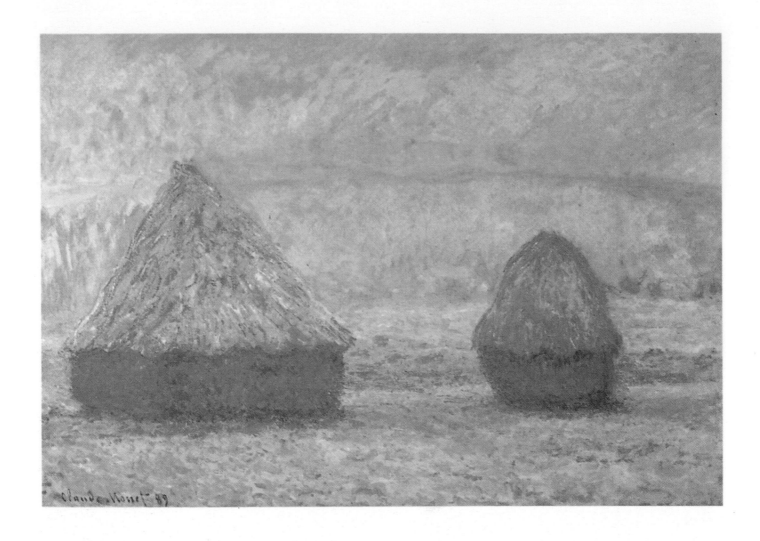

Les Meules, Giverny, effet du matin

1889 - oil on canvas - 65 x 92
Private collection

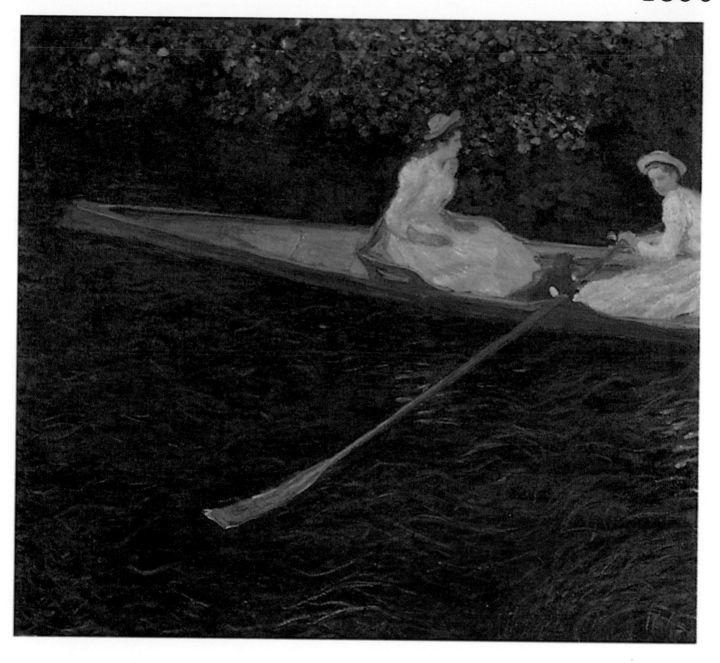

En canot sur l'Epte

1890 - oil on canvas - 133 x 145
Museu de Arte de Sao Paulo, Sao Paulo

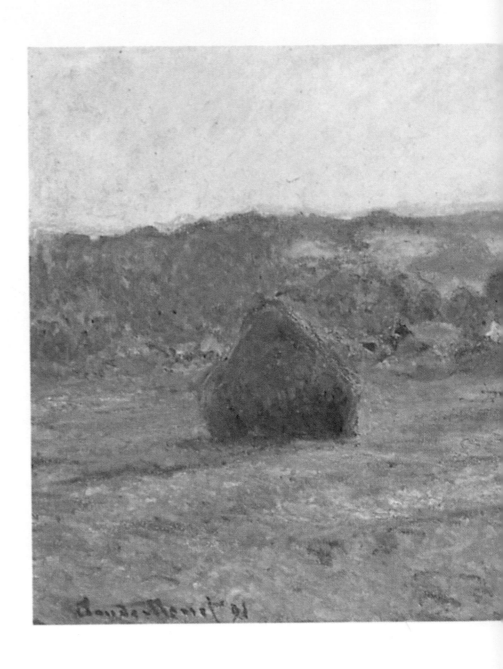

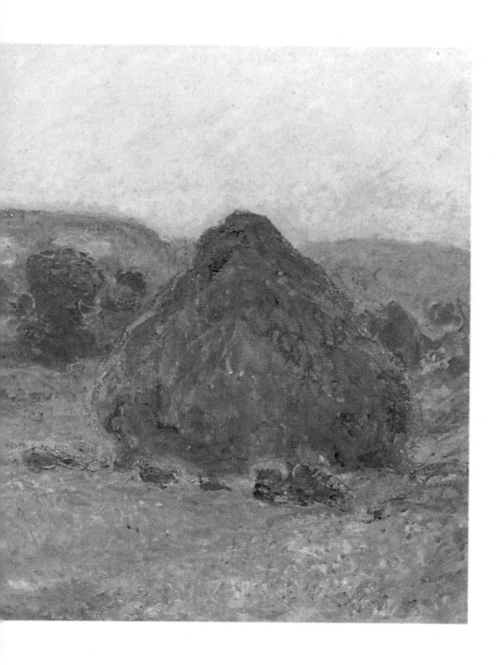

Meules, fin de l'été, effet du soir

1890-91 - oil on canvas - 60 x 100
The Art Institute of Chicago, Chicago

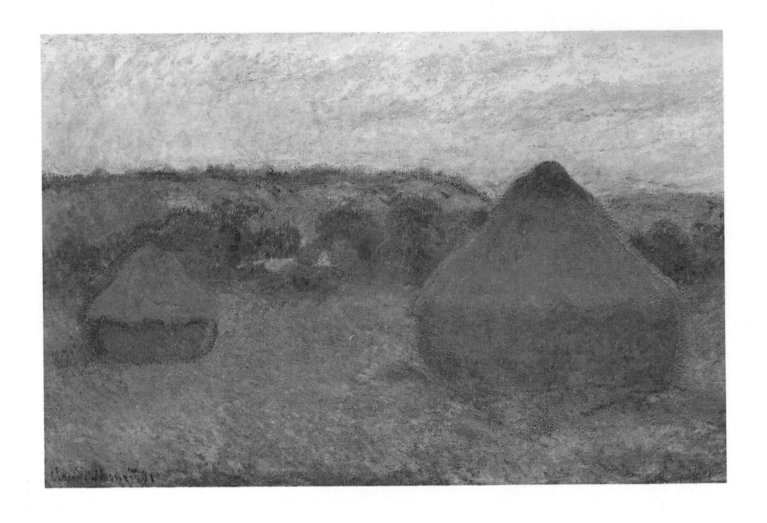

Deux meules, déclin du jour, automne

1890-91 - oil on canvas - 65 x 100
The Art Institute of Chicago, Chicago

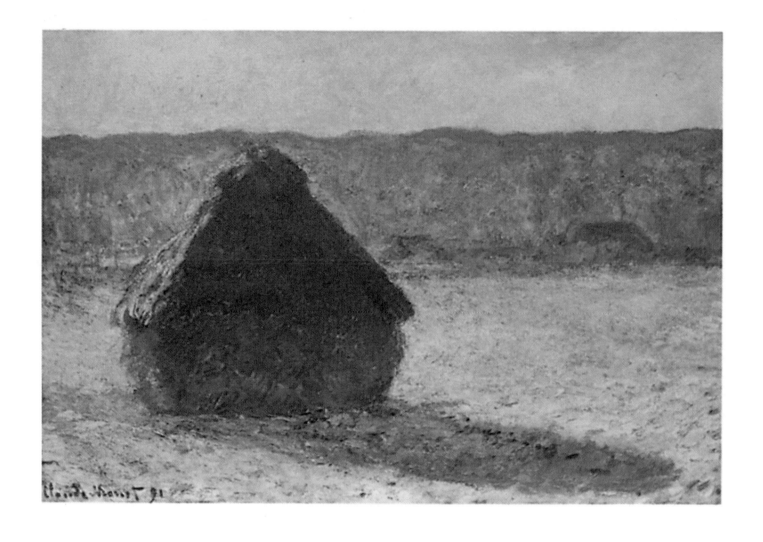

Meule, effet de neige, le matin

1890-91 - oil on canvas - 65 x 92
Museum of Fine Arts, Boston

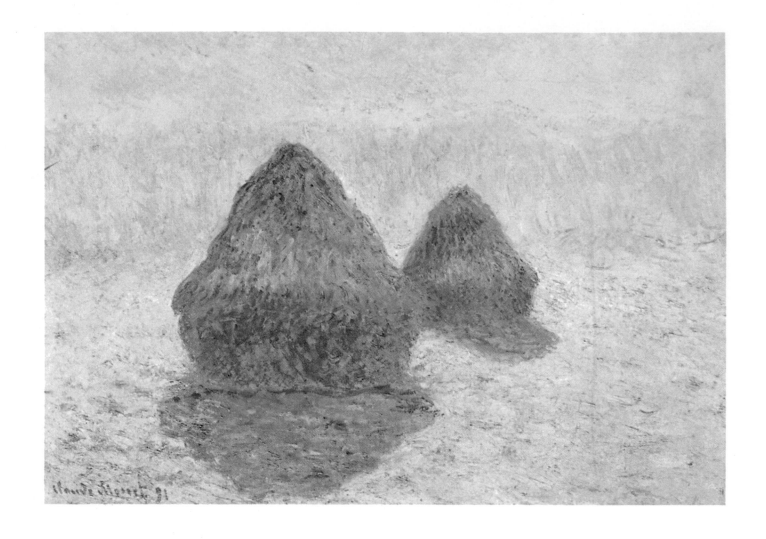

Meules, effet d'hiver

1890-91 - oil on canvas - 65 x 92
Metropolitan Museum of Art, New York

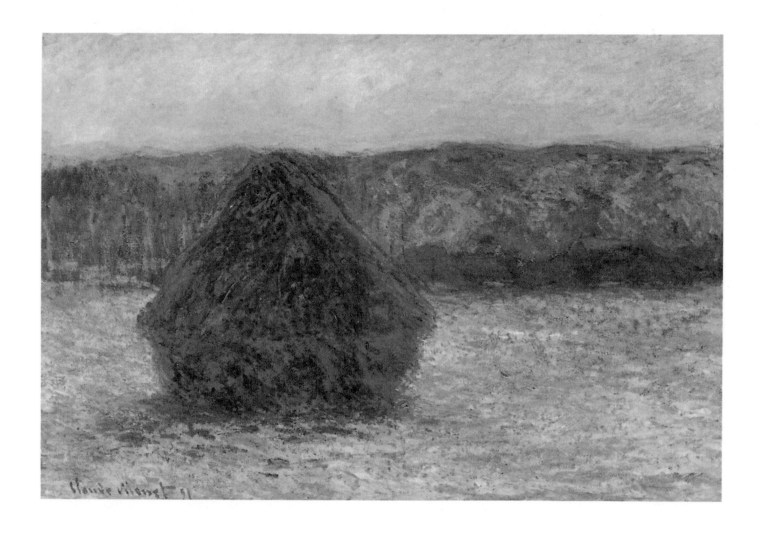

Meule, dégel, soleil couchant

1890-91 - oil on canvas - 65 x 92
The Art Institute of Chicago, Chicago

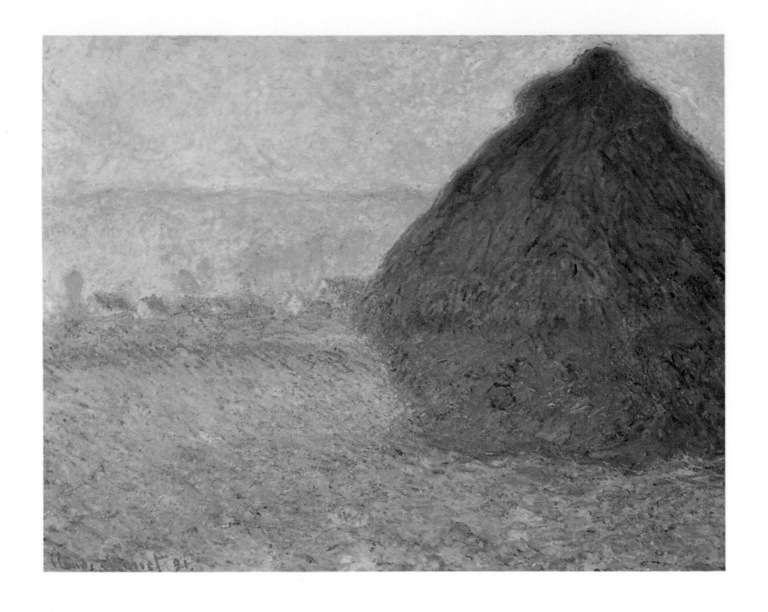

Meule, soleil couchant

1890-91 - oil on canvas - 73 x 92
Museum of Fine Arts, Boston

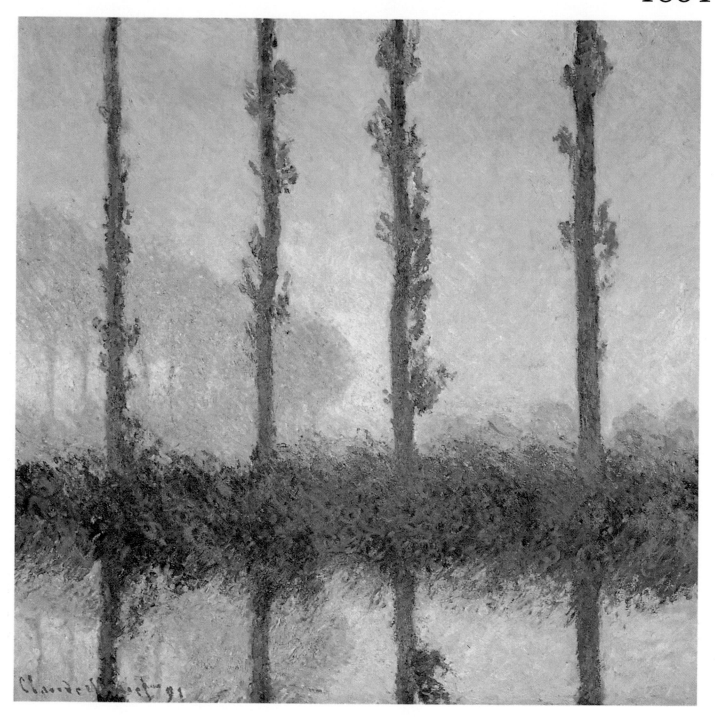

Les Quatre arbres

1891 - oil on canvas - 82 x 82
Metropolitan Museum of Art, New York

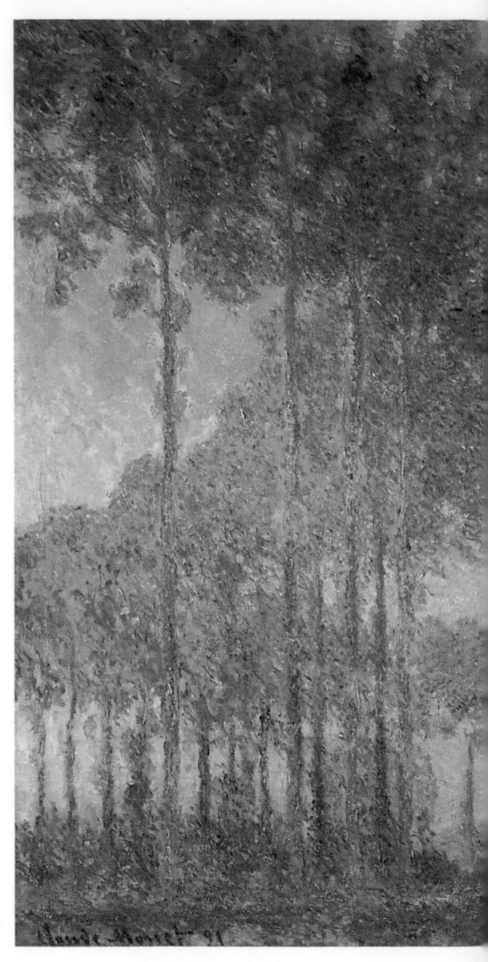

**Peupliers au bord de l'Epte,
vue du marais**
1891 - oil on canvas - 88 x 93
Private collection, U.S.A.

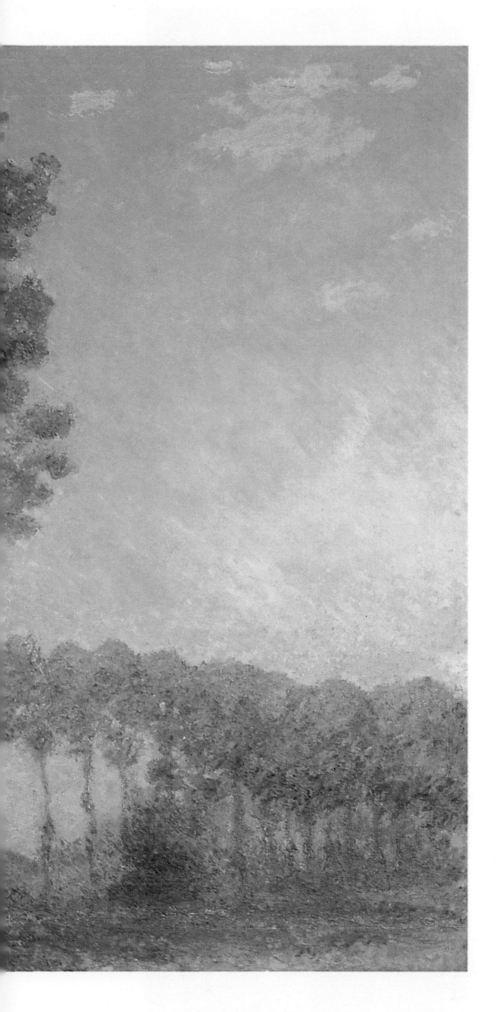

Following pages:

Peupliers, coucher de soleil

1891 - oil on canvas - 102 x 62
Private collection, U.S.A.

Les Peupliers,
trois arbres roses, automne

1891 - oil on canvas - 92 x 73
Philadelphia Museum of Art, Philadelphia

Les Peupliers, effet blanc et jaune

1891 - oil on canvas - 100 x 65
Philadelphia Museum of Art, Philadelphia

Les Trois arbres, été

1891 - oil on canvas - 92 x 73
National Museum of Western Art, Tokyo

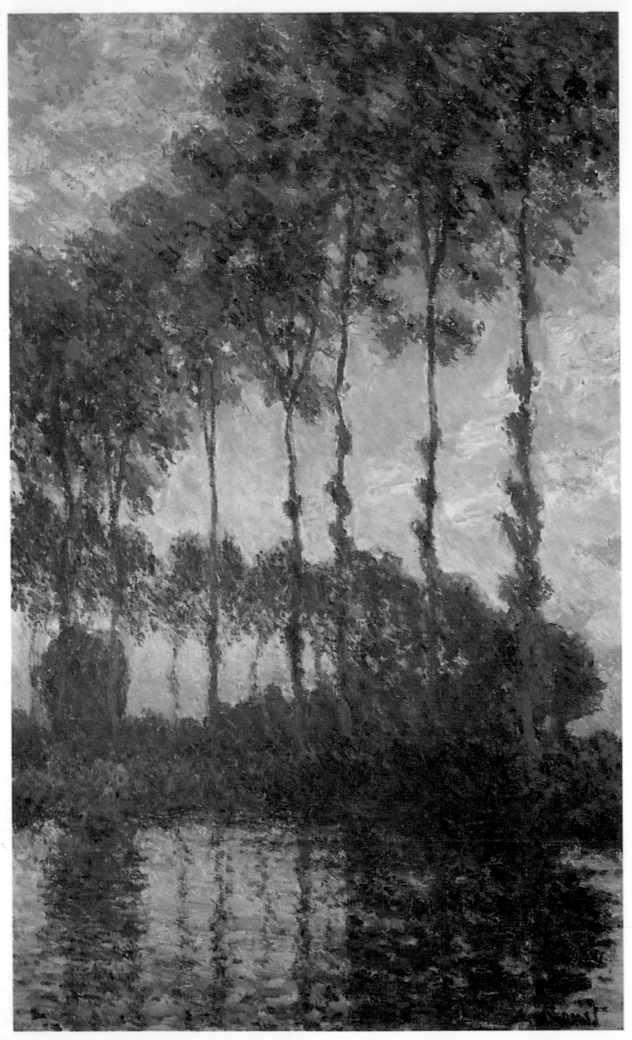

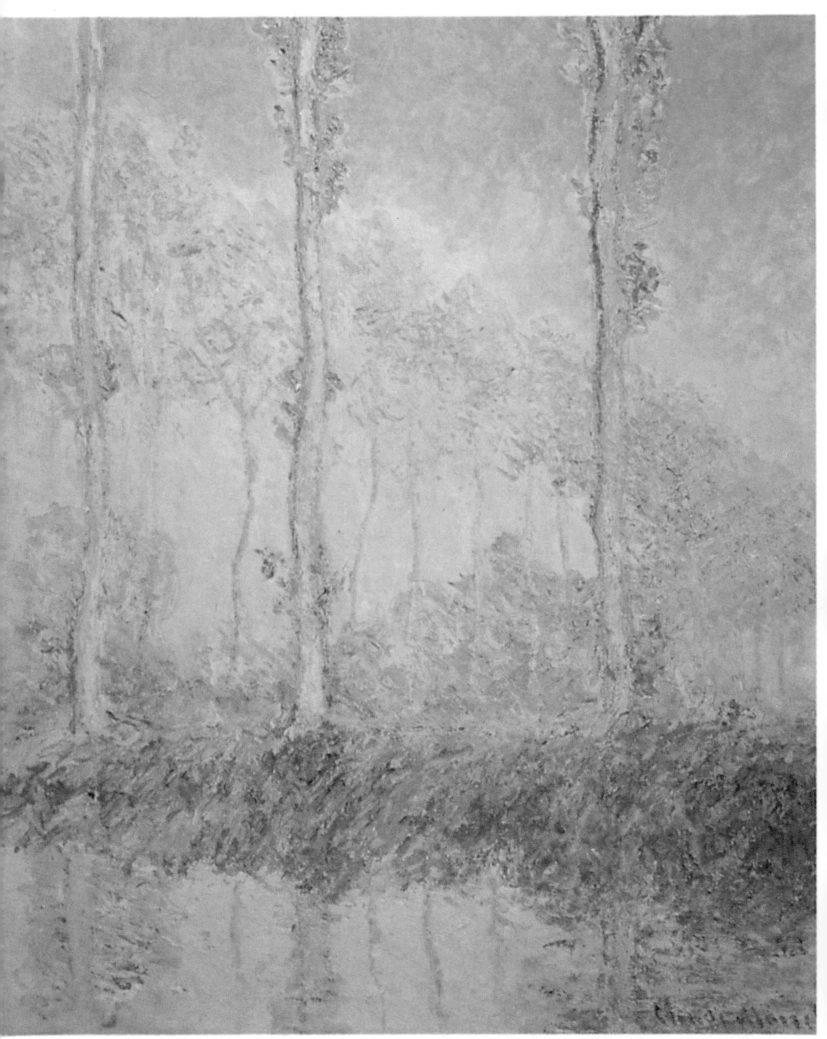

273

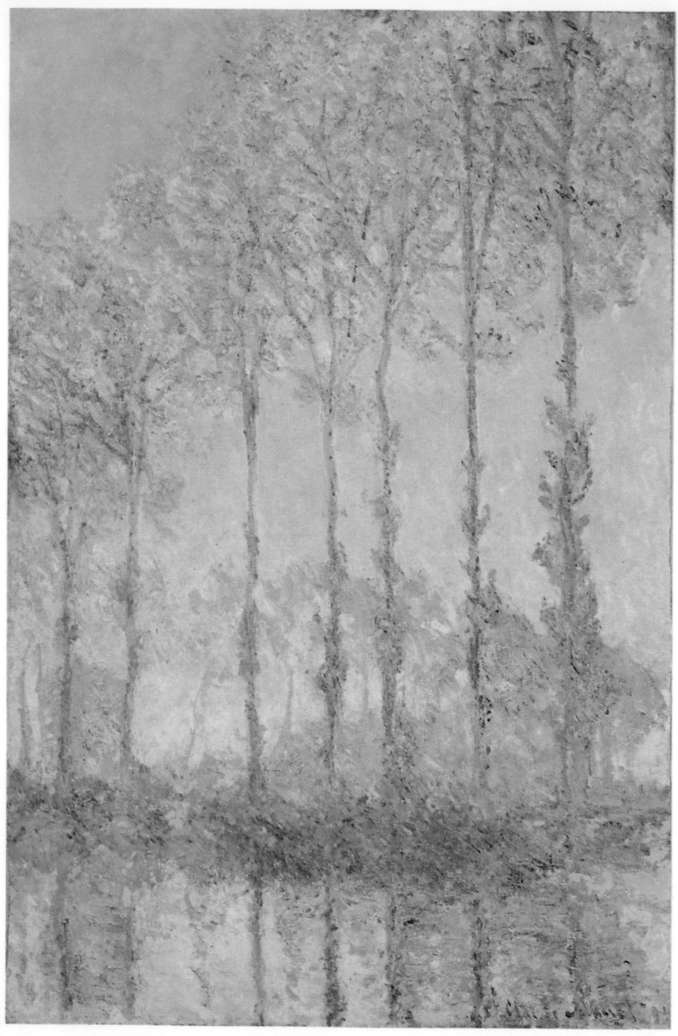

274

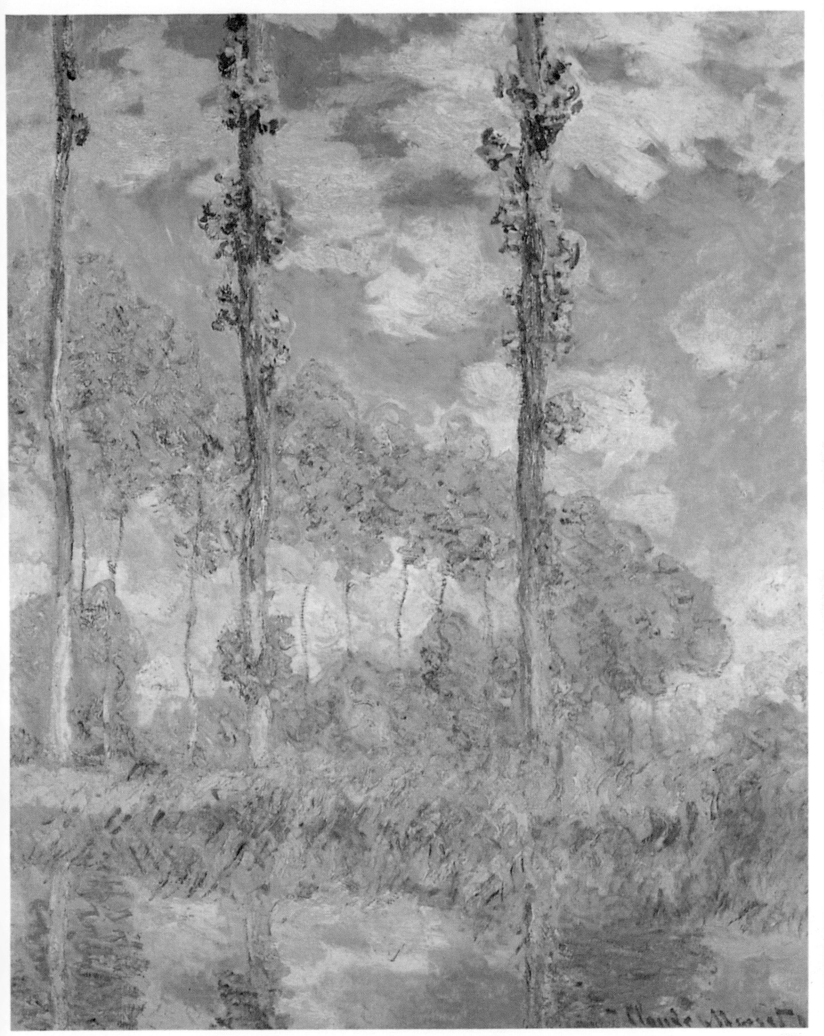

275

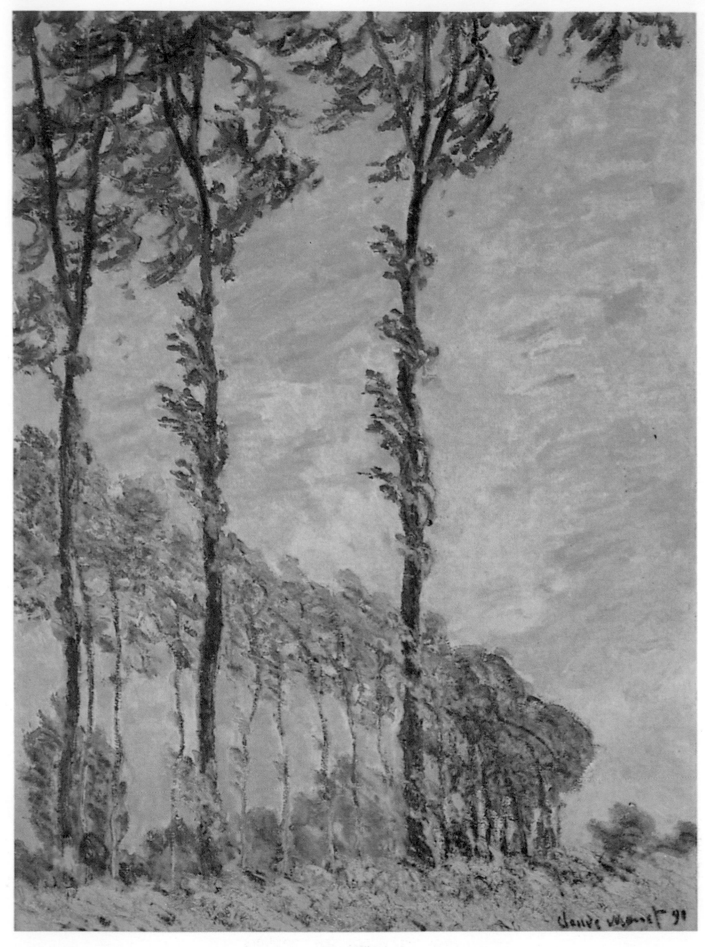

Peupliers

1891 - oil on canvas - 90 x 93
Fitzwilliam Museum, Cambridge, Great Britain

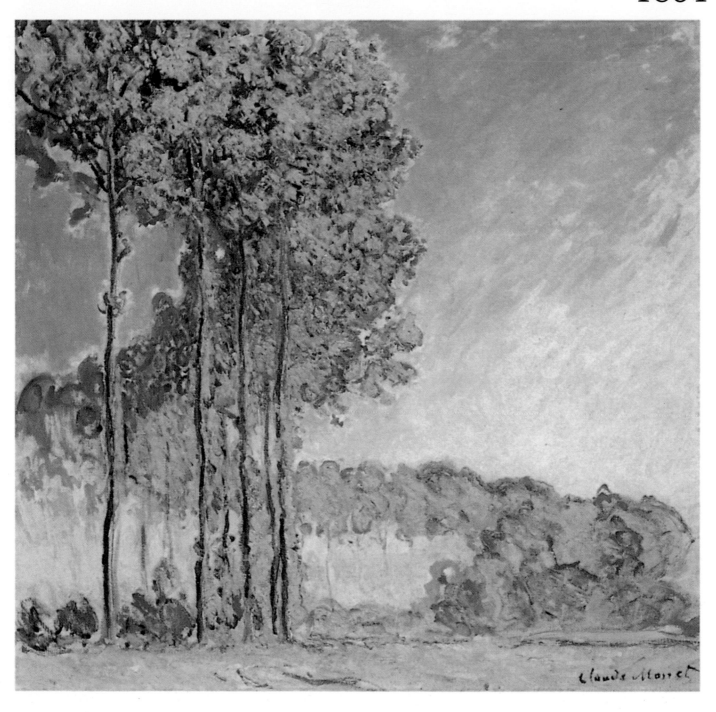

Effet de vent, série des peupliers

1891 - oil on canvas - 100 x 73
Private collection, Paris

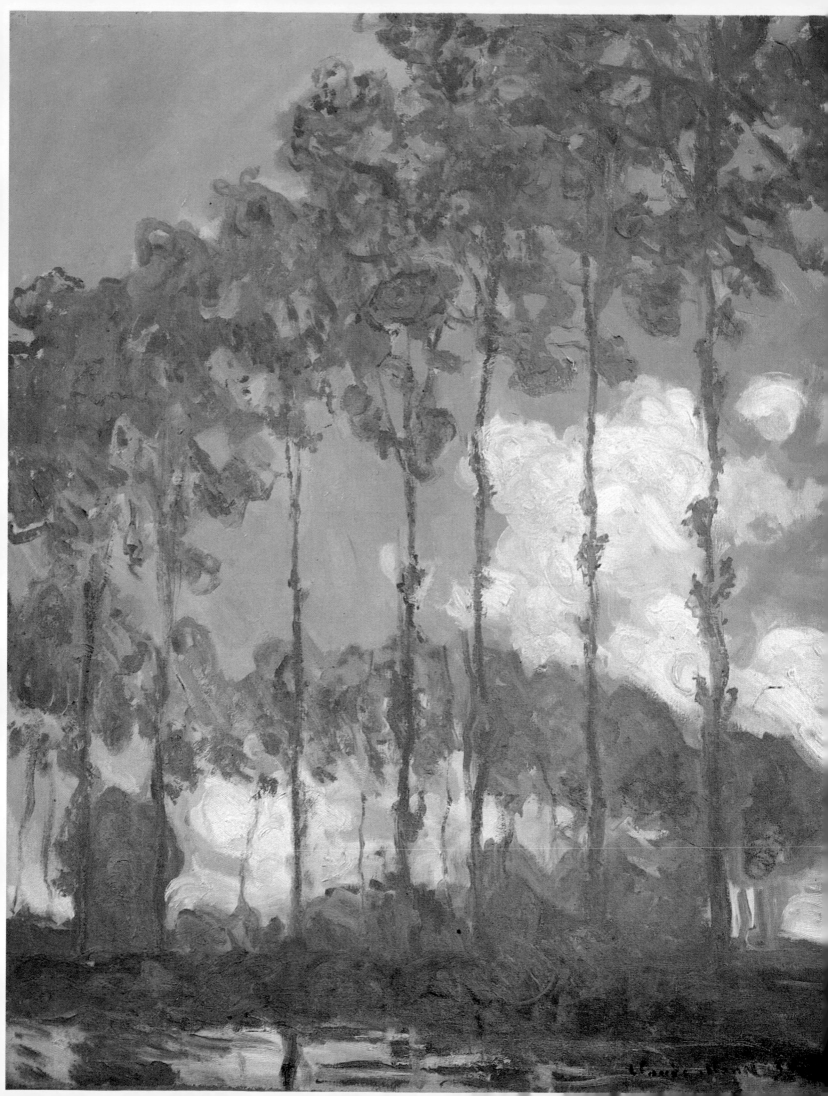

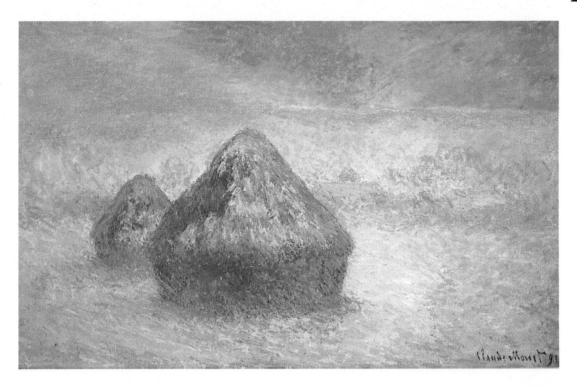

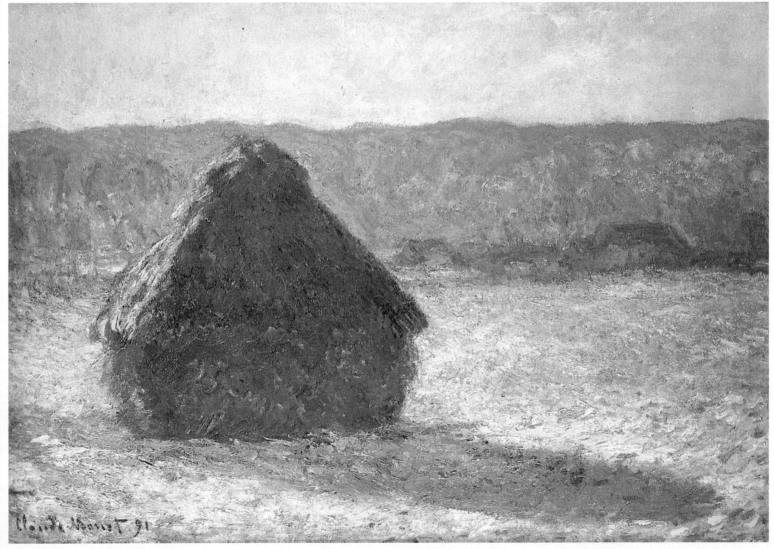

Les Peupliers au bord de l'Epte Meules, effet de neige, soleil couchant Meule, effet de neige, le matin

1891 - oil on canvas - 92 x 73 *1891 - oil on canvas - 65 x 100* *1891 - oil on canvas - 65 x 92*

The Tate Gallery, London *The Art Institute of Chicago, Chicago* *Museum of Fine Arts, Boston*

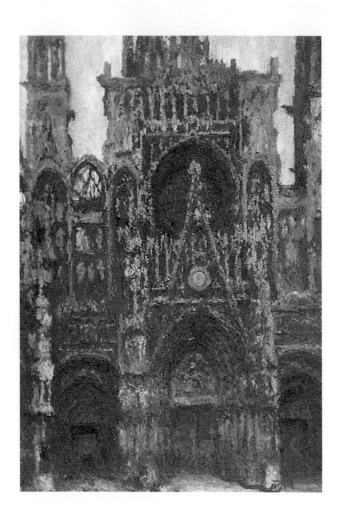 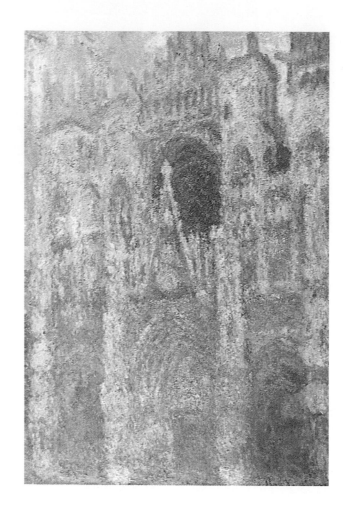

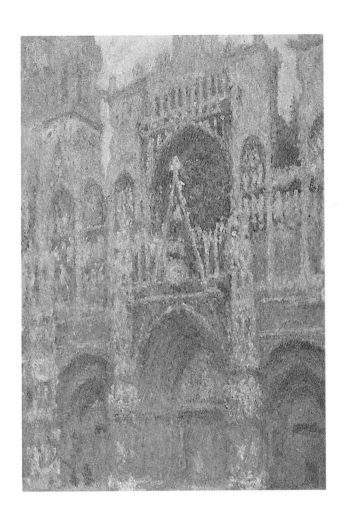 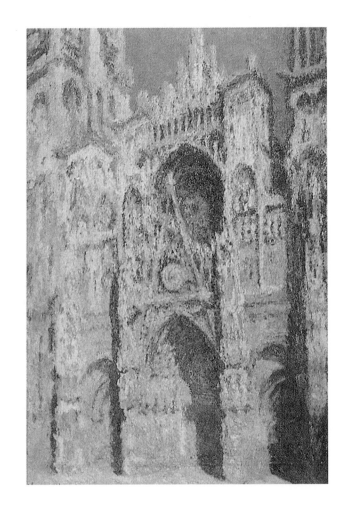

La Cathédrale de Rouen (four views)

1894 - oil on canvas
Musée d'Orsay, Paris

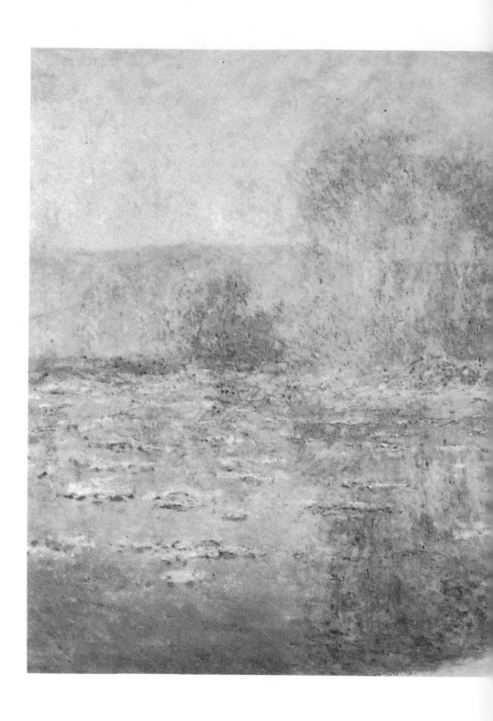

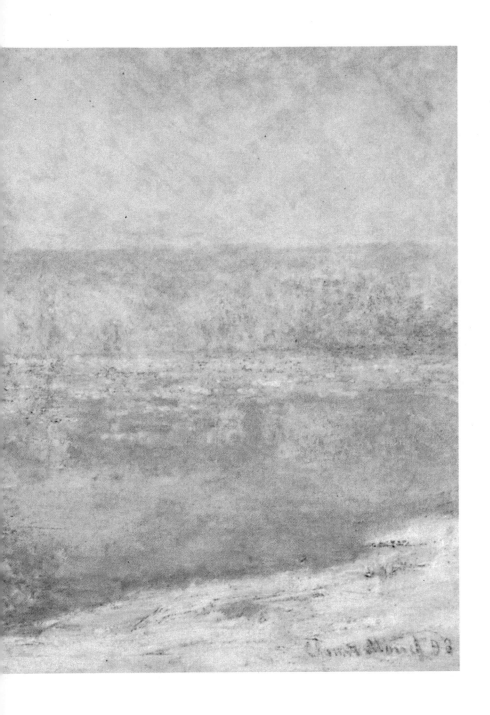

Les Glaçons, Bennecourt

1893 - oil on canvas - 65 x 100
Private collection

284

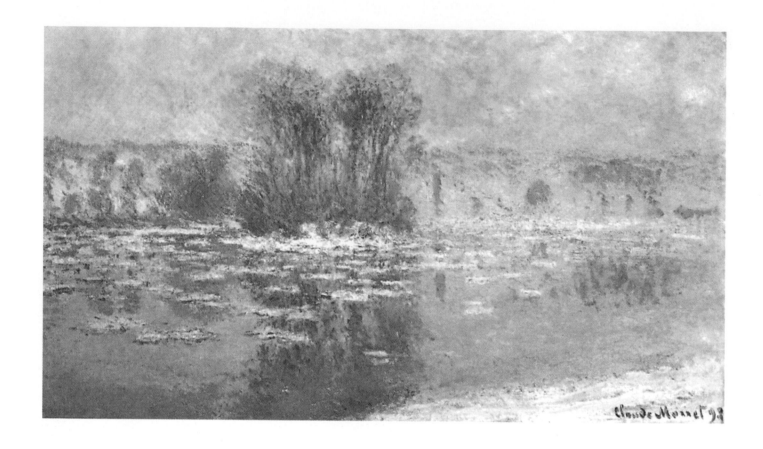

Glaçons à Bennecourt

1893 - oil on canvas - 60 x 100
Private collection

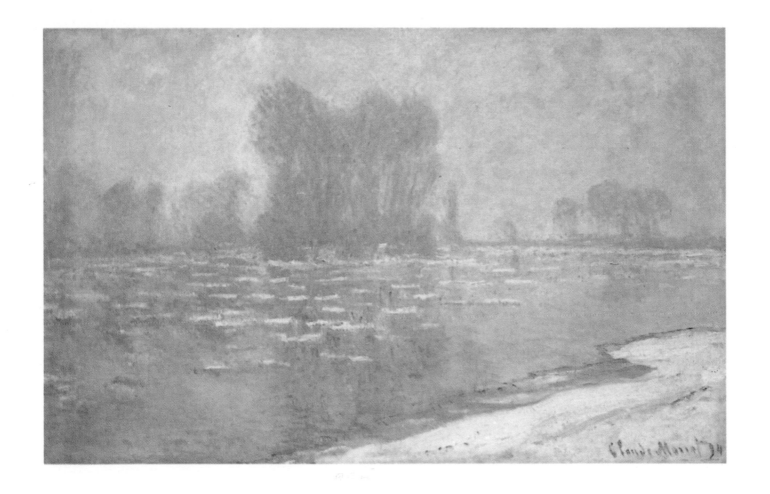

Matin brumeux, débâcle

1893 - oil on canvas - 65 x 100
Philadelphia Museum of Art, Philadelphia

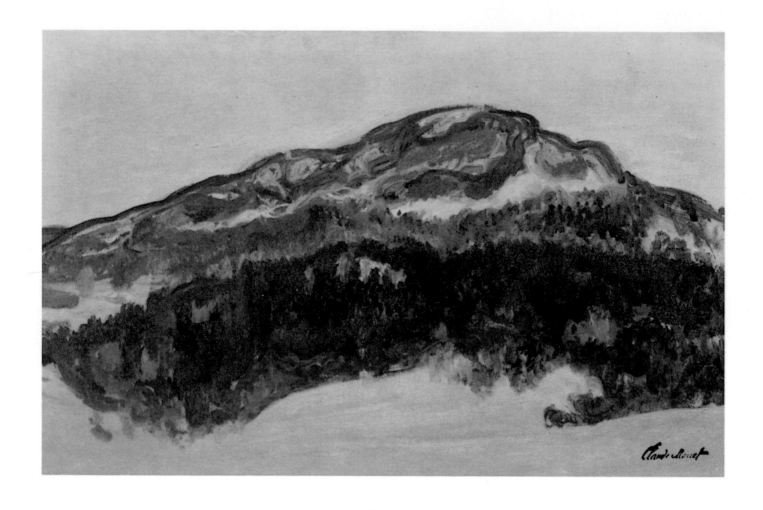

Le Mont Kolsaas en Norvège

1895 - oil on canvas - 65 x 100
Musée Marmottan, Paris

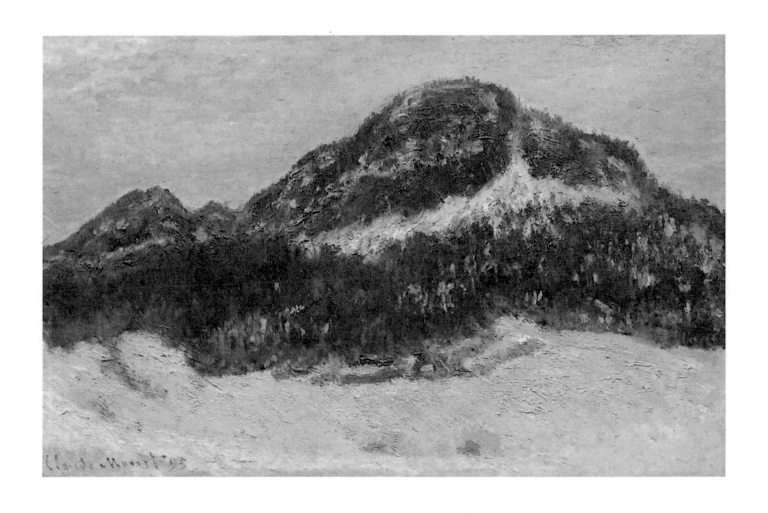

Le Mont Kolsaas

1895 - oil on canvas - 65 x 100
Private collection

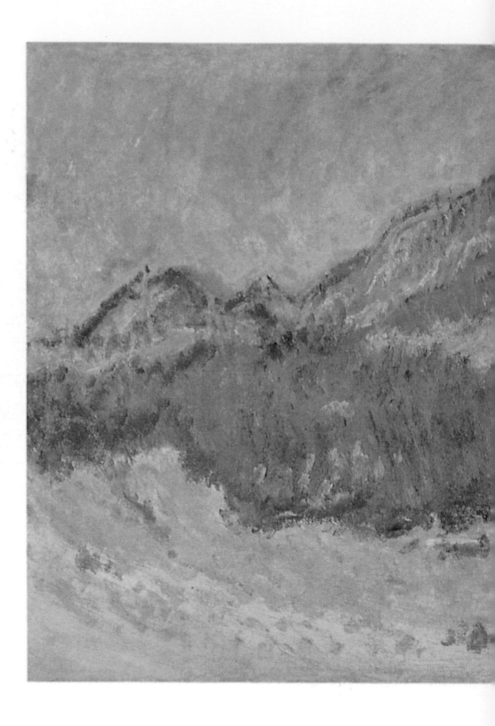

289

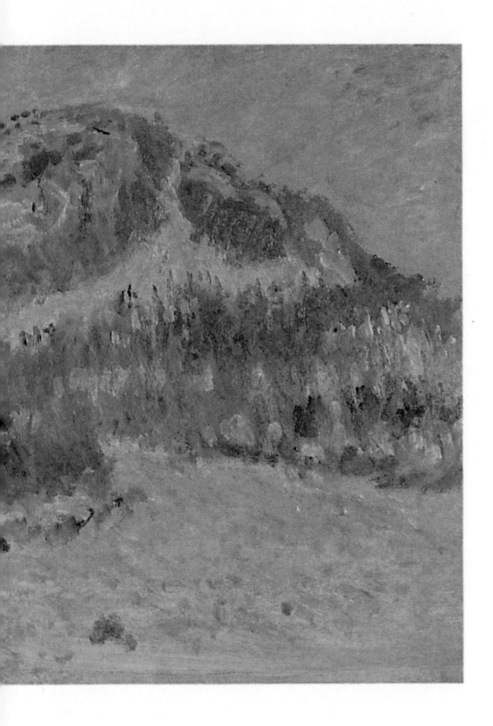

Le Mont Kolsaas, reflets roses

1895 - oil on canvas - 65 x 100
Musée d'Orsay, Paris

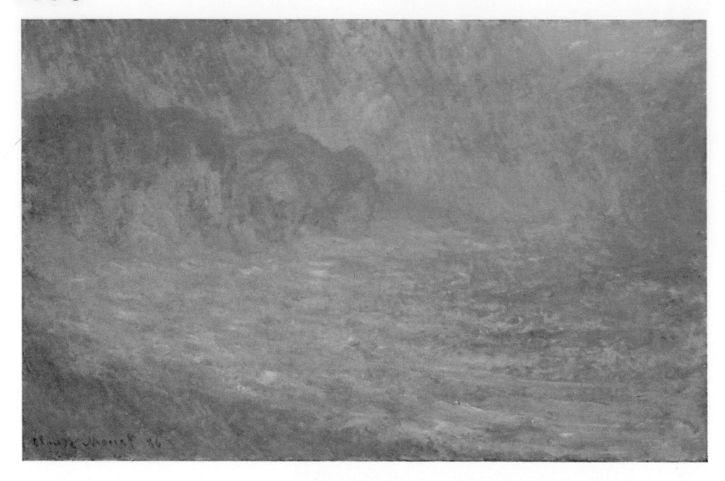

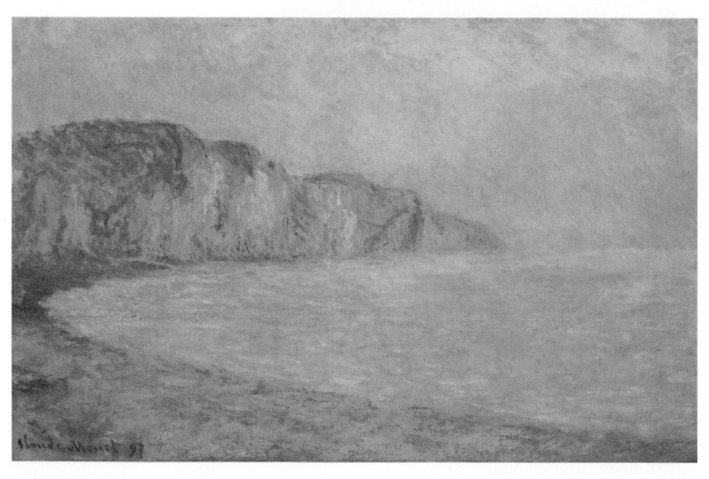

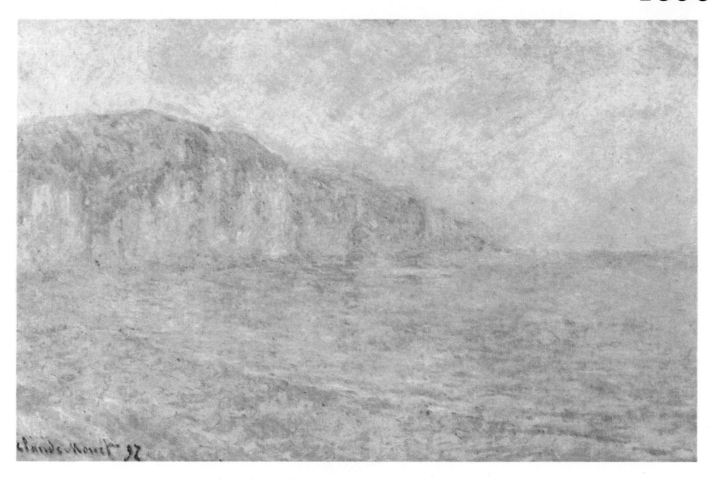

La Pluie, Pourville

1896 - oil on canvas - 65 x 100
Private collection

Falaise de Pourville, le matin

1896-97 - oil on canvas - 65 x 100
Musée des Beaux-Arts de Montréal, Montréal

Falaises de Pourville, le matin

1896-97 - oil on canvas - 65 x 100
J. Paul Getty Museum, Malibu, California

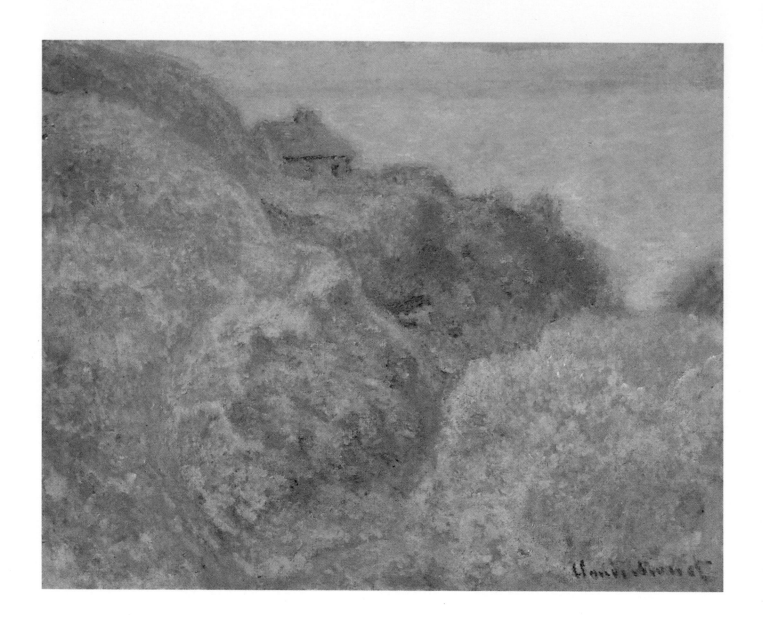

Cabanne de douaniers à Varengeville

1896 - oil on canvas - 65 x 81
Metropolitan Museum of Art, New York

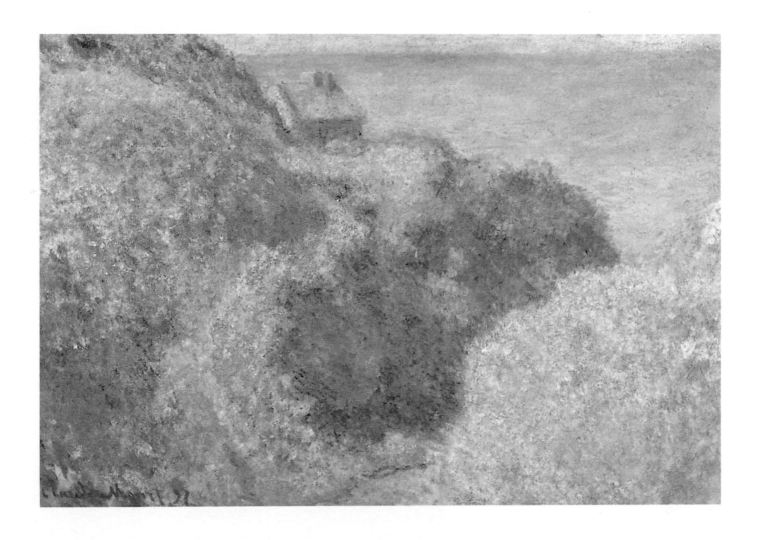

La Gorge de Varengeville, fin d'après-midi

1896-97 - oil on canvas - 65 x 92
Fogg Art Museum, Cambridge, Massachussetts

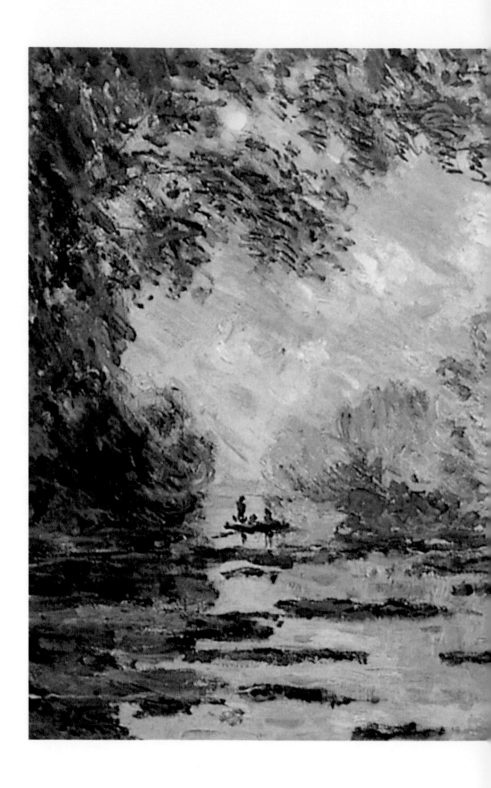

Bras de Seine à Giverny

1896 - oil on canvas
Musée Marmottan, Paris

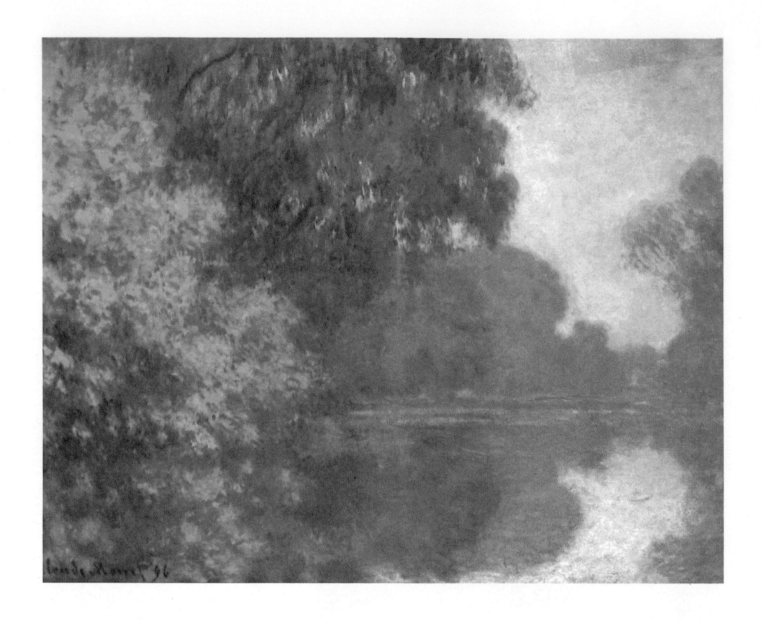

Bras de Seine près de Giverny

1896 - oil on canvas - 73 x 92
Museum of Fine Arts, Boston

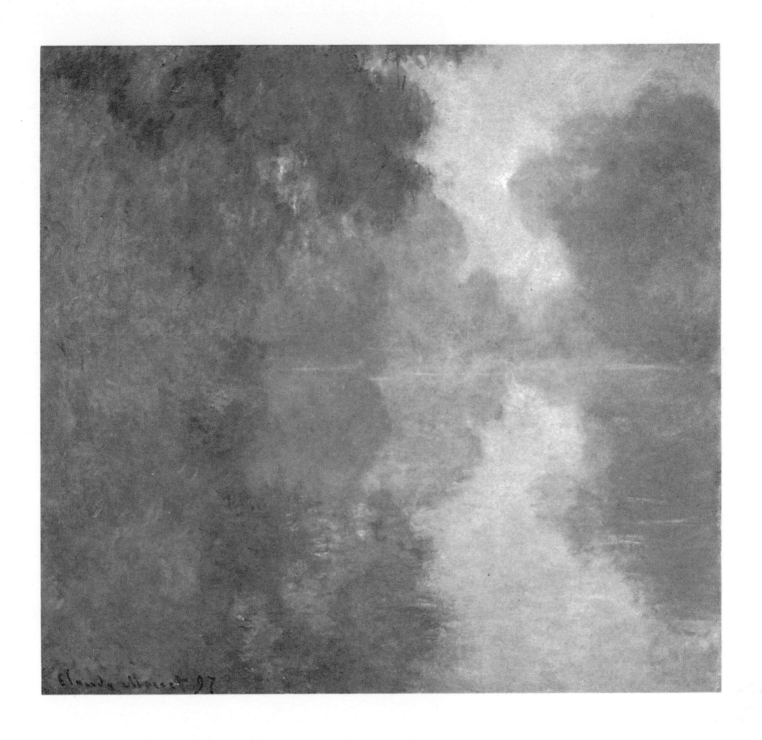

Bras de Seine près de Giverny, brouillard

1896-97 - oil on canvas - 89 x 92
North Carolina Museum of Art, Raleigh, North Carolina

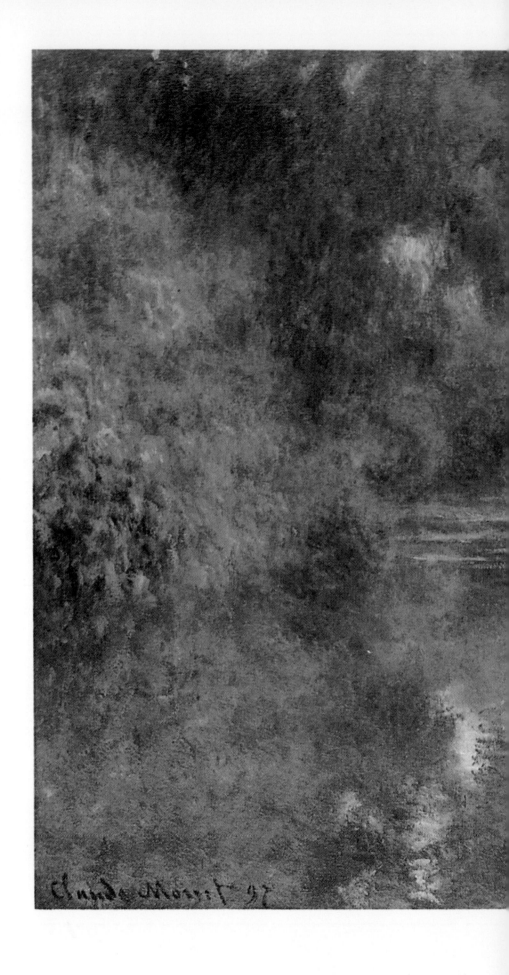

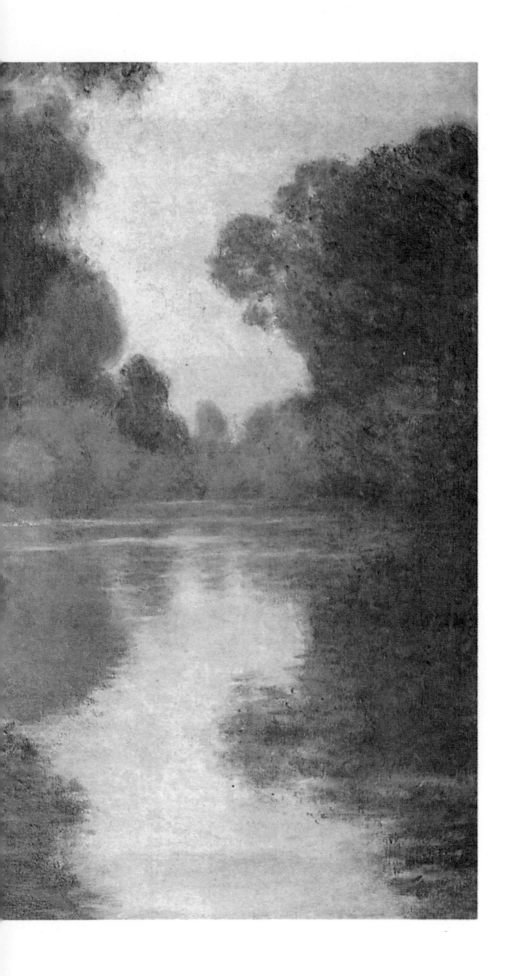

Bras de Seine près de Giverny

1897 - oil on canvas - 81 x 92
Museum of Fine Arts, Boston

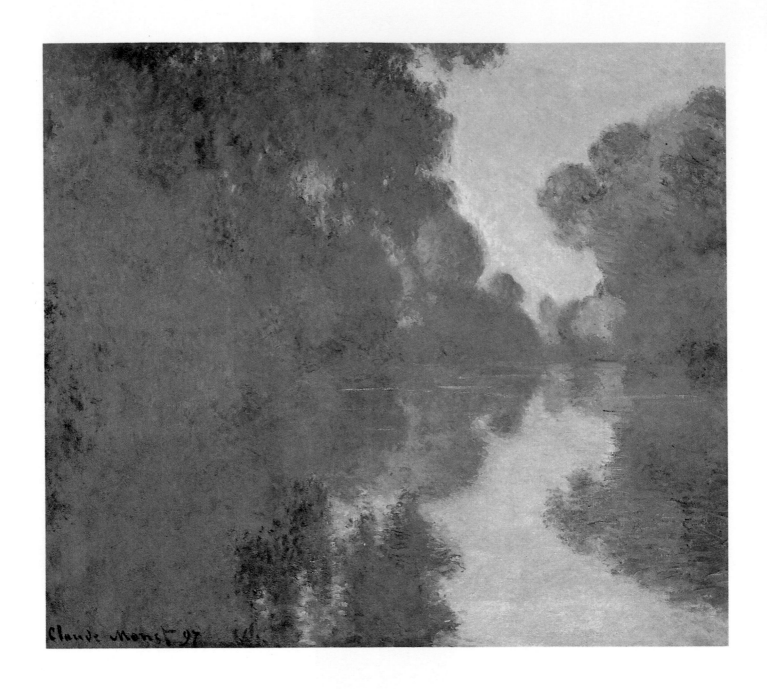

Le Matin sur la Seine, temps net

1897 - oil on canvas - 81 x 92
Metropolitan Museum of Art, New York

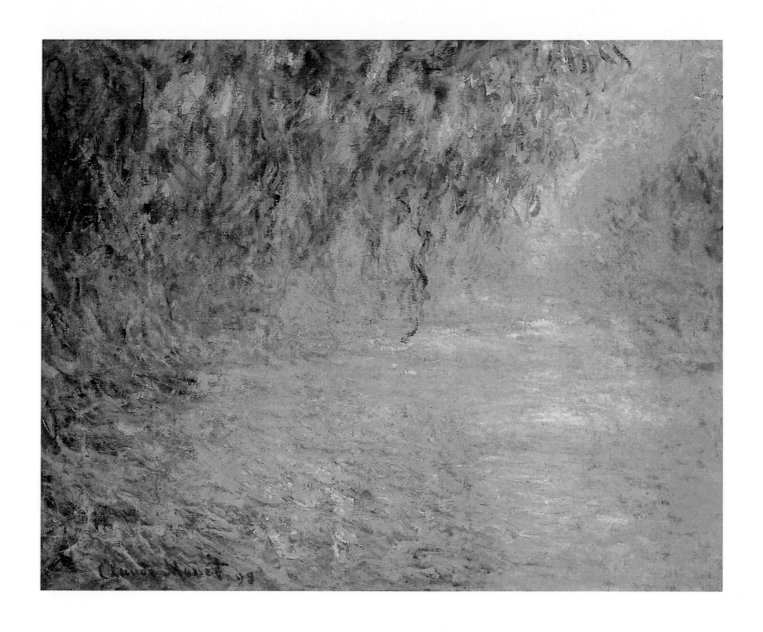

Matinée sur la Seine, temps de pluie

1898 - oil on canvas - 73 x 92
National Museum of Western Art, Tokyo

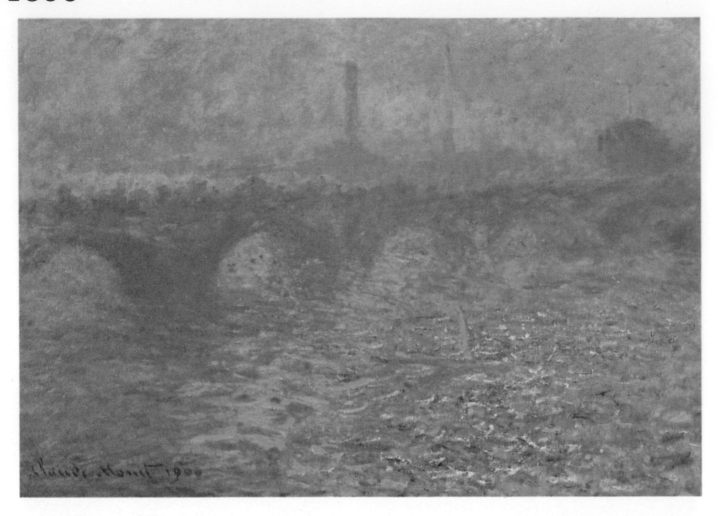

London, Waterloo Bridge

1899-1900 - oil on canvas - 65 x 92
Santa Barbara Museum of Art, Santa Barbara, California

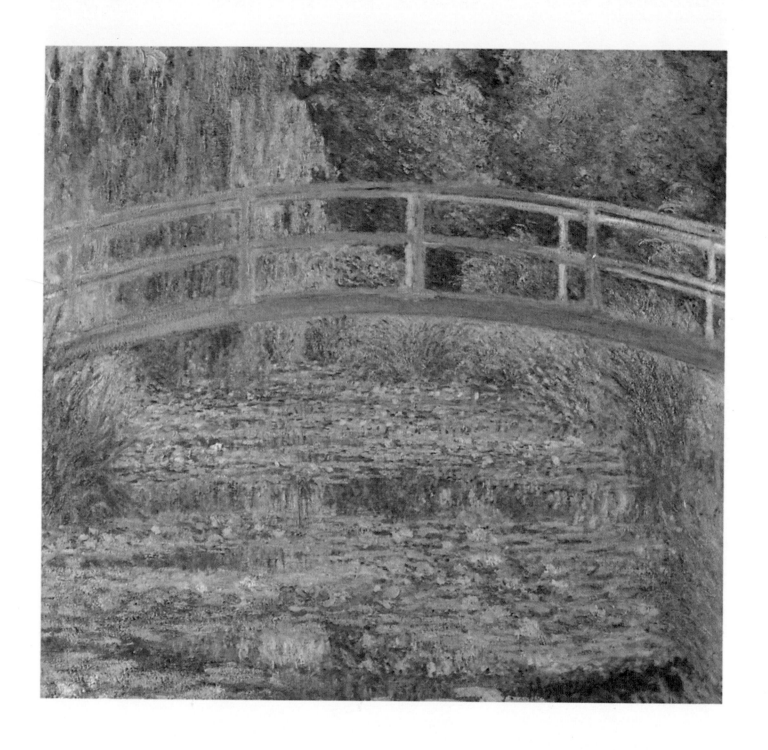

Le Bassin aux nymphéas

1899 - oil on canvas - 89 x 92
National Gallery, London

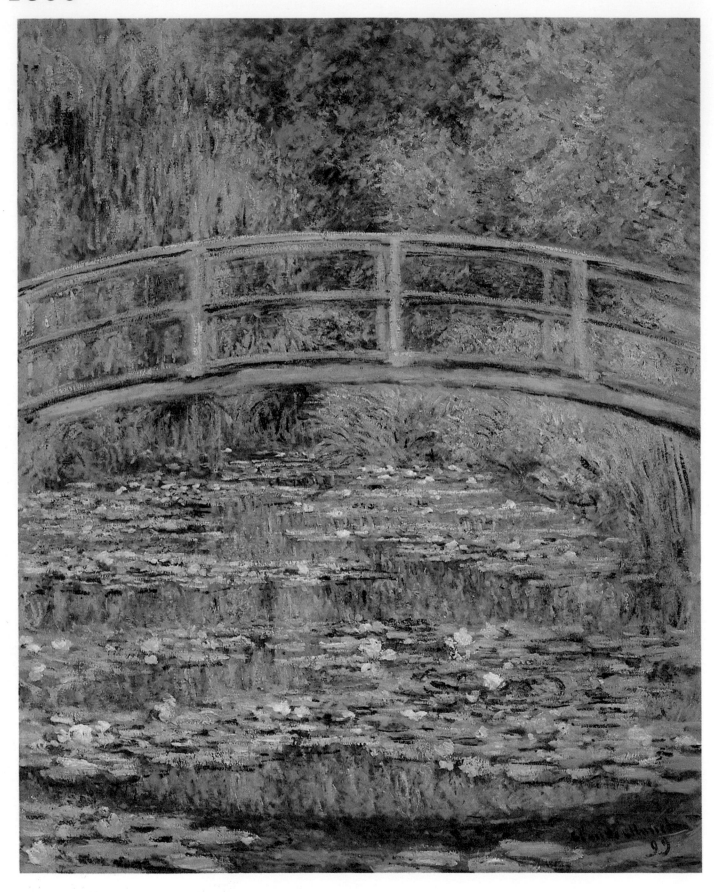

Le Bassin aux nymphéas

1899 - oil on canvas - 93 x 74
Metropolitan Museum of Art, New York

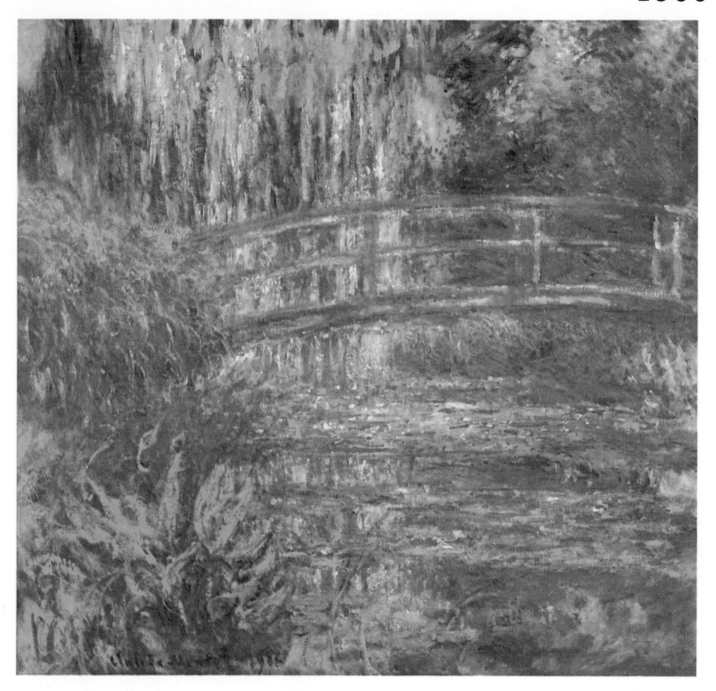

Le Bassin aux nymphéas

1900 - oil on canvas - 89 x 93
Museum of Fine Arts, Boston

Le Bassin aux nymphéas, le pont
1905 - oil on canvas - 95 x 100
Private collection

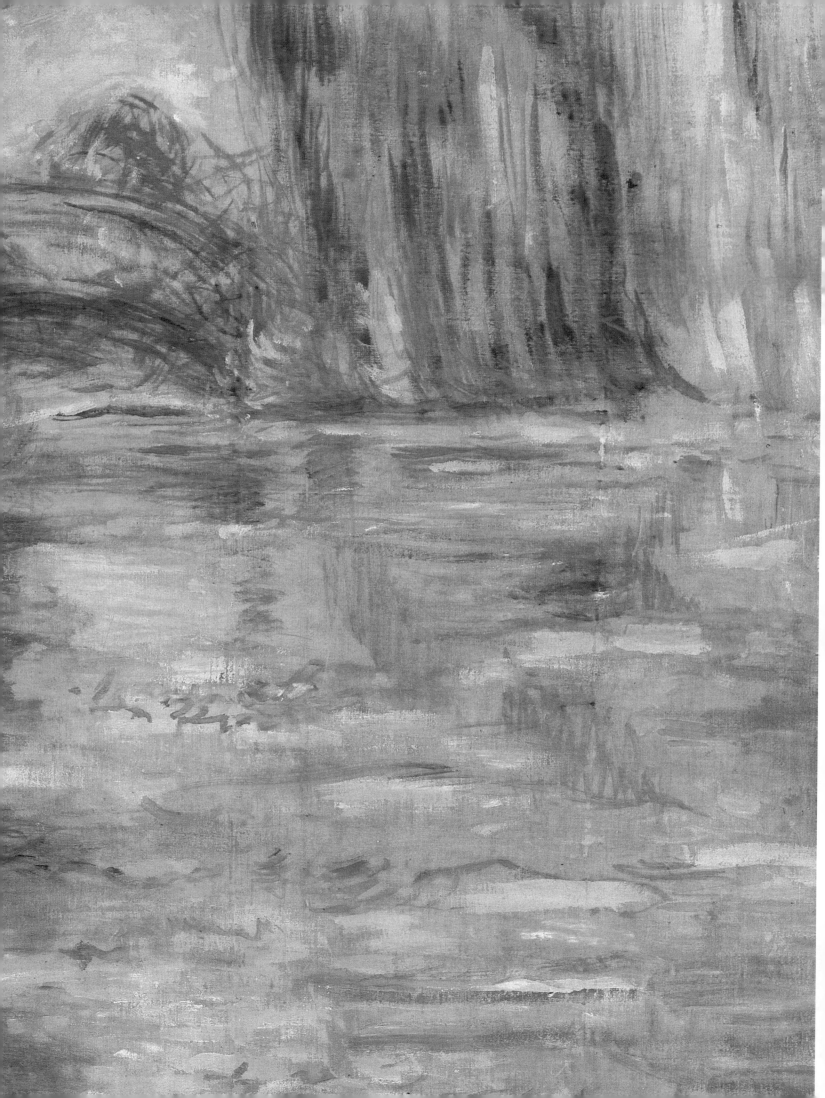

Le Pont sur le bassin aux nymphéas

1900 - oil on canvas - 90 x 99
The Art Institute of Chicago, Chicago

Waterloo Bridge, matin brumeux

1902 - oil on canvas - 65 x 100
Hamburger Kunsthalle, Hamburg

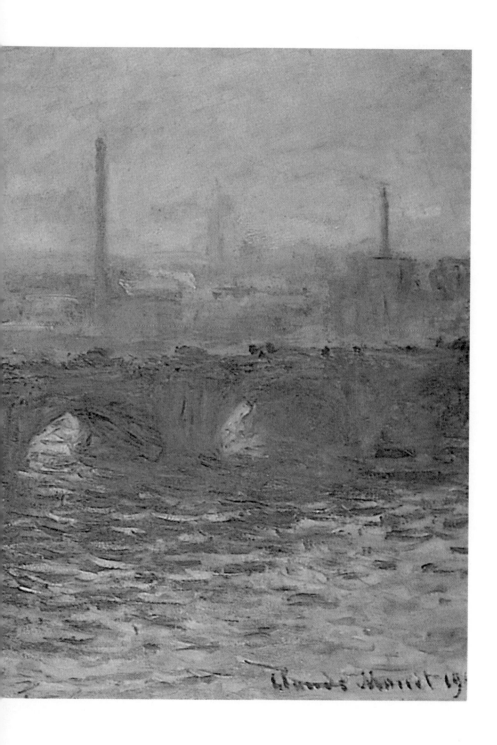

Waterloo Bridge, temps couvert

1899-1900 - oil on canvas - 65 x 100
Hugh Lane Municipal Gallery of Modern Art, Dublin

312

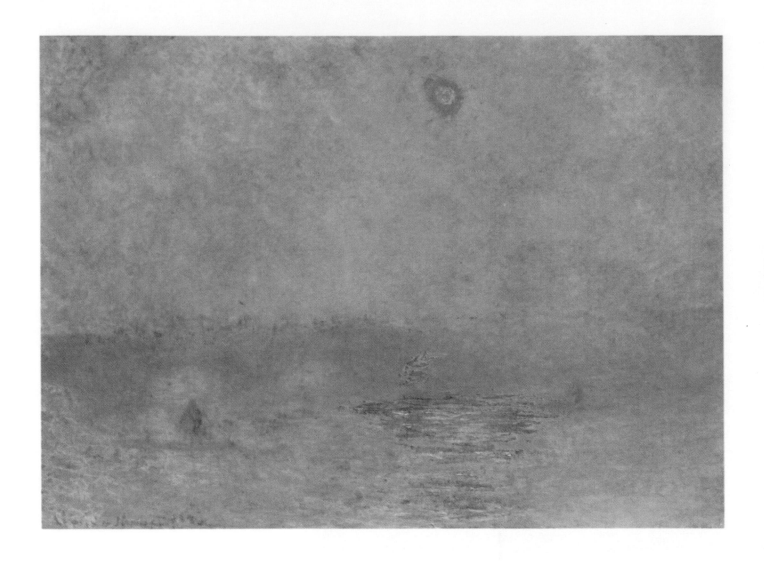

Waterloo Bridge, soleil dans le brouillard

1903-04 - oil on canvas - 73 x 100
National Gallery of Canada, Ottawa

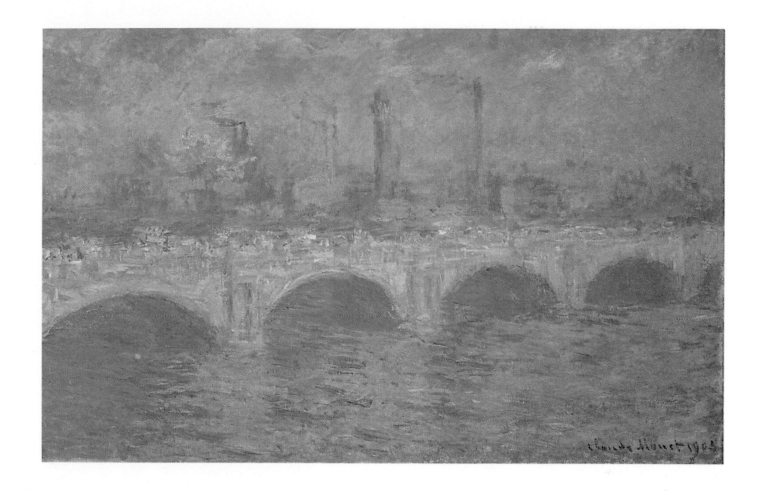

Waterloo Bridge, effet de soleil

1903-04 - oil on canvas - 65 x 100
Carnegie Museum of Art, Pittsburgh

Parliament,
trouée de soleil dans le brouillard

1904 - oil on canvas - 81 x 92
Musée d'Orsay, Paris

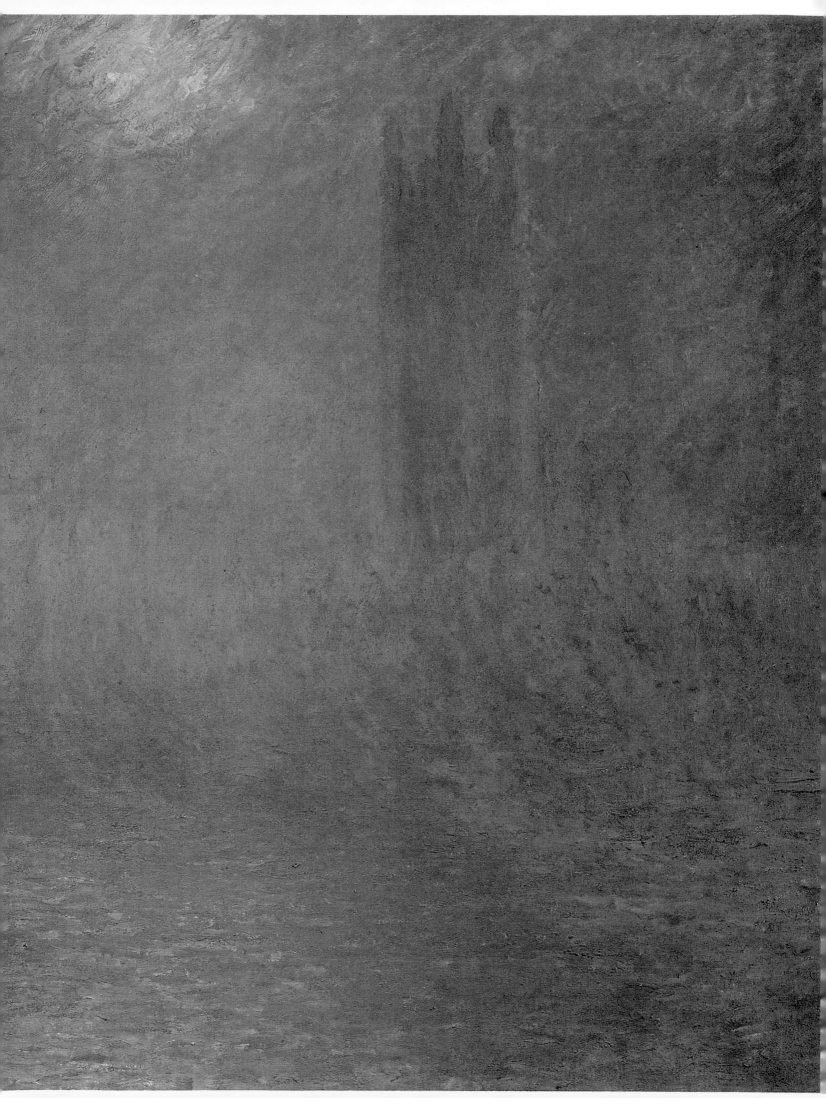

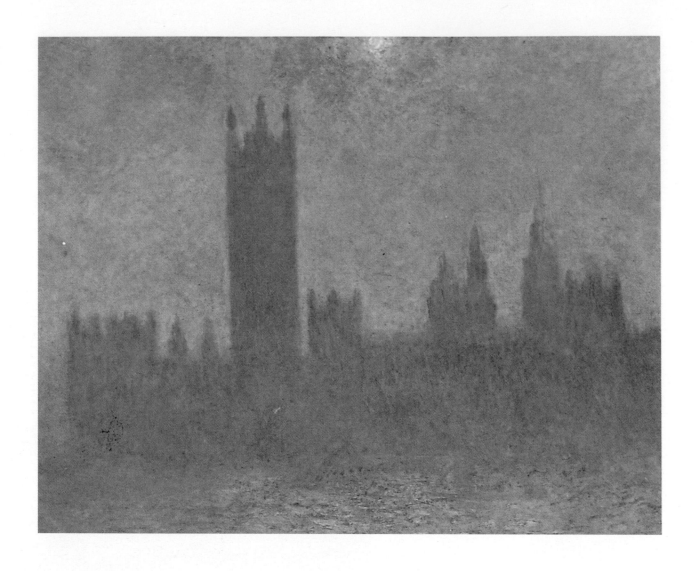

London, Parliament,
effet de soleil dans le brouillard

1904 - oil on canvas - 81 x 92
Private collection

Parliament, coucher de soleil

1904 - oil on canvas - 81 x 92
Private collection

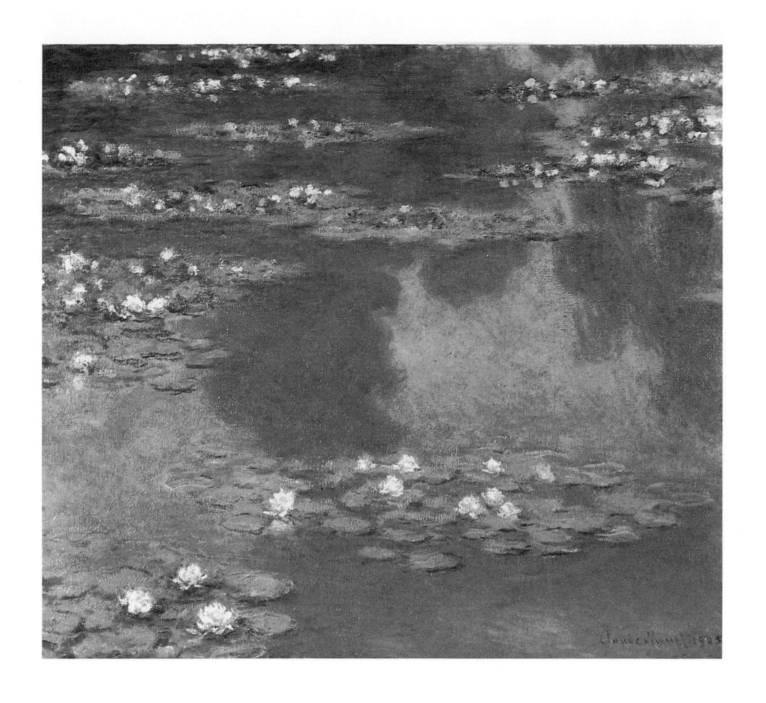

Nymphéas

1905 - oil on canvas - 90 x 100
Museum of Fine Arts, Boston

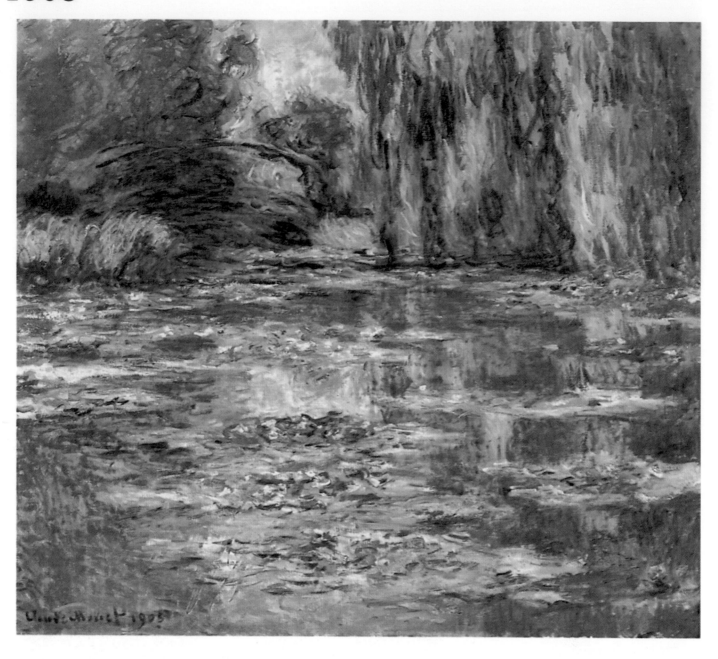

Bassin aux nymphéas, le pont

1905 - oil on canvas - 90 x 100
Private collection

Nymphéas, le soir

1907 - oil on canvas - 100 x 73
Musée Marmottan, Paris

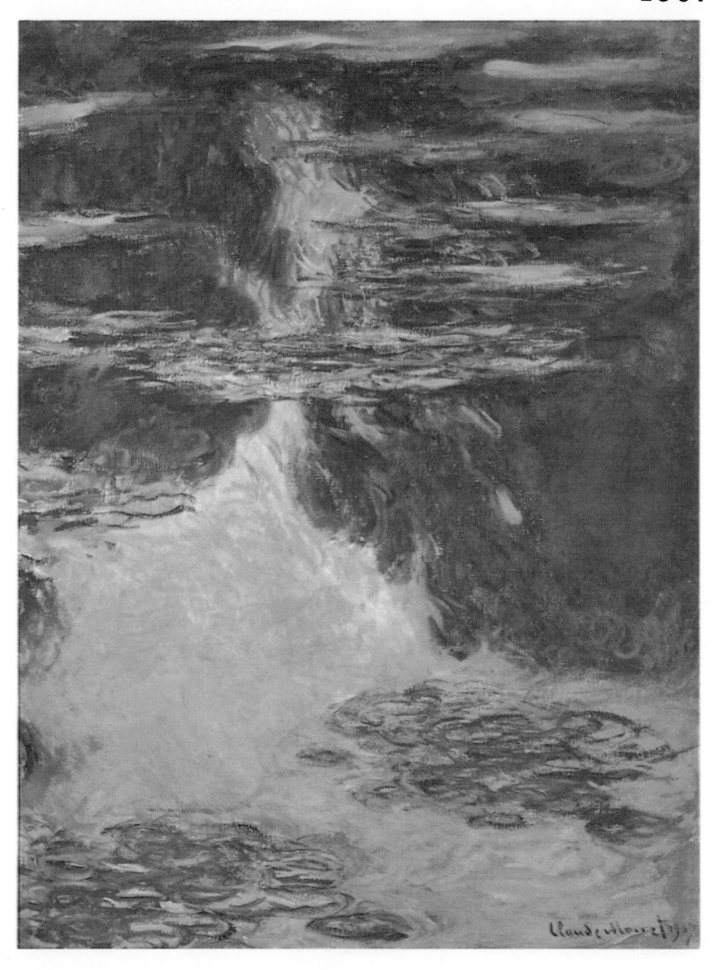

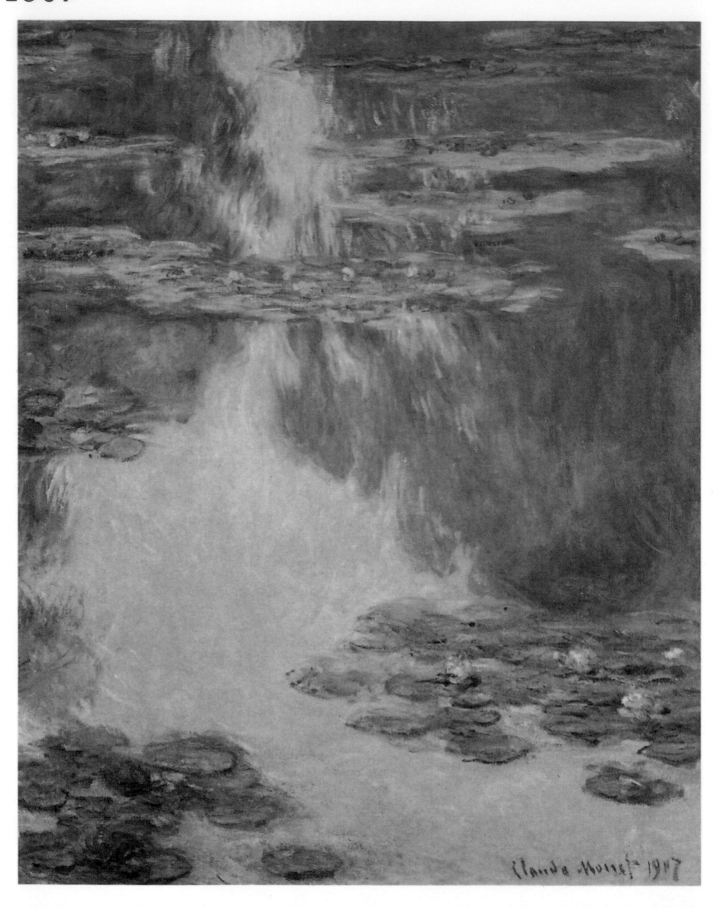

Nymphéas

1907 - oil on canvas - 92 x 73
Private collection

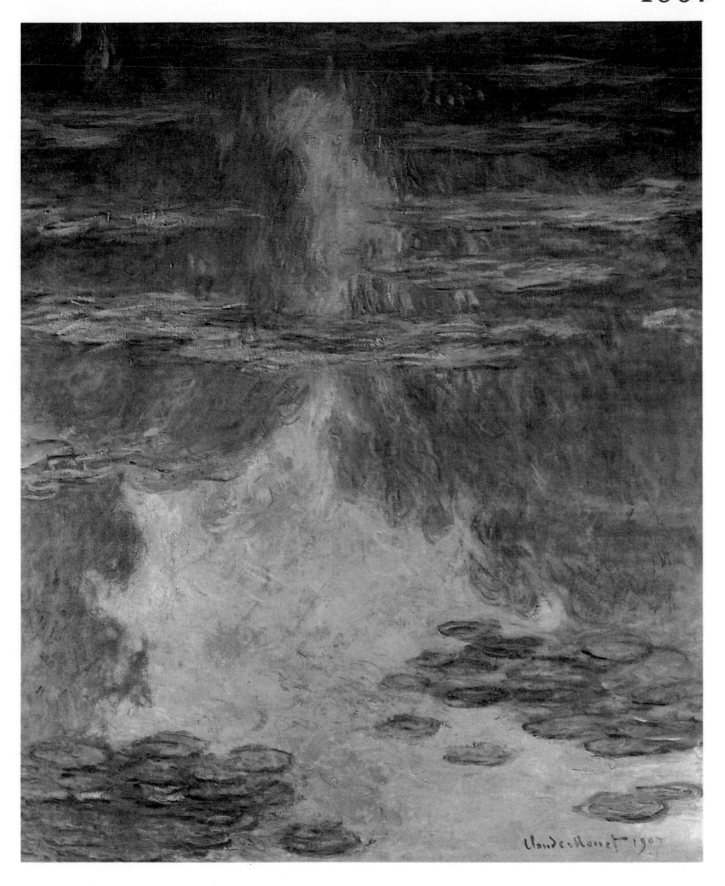

Nymphéas

1907 - oil on canvas - 100 x 81
Private collection

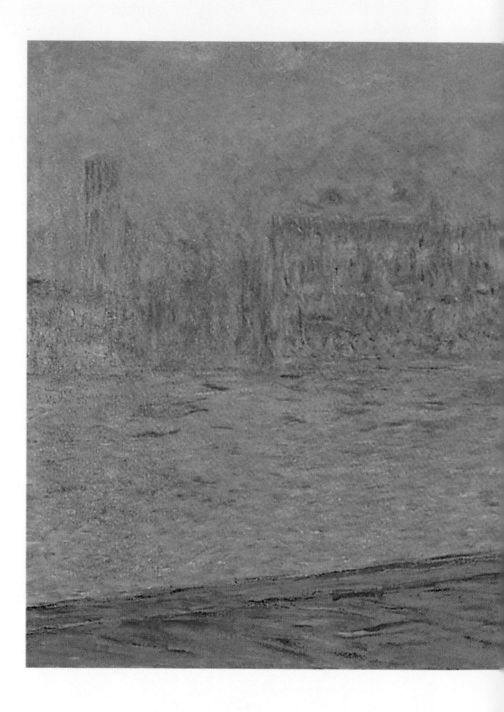

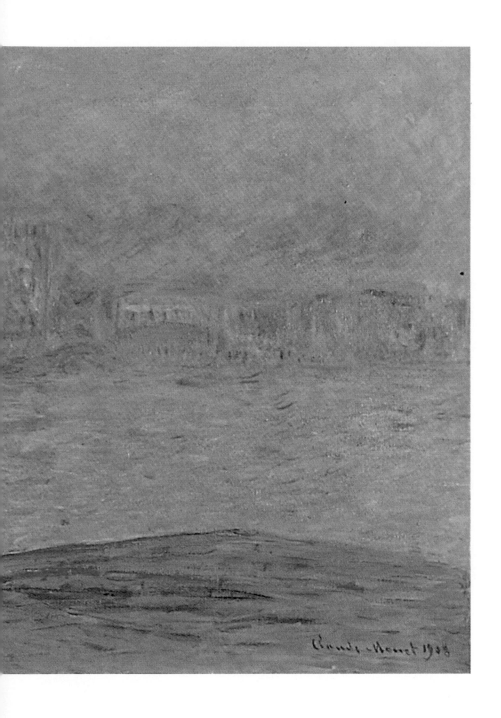

Le Palais ducale vu de Saint-Georges Majeur

1908 - oil on canvas - 65 x 100
Kunsthaus Zurich, Zurich

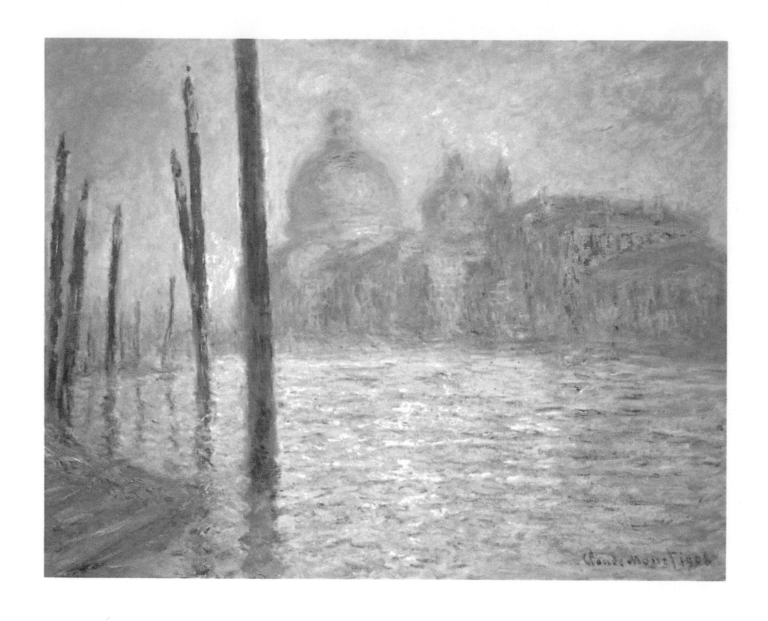

Le Grand Canal

1908 - oil on canvas - 73 x 92
Private collection

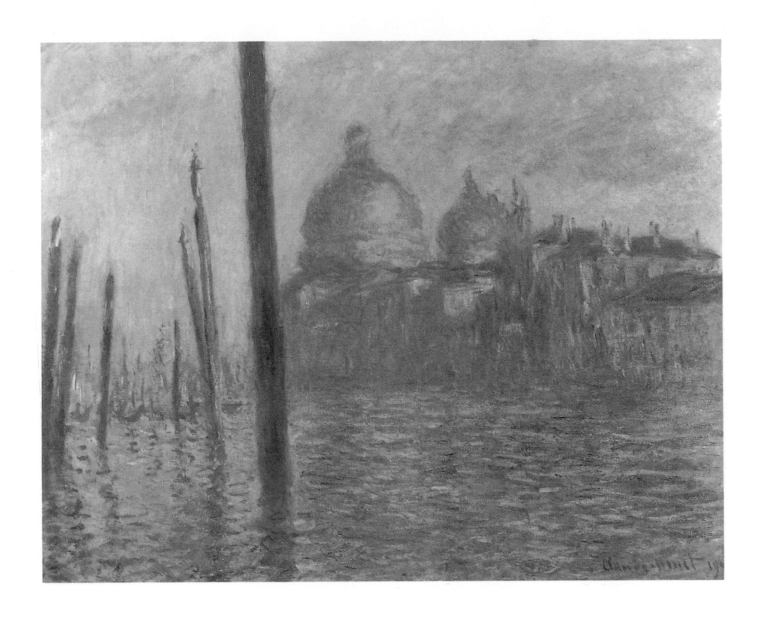

Le Grand Canal

1908 - oil on canvas - 73 x 92
Museum of Fine Arts, Boston

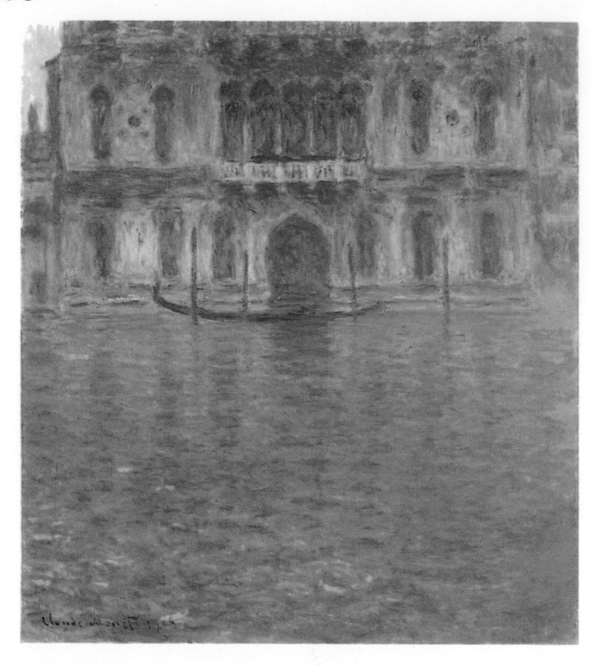

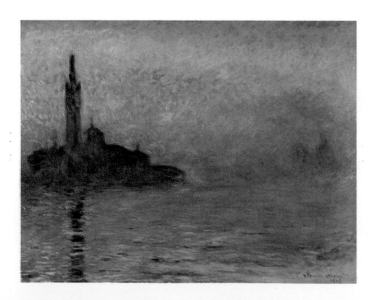

Le Palais Contarini

1908 - oil on canvas - 92 x 81
Kunstmuseum St. Gallen, St. Gall

Crépuscule à Venise

1908 - oil on canvas - 73 x 92
Bridgestone Museum of Art,
Ishibashi Fondation, Tokyo

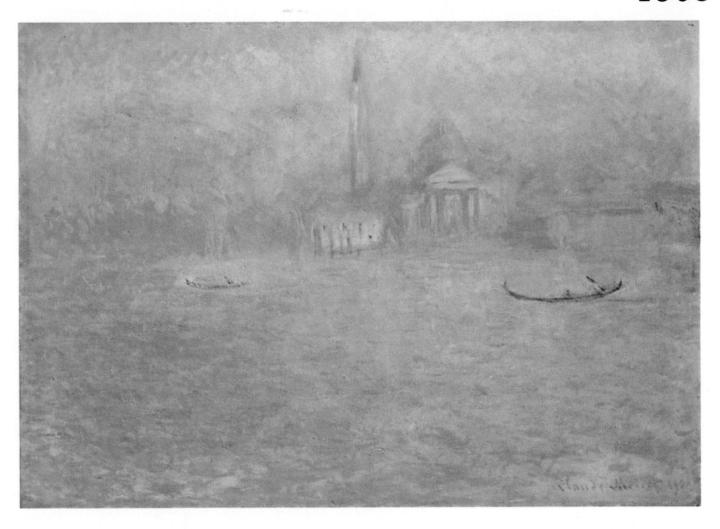

Saint-Georges Majeur

1908 - oil on canvas - 60 x 80
National Museum of Wales, Cardiff

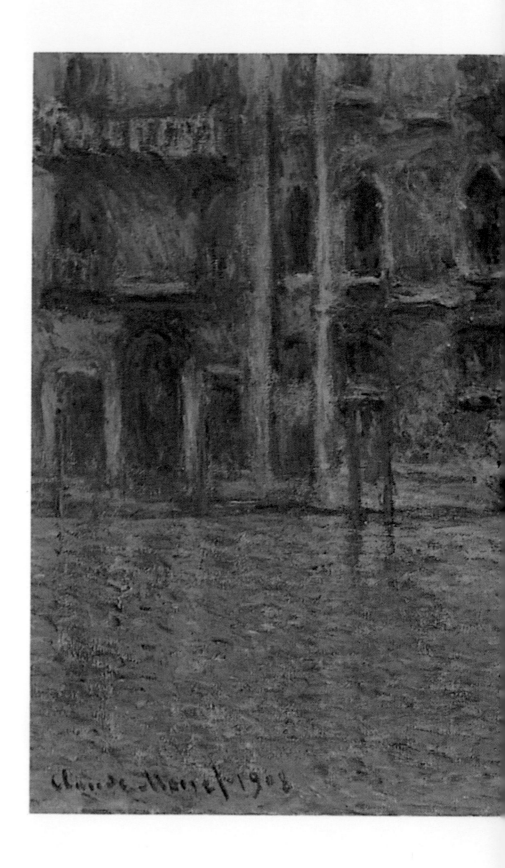

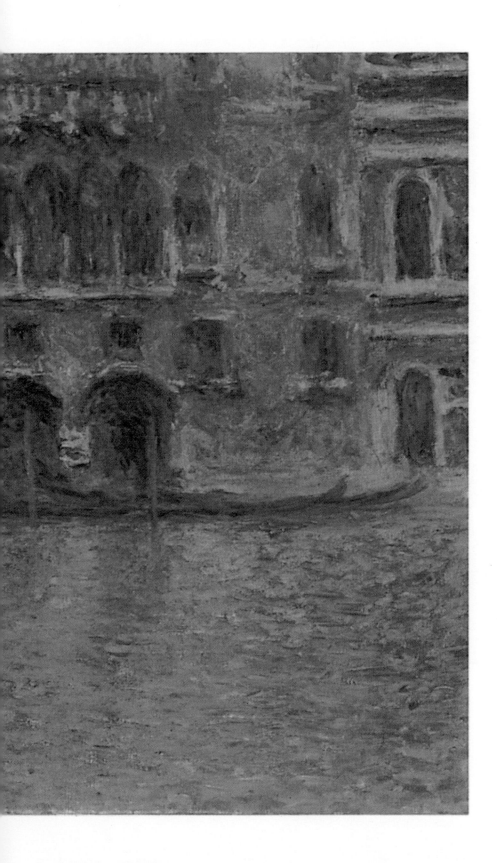

Le Palais da Mula

1908 · oil on canvas · 62 x 81
National Gallery of Art, Washington, D.C.

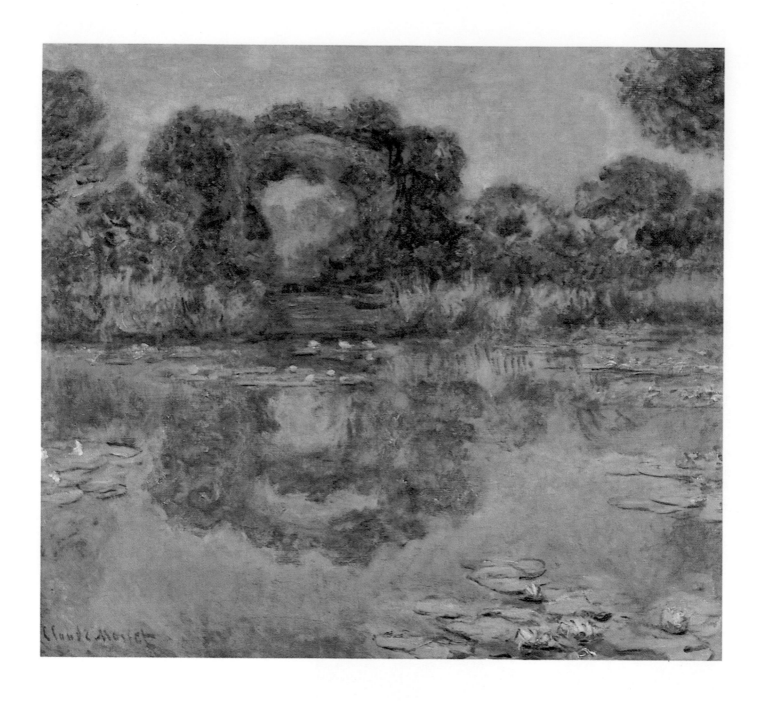

Les Arceaux fleuris, Giverny

1913 - oil on canvas - 81 x 92
Phoenix Art Museum, Phoenix

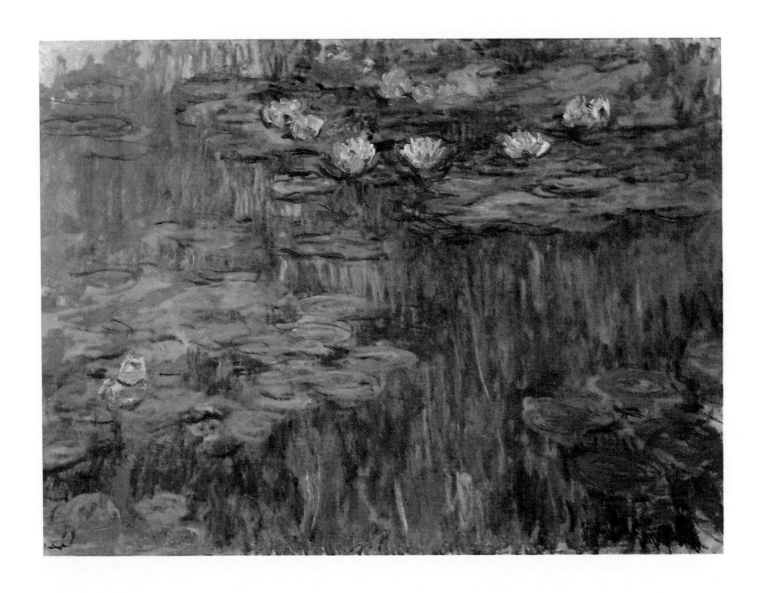

Nymphéas

1915 - oil on canvas - 150 x 200
Musée Marmottan, Paris

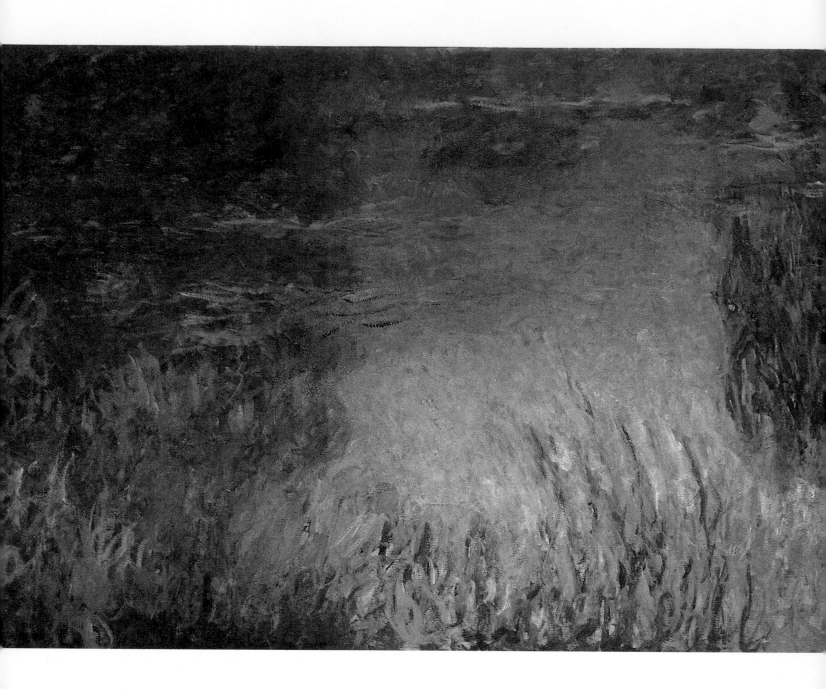

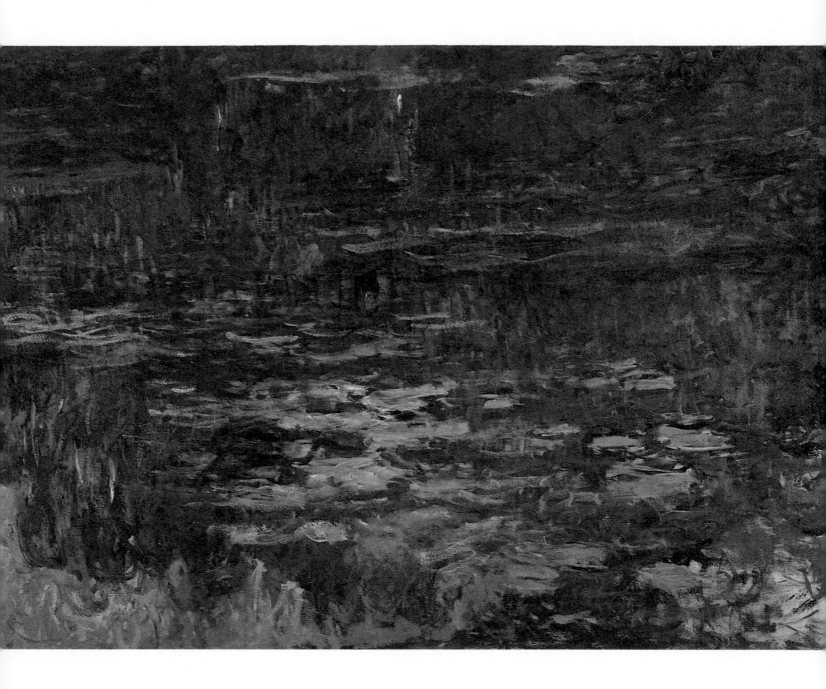

Nymphéas

1914-18 - oil on canvas - 197 x 594
Musée d'Orsay, Paris

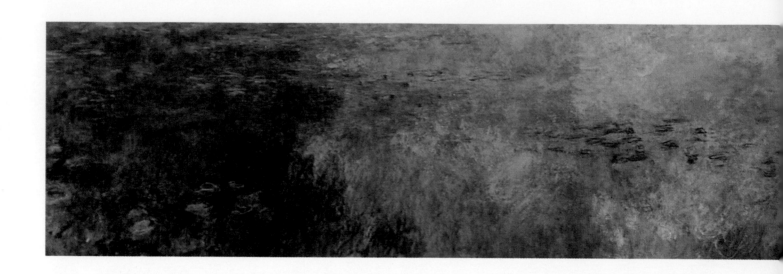

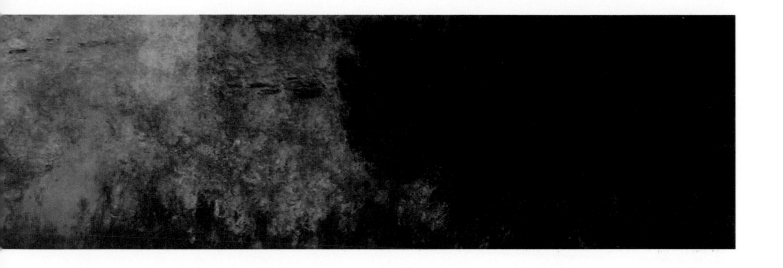

Le Bassin aux nymphéas sans saules,

les nuages

1916-26 - oil on canvas - 200 x 425
Musée de l'Orangerie, Paris

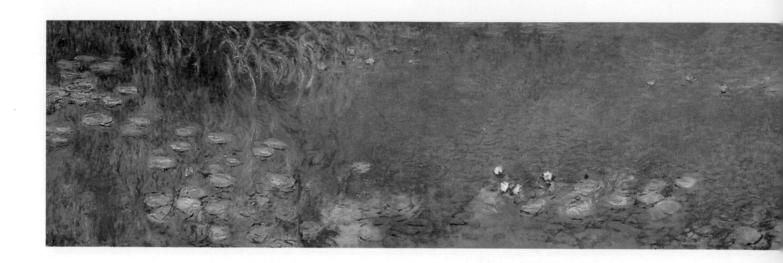

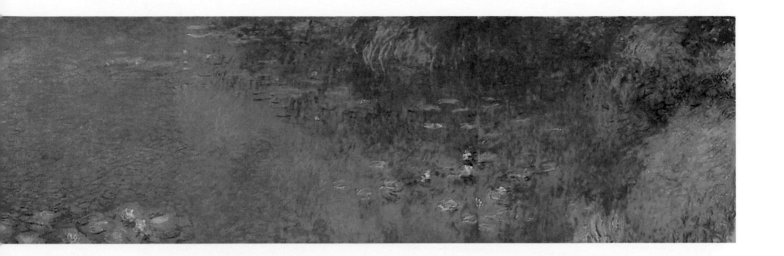

Nymphéas de l'Orangerie, matin

1914-26 - oil on panel - four panels
200 x 212
200 x 425
200 x 425
200 x 212
Musée de l'Orangerie, Paris

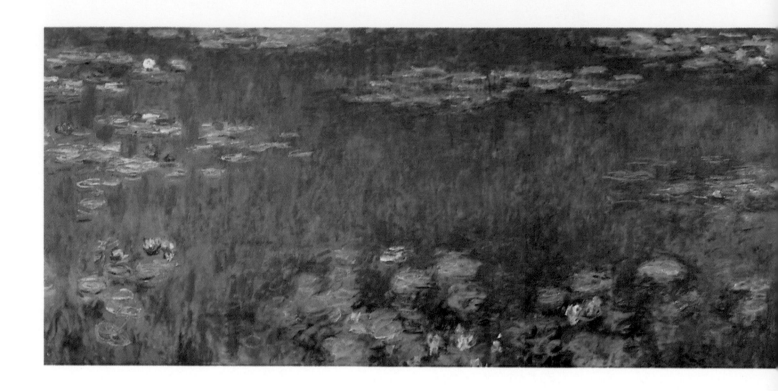

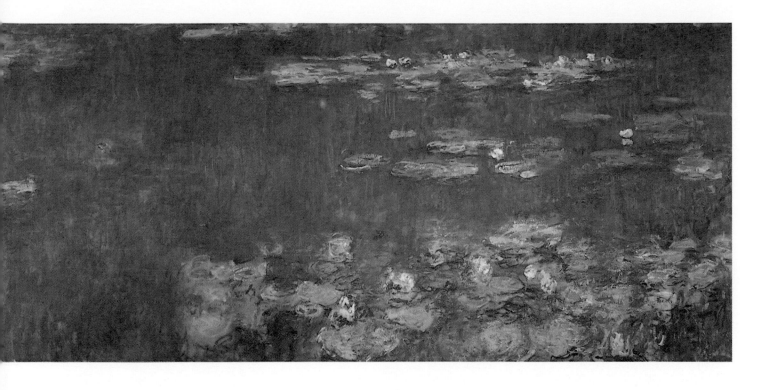

Nymphéas de l'Orangerie, reflets verts

1914-26 - oil on panel - diptych: 200 x 425 each of two panels
Musée de l'Orangerie, Paris

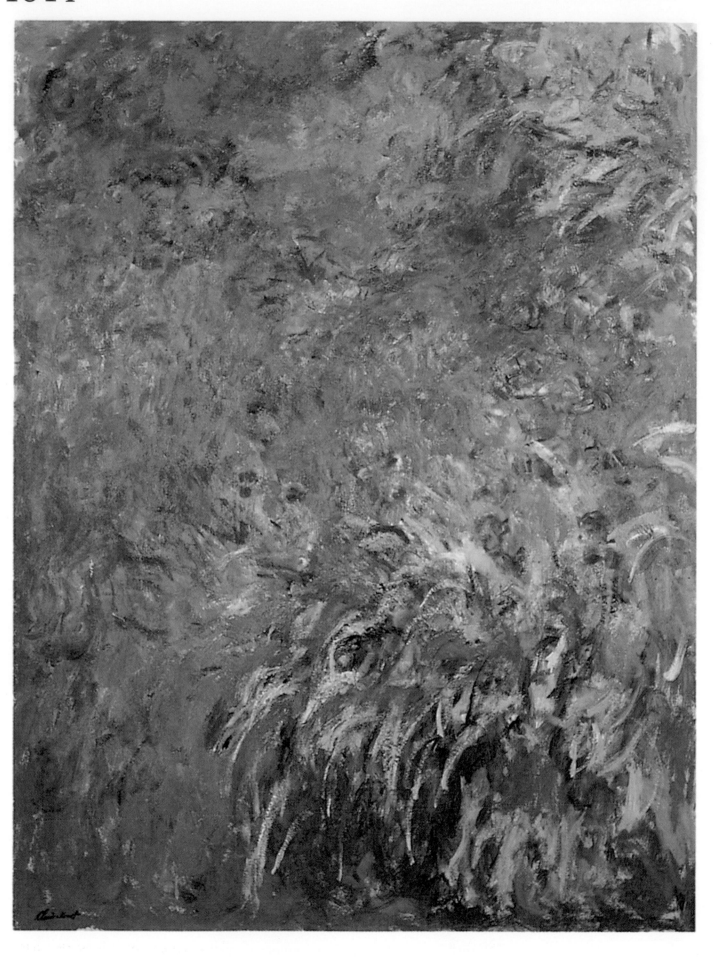

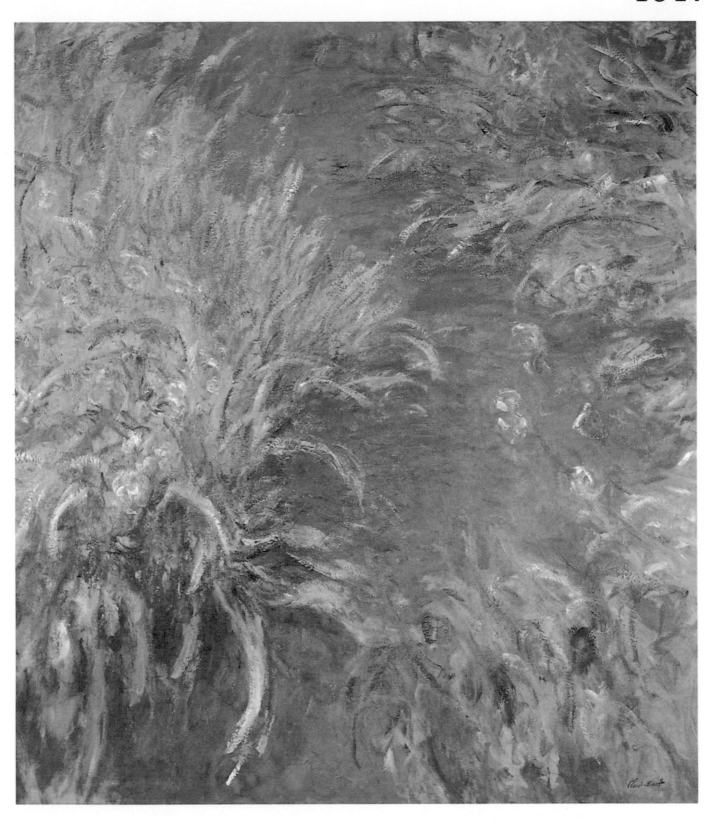

Iris

1914-17 - oil on canvas - 199.4 x 150.5
Virginia Museum of Fine Arts, Richmond

Le Chemin au milieu des iris

1916-17 - oil on canvas - 200 x 180
Private collection

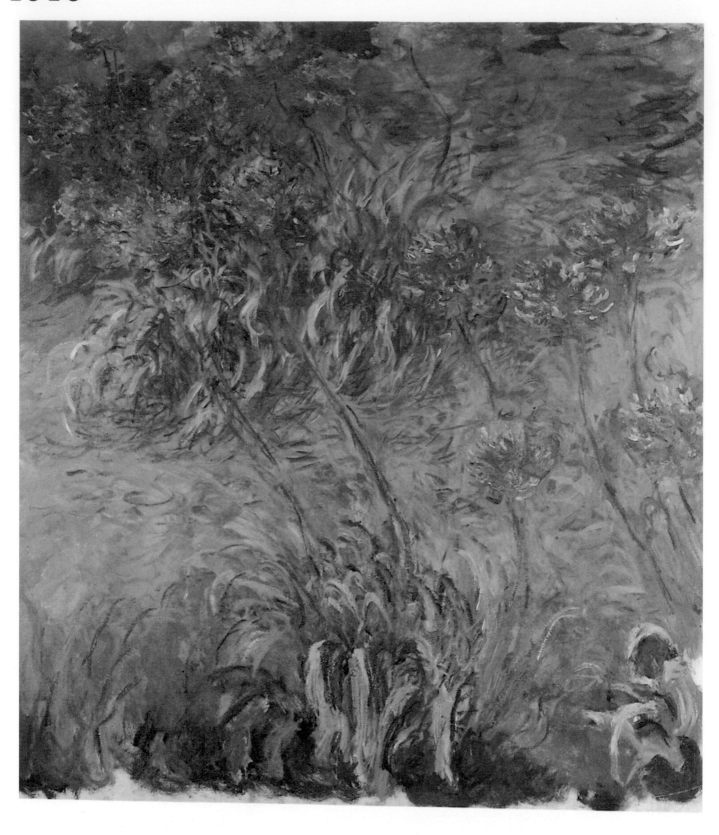

Le Parterre aux Agapanthes

1916-17 - oil on canvas - 200 x 180
Private collection

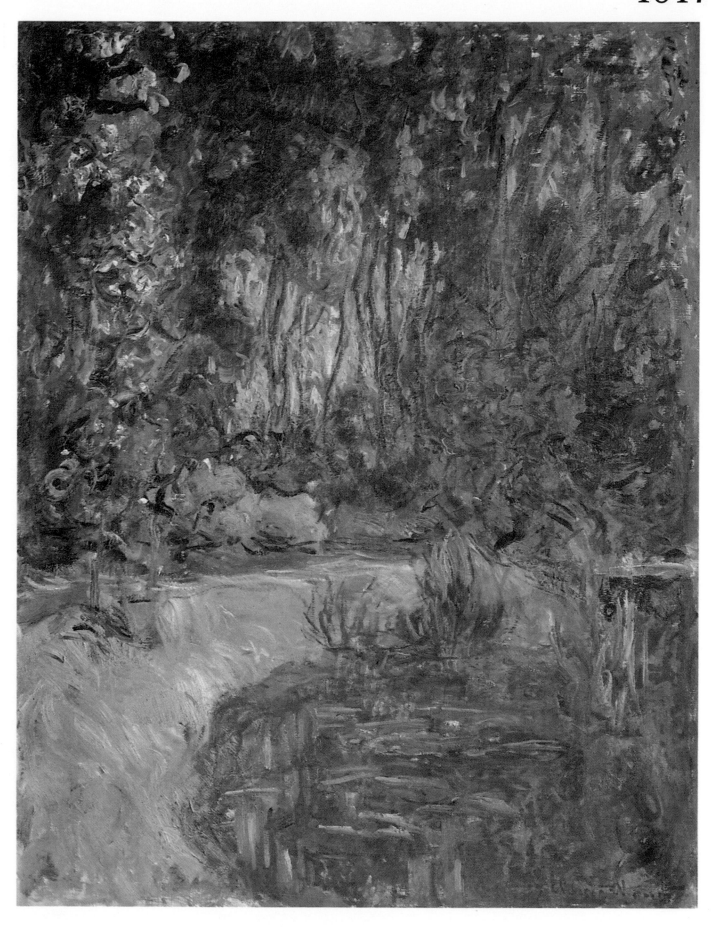

Coin de l'étang à Giverny

1917 - oil on canvas - 117 x 83
Musée des Beaux-Arts, Grenoble

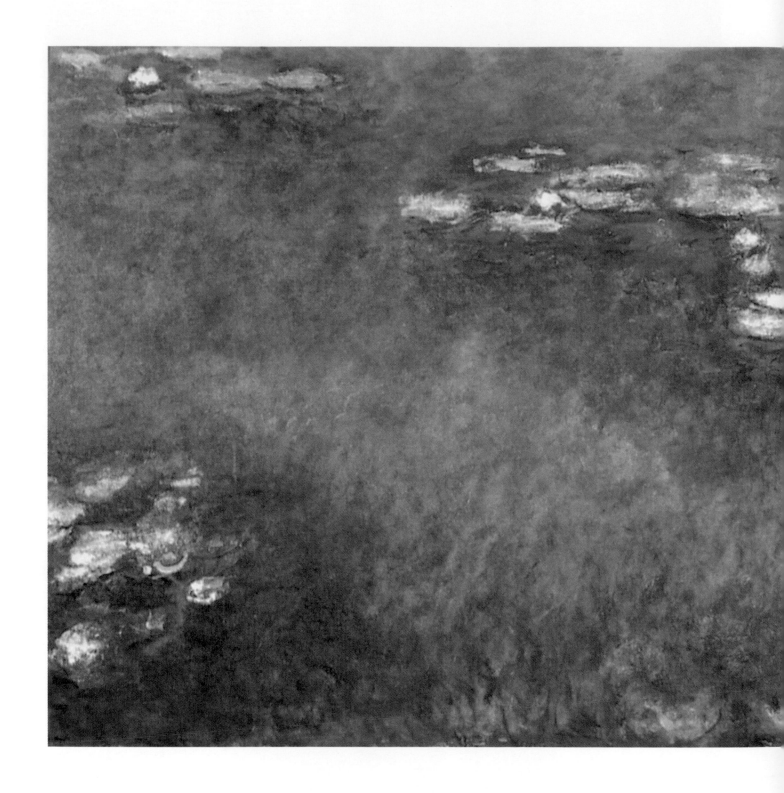

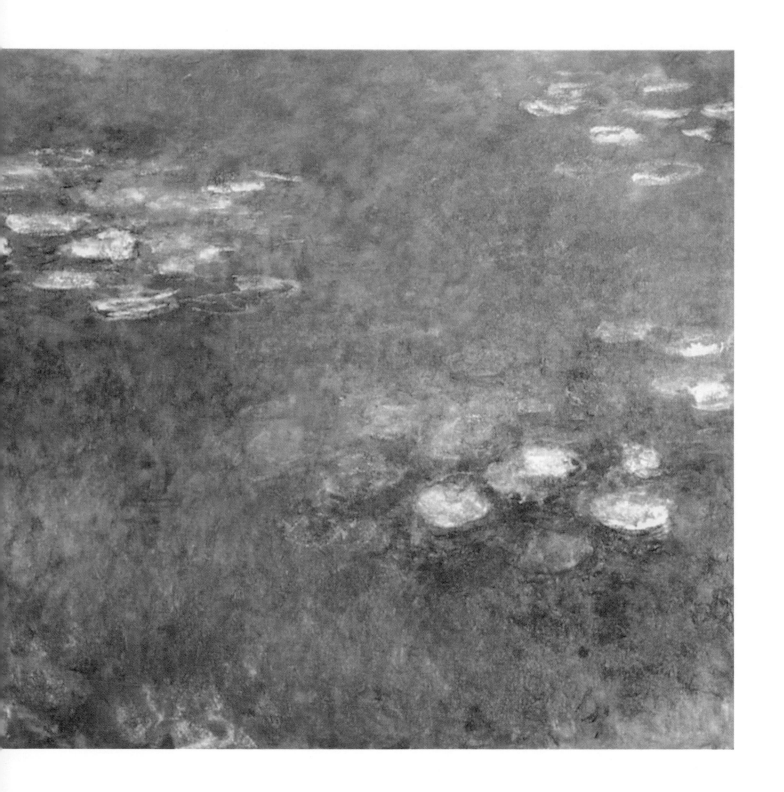

L'Agapanthe (center panel)

1914-26 - oil on panel
triptych: 200 x 425
St. Louis Art Museum, St. Louis

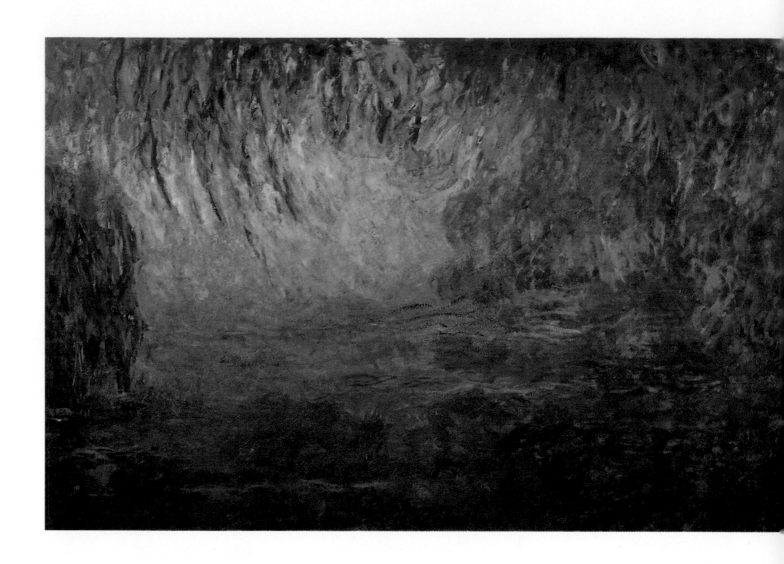

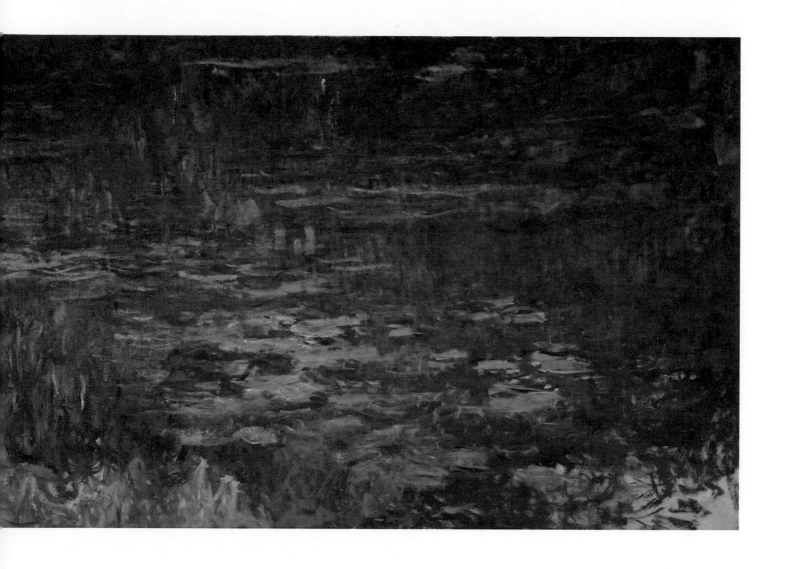

Nymphéas de l'Orangerie, soleil couchant

1914-26 - oil on panel
triptych: 200 x 425 each of three panels
Nelson-Atkins Museum, Kansas City

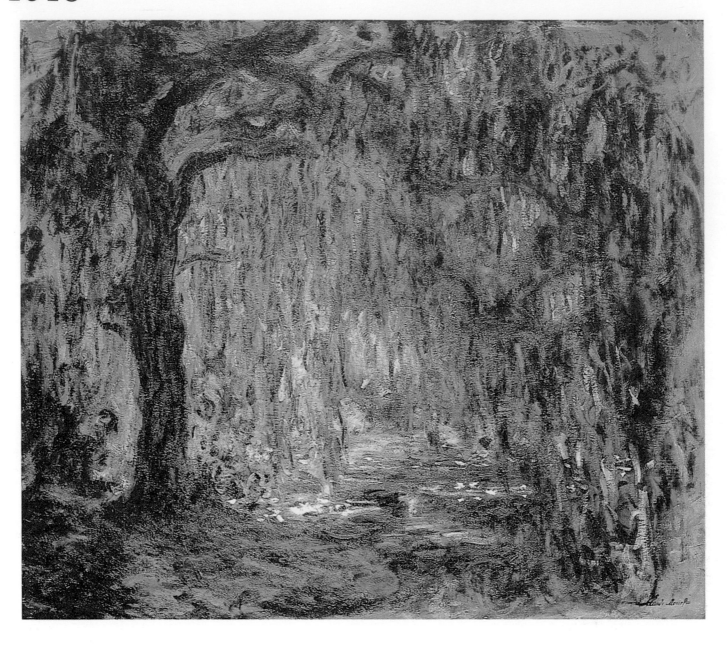

Saule pleureur

1918 - oil on canvas - 127.5 x 152.5
Private collection

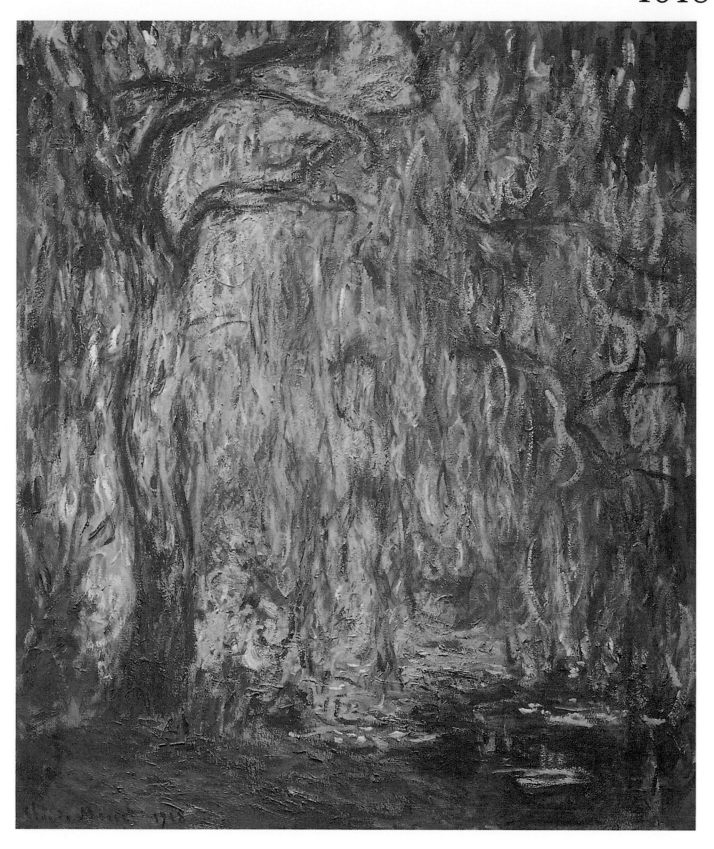

Saule pleureur

1918 - oil on canvas - 130 x 110
Private collection

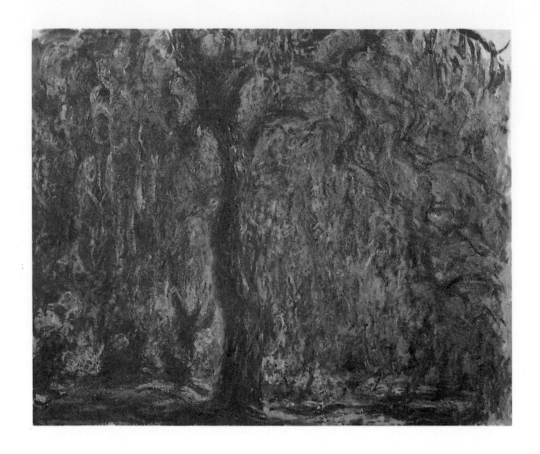

Saule pleureur

1919 - oil on canvas - 100 x 120
Musée Marmottan, Paris

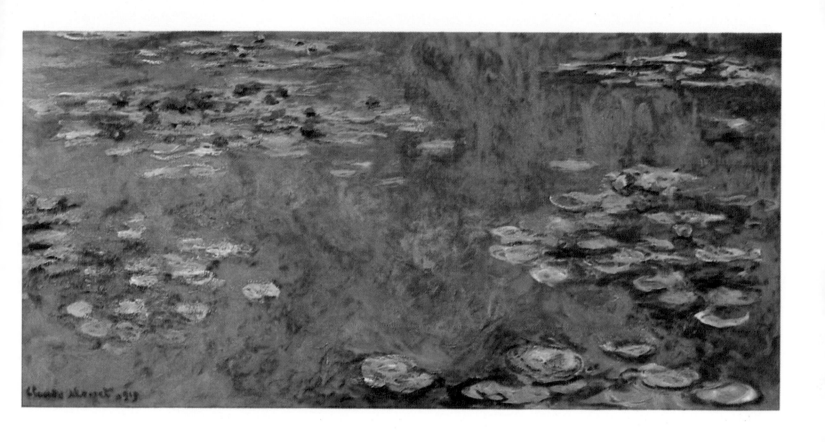

Le Bassin aux nymphéas

1919 - oil on canvas - 100 x 200
Private collection

352

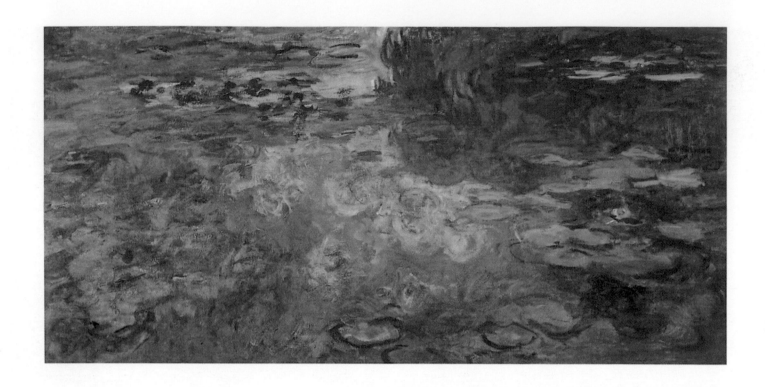

Le Bassin aux nymphéas

1919 - oil on canvas - 100 x 200
Private collection

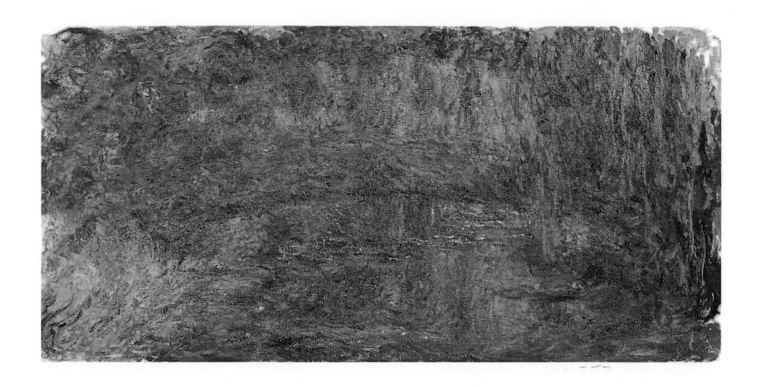

Le Pont japonais

1919 - oil on canvas - 100 x 200
Musée Marmottan, Paris

354

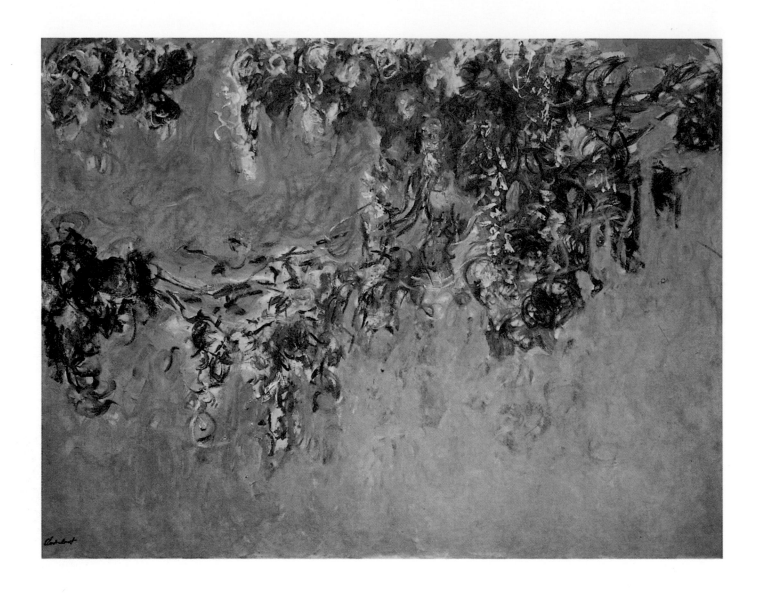

Glycines

1919-20 · oil on canvas · 150 x 200
Allen Memorial Art Museum, Oberlin, Ohio

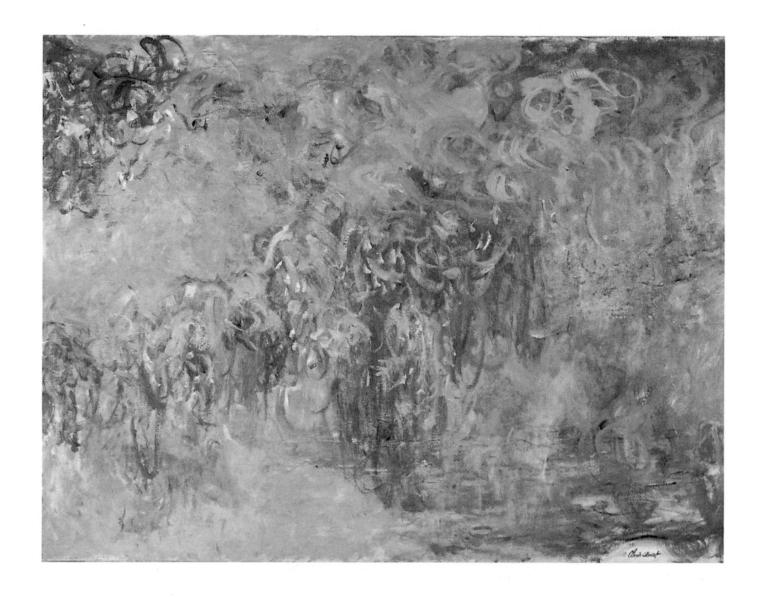

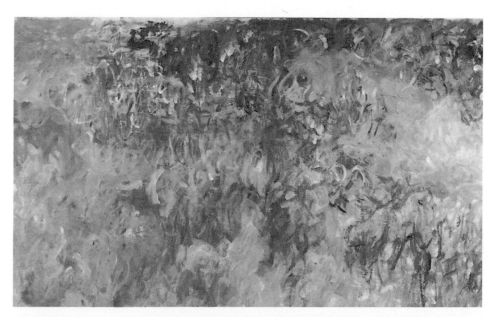

Glycines

1919-20 - oil on canvas - 150 x 200
Private collection

Glycines

1919-20 - oil on bois - 150 x 200
Private collection

Glycines

1919-20 - oil on canvas - 100 x 300
Musée Marmottan, Paris

L'Allée des rosiers, Giverny

1920-22 - oil on canvas - 89 x 100
Musée Marmottan, Paris

L'Allée des rosiers

1920-22 · oil on canvas · 81 x 100
Musée Marmottan, Paris

L'Allée des rosiers

1920-22 - oil on canvas - 73 x 105
Private collection

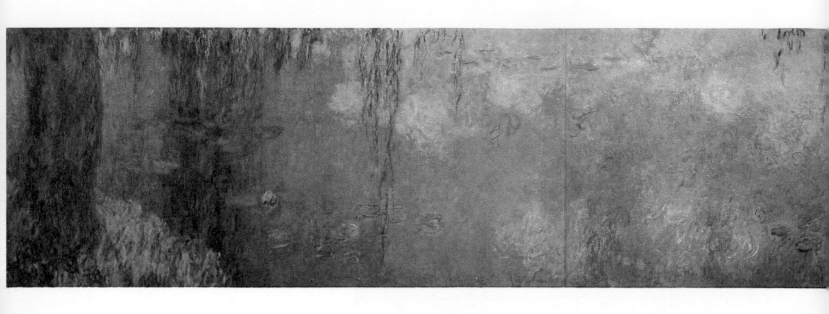

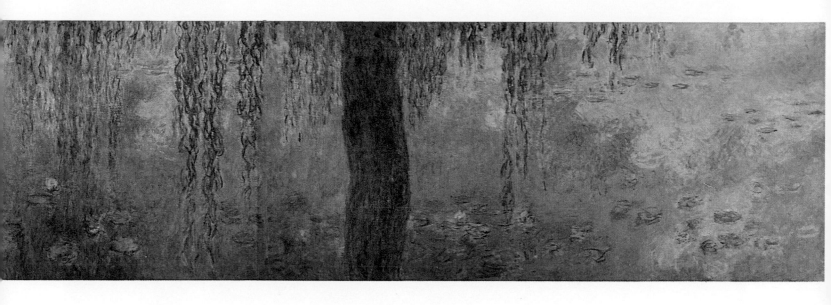

Le Matin aux saules,

1922 - oil on canvas - three panels 200 x 425 each
Musée d'Orsay, Paris

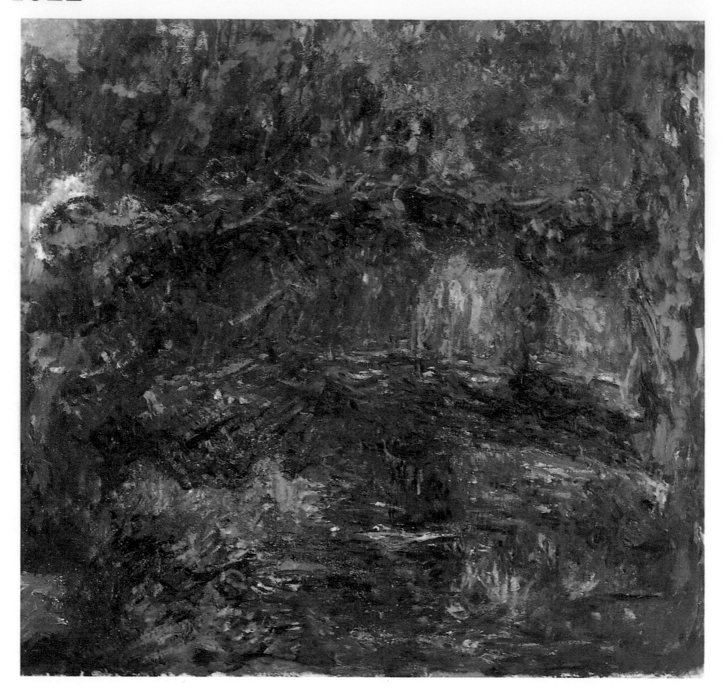

Le Pont japonais

1922-24 - oil on canvas - 89 x 93
Museum of Fine Arts, Houston

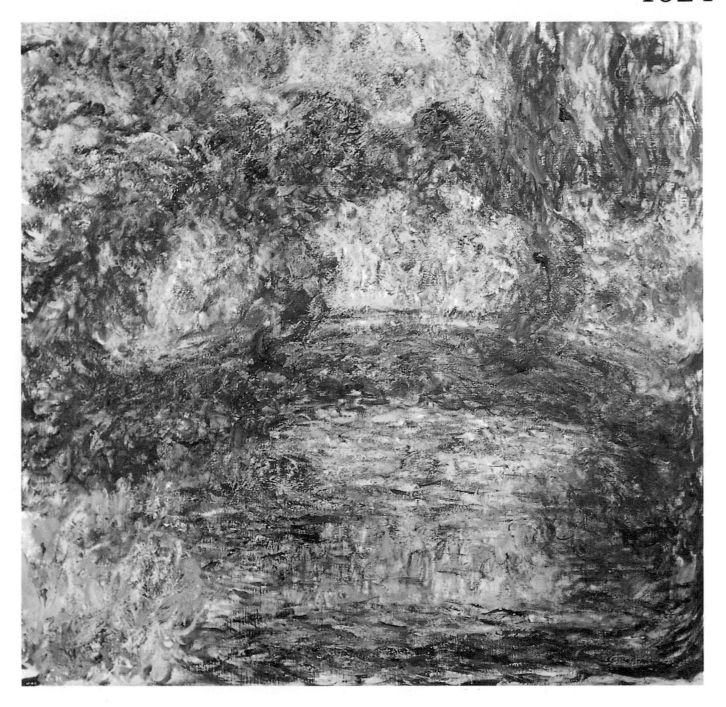

Le Pont japonais

1922-24 - oil on canvas - 87 x 90
Museu de Arte, Sao Paulo

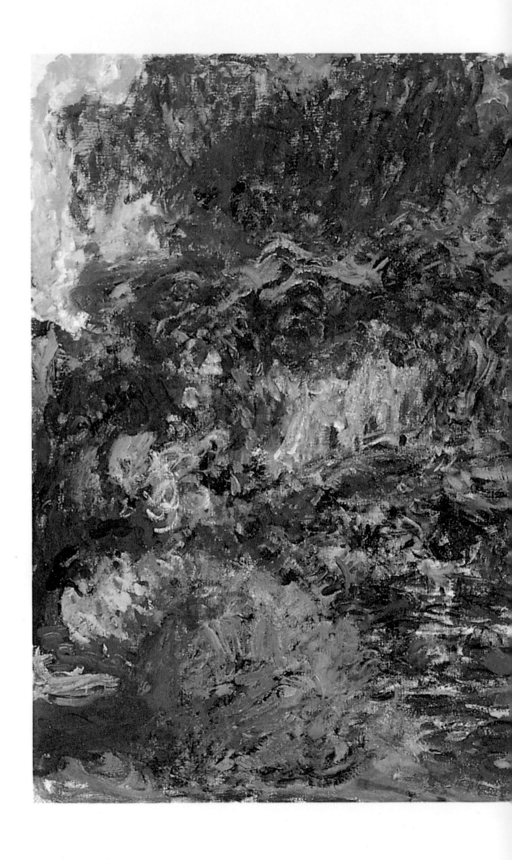

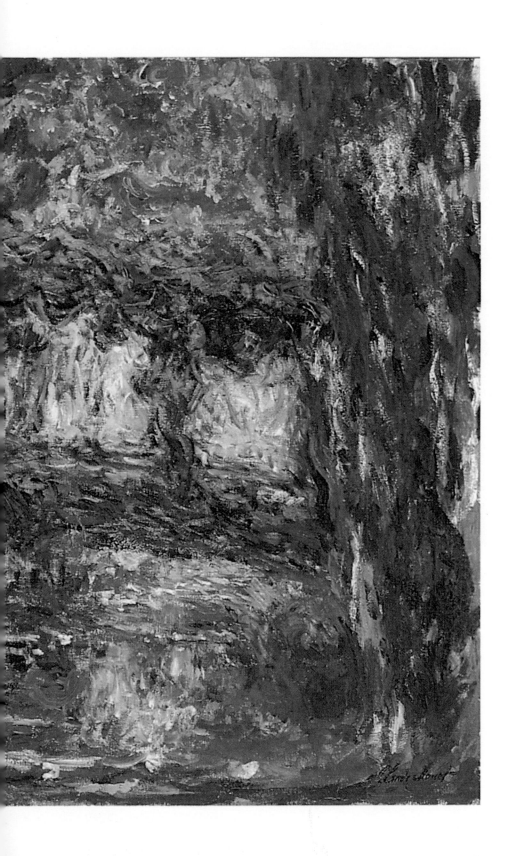

Le Pont japonais

1922-24 - oil on canvas - 89 x 116
Minneapolis Institute of Art, Minneapolis

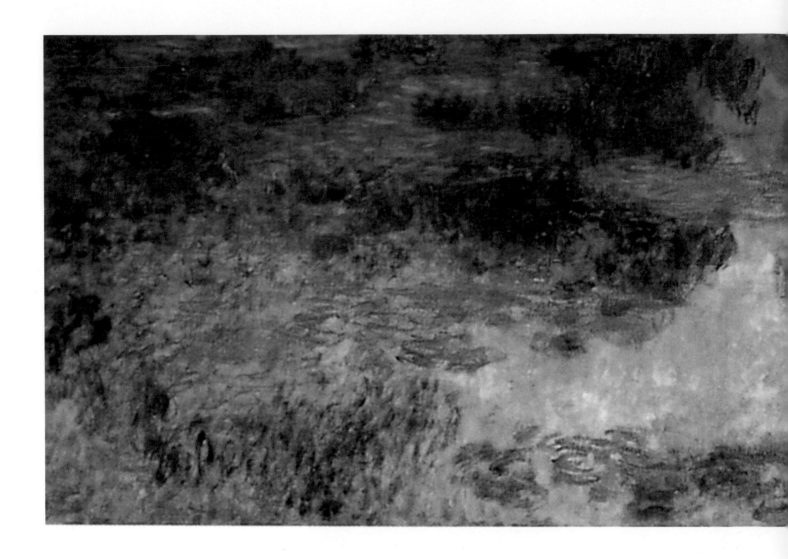

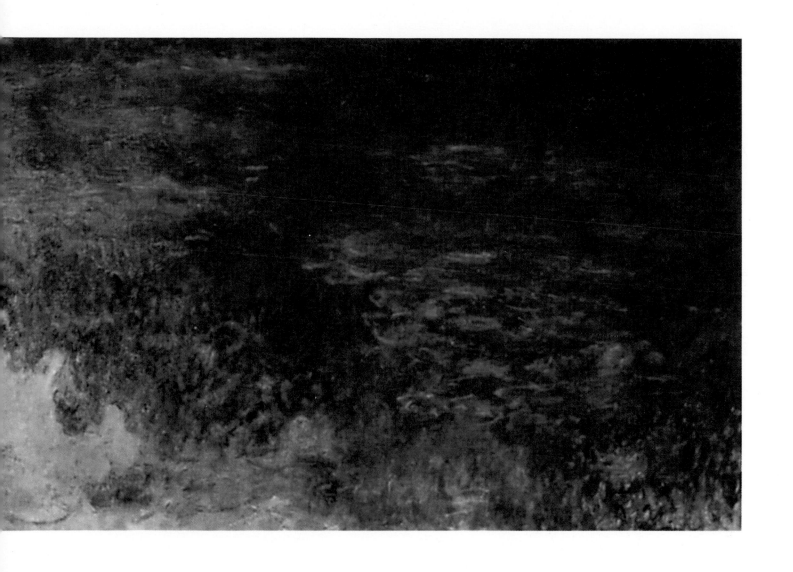

Le Bassin aux nymphéas, le soir

1922-24 - oil on canvas - two panels 200 x 300 each
Kunsthaus Zurich, Zurich

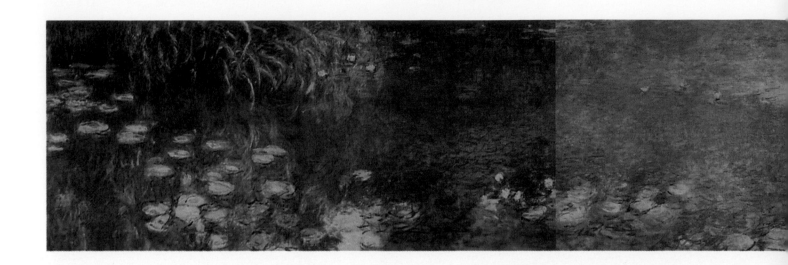

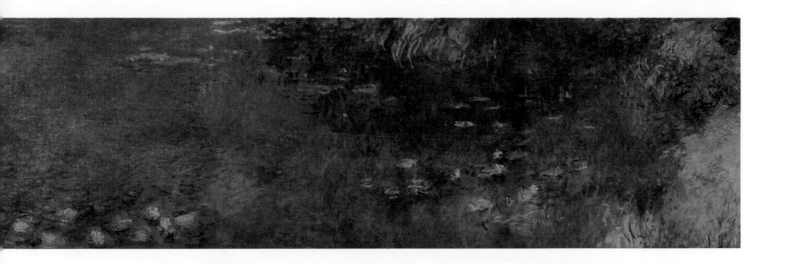

Le Bassin aux nymphéas sans saules, matin

1919-26 - oil on canvas on four panels:
200 x 212 - 200 x 425 - 200 x 425 - 200 x 212
Musée de l'Orangerie, Paris

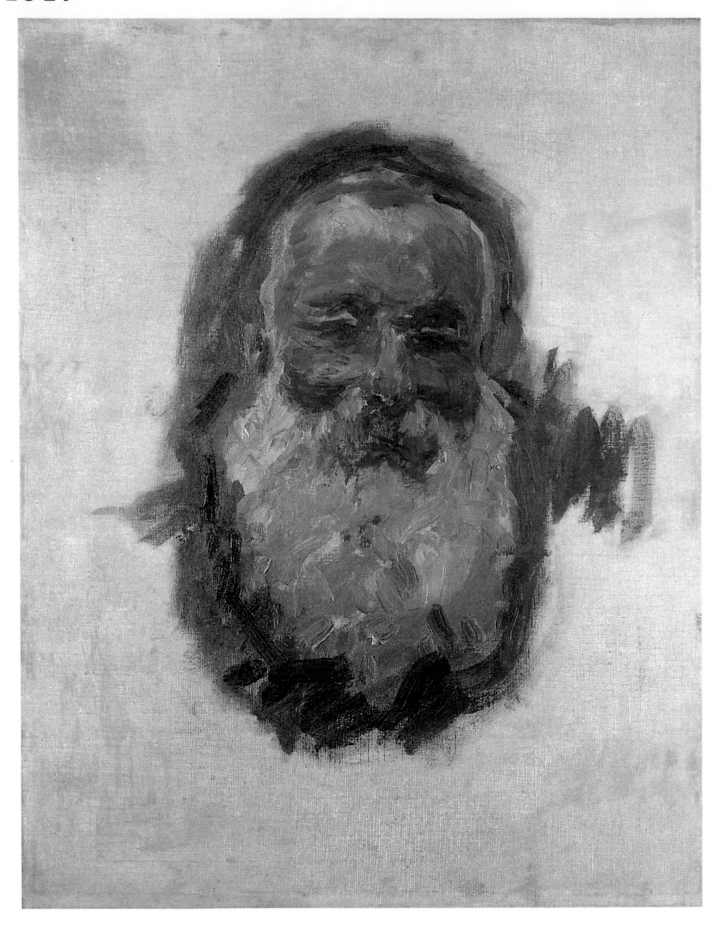

Self-portrait

1917 - oil on canvas - 70 x 55
Musée d'Orsay, Paris

INDEX

Composition : C2M Vernon
Photogravure : Minerve, Châtel-Censoir
Manufacturing : P.P.O., Pantin, France